WOMEN'S VOICES IN OUR TIME

STATEMENTS BY AMERICAN LEADERS

Edited by

Victoria L. DeFrancisco • Marvin D. Jensen
University of Northern Iowa

WAVELAND
PRESS, INC.
Prospect Heights, Illinois

> *To our mothers,*
> *Victoria and Mary*

For information about this book, write or call:

Waveland Press, Inc.
P.O. Box 400
Prospect Heights, Illinois 60070
(708) 634-0081

Table of Contents

Preface

My personal commitment to this project comes from being a feminist in academics. During the course of the research, I was forced to realize—on a very personal level—that the realm of public speaking tends to be elitist in several ways. In our country, the public forum has traditionally been defined by men of northern European descent. Consequently, in order to be more successful, women and others who attempt to speak out in public are often pressured to adopt traditional white male models. Public speaking has also been a forum largely distinguished by upper-class education values, which make it less accessible to others. Although it is necessarily limited, this collection is an important step in the documentation of women's attempts to claim the public speaking platform as their own. Each woman included does it with style, commitment, and competence.

I learned not only from their words, but also from the ways in which these women live their lives by their words. In choosing to present the speeches in context, rather than focus on critiques of the speeches as many textbooks do, we invite readers to form their own interpretations of the addresses, and to learn from the ways in which these women live their "eloquence" (as was so creatively shown in an alternative speech book by Foss and Foss, 1991).

Finally, what the reader may not know by reviewing the main text of this book is that the end product is an example of the way in which people can rise above their individual values and goals to accomplish a more important common good. Marvin and I had differing visions for the project, yet he remained the ever steady contributor. He kept the research moving forward. In the end, we were able to recognize our differences and maintain tremendous respect for each other. The book is the result of a truly collaborative effort. Thus the order of our names is alphabetical. I am grateful to him for the opportunity, the challenge, and the growth.

—Victoria Leto DeFrancisco

v

I want to express personal appreciation to my colleague and friend, Victoria DeFrancisco—and to the women in my life whose ideas have led me in new directions.

I look forward to the time when a book like this will not be necessary—a time when no voices are muted and leaders will be judged solely on the quality of their ideas. If we can create such a future, there will be volumes of new speeches with no reference to gender, race, age, or sexual orientation. For now, let us attend to the voices that have been restricted or silenced. Then, let us begin to value all human voices.

—Marvin D. Jensen

Acknowledgments

The editors wish first to thank the University of Northern Iowa for its support. The project was funded in part by the Department of Communication Studies, the Graduate College, and the Vice-President and Provost's Office. Special thanks to Judi Kikendall for her transcription and typing services through the duration of this project.

We also deeply appreciate the contributions of the following:Susan Allbee, Barbara Allen, Angela Allison, Marian Baker, Barnard College Wollman Library Archives, Marilyn Barnes, Sara Begus, Clea Benson, Chris Blair, Shelia Bland, Mary Bozik, Cynthia Ann Broad, Becky Burns, Mary Byrne, William Carmack, April Chatham, Trish Ciaravino, Columbia University Office of Public Information, Columbia University Rare Book and Manuscript Library, Columbiana, Camille Cruse, Bernard R. Crystal, and Cuyahoga Community College Library.

Also Barb Davis, Louise Fawcett, The Feminist Majority, Karen Foss, Sonja Foss, Ralph Frasca, Amy Gardner, Patricia Glenn, Rev. W. S. Grotewold, Jon Hall, Robert Hanrahan, Hartnell College Media Services, Hollee Haswell, David Hays, Cathy Henderson, Hope College Library, Constance Hunting, Arnold Ismach, Ithaca College, Wayne Jarvis, Kathleen Jespersen, KUNI, Julian P. Kanter, Lorraine Keller, Lawrence Kieffer, Olivia Armijo Killough, Jennifer King, Nancy Kirshner, Cheris Kramarae, and Laura Kress.

Also Vicki Langel, Sue Leary, Michelle Leto, Yan Li, Patsy Lynch, Jane E. Lowenthal, Stan Lyle, Dave Maley, Kim Maloy, Mirriam McLinden, Rosemary Meany, Tim Meier, Karen Mitchell, Monterey Peninsula College, Anne Morgan, National Organization for Women, The New York Public Library for the Performing Arts, Dan Nimmo, Office of the Governor—State of Texas, Office of Senator Charles Grassley, Deb Oliver, Omega Institute for Holistic Studies, Archana Pathak, Anna Perez, Laurie Prossnitz, Georgia Quirk, Martha Reineke, Joyce Rost, and Ann Russo.

Also Ryan Siskow, Wilma R. Slaight, Linda Smith, Robert Snyder, Laurel Stavis, Sherry Sylvester, Anita Taylor, The University of Iowa Women's Resource and Action Center, University of Northern Iowa Rod Library, The University of Oklahoma Political Commercial Archive, The

University of Texas Harry Ransom Humanities Research Center, Barbara Van Woerkom, Edward Wagner, David A. Walker, Faye Wattleton, Barbara Weeg, Wellesley College Alumni Office, Wellesley College Library Archives, Westbrook College, Western Theological Seminary Beardslee Library, The White House, Tim Wiles, Pat Wilkinson, Brad Williams, and Donna Zaccaro.

Photo Credits

Introduction

Voices of wisdom and inspiration and outrage, words that move and lead, are expressions of character—not reflections of gender. Yet, when these strong voices are feminine, the words are less often recorded and analyzed. Campbell (1991) has documented the small number of speeches by women in published anthologies, and Vonnegut (1992) has criticized the exclusion of female rhetors from the academic study of American public address. This collection, then, is one effort to let the voices of contemporary women leaders in the United States be heard, and allow their ideas to challenge both women and men. In editing this anthology, we have sought to be witnesses rather than critics—recreating the scenes and capturing the words so that readers may join the audiences.

"Contemporary" is an arbitrary designation, but we have chosen to begin with 1974—the year a little known congresswoman spoke of the requirements of honorable leadership. This black woman claimed the Constitution even as she clarified it. Twenty years later, an affluent white woman affirmed her commonality with all who suffer from AIDS—and called again for honorable leadership. From Barbara Jordan's statement to the House Judiciary Committee through Mary Fisher's challenge to the Republican convention, the selected speakers reflect varying goals and ideologies, yet each claims her right to be heard and her chance to make a difference.

"Leadership" is a concept subject to many definitions. Burns (1978) concludes that leadership in western culture has historically taken the form of "legitimated power"—authority made legitimate by "tradition, religious sanction, rights of succession, and procedures." These criteria of "legitimate" leadership, generally accepted by followers, have confirmed the authority of those already in power—and usually excluded minorities and women. The recent high rate of re-election of incumbents at all levels of American politics indicates the continuation of this pattern. Burns believes there is a need for leadership which derives from a new set of criteria: "integrity, authenticity, initiative, and moral resolve" (pp. 24–25).

The women whose speeches appear in this book are not leaders because of "legitimated power." Most of them have emerged in spite

of tradition. Some (e.g., Sister Theresa Kane and Bishop Leontine Kelly) address and exemplify departures from historic religious roles. Several have emerged by interrupting "rights of succession" (e.g., Barbara Jordan as a black representative from Texas and Elizabeth Holtzman by defeating 25-term Emmanuel Celler from Brooklyn). Some have made traditional procedures more inclusive (e.g., Mary Louise Smith as the first female chair of the Republican Party, Geraldine Ferraro as the first female Vice Presidential nominee of a major party, and Pat Cain as one of the first open lesbians to teach law in the United States).

Not all women speakers and leaders exemplify the new criteria suggested by Burns (and not all men lack them). But the speakers in this collection have been chosen with these criteria particularly in mind. Integrity, as demonstrated by consistency of positions and principles, is part of the credibility of such different women as Lillian Hellman, Faye Wattleton, and Barbara Bush. Authenticity, derived in part from personal struggle, leavens the words of Charlayne Hunter-Gault, Janice Payan, Ann Richards, and Theresa Kane. Initiative, reflected in the words and actions of Geraldine Ferraro, Mary Louise Smith, Barbara Jordan, and Cynthia Broad, is also demonstrated by Elizabeth Taylor (who uses her fame to draw attention to AIDS) and Maggie Kuhn (who calls on the forgotten aged to claim their own power). Perhaps most important is the moral resolve that many of the women in this book have shown in the risks they have taken—Anita Hill facing humiliation and derision, Molly Yard, Barbara Bush, and Mary Fisher facing hostile listeners, Theresa Kane challenging the Pope, and Nina Totenberg risking a prison sentence.

Recent discussions of feminine leadership styles (Helgesen, 1990; Watts, 1991: Rosener, 1991) suggest that we have much to learn from women regarding the very nature of leadership—including the feminine inclination to nurture others rather than seek power over them and the feminine tendency to value community achievement more than competitive victories. Several women in this collection (e.g., Smith, Ferraro, and Carolyn Heilbrun) are speaking about these qualities of leadership even as they exemplify them. Because these feminine leadership characteristics extend well beyond politics, we have included artists, teachers, journalists, religious and medical leaders, and social activists among the voices in this collection.

Vonnegut and Campbell have criticized the lack of published documentation of women's voices, and Vonnegut has particularly noted the minimal records of the words of American women prior to 1830. Vonnegut's concern for the "muted voices" was echoed recently by Angela Bowen, a black lesbian activist, who expressed a similar concern about contemporary women speakers—particularly those who represent a minority background or point of view. Bowen said: "We don't seem to be working very hard at passing down what we are doing. . . . We

exchange it a lot among ourselves . . . , but we miss these vast opportunities to keep educating, even people who are just a few years behind us, [to] keep the vision and the energy alive'' (Jensen, 1991c). (Ironically, Bowen's address—given at the University of Iowa on the day she made the preceding statement—is not included in this collection because the conference organizers lost the videotape.)

This collection is intended to provide and encourage such documentation of contemporary women's voices—including those who have too often been silenced because of race, age, sexual orientation, or unpopular views. We have also sought to document the speakers' intentions and approaches, as well as audience responses. When possible, we have interviewed speakers and listeners; these ''background voices'' are an important part of this book.

In addition to documentation, the preservation of women's speeches requires authentication. Establishing textual authenticity is a challenge that is not limited to muted speakers or lesser known statements. The Gettysburg Address has long been extant in five versions, all in Lincoln's handwriting, and each slightly different. Moreover, none of the five coincides exactly with the stenographic version which appeared in The New York Times one day after the speech—and a recently discovered manuscript has yet to be taken into account. Editing, then, becomes a process of making judgments—of aspiring toward authenticity—without presuming those judgments to be perfect or final. Editorial decisions can be complicated not only by multiple manuscripts, but also by technical impairments in recorded tapes, transcription errors (a surprisingly common flaw in records of government hearings), misspoken words or phrases, and extemporaneous departures from prepared manuscripts. Sometimes the goal of authentication seems to conflict with the goal of documentation due to the stipulations of some speakers that they be allowed to edit before publication. Not least, some of the speakers in this collection had the assistance of ghostwriters to a greater or lesser degree. Our judgment about ghostwriting is that the speaker is finally responsible for the words spoken and we have not investigated the creation of all the words.

Possibly the first step in accepting the limitations of authenticity is to recognize that a speech is complete only in its live presentation. Once documentation begins, authenticity inevitably decreases. Even a videotape compromises completeness by limiting the visual focus and excluding much of the listening behavior that affects and explains some of the speaker's words and behavior. What tape can fully capture the ''electricity'' that one listener remembers when Geraldine Ferraro spoke in the Indiana University Auditorium?

Reliance on a surviving manuscript (even the speaker's reading copy) presents further questions of authenticity because the manuscript obviously omits paralanguage and may not precisely reflect the actual

words that were said—including asides, extemporaneous additions, deletions, misstatements, and repetitions caused by audience interruptions. Which, for example, is more authentic: the text of Barbara Bush's Wellesley Commencement Address that was released to the press before she spoke, or the text later distributed by her press office—which includes some but not all of her departures from the advanced text? Or, it may be asked: why not rely solely on a transcription of the speech when such documentation is readily available in instances such as the Bush or Kuhn addresses? But does an exact transcription, including every repetition, nonfluency, self-correction, and spontaneous aside provide the desired historical documentation? Is not the "authentic" record of a public speech somewhat different from the verbatim record of testimony in a court of law?

As editors, we have concluded that judgments are part of our task, and we should work to preserve a text which faithfully conveys the speaker's intended language—which sometimes requires deletion of a misstatement or inclusion of a spontaneous departure from the prepared manuscript. We have found no reason to include vocal errors unless the speaker (e.g., Ferraro) did substantive extemporaneous rephrasing to repair the error. At the conclusion of each of the speeches in this collection, we have indicated the source of the text and the nature of the editing we or others have done. We believe that editing can serve authenticity, but only when editing is acknowledged.

We are keenly aware of other voices deserving to be heard and preserved which are absent from this collection. In some instances (e.g., Madalyn Murray O'Hair, Bylle Avery, Elizabeth Dole, Sarah Brady, and Kitty Carlisle Hart), we could not secure permission for speeches we wanted to include. In other instances (e.g., Betty Ford, Bell Hook, and Jeanne Kirkpatrick), we received no response to our inquiries. Surely, we have missed other voices due to the imperfections of our own research.

We are also concerned about speakers (e.g., Rosa Parks and Peg Mullen) whose words are muted because their extemporaneous speeches have seldom been recorded and do not transcribe well into manuscript form.

We regret that some recent important speeches are already lost. An example is Dianne Feinstein's statement to the Board of Supervisors when she became Mayor of San Francisco, December 4, 1978. Feinstein does not have a copy. The San Francisco History Room of the Public Library does not have a copy. The Board of Supervisors's *Journal of Proceedings* contains only a brief summary. *The San Francisco Examiner* made only brief references. The journalist who was present and quoted extensively for *The San Francisco Chronicle* may have made a stenographic copy—but he is dead. Thus, a voice called "collected and

compassionate'' (Gorney, 1978, p. A2) at a time of grave crisis is lost
to us.

In some instances (e.g., the speeches of Peggy Say), we have recovered
only fragments of longer speeches. Part of our continuing work is the
search for complete texts.

There are silences amid the voices in this collection. But we have tried
to fill part of the void described by Campbell and Vonnegut. We have
learned from the women in this book—and we invite readers to listen.

—Marvin D. Jensen and Victoria L. DeFrancisco

Barbara Jordan

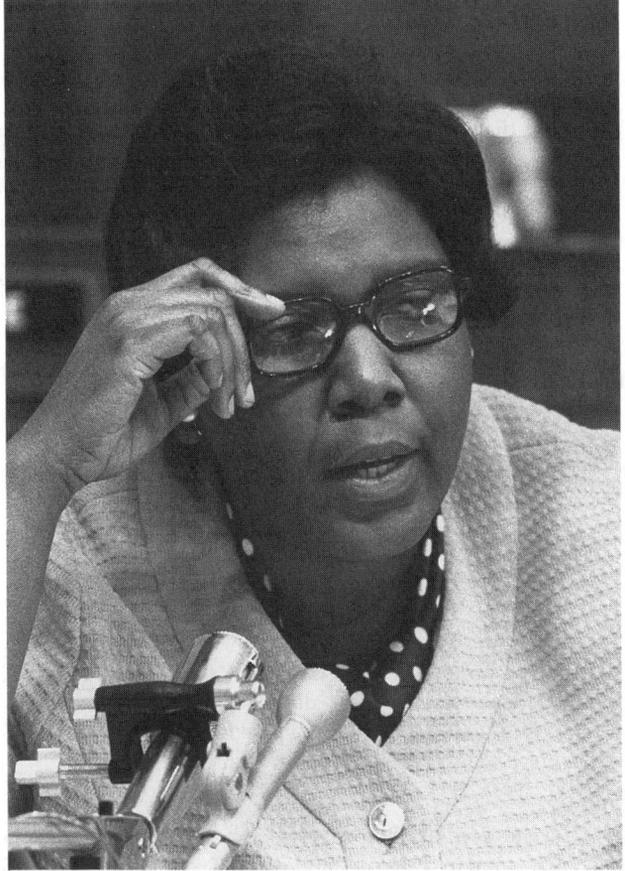

The possible impeachment of a president challenges the very nature of leadership. Such a process also requires the emergence of new leaders who must exemplify qualities which are lacking in the discredited leader. As described below, Barbara Jordan emerged as both a challenger of old leadership and a model of the alternative.

1

When the House Judiciary Committee began its impeachment inquiry in June 1974 it seemed a lackluster group made up of anonymities led by a nonentity. By the time it had finished its deliberations and voted to impeach the thirty-seventh President of the United States, it was a roster of stars. It had brought controversy, instruction, and stirring debate into the living rooms of America, and, as its televised proceedings continued, even inspiration and a measure of illumination.

Among the brightest stars in this new galaxy were two previously little-known women, Barbara Jordan and Elizabeth Holtzman. Perhaps they stood out at first mainly because they were women, but that was by no means all there was to it. Both were unusually gifted and would have attracted attention in any company. Both were articulate and felt strongly on the issues; beyond that, they proved to have qualities of character that suited them admirably to the task at hand: they were tough, uncompromising, intellectually rigorous—and dedicated to what they saw as their duty. (Edmondson and Cohen, 1975, p. 145)

Approach of the Speaker

Jordan addressed the Judiciary Committee July 25, 1974, and later reflected on her preparation:

[Chair] Rodino said: "This will be the format. . . . Each person on the committee will have fifteen minutes to make an opening statement on television."

Now, there were thirty-five of us. And I recall that when Rodino said that, I thought: I don't think that's necessary. I said: "Let's deal with the issue and make a decision on the basis of the facts we have accumulated to this point. We don't need speechmaking." But I did not have much support for that position. . . .

. . .

We arrived at the day for statements to begin, and the other people had prepared theirs, but I didn't have mine. I didn't intend to have an opening statement because I still didn't think that it was a good idea. All that speechmaking was a waste of the country's time, and the committee's time, and my time, was the way I felt about it then.

But of course it went right along as planned, with the committee members speaking all day and all night. It became apparent at some point that by the next evening they would get around to me, as we were proceeding by seniority. I was going to have to make a state-ment. Colleagues had come up to me all day to tell me: "I just can't wait to hear your opening statement. I want to hear what you have to say. I know you're going to let Nixon have it." I got this anticipation all day. One woman called up to say: "I have everything

figured out. You're going to be on at nine o'clock and I'm having half a dozen people come over to my house so we can sit there and listen to you. . . .''

So it was about five-thirty in the evening, and the Judiciary Committee was to reconvene at about eight-thirty. I went to my office and said to my assistant, Bud: "Would you believe the people who have come up to me today about my statement?" I was saying it in puzzlement; I knew there was nothing Bud could do about it. He asked: "Well, what are you going to say?" Now, Bud wanted to be perfectly clear that I really was coming out for impeachment. I told him: "Yes, I'm going to come out for impeachment. I have decided I am going to do that, and I am going to say why."

Then I told Marian Ricks, my secretary: "I know that you get off in fifteen minutes, but you're going to have to stay. I've got to write a statement, it seems." So while she was out there at her typewriter, I sat down at the desk in my office. It was now about six o'clock. I had all kinds of little disjointed notes that I'd written from all of my reading on impeachment. But I didn't have a statement. I had listened to statements for two days from other members. One thing that had struck me was how they had all started out by quoting the Preamble to the Constitution. Intoning about "We the People of the United States."

It occurred to me that not one of them had mentioned that back then the Preamble was not talking about *all* the people. So I said: "Well, I'll just start with that." I jotted down from this note and from that note and from this other note, and sent each page out to Marian when it was finished. I had already had my legislative assistant Bob Alcock parallel statements on impeachment—historical documents, Constitutions of the Confederacy, whenever impeachment had been talked about—against some of the offenses by Richard Nixon that we had talked about. So I also had that chart, that comparison about what had been said and what it was that Richard Nixon had done. (Jordan and Hearon, 1979, pp. 184–186)

Statement at the House Judiciary Impeachment Hearings

Mr. Chairman, I join my colleague, Mr. Rangel, in thanking you for giving the junior members of this committee the glorious opportunity of sharing the pain of this inquiry. Mr. Chairman, you are a strong man and it has not been easy but we have tried as best we can to give you as much assistance as possible.

Earlier today we heard the beginning of the Preamble to the Constitution of the United States, "We, the people." It is a very eloquent beginning. But when that document was completed on the 17th of September in 1787, I was not included in that "We, the people." I felt

somehow for many years that George Washington and Alexander Hamilton just left me out by mistake. But through the process of amendment, interpretation, and court decision, I have finally been included in "We, the people."

Today, I am an inquisitor. I believe hyperbole would not be fictional and would not overstate the solemnness that I feel right now. My faith in the Constitution is whole. It is complete. It is total. I am not going to sit here and be an idle spectator to the diminution, the subversion, the destruction of the Constitution.

"Who can so properly be the inquisitors for the nation as the representatives of the nation themselves? (*The Federalist Papers*, No. 65). The subject of its jurisdiction are those offenses which proceed from the misconduct of public men." That is what we are talking about. In other words, the jurisdiction comes from the abuse or violation of some public trust.

It is wrong, I suggest, it is a misreading of the Constitution for any member here to assert that for a member to vote for an Article of Impeachment means that that member must be convinced that the President should be removed from office. The Constitution doesn't say that. The powers relating to impeachment are an essential check in the hands of this body, the legislature, against and upon the encroachment of the Executive. In establishing the division between the two branches of the legislature, the House and the Senate, assigning to the one the right to accuse and to the other the right to judge, the framers of this Constitution were very astute. They did not make the accusers and the judges the same persons.

We know the nature of impeachment. We have been talking about it awhile now. "It is chiefly designed for the President and his high ministers" to somehow be called into account. It is designed to "bridle" the Executive if he engages in excesses. It is designed as a method of national "inquest into the conduct of public men" (*The Federalist Papers*, No. 65). The framers confined in the Congress the power, if need be, to remove the President in order to strike a delicate balance between a President swollen with power and grown tyrannical, and preservation of the independence of the Executive. The nature of impeachment is a narrowly channeled exception to the separation of powers maxim; the Federal Convention of 1787 said that. It limited impeachment to "high crimes and misdemeanors" and discounted and opposed the term "maladministration." It is to be used only for great misdemeanors, so it was said in the North Carolina ratification convention. And in the Virginia ratification convention: "We do not trust our liberty to a particular branch. We need one branch to check the others."

"No one need be afraid," it was said in the North Carolina ratification convention; "no one need be afraid that officers who commit

oppression will pass with immunity."

"Prosecutions of impeachments will seldom fail to agitate the passions of the whole community," said Hamilton in *The Federalist Papers*, No. 65, "and to divide it into parties more or less friendly or inimical to the accused." I do not mean political parties in that sense.

The drawing of political lines goes to the motivation behind impeachment; but impeachment must proceed within the confines of the constitutional term "high crimes and misdemeanors."

Of the impeachment process, it was Woodrow Wilson who said that "nothing short of the grossest offenses against the plain law of the land will suffice to give them speed and effectiveness. Indignation so great as to overgrow party interest may secure a conviction; but nothing else can."

Common sense would be revolted if we engaged upon this process for petty reasons. Congress has a lot to do: appropriations, tax reform, health insurance, campaign finance reform, housing, environmental protection, energy sufficiency, mass transportation. Pettiness cannot be allowed to stand in the face of such overwhelming problems. So today we are not being petty. We are trying to be big because the task we have before us is a big one.

This morning, in a discussion of the evidence, we were told that the evidence which purports to support the allegations of misuse of the CIA by the President is thin. We were told that that evidence is insufficient. What that recital of the evidence this morning did not include is what the President did know on June 23, 1972. The President did know that it was Republican money, that it was money from the Committee for the Re-Election of the President, which was found in the possession of one of the burglars arrested on June 17.

What the President did know on the twenty-third of June was the prior activities of E. Howard Hunt, which included his participation in the break-in of Daniel Ellsberg's psychiatrist, which included Howard Hunt's participation in the Dita Beard ITT affair, which included Howard Hunt's fabrication of cables, designed to discredit the Kennedy administration.

We were further cautioned today that perhaps these proceedings ought to be delayed because certainly there would be new evidence forthcoming from the President of the United States. There has not even been an obfuscated indication that this committee would receive any additional materials from the President. The committee subpoena is outstanding, and if the President wants to supply that material, the committee sits here.

The fact is that yesterday, the American people waited with great anxiety for eight hours, not knowing whether their President would obey an order of the Supreme Court of the United States.

At this point I would like to juxtapose a few of the impeachment criteria with some of the President's actions.

James Madison said in the Virginia Ratification Convention: "If the President be connected in any suspicious manner with any person and there be grounds to believe that he will shelter him, he may be impeached."

We have heard time and time again that the evidence reflects payment to the defendants of money. The President had knowledge that these funds were being paid and that these were funds collected for the 1972 Presidential campaign.

We know that the President met with Mr. Henry Petersen twenty-seven times to discuss matters related to Watergate, and immediately thereafter met with the very persons who were implicated in the information Mr. Petersen was receiving and transmitting to the President. Madison's words again: "If the President be connected in any suspicious manner with any person and there be grounds to believe that he will shelter that person, he may be impeached."

Justice Story: "Impeachment is intended for occasional and extraordinary cases where a superior power acting for the whole people is put into operation to protect their rights and rescue their liberties from violation."

We know about the break-in at the psychiatrist's office. We know that there was absolute complete direction in August, 1971, when the President instructed Ehrlichman to "do whatever is necessary." This instruction led to a surreptitious entry into Dr. Fielding's office.

"Protect their rights." "Rescue their liberties from violation."

The South Carolina Ratification Convention impeachment criteria: Those are impeachable "who behave amiss or betray their public trust."

Beginning shortly after the Watergate break-in and continuing to the present time, the President has engaged in a series of public statements and actions designed to thwart the lawful investigation by government prosecutors. Moreover, the President has made public announcements and assertions bearing on the Watergate case which the evidence will show he knew to be false.

Those who "behave amiss or betray their public trust."

James Madison said, again at the Constitutional Convention: "A President is impeachable if he attempts to subvert the Constitution."

The Constitution charges the President with the task of taking care that the laws be faithfully executed, and yet the President has counseled his aides to commit perjury, willfully disregarded the secrecy of grand jury proceedings, concealed surreptitious entry, attempted to compromise a federal judge while publicly displaying his cooperation with the processes of criminal justice.

"A President is impeachable if he attempts to subvert the

Constitution."

If the impeachment provision in the Constitution of the United States will not reach the offenses charged here, then perhaps that 18th century Constitution should be abandoned to a 20th century paper shredder. Has the President committed offenses and planned and directed and acquiesced in a course of conduct which the Constitution will not tolerate? That is the question. We know that. We know the question. We should now forthwith proceed to answer the question. It is reason, and not passion, which must guide our deliberations, guide our debate, and guide our decision.

This text is from Hearings of the Committee on the Judiciary, Debate on Articles of Impeachment, *U.S. House of Representatives, July 25, 1974. Minor editing has been done based on the version published in Jordan and Hearon, 1979, pp. 186–192.*

Responses to the Statement

Jordan writes of her speech: "We said what we had to say within our time span, and then we were through. The security was tight and no one applauded after you made a speech, so you didn't know how you had done" (1979, p. 186). When the Judiciary Committee adjourned for the evening, Jordan recalls seeing a crowd of people around her car in front of the Rayburn Building and being unsure of their intentions. She writes: "When I walked out the front door, they broke into this big cheer—screaming, 'Right on!' and waving fists in the air. And someone said: 'I knew that when you talked you were going to base whatever you were going to say on the law, if you had to go back to Moses.' And that was the first reaction I had to my speech" (Jordan and Hearon, 1979, p. 199).

In the following weeks, Jordan received many letters, from which the following responses are excerpted.

> You know why you are such a forceful speaker, because you are honest. . . . You should beg God to forgive you for your part in attempting to destroy a great man. As for the truth of what you say, your arrogance is exceeded only by your ignorance. . . . Your fifteen-minute statement to the committee was a literary masterpiece in my estimation. . . . Eloquence, forthrightness, incisive rationality, and dignity are rare qualities. Yet you, as a black woman from the South, vividly displayed these qualities. . . . Why don't you just shut up and quit crying in your beer and eliminate this self-pity? . . . I followed the televised Judiciary Committee hearing very closely and was most impressed with your cogency, articulation, and probity. You simply made me proud to be an American. . . . Your voice is

like listening to the most brilliant symphony. . . . This white, Yankee Republican would be honored at some future date to campaign for our 1st black, 1st woman President. If you were the candidate . . . You have changed the minds of myself, my wife, our relatives, and all our friends. . . . Your scholarship was breathtaking; your logic convincing; your sincerity unimpeachable. . . . When your time came, you were ready. (Jordan and Hearon, 1979, pp. 193–199)

Dan Rather (1979) reflected five years after her statement: "Her success was in part due to her ability to hold herself somewhat apart from and some would say above the crowd. She was different and it showed to her colleagues and to a huge national television audience."

Elizabeth Holtzman

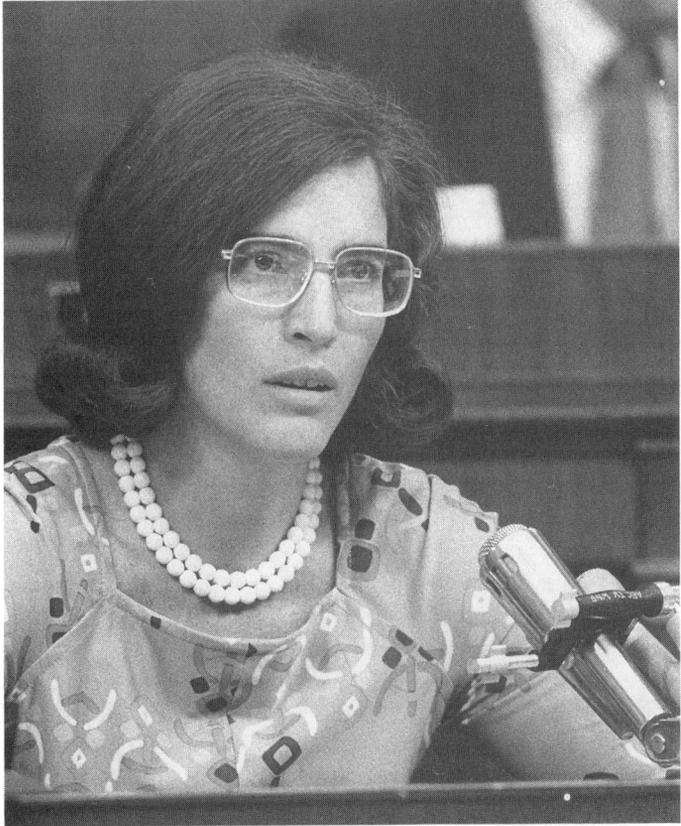

Background

Elizabeth Holtzman, Representative from the 16th Congressional District in Brooklyn, NY, also spoke during the televised House Judiciary hearings on the impeachment of President Richard Nixon. Speaking at the evening session on July 25, 1974, Holtzman was heard by millions of television viewers.

9

Approach of the Speaker

Elizabeth Holtzman had promised when entering Congress in 1972 that she would remain only as long as she retained a "sense of outrage." Edmondson and Cohen (1975) confirm that "every viewer of the Judiciary Committee hearings knows [that] Liz Holtzman has a capacity for sustained outrage" (p. 151). Yet, a congressional staff member observed in Holtzman a subdued manner in the period before the impeachment hearing. "All of a sudden, she became absolutely quiet. She just didn't say a word, it seemed, for the longest time. And when she finally did begin to speak out, you could tell she had grown. You always had to respect her intelligence, the way she did her homework, and her will, which is tremendous. But now, there was something else there to respect" (Phillips, 1974, p. 74).

Although Holtzman was an ardent opponent of Richard Nixon, she found no pleasure in the impeachment process. She said later that she was pleased if her participation made a favorable impression on people, but she added: "It was . . . horrible. The things we were dealing with weren't exhilarating. They were depressing and very saddening and horrifying and frightening" (Edmondson and Cohen, 1975, p. 154).

Statement at the House Judiciary Impeachment Hearings

I want to join with the other members of this committee in thanking you for conducting these proceedings with dignity and fairness consonant with the solemnity of the occasion.

Mr. Chairman, as we sit here to measure President Nixon's conduct against the standard set in the Constitution of the United States each one of us has questioned what the Constitution means and what duty our oath of office imposes on us, and each member on this committee is publicly groping for the right thing to do.

I am overwhelmed by the stark contrast this presents to the President's words and actions. Nowhere in the thousands of pages of evidence presented to this committee does the President ask what does the Constitution say? What are the limits of my power? What does my oath of office require of me? What is the right thing to do?

In fact, those thousands of pages bring to light things that I never even dreamed of when this proceeding began.

Wherever we looked in this inquiry we found Presidential conduct that was sorry and disgraceful. Mr. Nixon allowed the people's tax money to be used for the enrichment of his personal properties. Hiding behind the enormous respect for his high office, he failed to report

income and claimed tax deductions totaling almost $1 million. He appointed and kept in office as Cabinet members and close advisers persons whom he knew to be seriously unfit. He repeatedly and knowingly deceived the American people who trusted him and wanted to trust him. He surrounded the highest office in this land with scandal and dishonor.

The thousands of pages before this committee are witness, in my opinion, to a systematic arrogation of power, to a thoroughgoing abuse of the President's oath of office, to a pervasive violation of the rule of law. What we have seen is a seamless web of misconduct so serious that it leaves me shaken. And what affects me most deeply is the evidence that Richard Nixon sought to subvert the two essential principles that have shaped and preserved our 198-year history as a free people. He has obstructed, impeded, and corrupted the workings of our system of justice and he systematically used the awesome power of his office to invade the constitutional rights of the people.

Some have said there is no direct evidence. It is for this reason that I want to show, using examples from Watergate, that it is principally out of the President's own mouth and through his own words that we find the strongest evidence of the high crimes and misdemeanors he has committed.

Watergate—June 17, 1972—five men working on behalf of the President were arrested for breaking into and bugging the Democratic National Committee Headquarters in Washington. Nowhere in the thousands of pages of evidence do we find any suggestion that President Nixon tried to bring all the facts he knew to light or to bring to justice those responsible for this act. Instead, the evidence suggests that he consistently tried to prevent the truth from coming out.

Six days after the break-in, Mr. Nixon ordered the CIA to limit the FBI's investigation. The CIA was told that it was the President's wish that the investigation stop with the five suspects that had been arrested, and in fact the FBI investigation was impeded and contained.

In the fall of 1972, President Nixon specifically ordered that the House Banking and Currency Committee investigation into Watergate be stopped. In his own words, Nixon told his men to "screw this thing up," and in fact the House Banking and Currency Committee's investigation was stopped before it even started.

By March 1973, we find the President plotting to thwart fact finding by the Ervin committee in the Senate.

On March 22, the President contemplated a number of courses of action. The first was in his words, "I want you all to stonewall it. Let them plead the Fifth Amendment, cover up or anything else, if it will save it, save the plan."

And in fact two of Mr. Nixon's closest aides were indicted for perjury

before the Senate subcommittee.

A second scheme was to avoid the Senate select committee by going to the grand jury and these are the directions the President gave to his aides for testifying before the grand jury and I quote:

"Just be damn sure you say 'I don't remember,' 'I can't recall,' 'I can't give any honest, an answer [sic] to that that I can recall,' but that is it."

And in fact Ehrlichman and Mitchell were indicted for committing perjury before the Watergate Grand Jury on the grounds they stated they could not remember.

It is clear to me that the President was approving or at least acquiescing in hush money payments [in an] amount of over $400,000 to buy the silence of Watergate burglars. The President discussed the matter of paying Hunt ten separate times in a conversation on March 21 with Dean and Haldeman and the last time the President discussed it he said, and I quote:

"That's why for your immediate thing you have got no choice with Hunt but the 120, or whatever it is. Right? . . . Would you agree that that's a buy time thing? You better damn well get that done, but fast. Well, for Christ's sake, get it."

Perhaps some people find ambiguities in that conversation. I don't.

On the subject of executive clemency, the record is clear and convincing. For example, in April of 1973, the President was afraid that Magruder would reveal Haldeman's role in the Watergate break-in to the Special Prosecutor. President Nixon told his aide Ehrlichman to try to soften Magruder's testimony by showing the President's personal concern for Magruder and thus suggesting executive clemency. These are the President's words:

"I would say, 'Jeb, let me just start here by telling you the President holds great affection for you and for your family.' Also, I would first put that in so that he knows I have personal affection. That is the way the so-called clemency has got to be handled." And Ehrlichman reported back to the President that the clemency message was transmitted to Magruder.

In late March and April 1973, the President tried to obstruct the renewed investigation by the Watergate Grand Jury and the Department of Justice. After John Dean had confessed to the President his own pre-break-in involvement and that of Haldeman, Ehrlichman and Colson, the President on March 27 instructed John Ehrlichman to tell the Attorney General of the United States, Richard Kliendienst, an untruth. These were the President's directions to Ehrlichman:

"I think you have got to say Dean was not involved, had no prior knowledge. Haldeman had no prior knowledge, Ehrlichman had none. And Colson had none."

And Ehrlichman transmitted the message.

During the period from April 15, 1973, to April 30, 1973, the President personally spoke twenty-seven times with the Acting Attorney General, Henry Petersen, who was in charge of the Watergate investigation. The President lied to Petersen. The President obtained confidential information from Mr. Petersen which he then used to coach witnesses, and despite all of the information President Nixon had about his aides' involvement in Watergate, he held back what he knew and told Petersen nothing.

To this day, President Nixon has never told all he knows about Watergate to any investigating body. And to this day, President Nixon continues to impede an investigation, this time our committee's constitutional inquiry. He has given us partial documents representing them to be complete. He has given us tape recordings containing unexplained silences, and he has refused to comply with our lawful subpoenas for tape recordings and documents. This on top of the fact that he permitted a critical tape held in his sole possession to be erased— after a subpoena for it was issued by the Special Prosecutor.

In sum, since almost June 17, 1972, Mr. Nixon has tried to hide incriminating evidence about his involvement and that of his aides in the Watergate coverup. First, by attempting to prevent investigations from taking place. And when he could not prevent such investigations, by encouraging witnesses to lie about the incriminating evidence. And when he could not get witnesses to lie about incriminating evidence, by withholding that incriminating evidence. And when he could not withhold that incriminating evidence, by allowing that evidence to be destroyed.

And what is even more disturbing to me is that the illegal burglary and wiretapping, the obstruction of justice that is so painfully clear in the Watergate matter, was not an isolated instance of wrongdoing. We have seen that the President authorized a series of illegal wiretaps for his own political advantage, and not only did he thereby violate the fundamental constitutional rights of the people of this country but he tried to cover up those illegal acts in the very same way that he tried to cover up the Watergate. He lied to the prosecutors. He tried to stop investigations. He tried to buy silence, and he failed to report criminal conduct.

And if this weren't enough, the President misused the CIA and the FBI by trying to get them to execute the plans for the illegal surveillance and burglary, and to carry out the coverup of these acts.

Mr. Chairman, I feel very deeply that the President's impeachment and removal from office is the only remedy for the acts we have seen. First, because the Presidential coverup is continuing even through today. There is no way it can be ended short of the President's removal. And

second, because the violation of the people's constitutional rights has
been so systematic and so persistent, I must conclude that it is only
through the President's removal from office that we can guarantee to
the American people that they will remain secure in the liberties granted
to them under the Constitution.

This text is from Hearings of the Committee on the Judiciary, Debate on Articles of
Impeachment, *U.S. House of Representatives, July 25, 1974. The editors have made minor
corrections in grammar and punctuation.*

Responses to the Statement

One journalist wrote a week after Holtzman's statement:

> The cause of female recognition in the political field has surely been
> dramatically advanced by the impressive performance of the only
> two women on the House Judiciary Committee. . . .
>
> Even though they are merely in their first terms, Barbara
> Jordan . . . and Elizabeth Holtzman . . . had already gained the respect
> of their male colleagues, but it took national television to show the
> American public just how effective congresswomen can be when they
> are given the right opportunity.
>
> Millions of citizens must have improved their knowledge of the
> Constitution by listening to them. . . . Miss Holtzman was notably
> useful in helping the public to understand the modern method of
> drafting charges against defendants. (Fritchey, 1974, p. A17)

A more personal, light-hearted response came from one of her "peers."
Judith Martin (1974) identified herself as one of the "quintessential
American women—a slim, thirtyish, attractive, brown-haired person
with oversized glasses who is interested in getting at the truth of things."
Unfortunately, she wrote, this "American woman" was usually found
on television "applying rigid and important tests to different kitchen
floor waxes, and making forthright statements about how to get the
insides of the collars of men's shirts clean enough so that the men
wouldn't scold." But after the televised impeachment hearings, Martin
could write: "Elizabeth Holtzman, this is a valentine to you, from some
of us who had heard that democracy meant being represented by one's
peers, but who never had a peer of our very own in government until
you came along. We looked at you on the televised Judiciary Committee
hearings, and we decided—that we love you" (p. M14).

Not everyone, of course, appreciated Holtzman's statement nor her
vote. She found from her mail that "many people thought that

the . . . break-in at Ellsberg's psychiatrist's office was perfectly fine—
because Ellsberg was a traitor.'' She said such responses show that these
people ''have no perception of what democracy is all about''
(Edmondson and Cohen, 1975, p. 156).

Lillian Hellman

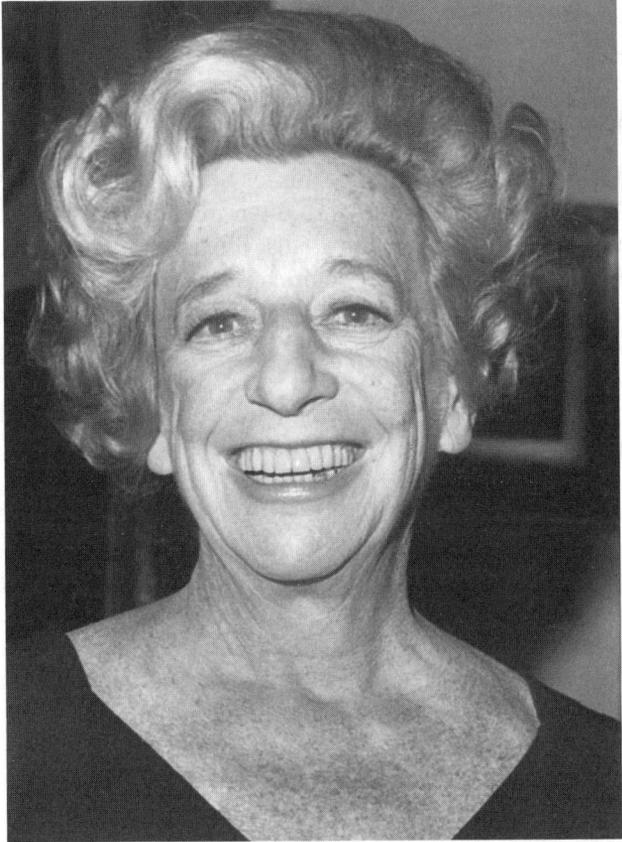

Background

Lillian Hellman is remembered as the playwright who created *Watch on the Rhine*, *Toys in the Attic*, and *The Little Foxes*. She is also remembered as a far left political activist who was both a victim of the McCarthy era and a brave voice against it. Her later writings included

the memoirs *An Unfinished Woman* and *Pentimento*. The speech which follows was given in the year following Richard Nixon's resignation and the year before publication of *Scoundrel Time*, the memoir of her struggle with McCarthyism. Thus, political abuse of power and personal response to such abuse were natural themes. She spoke on May 14, 1975, to the graduating class of Barnard College, at a special ceremony during which candidates for Bachelor of Arts degrees were presented to the President of the College.

Approach of the Speaker

Lillian Hellman said she did not like to give speeches, but nonetheless her public statements were often memorable. She spoke frequently at political meetings in the 1940s. She testified courageously when called before the House UnAmerican Activities Committee in 1952. She responded to a standing ovation at the 1977 Academy Awards by chastising the Hollywood audience for "its superficiality and its materialism" (Wright, 1986, p. 378). Her public statements often expressed outrage against perceived injustice and hypocrisy, reflecting her comment to an interviewer that "anger . . . carried me like a lifesaver" (Moyers, 1986, p. 145). Her style and motivation as a playwright, memoirist, and speaker are suggested in her statement: "There are no new situations basically, but there are new ways to say anything, new eyes to focus on any scene. Good writing is saying old things differently" (Moody, 1972, pp. 183–184). Hellman was often at odds with her apparent allies—a liberal who saw many liberals as weak, an independent woman who criticized the focus of the women's movement. When asked about the passage in the following address where she criticized preoccupation with "who carries out the garbage," Hellman said: "I don't think it's of any great moment who carries out the garbage. I think it is important that people be economically equal. So that if somebody feels like walking out, there's a way for her to earn a living rather than suffering through a whole lifetime because she can't" (Doudna, 1986, p. 204). "The problem," she said on another occasion, "was not whether a woman ought to wear a brassiere, but whether she could afford to buy one" (Feibleman, 1988, p. 182).

Never interested in telling her listeners only what they wanted to hear, Hellman wrote and spoke her independent views. She was a leader, but never a cheerleader.

Commencement Address at Barnard College

I hope this is a happy day for you. Because tomorrow you will join the rest of us. I do not mean to say that life is full of trouble, but there is, of course, trouble ahead for anybody who leads a full life. That's the way it always has been, that's even the way it should be.

I say this now because it has often seemed to me that we were unprepared by teachers and parents for the time ahead of us. Americans, unlike any other people in the world, have a deep historical belief in something called "happiness."

In their efforts to make us feel more "secure"—that awful new word—the people who bring us up tell us very little about a real world. The belief that all ahead is going to be "good" comes from a view of what never was, what our elders never found for themselves. There was a time when this hopeful babbling brook in the American character did have a kind of truth.

We were a large rich country, the opportunities were great, the system for the white man was mostly unoppressive, the lowest man could be President. And here, indeed, we were right. The lowest man has been President. And Mr. Nixon's surrounding clean-cut kiddies did come up from nowhere, and did undoubtedly fulfill the hopes of their mothers and fathers as they sat spinning new tricks in a new language in the White House.

It is natural enough that older people would believe that the young will be able to skip their struggles and go on to something easier and better. Life in America has indeed become easier for most people: the car is more efficient than the horse; death in childbirth has sharply fallen; certain diseases have totally disappeared; and even a kind word can be said occasionally for a computer. Almost everything is better. Everything is so much better that we have been blinded into thinking that not much could go wrong.

But it has gone wrong. In the South, when I was born, there still remained an intense interest in personal rights and freedom. For the white man, of course, only for the white man. But that at least is better than for no man at all. That concern with personal freedom permitted eccentricity, and made for an interesting people. The excellence of Southern writers in our time has proved that.

But now the South, almost in the lead, accepts what has come upon us: the overactive state of the powerful and the overpassive state of the powerless. Both groups know perfectly well that the country is controlled by big business, and that big business has large controls over government. Such controls have now become so open that the titans of the nineteenth century, usually observing some rules of the country

club manners, hired smaller men to do their dirty tricks.

Within the last few years, it is evidently considered extravagant to waste money on such messengers; the milk people go themselves to the White House, Mr. Geneen of I.T.T. goes directly to the CIA with proposals for Chile, a number of airlines sent their presidents and one airline worked out a new system of ticket forgery to hide its illegal contributions to Mr. Nixon.

And yet parents and teachers are old enough to remember Mr. Nixon's California history, his time on the House UnAmerican Activities Committee, his lies and his trickery in the 1950s. But there seemed little interest in stopping him on his long run for his Presidency. Many people thought a man's past should not be held against him, and when you said that, you proved yourself something called tolerant. That, by the way, has become a remarkable word in our language, and you will hear it misused every day.

I have been teaching for many years, watching with great interest the changes in action and thought of those I taught. I was impressed, and I still am, at how much better educated you are, how much better kind of grown-up you are than the people I went to college with. But for a long, long time I wondered why the world, the outside world, the world of their country, so little concerned the people I was teaching.

They read carefully, they seemed to understand what they read, but they understood in space. The plays of Shakespeare, for example, were admitted to be great, but the actions of kings, the ambitions of princes, the murders, the nobility, the venality, were read as having happened in a long ago forgotten world. No strings in the plays led students to their own lives, there were no reflective nods of recognition toward their own vanities or ambitions or to what was happening in the world.

Even Mr. Ibsen's more recent Nora, having slammed the door and opened it for women's liberation, was embraced by students, but not really recognized for what she did, or couldn't do. It seems to me that the true wisdom of the play is contained in a story about Henrik Ibsen and the critic, George Brandes.

They were taking a walk on a wintry day in Oslo. They passed an open park with a great wind blowing through it. The park was empty except for a middle-aged woman sitting on a bench. Ibsen shook his head and said, "Poor lady." Brandes said, "I have always wanted to ask you. Whatever happened to Nora?" Ibsen turned round, pointed back to the lady on the bench and said, "That is Nora."

Ibsen was saying, of course, what is still the basic problem: how can there ever be liberation of women unless they can earn a living? The talk of brassieres or no brassieres, who carries out the garbage can or washes the dinner pots, whether you are a sex object—whatever the hell that is—has very little meaning unless the woman who slams the

door can buy herself dinner and get out of a winter wind.

In 1961, something began to happen. It was the beginning of the student movement. It had not occurred to me that I would ever again watch young people protesting the values on which they had been raised. This is not to say that I approved of everything that was done, or even understood it. But whatever were the mistakes of the youth movement, and there were many among the kiddies who were both wild and silly, we all owe them a great debt for helping to end the disgusting Vietnam war.

I was at the time teaching at Harvard. What worried me was that most students knew what they were against—the war—but they had not read very much, nor studied, nor worried enough about the forces that had made and continued the war.

No people can function for more than time's minute by knowing only what they are against. Man is made to fight well for something he truly believes in. And you can only believe in something by thinking about it, reading about it, appraising yourself. Thus, when the Vietnam war began to be over—in the American student sense, not for the poor Vietnamese—that lack of belief began to show.

Beginning in 1969 and 1970, the difference between my graduate students and my undergraduate students was very large. The under-graduates said they were tired of the whole thing. The graduate students were proud of what they had done, but they were influenced by those who were tired: nothing is more catching than weariness, and nothing is more corrupting.

Thus, in the last years, most students have gone back to a calm, pleasant, well-mannered shrugging acceptance of life in America as it is. The powerless, and that is most of us, have thrown up our hands in disbelief that government was ever intended to belong to us. And we have had those hands high in hopelessness for a long time.

That is very sad. It is my deep belief that if you live in a country you owe it something, as it, of course, owes you. You who are graduating today, far more than those who graduated in the Sixties, have very possibly lived through the most shocking period of American history. You have seen a White House disgraced. You have heard a president of your country lie over and over again to you. You have seen a pious-talking vice president thrown out because he was a crook.

Perhaps more important than anything they did individually, you know that government agencies—the CIA, the FBI, the Department of Justice, and God knows what yet hasn't come to light—have spied on innocent people who did nothing more than express their democratic right to say what they thought. You have read that the CIA has not alone had a hand in upsetting foreign governments it did not like; but has very possibly been involved in murder, or plots to murder. Murder. We didn't

think of ourselves that way once upon a time.

I came here today—I don't like to make speeches—to say that I think it is your duty to put an end to all that. Your absolute duty. I wish you well.

This text is in the form published by Mademoiselle *(August 1975), with additional editing based on the text provided by The Wollman Library of Barnard College. Reprinted with permission from the Hellman estate.*

Responses to the Address

Lillian Hellman's address was published without editorial comment by *The New York Times* on June 4, 1975. It drew the following response from Stanley R. Klion (1975) in a letter to the editor.

> I read with much interest Lillian Hellman's commencement address to Barnard College. . . . Since I have a daughter graduating from a similar institution, it was obviously timely for me. And in truth, I was not only disappointed but offended.
>
> There is little doubt that Miss Hellman's challenge was appropriate for her audience. Our bright young people must take leadership roles to correct our mistakes and to better their lot. But to characterize the total control of our society as an instrument of an all-encompassing "big business" with their "dirty tricks" is equivalent to observing that all professors are naive, left-leaning, and unworldly. To be sure, the business community has had more than its share of unprincipled men and women and deplorable behavior. On the other hand, academia is not immune to similar charges, ranging from a strong and pervasive anti-business bias which infects the teaching of impressionable young people to internecine tenure fights. Would it be proper, therefore, at business school commencements to flog the entire academic community for the biases of a few of its members? The business community Miss Hellman so deplores also includes— indeed, largely consists of—moral men and women seeking to contribute to society through their organizations and with their personal efforts. Some are more effective than others, but so are some teachers.
>
> One can hardly quarrel with the desirability of correcting basic flaws in our society. But damning the business community in toto is neither constructive nor helpful. It is not worthy of Miss Hellman, and she should realize that fact. (p. 26)

In contrast, one 1975 Barnard graduate recalls that she "really liked the speech," remembering Lillian Hellman as "very feisty," with a "realistic view of the world." She also remembers that many of her

fellow graduates did not like the speech, feeling it was "too negative" (Jensen, 1991a). One of her classmates wrote recently of the speaker and occasion:

> I graduated from Barnard what has come to seem like oh so many years ago (16, to be exact) on a bright day in May. The guest speaker that year was Lillian Hellman, a woman of granite features and obdurate convictions; her certitude about the choices that lay before us seemed an impossible remove from the clamorous reality not only of Morningside Heights, but of the world as I knew it. . . . Maybe it is the nature of such moments, white-hot as they are, to be pushed to the sides of our lives—to evade direct emotional scrutiny. Perhaps we are afraid that to look too closely at them might prove dangerous, like staring into the sun. (Merkin, 1991, pp. 47–48)

When publishing her address in *Encore*, editor Ida Lewis (1975) wrote of Hellman: "Her views on the true responsibilities of students should be considered by those beginning their education, as well as those beginning their foray into life" (p. 6).

Theresa Kane

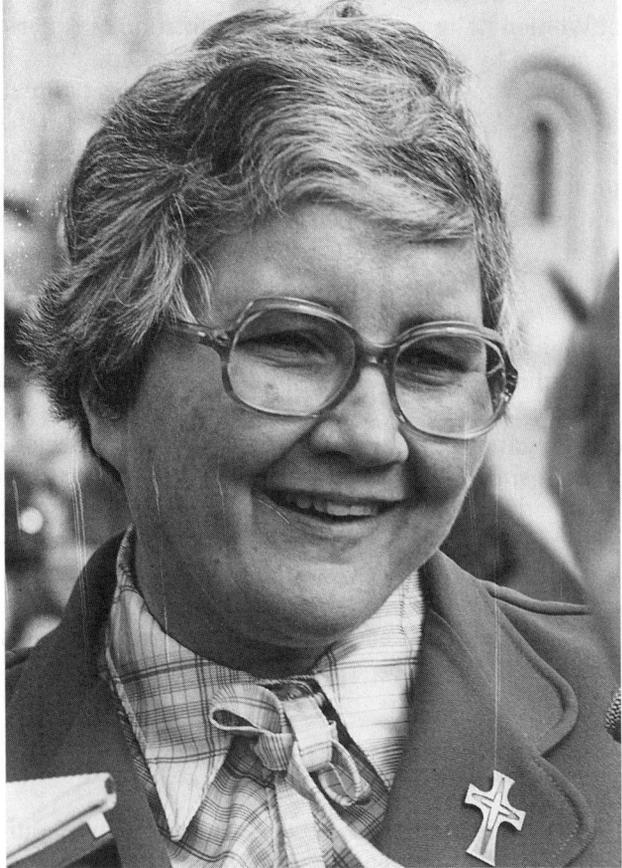

Background

Sister Theresa Kane, administrator general of one of the largest orders of American nuns (the Sisters of Mercy of the Union) and president of the Leadership Conference of Women Religious, gave the formal greeting to Pope John Paul II at the Shrine of the Immaculate Conception in

Washington, D.C., October 7, 1979. Her specific audience was the Pope himself, seated at the front of the church. Also present were approximately five thousand nuns and numerous journalists. Portions of her remarks were later broadcast nationwide.

Although her speech must be understood as a response to the Vatican's longstanding limitations on the role of women in church leadership, it also followed two specific incidents during the Pope's American tour. First, he had declined to grant an audience to the Leadership Conference of Women Religious, the only organization of American nuns officially approved by the Vatican. Second, in Philadelphia, he had specifically rejected women's ordination—to the standing applause of an audience of priests. While many traditional nuns gathered at the Shrine supported the Pope's position, others had considered ways of expressing respectful protest. Some made pale blue armbands to be worn during the Pope's address; a few had held an all-night prayer vigil outside the Pope's room at the Apostolic Delegation. Some nuns considered a walk-out from the Shrine, but decided instead to stand during his address. (This group statement was finally abandoned so as not to block the view of other women in the audience; nonetheless fifty-three nuns did rise as individuals—one at the moment when the Pope called for "public witness.") In this atmosphere of diverse opinion, in the shadow of prior and anticipated protest, Theresa Kane rose to speak. One observer wrote in retrospect: "It was a moment when the ecclesiastical firmament trembled a little. What made it all the more remarkable was that her gesture was not one of a radical. The very fact that Sister Theresa Kane, a moderate conservative from the top echelons of Roman Catholic sisterhood, could have summoned the courage to speak confirmed what many onlookers already knew: these are restless times for women in religion" (Carpenter, 1980, pp. 19, 149).

Approach of the Speaker

Descriptions of Sister Theresa's personal nature and ongoing work are consistent with her behavior on this particular day. She is described as practical and unselfconscious, a woman of conviction and action who does not seek drama but will not be silent in the face of injustice. She acknowledged to an interviewer "a sense of rage" within herself about wrongs done to women in the church (Gordon, 1982). She said that her state of mind in October 1979 was influenced by years of negotiating with priests and bishops to secure basic living costs and retirement security for nuns who were no longer willing to live in convents. She reflected: "Without realizing it I began to see I had a stake in this church and I had something to say about it." Although she is remembered as a challenger of authority, she was also willing to be challenged. She

insisted to the sisters in her order "that they must challenge her, that they must tell her if she is not expressing their interests." When asked about her feelings on the day of her remarks to the Pope, she said "she was not frightened . . . she knew it had to be done" (Gordon, 1982, pp. 67, 69). In the days following her remarks at the Shrine, Sister Theresa returned to her daily administrative work, declining to take calls from reporters. A spokesperson at the headquarters of the Sisters of Mercy of the Union said, "she doesn't want to become a media event" (Hyer, 1979, p. A30).

Greeting to Pope John Paul II

In the name of the women religious gathered in this shrine dedicated to Mary, I greet you, Your Holiness Pope John Paul the Second. It is an honor, a privilege, and an awesome responsibility to express in a few moments the sentiments of women present at this shrine dedicated to Mary, the Patroness of the United States and the Mother of all humankind. It is appropriate that a woman's voice be heard in this shrine and I call upon Mary to direct what is in my heart and on my lips during these moments of greeting.

I welcome you sincerely; I extend greetings of profound respect, esteem, and affection from women religious throughout this country. With the sentiments experienced by Elizabeth when visited by Mary, our hearts too leap with joy as we welcome you—you who have been called the Pope of the People. As I welcome you today, I am mindful of the countless number of women religious who have dedicated their lives to the Church in this country in the past. The lives of many valiant women who were catalysts of growth for the United States Church continue to serve as heroines of inspiration to us as we too struggle to be women of courage and hope during these times.

Women religious in the United States entered into the renewal efforts in an obedient response to the call of Vatican II. We have experienced both joy and suffering in our efforts. As a result of such renewal women religious approach the next decade with a renewed identity and deep sense of our responsibilities to, with, and in the Church.

Your Holiness, the women of this country have been inspired by your spirit of courage. We thank you for exemplifying such courage in speaking to us so directly about our responsibilities to the poor and the oppressed throughout the world. We who live in the United States, one of the wealthiest nations of the earth, need to become ever more conscious of the suffering that is present among so many of our brothers and sisters, recognizing that systemic injustices are serious moral and social issues that need to be confronted courageously. We pledge

ourselves in solidarity with you in your efforts to respond to the cry of
the poor.

As I share this privileged moment with you, Your Holiness, I urge
you to be mindful of the intense suffering and pain that is part of the
life of many women in these United States. I call upon you to listen
with compassion and to hear the call of women, who comprise half of
humankind. As women we have heard the powerful messages of our
Church addressing the dignity and reverence for all persons. As women
we have pondered upon these words. Our contemplation leads us to
state that the Church, in its struggle to be faithful to its call for reverence
and dignity for all persons, must respond by providing the possibility
of women as persons being included in all ministries of our Church.
I urge you, Your Holiness, to be open to and respond to the voices
coming from the women of this country who are desirous of serving
in and through the Church as fully participating members.

Finally I assure you, Pope John Paul, of the prayers, support, and
fidelity of the women religious in this country as you continue to
challenge us to be of holiness for the sake of the Kingdom. With these
few words from the joyous, hope-filled prayer, the Magnificat, we call
upon Mary to be your continued source of inspiration, courage and hope:
"May your whole being proclaim and magnify the Lord, may your spirit
always rejoice in God your savior; the Lord who is mighty has done
great things for you; holy is God's name."

This text is reprinted with permission from the Associated Press version appearing in The
New York Times, *October 8, 1979. For editing purposes, the manuscript has been cross-
checked with a text published by* Redbook *(April 1980).*

Responses to the Speech

Sister Theresa was primarily addressing Pope John Paul II, in a sub-
stantive way that transcends the ceremonial nature of most speeches of
this kind. Ironically, some church representatives familiar with the
acoustics of the Shrine do not believe the Pope, who was seated well
behind her, could have heard her words (Hyer, 1979, p. A30). However,
the Pope's nonverbal behavior seems to refute these views. When Sister
Theresa spoke of "the possibility of women as persons being included
in all ministries of our church," the Pope raised his hands as though
to intercede and appeared to shake his head with a pained expression
on his face. In his address following the greeting, the Pope did not
acknowledge Sister Theresa's comments, but he did speak of the Virgin
Mary as the model for nuns before he began his prepared text. His more

direct verbal responses came on October 11, during the first day after his return to the Vatican. At a Mass for members of the Council of Laity, he said that women should "find the exact role assigned to them in the church." Later that day, he singled out a group of 600 Italian mothers superior among the thousands gathered for a public audience in St. Peter's Square and said: "I would like to suggest to you, superiors, the firmness and delicacy necessary at this moment. Show yourselves above all to be sensible and illuminated mothers and never irritated or embittered about anything" (Hyer, 1979, p. A30). (A mother superior is the traditional title comparable to Sister Theresa's title of administrator general.)

The nuns gathered in the Shrine comprised the secondary audience for Sister Theresa's speech. Their most unified response came early, when there was sustained applause after her words: "It is appropriate that a woman's voice be heard in this shrine and I call upon Mary to direct what is in my heart and on my lips during these moments of greeting." However, only about half of the nuns applauded at the end of the greeting, with many nuns in habits remaining silent. Many of the latter nuns applauded loudly a few minutes later when the Pope emphasized "poverty, chastity and obedience" as "the essence of religious consecration"; they applauded again at his suggestion that nuns should go back to wearing "suitable religious garb." Immediately after the Pope's address, Sister Theresa was congratulated by some nuns outside the Shrine, while others approached reporters to say "she doesn't speak for us all." One nun called her remarks "biased and inappropriate"; another said: "It disturbs me that she says we have all this pain and agony because we can't be priests. I am perfectly happy, I don't want to be a priest, and I don't think women should be" (Hyer and Rosenfeld, 1979, p. A25).

Three days later, Mother M. Sixtina (1979), provincial superior of the Sisters of St. Francis of the Martyr St. George, took out an ad in *The Washington Post* which read:

> We, who most likely speak for the large majority of religious women in the United States, apologize to His Holiness, Pope John Paul II, for the public rudeness shown him by Sister Theresa Kane, R.S.M., this past Sunday in Washington, D.C.
>
> One does not treat any foreign guest by attempting to correct him publicly before the world. Yet, for those who accept the Catholic premise, a person with no teaching office in the Church does not presume to correct the one to whom the whole flock was commissioned by Christ.
>
> Sister Theresa was not only impertinent to the Holy Father, but she has also offended the millions of us who love him and gladly accept his teaching. (p. C8)

But others disagreed. Bishop Thomas Kelly, secretary of the National Council of Bishops, said: "She had a responsibility to make the truth known to the Holy Father as she saw it, and to represent her membership." Sister Mary O'Keefe, co-director of the National Assembly of Women Religious, called Sister Theresa's statement "beautiful, gentle and reverent, but saying everything that needed saying. She is a heroic woman" (Woodward and Lord, 1979, p. 125). While not necessarily offering the final response, author Mary Gordon (1982) reviewed the text nearly three years later and wrote: "I am moved by its quiet dignity, its clear certainty, its combination of loyalty and decisiveness" (p. 66).

Eleanor Smeal

Background

On September 5, 1985, Eleanor Smeal addressed the National Press Club in Washington, D.C. It was her first major speech since winning back the presidency of the National Organization for Women (NOW) in July of that year. Smeal previously served as president of NOW from 1977 to 1982. Her reelection was hailed by *The Washington Post* as ''an

important milestone in the feminist movement's continuing debate over its tactics and direction" (University of Northern Iowa Public Relations Office, 1992, p. 4).

Following her reelection, Smeal kept up the hectic campaign pace and her aggressive style of leadership by presenting up to a dozen speeches a week, including addresses to labor unions, college students, feminist groups, and NOW chapters. She is known as an effective debater, public speaker, and influential lobbyist in Washington, D.C., abilities which she attributes to growing up in an Italian family (Peterson, 1986, p. 50).

The National Press Club address was given to an audience of approximately three hundred NOW supporters, National Press Club members, and reporters on assignment. Her speech was in the club ballroom, followed by a question and answer period, and a reception in the First Amendment Lounge. The National Press Club hosts seventy to ninety speeches a year and is said to be one of the nation's best forums for airing public issues. Smeal's speech was part of the club's regular luncheon series. The event was aired on 303 National Public Radio stations and 1,900 stations on the Cable Satellite Public Affairs Network (C-Span).

Smeal was introduced by the Press Club President, David Hess of Knight-Ridder Newspapers, who said in part:

> Today's speaker, Eleanor Smeal, is back—[Laughter]. . . Back . . . Back as president of the National Organization for Women and back in the forefront of the women's movement. It has been three years since the former Pittsburgh housewife last held the post, working to mobilize women nationwide to help pass the Equal Rights Amendment and advance other feminist causes.
>
> Since 1982, Ms. Smeal has worked in her own political consulting business and has published a newsletter on women's issues. A mother of two, Ms. Smeal also wrote a book on the women's vote and the presidency. Her battle for re-possession of the NOW presidency was hard-fought, bringing her head to head with Judy Goldsmith, her successor in 1982.
>
> In that tussle with Goldsmith, last July in New Orleans, the election was described by the *Philadelphia Inquirer* as a "fight between low-key leadership and high-key leadership, between conciliation and confrontation, between respectfulness and raising a little hell."
>
> In case you haven't guessed, raising hell won, and Ms. Smeal is here today to tell us how she plans to channel her energy and in what direction she will be steering NOW.
>
> Her task may *not* be so easy. Apart from some hard feelings lingering in the NOW organization after the recent election, times have changed. President Reagan has been in office for five years, and his conservative agenda is alive and thriving.

. . . .

Critics of Smeal say this is not the era for marches down Pennsylvania Avenue, harsh speeches, and her brand of confrontational politics. Smeal's supporters say, however, that this is precisely the time for a dynamic leader, one who can rev up a crowd and inspire a devoted militancy.

We're here today to hear how she plans to strive for her goals. It's my pleasure to present the president of NOW—Eleanor Smeal.

Approach of the Speaker

In a recent interview with DeFrancisco (1992b), Smeal reflected on this and other speeches: "I classify myself as a motivational speaker. . . . [I work] for people to change their lives, to do something." In reference to her goals, she said she tries to "impart information and to motivate, to charge." Smeal said that she generally gives extemporaneous speeches from brief notes: "I speak almost every time differently. . . . I know these issues-areas very well." Talking further about her style of delivery she said, "I'm on some days, off some . . . if you speak this often—my voice is really [hurting]. I believe that . . . I am [not only] speaking with my voice, but with my body, too. If I know that they instantly get it, I might not even finish the sentence, because . . . it's more like a conversation. [If you don't do this,] you lose the dialogue."

She said people often ask her why she keeps up such a difficult public appearance schedule. "I have to tell you, it's not dollars. I think a lot about money, but I'm not a bread-and-butter person, or else I wouldn't be doing this. I'm much more interested in principles and justice and fair play." She said, "I hope [people respond] as if their lives depended on it because some of them will."

"We've Just Begun"

If I ever doubted whether it was time to raise hell, all I had to do was read today's newspapers. The three-judge panel of the Ninth Circuit Court said that the 1964 Civil Rights Act does not obligate the state of Washington to eliminate an economic inequality which it did not create. That's the great principle in jurisprudence of Adam and Eve. Take it to your creator. God knows that man, who created this system of injustice that we work under, has no responsibility.

A lot of people would ask me what my reaction to that decision is. I say it's only fighting mad. We intend to break out of the ghetto of low wages that has been created for us one way or another.

What the Washington case shows is that we have to fight simultaneously on several fronts. While we were fighting in the court,

we were also fighting in the state legislature in Washington state. The Washington state legislature has passed a law there that says by 1993 they are going to have pay equity in the state system and, in fact, the legislature has passed a $42 million back-pay appropriation to help correct the inequity. There would have been no gains there if we had not fought the court case.

I believe the Washington state case set off a revolution in the fight to break out of the wage ghetto for women. And right now, throughout this country, in some 100 jurisdictions, similar pay equity cases are being fought through the courts. Or we're pursuing legislation at the state level. Or we're pursuing county commission ordinances to change the inequities.

And, as we fight in these arenas, where the real battle is taking place is in the court of public opinion. This three-man panel in the Ninth Circuit did not make this decision in a vacuum. They read the newspapers. They read what the right wing is saying, what business is saying. They know only too well what the opposition is saying about comparable worth and equal pay.

The lines about a "cockamamie" idea, about "looney-tunes," have gotten out there far more than the fight for justice, and that's why I think it's time to raise hell, to spread the word, to organize women. Because there's no question in my mind but that rights are never won unless people are willing to fight for them.

In 1848, some women and men met in a very, very small little town, Seneca Falls, and they wrote a Declaration of Human Sentiments. The Declaration of Human Sentiments was modeled after our own Declaration of Independence, and it was very, very, simple. They said, "We hold these truths to be self-evident, that all men and women are created equal. That they are endowed by their Creator with certain inalienable rights, and among these are life, liberty, and the pursuit of happiness." I think it's time for the feminist movement, for the progressive movement, to review history and declare their own independence. It is time that we stop thinking about what is fashionable and what is not fashionable in this city, what's in and what is not in. I am told that when I say it's time to go into the streets these are the politics of the '60s.

The politics of the '60s . . . you know we could have one decade, those of us who are concerned about human rights in this century, but God forbid if we take a little more. We can have that little decade. But, when we're trying to fight to make sure that there is forward movement, and progress, and that the great gains of the civil rights decade of the '60s are not lost, then we are told that we are passé.

We want to use terms like equal opportunity employer, but we don't want them to mean anything. We want to just feel good. Well, the job

of a person fighting for equality is not to make anybody feel good while there's injustice in our system, but to make us all uncomfortable.

The right wing, I feel, is being given a honeymoon, an outrageous honeymoon. Jerry Falwell just took a whirlwind, five-day trip to South Africa in the pursuit of the myth of the happy slave. Jerry Falwell went there and, no question about it, he found a few blacks who didn't agree with Bishop Tutu. In fact, he could once again pursue the classic defense of injustice, by justifying no change or ever-so-imperceptively-small change, on the basis that change will hurt the victims of injustice.

Well, we know that there was a huge uproar over Jerry Falwell's trip. His thinly veiled racism was seen by many of us for what it was. But that thinly veiled racism and, in my opinion, sexism, is running rampant in this country, and we are hardly questioning it.

In reviewing all the articles about what the president is going to do about the sanctions, we constantly see that little phrase, "He'll veto it if he thinks it will hurt the blacks." The only time we ever care about what the victims of injustice think is when we try to change the injustice itself.

After fifteen years of fighting for women's equality, the only time I'm ever asked what women think is when I'm asked, "Mrs. Smeal (and they do generally say 'Mrs.'), how many women agree with you anyway?" And invariably, as we march down the street, some woman is interviewed who thinks we're all nuts. She thinks it's just perfectly fine the way it is. And that's it. Dismiss it. If we don't represent huge numbers, if there's not an instant poll right now, whatever the injustice is, it's okay.

Look at what this three-judge panel did. They are very educated men. They ruled that you don't even have to deal with injustice as long as everybody else does the same thing. That's called the free market system. You get away with discrimination if everybody else practices discrimination. Justifying the injustice.

We have a lot of experience in justifying injustice. In fighting it, we have ever so little experience. We recall the great names who have fought injustice. But we make sure of one thing—that they're all dead. Well, there's a lot of us around and we've got a lot of kick left in us, and we intend to raise hell while we're still living. And I don't think we can overcome any too soon.

We are fighting, I believe, for fundamental liberty and justice in our lives. Look at the abortion issue—the right to determine when and if you're going to be pregnant—really, the right to survive. Oh, I do love the great intellectual questions, such as, "Does a fertilized egg have more rights than I do?"

You know, I'm not debating that very much. I can't get over the fact that most people who want to debate this question are men. I'm

not a sexist, and I generally do not call attention to the sex of my opposition, but I can't help noticing that most of the people picketing abortion clinics also are males. The Jerry Falwells, the Jesse Helmses, the Orrin Hatches—they never will have to face this decision. But we do.

I feel, without question, that we are dealing with life and death, that women have a right for their lives and their opportunities. And more importantly, every person on the face of this earth has an obligation to make her or his own decisions that impact on her or his own life.

Right now we are, I think, abandoning one of the great principles of our country: freedom of religion. The Pope has just visited Kenya and he said to that starving nation that birth control is wrong, a country whose average size of family is seven, that is racked by starvation. You know, in the sub-Saharan Desert area, nine million people will starve this year and 150 million people are at different levels of starvation. The average age of death is four. And he preaches no birth control.

We hardly can feed the people we have, and he preaches no birth control. That message is not just a message for Kenya. That message is having worldwide impact, and it's having an impact right here in this country.

The fight to outlaw abortion is fundamentally an attack on birth control. Let there be no mistake about that. It's fundamentally an attack on freedom of religion, and it's fundamentally an attack on a woman's right to her life and her pursuit of happiness.

I believe that every woman and every man who cares about a quality of life worth fighting for had better stand up, while they can still stand up, and join with us in a fight to keep abortion and birth control safe and legal. That's why I am organizing a mass mobilization in the spring of 1986 for abortion and birth control. I hope hundreds of thousands of people come here to Washington, but that will be only the first of many marches and many acts.

You know, there are a lot of people who want to advise us, who think we should operate only within the system of passing laws and getting Supreme Court decisions. Well, we did that with abortion. There is a Supreme Court decision that legalizes it, and, as you know, the opposition is not accepting that ruling as permanent. They are mobilizing. They are in the streets. They are threatening life and safety. They are using the tactics of the '60s in 1985. They're using tactics that they claim are those of civil rights (violent and nonviolent), and they're fighting for what they believe in. They are very loud for a very small minority. Those of us who believe that women have the right to birth control and abortion must fight back. The Supreme Court alone cannot stand and defend the fundamental rights of people.

Thomas Jefferson once said that "the price of liberty is eternal vigilance." We also must be prepared to march, prepared to fight, and

prepared to defend our liberty. We also must be prepared to fight to expand our liberties. We cannot just fight for the gains of yesteryear. We must fight for full equality.

The fight for the Equal Rights Amendment, I am told, is something we should give up. Well, we're not about to give it up. We're not about to give it up because we have a job to complete and the dream of full equality for all women to fulfill. The case-by-case approach is intolerable. Full equality is essential. But, if we don't fight for the dream of full equality, we will watch it be eroded statute-by-statute and case-by-case. So, we are going to make sure that we mount a campaign, this time at the state level in Vermont, that will show that, indeed, there is plenty of fight left in the Equal Rights Amendment.

When the suffragists were stopped at the state level, they went to the federal level. And when they were stopped at the federal level, they went back to the state level. And they kept it up. For 56 state referendum campaigns, 480 legislative campaigns, 470 state constitutional campaigns, 277 state party campaigns, 30 national party conventions, 19 campaigns, and 19 successive Congresses, they kept it up. They kept it up until suffrage was theirs. And I believe we must keep it up, and keep it up, until equality is ours.

And I don't think we should step back from any hard or tough question. The opposition has a way of throwing every issue of the day at us, and a way of pretending that they are the only righteous people on this earth.

They claim we are the destroyers of the family, that we are the people without morals, and without concerns for the future. They make claims such as, "ERA leads to AIDS." They try to make this great connection. And we either laugh, because we don't know what to do with it, or we avoid the issue. I say it's time to stop avoiding these issues. They're not joking matters.

The right wing has a way of always singling out some class of people in our society and making them the untouchables, claiming God's wrath is upon them. They teach bigotry and hate, and we've got to recognize that for what it is. When they say ERA leads to AIDS, they are going after an oppressed class of people, lesbians and gay men. They are spreading ignorance and hate that could lead to the demise of all of us, because this is a dreadful disease that is spreading throughout the population of the world.

We are proud of fighting for the liberty of all people, and we are proud that we fight for gay and lesbian rights. We won't allow this issue to be distorted or to be used against women's equality. We won't step back from any issue. We will recognize bigotry for what it is, wherever it raises its ugly head. And we intend to wrap it around the neck of the right wing as we fight for liberty and justice for all.

I feel that one of the biggest problems that we have is that we haven't taken the right wing, fascist opposition seriously enough. In 1957 to 1961, I was at Duke University. I didn't know very much about the South. I was raised along the Great Lakes, around Erie, Pennsylvania. When I went to college, I decided to go to Duke. I didn't know that it was segregated. I had read about segregation, but I didn't know what it meant. I was first generation Italian-American. I could tell you all about discrimination against Italians, but I didn't know very much about discrimination against black people in the South.

But I got a crash course. Before you knew it, I was on the picket line at some movie theater in downtown Durham. It outraged me that black people were only allowed to sit in the unairconditioned balcony. So, when they asked for volunteers, I ended up there. The thing I will never forget is being called a "nigger-lover" and being spat on, because I believed people had a right to sit anywhere they wanted when they bought a ticket. I couldn't get over that hatred. I couldn't get over what made them think it was all right to call me such names.

The reason I bring this up now is because we're about to fight all over again unless we make a stand today. The Civil Rights Restoration Act is in Congress, and it's being tied up by all kinds of amendments. It's being called an abortion issue.

You know, when they want to kill something these days that deals with civil rights or women's rights, they slap on an abortion amendment. They make it an abortion issue. The great Civil Rights Act of 1964 is in trouble. Title IX for education rights for women is in trouble. The Older American Discrimination Act is in trouble as well as protection for the physically disabled. Why? Because the Supreme Court and the Reagan administration have ruled that the federal government can fund discrimination. We're about to see the unraveling of all the gains of the last 30 and 40 years.

Well, there's no way we're going backwards.

We're going to launch an emergency campaign to save the Civil Rights Act, and I don't want to hear any American praise Martin Luther King or any other great civil rights leader if that person isn't doing anything to save the Civil Rights Act in 1985. It's time to show where you stand today, not to recall the great triumphs for human progress of yesterday. I want to see a campaign that will stir the soul of this country again for justice.

I don't want to hear that we don't have idealism in this country, that the young kids only are interested in the almighty dollar and don't really care about the fight for equality and justice. I believe they do, so we're launching a campus campaign to save the Civil Rights Restoration Act, to save women's rights, and to move forward.

There's a movie out now called "Back to the Future." I can't say

I'm a movie buff, but I think it's about time we went back to the business of the future of this country and stopped romanticizing the eighteenth and nineteenth centuries. We must look to the future of this nation and work to make this world safe for justice.

I also believe that we're on the verge of a major comeback in the women's movement. You should know that, according to a Lou Harris survey, 43 percent of the American people believe we have just begun. Now, there's one American who I don't quote much, but there's one thing on which I agree with him: "You ain't seen nothing yet."

We've just begun. We are going to lead a movement that will be big enough, and proud enough, to do justice to the dream of equality for all people.

This text, as published in Representative American Speeches *(1985–1986, pp. 50–57), was edited by Smeal's staff from her extemporaneous remarks. Reprinted with permission from Eleanor Smeal.*

Responses to the Speech

Commenting on Smeal's impact as a public speaker, a *Philadelphia Inquirer* reporter wrote:

> She's hard to pick out in a room. Short and ordinary-looking, with dark brown eyes and graying hair. Eleanor Smeal commands no attention. She blends into the crowd . . . until she starts to speak. The words pour out in a torrent. The dark eyes blaze. Breathless and whispering one minute, shouting and piercing the air the next, her voice can cause a wave of fervor. . . . (Messacappa, 1985, p. 1)

In this instance, Smeal evoked responses from her audience that were unusual enough to be reported in the press. When she called the fight to outlaw abortion "an attack on birth control," her voice was described as "rising with the volume of the audience's applause" (Gailey, 1985, p. A18).

But her characterization of some of her opposition as fascists and bigots drew the most attention. During the question period which followed, she was asked by a member of the audience to identify some of the fascists she had in mind. She replied: "I'll be glad to" and then named Senators Jesse Helms and Orrin Hatch, direct-mail fund-raiser Richard Viguerie, and Paul Wayrich of the Committee for the Survival of a Free Congress. She added: "When they stop calling us leftists, Communists, and pinkos, I'll stop calling them fascists" (Gailey, 1985, p. A18). Focusing on these statements, *The New York Times* headlined its

coverage of the speech "NOW Chief Describes Plans to Fight 'Fascists and Bigots.'" A few days later, The Des Moines Register (1985) also focused on this passage in an editorial:

> Avoid name-calling, because it induces people to stop listening to your argument and start thinking up names to call you.
>
> That's a good rule to follow, and it's disappointing to see it violated by Eleanor Smeal. . . .
>
> She told the National Press Club the other day that "fascists and bigots" on the Republican right have made an effort to roll back gains that women and minorities have made in recent decades.
>
> We agree with Smeal on many issues and we, too, are alarmed by some developments. But that kind of language doesn't help her cause. It does her adversaries no harm and makes her allies wonder about her judgment.
>
> Smeal should get it through her head that it's entirely possible for a person to disagree with her without being a fascist or a bigot. (p. 10A)

Of Smeal's choice of words in attacking her opponents, Ann Lewis, National Director of Americans for Democratic Action, observed: "I can't think of another woman leader who would do it. It's not their style" (Peterson, 1986, p. 51).

Mary Louise Smith

Background

Mary Louise Smith was the National Chair of the Republican Party from
September 1974 until January 1977, the only woman ever to have held
that position. From March 1982 until November 1983, she was Vice Chair
of the United States Commission on Civil Rights. Smith is a founding

member of the Iowa Women's Political Caucus and a member of the
Advisory Board of the National Women's Political Caucus. On this
occasion (October 6, 1987), she was addressing a conference hosted by
the Department of Communication of the University of Oklahoma. The
conference was entitled: "The Uncertain Trumpet: Confusion and Clarity
in American Political Images." The conference was intended to bring
together party leaders, political consultants, journalists, pollsters, and
scholars to discuss the changing orientations of the major parties and
electoral politics through the remainder of the century. Earlier in the
conference, Fred Harris (former National Chair of the Democratic Party)
had given the keynote address and Mary Louise Smith closed the meeting
with this capstone address. One organizer felt the conference was "very
lucky" in the balance between the two speakers because Smith "carried
her part extremely well" (Jensen, 1992f).

Approach of the Speaker

Commenting on this address in contrast to her speeches given in the
1970s, Smith told the editor (Jensen, 1992a) that the earlier speeches
"reflect my thinking" but were much more "partisan" with the intention
of "rallying the troops." She said that "my own philosophy has come
through much stronger in the recent speeches."

Reflecting on her process of preparing a speech (which she writes in
longhand), Smith said in a later interview (Jensen, 1992j): "I'm a
somewhat laborious writer. Writing, I think, does not come easily to
me." She remembered telling Paul Engle, one of the founders of the
Writer's Workshop at the University of Iowa, that "writing is really hard
work," and he responded: "That's why they call it a work of art; it's
not an easy thing to do." Recalling her preparation of this particular
address, she said: "I followed, I remember with this speech, what I really
like to do with most speeches. . . . I think about them a long time. I do
not sit down and start pounding out a speech. . . . In this case . . . I had
the luxury of some time and I like that. Because a speech takes its form
in my mind long before it ever gets on paper."

While tailoring this and other speeches to particular audiences, Smith
said that there are several themes which recur in almost all of her
speeches. One is an affirmation of the two-party system. She said: "A
lot of my motivation for this speech comes from my complete dedication
to the two-party system. I'm an advocate. I'm a believer. I'm a
spokesperson." A second theme is the role of women in the political
system: "I almost will take a subject and have to manipulate it to get
in something about women in politics. . . . I would not, for instance,
with an audience like this talk about . . . partisan [issues] like abortion
or gun control or the death penalty . . . but I would about women's

participation because it is that important to me.'' Increasingly, another theme that appears in almost every speech is leadership. Smith said:

> I think it is important for people of not so much my generation, but the next generation and/or the next generation down, to see some role models—particularly for women because I think women have not been willing to take some risks that leadership required, and they haven't always sought leadership positions. If it came to them— ok—but they haven't sought them out. I think it's important for men, too. But men have had more mentors to learn from, and women have not had the mentors.

Smith's reading manuscript had numerous handwritten insertions in the margins. When asked when these were added, she said: "It could have been that morning, it could have been an hour before . . . sometimes something that's going through my head on the plane going there." She added: "A speech is a very important thing to me. . . . I don't take it lightly. It's going around in my mind for a long time and up until the moment that I give it."

The videotape of this speech also shows numerous departures from the text. She said of this: "It can just be another one of those inspirations. . . . I'm not reading an empty thing and not knowing what my words are. I don't give a speech that way. And all of a sudden, I'll think of something else I want to say—and so I'll insert it—and that's what you'll see when you listen to a tape that way."

Smith also spoke of the importance of audience response: "Anyone who does any kind of public speaking will tell you that their response is a critical part of a good speech. . . . It doesn't just all flow out. There's an awful lot that flows back. . . . I know some of the best speeches I've ever given—maybe the words were the same, but clearly the spirit of them was enhanced by the audience. . . . I'm conscious . . . when I look at somebody and get a look back; it's not just an empty sea of faces.''

"Now is the Time . . ."

A few weeks ago I saw a commercial spot on television sponsored by a power company. Capitalizing on the universal appeal of children, an unseen interviewer asked each youngster how electricity is made and where it comes from. There were three little boys—probably five to six years old—all male children, of course, because everyone "knows" that females don't know about things like electric power. They were asked questions in turn. The first child's answer failed to get my attention; the second one said something kind of vague and childishly imaginative about laser beams and the exotic, hi-tech—but the third child explained

that the electric company "has these wires, you see," and then he said: "there is this button, and then you push the button and pfttt—."

It occurs to me that such a description is, in all likelihood, a fairly accurate reflection of the way many people feel about political parties—*they are just there.* Most people take parties for granted without really knowing very much about them. Why do we have political parties, what do they do and how do they do it, how long have they been there? Or do you, every two to four years, just pull a lever, or push a button and pfttt—things just happen?

Well now, from the ridiculous to the sublime. A little less than a year ago on November 17, 1986, in Des Moines to initiate a year long program honoring the bicentennial of the U.S. Constitution, Henry Steele Commager, distinguished historian, delivered the first annual Iowa humanities lecture entitled "A More Perfect Union."

In this address Mr. Commager speaks dramatically of the creation of a new nation and says that this new United States then "managed to invent or create every major political and constitutional institution that we boast today, and that not one of comparable significance has been invented since." He lists these political and constitutional institutions as follows:

1) The Written Constitution;
2) The Revolutionary Principle of Democracy;
3) The End of Colonialism and Formation of the Coordinate State;
4) The Establishment of Limits on Government;
5) The Separation of Church and State and the Principle of Religious Freedom;
6) The Supremacy of the Civilian to the Military Authority.

And "A Seventh Contribution," Mr. Commager writes, "we may even call it an invention—was the modern political party. When that emerged, as it did in the final decade of the eighteenth century, it was indeed something new under the political sun."

"The Modern Party," Mr. Commager goes on to say, "as distinct from faction—is an American invention. First," he continues, "it grew from the bottom up, not the top down, that is, and it was and has remained one of our most democratic institutions, and, ever since Andrew Jackson, has been led, officially or unofficially, by common men. Second, it emerged not as a body of miscellaneous factions, but in a two-party form, which meant that it emerged as a national, not a local institution, and—with dramatic exceptions in 1860 and in our own time—has been nationalizing rather than fragmenting. And, third, it has—again with the exception of the struggle over slavery—been non-ideological and concerned primarily with programs and policies

designed to win office. It is well we should all keep in mind that when, in 1856–60, the parties broke up, the union broke up."

Mr. Commager goes on to conclude with an inspiring dissertation on what he lists as the eighth and final contribution, "The Creation of the Federal Union."

With that very brief overview setting the tone for my subsequent remarks, I would like to begin by making some personal observations. I am a deep believer in the two-party system. With inevitable adaptations to modern technology, and unless we ignore the warning signs entirely, I really believe the parties will survive, or be born again—if I can use that phrase—in much, if not exactly, the same form as we know them today. I have come to this conclusion because of the cyclical nature of the political process and because I see nothing on the horizon that is going to present a reasonable alternative.

This conference, "The Uncertain Trumpet: Confusion and Clarity in American Political Images," has provided one of the most timely and comprehensive examinations of political parties in which it has been my privilege to take part. Experts, all specialists in their particular fields, have explored party alignments and dealignments, party strengths and weaknesses, perceptions and reality, technology and tradition. Now, risking over-simplification, I come to you with the message that "now is the time for all good men and women to come to the aid of the party."

You cannot put political parties on automatic pilot and expect the system to work. Parties, as any other affiliation or relationship, make demands on people. Parties require understanding, support, encouragement, energy, vitality, commitment and enthusiasm.

We know that political parties are not mentioned in the Constitution. The men who labored through those hot summer months over 200 years ago to produce that remarkable document were apprehensive and fearful of any concentration of power, but there is evidence that at the same time they knew that something would have to form a bridge between the people and their government. We know too that within the first 10 years of this republic, various interests began to come together, coalition building began, and parties were born.

Political parties succeeded, as well, in forming the framework for what was the great genius of our founding fathers. I refer, of course, to the accommodation—the balancing—of the value and dignity of the individual and the weight and rule of the majority.

Briefly that is the genesis and anatomy of the political party system. Granted that the system may not be perfect—it may not have always worked as we would like it to. We all know things about political parties—whether ours or the other party—that we don't like. But the fact remains that for 200 years the U.S. has grown and prospered under the most effective, most resilient and stable system of government in the

entire world. It has come to be dominated by two major political parties and it is based on the premise that people will participate in their government. You can examine all the other things. You can examine the political consultants and you can examine what PACs are doing and you can examine polling and electronic mailing, but the fact remains that there have to be people.

As long as there is discussion and dissent, between the parties and within the parties, as long as people in great enough numbers come together, recognizing that there is strength in diversity, as long as the citizenry uses the power of the ballot and the party to demand accountability from officials, the American system of government *will* work and it should remain healthy.

If sufficient numbers of people become indifferent for whatever reasons, and drop out, government will not grind to a screeching halt. Sometimes we would be better if it did. But it grinds on. All that happens is that an unreasonable amount of power falls into the hands of the few who remain active (and remember that those few who remain active may not represent your point of view); the rest of the people simply lose an even greater measure of their own freedom and ability to influence the governance of this nation. The dropouts, of course, can complain (that's part of our system too), but their voices will be like those in the wilderness.

What I have just described has happened before our very eyes— this dropping away from the party system—but not just overnight. This phenomenon has been talked and written about—I know in my own case—for at least ten years, perhaps fifteen or more.

Over this period of time there has been an erosion of party strength and consequently a decrease in coalition building capacity. This decline in party strength has been the result of a variety of factors, which include the greater mobility of our population—rootlessness, if you will—well intentioned reforms and methods of financing, advances in technology, media coverage, and rising costs. As parties grow weaker the opportunities increase for special interest and single-issue groups to grow and flourish.

The tendency of parties—and candidates—to try to accommodate every philosophical current in the electorate has blurred the public perception of what parties stand for. Many of the voters who have drifted away and dropped out of the two-party system may now call themselves "independents."

My next remarks are not made to put down independents. They're a very vital group of voters. They're important to both parties. And they're wooed with a great deal of passion and enthusiasm—to see where those swing votes are going to go. But, sadly, the term "independent" belies their situation. There is no one more dependent than these independent

voters. . . . I could accept it better if they called them "undecided" or "unenrolled" or "unaffiliated." . . . They abdicate their responsibility and opportunity to exert their influence upon important early decisions that are made in the party—like the election of leadership, like the nomination of candidates, like the writing of platforms, like the writing of party rules. Then these so-called independents are left, if they vote at all, with a narrow choice between the candidates the parties have selected and the platform the parties have written—all influenced by those that were left in control.

People identify with a political party because they believe, in general, that party represents the direction they want our government to go and provides a vehicle for electing people to carry out those principles. Traditional, disciplined party people understand coalition politics. The broadest possible participation in the political process should be viewed as desirable unless, of course, it is practiced in a fashion that grossly distorts and abuses the system and thereby undermines party strength and structure. A narrow, doctrinaire approach drives people away.

Members of a political party will never agree on everything, nor should they. A party unwilling to accommodate and adapt to differences of opinion or a party that allows the development of a very narrow focus, whether it be from religious fervor or extreme ideological zealotry, will eventually self-destruct.

The successful future of a political party lies in its ability to maintain a strong, disciplined, and cohesive structure that transcends differences. Individuals act in their own interests, of course, but also for the greater good. Unity does not require silence and loyalty does not demand capitulation.

For a long time there has been a card, purse or pocket size usually, that says "I am a Republican because . . ." or "We believe . . ." There must be one for Democrats too—or something similar. Those declarations say nothing about prayer in schools or abortion or gun control. They do not lay out a legislative agenda. But those declarations constitute something of a charter or mission statement. Those principles are still sound and I believe they are the things that will bring people back and restore vitality to the political system. Both parties have learned the value of organization, recruitment, public relations, sound financing, and issue development. But none of it will work without people—large numbers of people—men and women from all walks of life and from all levels of society. And a political party—like any other organization, institution, or government entity—that fails to recognize the growing importance of women in our society and the equally significant influence of minorities is destined to learn the hard way. People ask me about women's role in politics. My answer is very simple. Women's role is

exactly the same as men's role in politics. I know of nothing in politics that a man can do that a woman cannot do just as well. But until our parties learn and put into practice this concept of full partnership, they will be operating at half pace.

Before I conclude I want to mention one other element of participation. Political parties—society in general, for that matter—indulge in an ongoing search for leadership. This search for leadership, and leadership itself, in every field of endeavor requires constant renewal. It is not a static thing—it is not to be taken for granted. It too must be supported, encouraged, and nourished. And the development of leadership places unique responsibilities upon the followers as well.

In a very real sense followers are one dimension of leadership, for they are the ones who supply the energy, fire the engines, and complete the round-trip circuit of inspiration and motivation that makes things happen.

Dr. Albert Schweitzer, in speaking of public leaders, particularly in times of crisis, having to act in unprecedented ways, said "leaders must be strengthened in their determination to do new and bold things that must be done. The leaders," Dr. Schweitzer said, "will act only as they become aware of a higher responsibility that has behind it a *wall of insistence* from the people themselves."

We are that wall—all of us! And nowhere is the need for that kind of involvement greater and the lack of it more striking than in political and public life. You know the dismally low numbers that reflect voter turn-out, and they measure *just* voting—the very least a person can do. What about the people that keep headquarters open and give of their resources and do voter turn-out? When you look at those numbers, it drops abysmally low.

Where is that *"wall of insistence"* made up of people voicing their high expectations and enthusiastic encouragement, as well as their outrage and indignation when necessary? And above all, where are the men and women voicing their willingness to *hold leaders accountable*?

In conclusion let me acknowledge what everyone in this room knows. It is much easier to define and analyze a problem than it is to devise a solution. The diagnosis is only the beginning, it is the cure that counts.

In any event the fact that we are gathered here at the University of Oklahoma to discuss political parties is a positive thing. In the course of this conference, we have had an assembly of distinguished educators, journalists, media representatives, professional and practical politicians, technologists, consultants—plus, of course, the people who have been interested and concerned enough to listen to these presentations. I know of no group of people better equipped and more advantageously positioned to tell the world the "old but good" story of citizen politics.

Parties themselves, I will admit, have a monumental responsibility to come to grips with what is happening and tell it like it is. It is time to let the general public know what is happening, what can happen, and let America know what is going on.

I think to myself sometimes that maybe things really do have to get worse before they get better. If today's parties should wither and die, and some new alignments occur, call them what you will, but characterized by rigidly defined doctrine, then the face of politics will surely change but our nation is strong enough to survive.

It is perfectly predictable however that someday a fault line will develop in those newly formed organizations, things will begin to fall apart because their members, linked as they might have been in one idea, will find out they can't agree for very long either. Then someone will say "we need a system that is more flexible, more inclusive, more mainstream. There is strength in diversity—let's form a coalition."

We surely could save ourselves a lot of trouble—and now is the time!

This text is based on a manuscript provided by Mary Louise Smith and is used with her permission. The editors have amended some passages and included some extemporaneous remarks based on a videotape provided by the Political Commercial Archive of the University of Oklahoma. When reviewing the manuscript before publication, Mary Louise Smith suggested four minor, nonsubstantive phrasing changes for increased clarity.

Responses to the Speech

Several substantive questions followed Smith's address—regarding fund-raising, the role of public relations in politics, ways of increasing voter turnout, the wisdom of open primaries, and the strategy used by the Republican Party to improve its image after Watergate. The moderator thanked Smith "for your excellent presentation and insightful views into our political process."

When interviewed in August 1992, one member of her audience said that he no longer remembered the specific content of her speech, but had a clear memory of Smith as "thoughtful, forthright, and candid." He found her a "woman of high principles and personal integrity," who "wasn't dodging difficult ethical questions about the party or the political process." He concluded: "This is exactly the kind of person, male or female, that we need active in the political process" (Jensen, 1992g). Another audience member also reflected on her credibility, saying that he was "very impressed with her preparation, analysis, and content." He noted that she was "not a dynamic speaker, not flashy or fiery," but a "competent craftsperson," who was "extremely capable,

factual, able.'' He said that he particularly appreciated that her address was tailored to the particular audience and was not a generic speech. This listener identified himself as a Democrat who is ''partisan as hell,'' and concluded about Smith's speech: ''I would have been critical if there had been reason and there wasn't'' (Jensen, 1992f).

Ann W. Richards

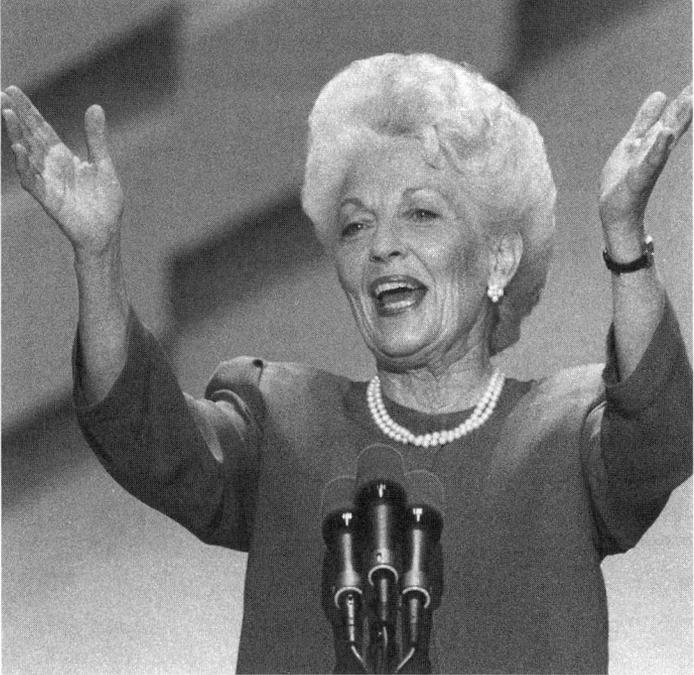

Background

Ann W. Richards, then State Treasurer of Texas, delivered the keynote address at the Democratic National Convention in Atlanta, July 18, 1988. Her immediate listeners in the convention hall were 15,000 delegates and guests; her larger audience included an estimated 70 million television viewers. She was the second woman to keynote a Democratic convention in the 160-year history of the party. Her selection inevitably invited comparisons to Barbara Jordan, the 1976 keynoter, and her immediate predecessor—the 1984 keynoter Mario Cuomo. At the time of her address, she was much less known than Jordan and Cuomo had been, and her reputation as a public speaker was dissimilar to the

eloquence and intellectual depth of the other two speakers. Her speaking style was best known for its humor, attributed by one journalist to the influence of "Southern storytelling" but sounding "at times like . . . gags on the David Letterman show" (Applebome, 1988, p. A13). Leaks about the probable content tended to focus on the expected humor, including the passages about "the Reagan . . . Bush era," "a real Texas accent," and Ginger Rogers "in high heels" (Schwartz, 1988, A22). In spite of the preconvention comparisons to her predecessors, George Christian (press secretary for President Johnson) called her "an inspired choice." Christian predicted: "She'll be different from Cuomo, wittier and more laid back, but she's an outstanding speaker who I think can set the tone for this convention as well as anyone could. I think she'll provide an immediate lift" (Applebome, 1988, p. A13). Cuomo seemed to agree when he called to offer congratulations on her selection: "I hope you'll remember me after you give your speech because no one else will. You'll be the superstar of the party" (Romano, 1988, p. B4).

Approach of the Speaker

In the opening lines of her autobiography, Richards (1989) writes that she always speaks with her mother in mind, because if her mother (a smart woman who likes straight talk) doesn't understand her speech, no one else will either. She also describes her own perspective on public speaking:

> Speaking in public is a very personal piece of business. Giving a good speech, especially one with some passion and emotion, you're revealing a lot about yourself. You're putting yourself in a very vulnerable position. It's sort of like Lady Godiva riding down Main Street without clothes on. Or stepping up on a scale and getting weighed. There's every possibility in the world that you'll be found wanting. (pp. 11–12)

In preparing the keynote address, Richards sought the assistance of several speech writers, including John Sherman, Suzanne Coleman, and Mary Beth Rogers. She also called on several people to write lines— including Erma Bombeck and Jane Wagner (who writes for Lily Tomlin). She sought advice from numerous people, including Barbara Jordan and Ted Sorensen (John F. Kennedy's speech writer). Early in the process, she viewed tapes of Jordan's and Cuomo's addresses and "quickly became very depressed" (Richards, 1989, p. 19). However, Cuomo reminded her: "The reason [you were invited] was that over a period of time you have performed speeches and performed well. Keeping that in mind, just be yourself." Being herself was described by one journalist

as "being bright, witty, humorous and compassionate" (Ratcliffe, 1988, p. 1).

Richards was aware that humor is one of her strengths as a public speaker, but she also understood that her wit needed to serve a substantive message. She said in the days before the address: "This situation does not call for a stand-up comic. . . . Oh, I'll start off with a little humor. But we're not dealing with a roast here" (Romano, 1988, p. B1). She offered her theory of humor in an interview a week before the convention, commenting: "The thing about jokes is that the best ones are the kind that people are not sure of. . . . They're just a little bit anxious that maybe this is something I don't want to hear, and then when the punch line is over, they're so relieved that they're not going to be embarrassed." She went on to describe substantive topics ("optimistic chords") that she wanted to address in Atlanta—e.g., leadership and American families. She said: "I'd like people to come away from my speech thinking, 'She really understands me, and I'm going to listen to what the Democrats have to say.' If I do nothing more than open people's ears, so they can hear and listen and question, then I will have done my job" (Applebome, 1988, p. A13).

Richards (1989) writes of knowing the opening and closing of the speech early and then struggling with a "patchwork" from the writers assisting her. Sherman's final draft was lost in a computer the day before she was to leave for Atlanta and had to be reconstructed from notes and earlier drafts (Schwartz and Grove, 1988, A7).

Two days before the convention, she was still unsatisfied with the tone and substance of the speech. She reflected later (1989):

> I just felt like we were being too eloquent, too lofty-sounding. I wanted to speak so that my Mama understood what I was talking about.
>
> Right from the beginning of the speech I wanted to make it clear that "We're about to have some fun." I wanted an overall feeling that made people know that politics does not have to be all gloom and doom and lofty rhetoric, that it is really personal, and that it's fun. That it is, next to baseball and football, the All-American pastime.
>
> . . .
>
> I knew several things that had to be done in the speech. I wanted to say, from the beginning, that I know that my accent is different from yours, and for the majority of you in that television audience I know I don't sound like you. And I wanted to say it in a way that would be funny so that they would accept me and my accent.
>
> I wanted to say, also right away, I realize that I am female, and that not many females get to do what I am doing, but I hope you will listen to me. And I wanted to say something that would make the women feel good about me being there, and get that issue settled

so that I did not focus on women's issues again in the speech.

I wanted to say, "I am no different than you are. All you people
sitting out there in your living rooms listening to this person speak,
I am an American who cares intensely about her country and its
politics." (pp. 23-24)

Richards spent hours rehearsing the speech, often in the room
immediately beneath the podium. She worked with the TelePrompTer,
practiced eye contact, and asked for changes in lighting arrangements.
She said "she was having a hard time pacing her punchy stump style
into a 30-minute television event. 'People don't want to be harangued
in their living rooms, and I'm working on that. . . . The TV medium
is so hot. Your voice goes up, your hands look wild. . . . I'm not quite
there yet' " (Romano, 1988, B1, B4).

As indicated by the above, Richards was concerned about both
substance and style. In addition, she understood the difference between
oral and written style. She wrote later (1989) that although copies were
given to the press in advance, "it wasn't going to be the same speech
read as it was delivered. It was just not a reading speech, it was a delivery
speech. A lot of speech writers are writers first, not speech makers, and
they make the mistake of writing things that read beautifully but don't
speak well. There's a real difference" (p. 29).

In the last hours before the speech, Richards rested in her hotel
room—listening to the soundtrack of *Chariots of Fire*. She then went
to the hall to face thousands of live listeners and millions of television
viewers, but still intending to speak so her Mama understood what she
was talking about.

Keynote Address at the Democratic National Convention

Thank you. Thank you. Thank you very much!

Good evening, ladies and gentlemen. Buenas noches, mis amigos!

I am delighted to be here with you this evening, because after
listening to George Bush all these years, I figured you needed to know
what a real Texas accent sounds like.

Twelve years ago, Barbara Jordan—another Texas woman—made
the keynote address to this Convention, and two women in 160 years
is about par for the course. But if you give us a chance, we can perform.
After all, Ginger Rogers did everything that Fred Astaire did, she just
did it backwards and in high heels.

I want to announce to this nation, that in a little more than 100 days,
the Reagan-Meese-Deaver-Nofziger-Poindexter-North-Weinberger-Watt-

Gorsuch-Lavelle-Stockman-Haig-Bork-Noriega-George Bush . . . will be over!

You know, tonight I feel a little like I did when I played basketball in the eighth grade. I thought I looked real cute in my uniform. And then I heard a boy yell from the bleachers, "Make that basket, birdlegs!" And my greatest fear is that same guy is somewhere out there in the audience tonight, and he's going to cut me down to size. Because where I grew up, there really wasn't much tolerance for self-importance—people who put on airs.

I was born during the Depression, in a little community just outside Waco, and I grew up listening to Franklin Roosevelt on the radio. Well, it was back then that I came to understand the small truths and the hardships that bind neighbors together. Those were real people with real problems, and they had real dreams about getting out of the Depression.

I can remember summer nights when we'd put down what we called a Baptist pallet, and we listened to the grown-ups talk. I can still hear the sound of the dominoes clicking on the marble slab my daddy had found for a tabletop. I can still hear the laughter of the men telling jokes you weren't supposed to hear, talking about how big that old buck deer was, laughing about mama putting clorox in the well when the frog fell in.

They talked about war and Washington and what this country needed. They talked straight talk. And it came from people who were living their lives as best they could. And that's what we're going to do tonight. We're going to tell "how the cow ate the cabbage."

I got a letter last week from a young mother in Lorena, Texas, and I want to read part of it to you. She writes:

> Our worries go from pay day to pay day, just like millions of others. And we have two fairly decent incomes, but I worry how I'm going to pay the rising car insurance and food.
>
> I pray my kids don't have a growth spurt from August to December so I don't have to buy new jeans. We buy clothes at the budget stores and we have them fray and fade and stretch in the first wash. We ponder and try to figure out how we're going to pay for college, and braces, and tennis shoes. We don't take vacations and we don't go out to eat.
>
> Please don't think me ungrateful. We have jobs, and a nice place to live, and we're healthy. We're the people you see every day in the grocery stores. We obey the laws, we pay our taxes, we fly our flags on holidays, and we plod along trying to make it better for ourselves and our children and our parents. We aren't vocal anymore. I think maybe we're too tired. I believe that people like us are forgotten in America.

Well, of course you believe you're forgotten—because you have
been!

This Republican Administration treats us as if we were pieces of
a puzzle that can't fit together. They've tried to put us into compartments
and separate us from each other. Their political theory is "divide and
conquer." They've suggested time and time again what is of interest
to one group of Americans is not of interest to anyone else.

We've been isolated. We've been lumped into that sad phraseology
called "special interests." They've told farmers that they were selfish,
that they would drive up food prices if they asked the government to
intervene on behalf of the family farm, and we watched farms go on
the auction block while we bought food from foreign countries. Well,
that's wrong!

They told working mothers it's all their fault that families are falling
apart because they had to go to work to keep their kids in jeans, and
tennis shoes and college. And they're wrong!

They told American labor they were trying to ruin free enterprise
by asking for 60 days' notice of plant closings. And that's wrong!

And they told the auto industry, and the steel industry, and the timber
industry, and the oil industry—companies being threatened by foreign
products flooding this country—that you're protectionist if you think the
government should enforce our trade laws. And that is wrong!

When they belittle us for demanding clean air and clean water, for
trying to save the oceans and the ozone layer, that's wrong!

No wonder we feel isolated and confused. We want answers, and
their answer is that something is wrong with you. Well, nothing's wrong
with you. Nothing's wrong with you that you can't fix in November!

We've been told that the interests of the South and the Southwest
are not the same interests as the North and Northeast. They pit one group
against the other. They've divided this country. And in our isolation we
think government isn't going to help us, and we're alone in our feelings.
We feel forgotten. Well, the fact is that we are not an isolated piece
of their puzzle. We are one nation. We are the United States of America!

Now, we Democrats believe that America is still the country of fair
play, that we can come out of a small town or a poor neighborhood
and have the same chance as anyone else, and it doesn't matter whether
we are Black or Hispanic or disabled or women.

We believe that America is a country where small business owners
must succeed, because they are the bedrock, backbone of our economy.

We believe that our kids deserve good day care and public schools.
We believe our kids deserve public schools, where students can learn,
and teachers can teach.

And we want to believe that our parents will have a good
retirement—and that we will too. We Democrats believe that Social

Security is a pact that cannot be broken.

We want to believe that we can live out our lives without the terrible fear that an illness is going to bankrupt us and our children.

Democrats believe that America can overcome any problem, including the dreaded disease called AIDS.

We believe that America is still a country where there is more to life than just a constant struggle for money.

And we believe that America must have leaders who show us that our struggles amount to something and contribute to something larger, leaders who want us to be all that we can be. We want leaders like Jesse Jackson.

Jesse Jackson is a leader and a teacher, who can open our hearts, and open our minds and stir our very souls. And he has taught us that we are as good as our capacity for caring—caring about the drug problem, caring about crime, caring about education, and caring about each other.

Now, in contrast, the greatest nation of the free world has had a leader for eight straight years that has pretended that he cannot hear our questions over the noise of the helicopter. And we know he doesn't want to answer. But we have a lot of questions, and when we get our questions asked, or there is a leak, or an investigation, the only answer we get is, "I don't know" or "I forgot."

But you wouldn't accept that answer from your children. I wouldn't. Don't tell me you "don't know" or you "forgot."

We're not going to have the America that we want until we elect leaders who are going to tell the truth. Not most days, but every day. Leaders who don't forget what they don't want to remember.

And for eight straight years, George Bush hasn't displayed the slightest interest in anything we care about. And now that he's after a job that he can't get appointed to—he's like Columbus discovering America. He's found child care. He's found education. Poor George. He can't help it. He was born with a silver foot in his mouth!

Well, no wonder. No wonder we can't figure it out. Because the leadership of this nation is telling us one thing on TV and doing something entirely different. They tell us that they are fighting a war against terrorists, and then we find out that the White House is selling arms to the Ayatollah. They tell us that they're fighting a war on drugs, and then people come on TV and testify that the CIA and DEA and the FBI knew they were flying drugs into America all along. And they're negotiating with a dictator who is shoveling cocaine into this country like crazy. I guess that's their Central American strategy.

Now, they tell us that employment rates are great, and that they're for equal opportunity. But we know it takes two paychecks to make ends meet today, when it used to take one. And the opportunity they are so

proud of is low wage, dead-end jobs. And there is no major city in America where you cannot see homeless men sitting in parking lots holding signs that say "I will work for food."

Now, my friends, we really are at a crucial point in American history. Under this Administration we have devoted our resources into making this country a military colossus, but we've let our economic lines of defense fall into disrepair. The debt of this nation is greater than it has ever been in our history. We fought a world war on less debt than the Republicans have built up in the last eight years. You know, it's kind of like that brother-in-law who drives a flashy new car but he's always borrowing money from you to make the payments.

But let's take what they're proudest of—that is, their stand on defense. We Democrats are committed to a strong America. And, quite frankly, when our leaders say to us we need a new weapons system, our inclination is to say, "Well, they must be right." But when we pay billions for planes that won't fly, billions for tanks that won't fire, and billions for systems that won't work, that old dog won't hunt.

And you don't have to be from Waco to know that when the Pentagon makes crooks rich and doesn't make America strong, that it's a bum deal.

Now, I'm going to tell you, I'm really glad that our young people missed the Depression and missed the great big war. But I do regret that they missed the leaders that I knew—leaders who told us when things were tough and that we'd have to sacrifice, and that these difficulties might last for a while. They didn't tell us things were hard for us because we were different, or isolated, or special interests. They brought us together, and they gave us a sense of national purpose.

They gave us Social Security, and they told us they were setting up a system where we could pay our own money in, and when the time came for our retirement, we could take the money out.

People in the rural areas were told that we deserved to have electric lights, and they were going to harness the energy that was necessary to give us electricity so my grandmama didn't have to carry that old coal-oil lamp around.

And they told us that they were going to guarantee when we put our money in the bank, that the money was going to be there, and it was going to be insured. They did not lie to us.

And I think one of the saving graces of Democrats is that we are candid. We talk straight talk. We tell people what we think. And that tradition and those values live today in Michael Dukakis from Massachusetts.

Michael Dukakis knows that this country is on the edge of a great new era, that we're not afraid of change, that we're for thoughtful, truthful, strong leadership. Behind his calm there's an impatience to unify

this country and to get on with the future. His instincts are deeply American. They're tough, and they're generous. And personally, I have to tell you that I have never met a man who had a more remarkable sense about what is really important in life.

And then there's my friend and my teacher for many years, Senator Lloyd Bentsen. And I couldn't be prouder both as a Texan and as a Democrat, because Lloyd Bentsen understands America—from the barrio to the board room. He knows how to bring us together by region, by economics, and by example. And he has already beaten George Bush once!

So, when it comes right down to it, this election is a contest between those who are satisfied with what they have, and those who know we can do better. That's what this election is really all about. It's about the American dream—those who want to keep it for the few, and those who know it must be nurtured and passed along.

I'm a grandmother now. And I have one nearly perfect granddaughter named Lily. And when I hold that grandbaby, I feel the continuity of life that unites us, that binds generation to generation, that ties us with each other.

And sometimes I spread that Baptist pallet out on the floor and Lily and I roll a ball back and forth. And I think of all the families like mine, and like the one in Lorena, Texas, like the ones that nurture children all across America.

And as I look at Lily, I know that it is within families that we learn both the need to respect individual human dignity and to work together for our common good. Within our families, within our nation, it is the same.

And as I sit there, I wonder if she'll ever grasp the changes I've seen in my life—if she'll ever believe that there was a time when Blacks could not drink from public water fountains, when Hispanic children were punished for speaking Spanish in the public schools, and women couldn't vote.

I think of all the political fights I've fought, and all the compromises I've had to accept as part payment. And I think of all the small victories that have added up to national triumphs, and all the things that would never have happened, and all the people who would have been left behind if we had not reasoned, and fought, and won those battles together. And I will tell Lily that those triumphs were Democratic Party triumphs.

I want so much to tell Lily how far we've come, you and I. And as the ball rolls back and forth, I want to tell her how very lucky she is. That for all of our difference, we are still the greatest nation on this good earth. And our strength lies in the men and women who go to work every day, who struggle to balance their family and their jobs, and

who should never, ever be forgotten.

I just hope that—like her grandparents and her great grandparents before—that Lily goes on to raise her kids with the promise that echoes in homes all across America: that we can do better. And that's what this election is all about.

Thank you very much.

This text was provided by the Office of The Governor, State of Texas. One sentence has been edited to omit repetition caused by applause.

Responses to the Address

The response from Ann Richards' immediate audience was enthusiastic. She was interrupted by cheering and applause more than forty times and her speech was followed by a spirited demonstration in the Omni Convention Hall. While demonstrations are routinely staged at political conventions, the enthusiasm of individual delegates was genuine.

Several theatrical and literary observers assembled by *The New York Times* were less uniform in their appraisals. One commented on "standard clichés" and another criticized the "tired opening." One commented on slow delivery in the opening, and another found the speech "a little sad . . . in comparison to the intellectual speeches" of Adlai Stevenson at past Democratic conventions. But one of these observers said he was moved and stated: "I found the content wonderful. . . . It made me feel good about being an American. It was what I believed" (Reinhold, 1988, p. A17). Some rhetorical critics would later argue that Richards' personal anecdotes, concrete examples, and brief narratives reflected an emerging "feminine style" (Dow and Tonn, 1993, p. 289).

Lily Tomlin wired a one-word message: "Triumph," and Anna Quindlen wrote in *The New York Times* that Richards "gave a woman's speech without for a moment losing the men" (Diehl, 1988, p. 1). One of the most important responses came from Michael Dukakis who said: "How can I match that?" (Toner, 1988, p. A1). Possible long-term responses came from Texas voters two years later. A Democratic pollster had said before her address: "This is her debut. . . . This could positively ignite her. Or deflate her" (Pedersen, 1988, p. 22). One visitor at the convention was sure it would deflate her; Jim Mattox, her upcoming opponent in the gubernatorial primary, said: "People won't remember two weeks later who made that speech" (Slater, 1988, p. 8A). Twenty-eight months later, Ann Richards was elected Governor of Texas.

Cynthia Ann Broad

Background

She is an outstanding teacher who goes out of her way to educate, inspire and assist her colleagues. I know of no other teacher who devotes so much of herself to both her students and other teachers. She is an inspiration to me on a daily basis. (A respondent to the editors' speaker survey, July, 1991).

Cynthia Ann Broad is a special education teacher at Grosse Pointe Shores, Michigan, with twenty-one years of teaching experience. Her speech was given in acceptance of the state Department of Education's "Teacher of the Year" award, 1989–1990. Broad was selected from a pool of ninety outstanding teachers nominated for the award. She has also been named an "Outstanding Teacher of America" (1972) and more recently, she received a national educator award from the Milken Family Foundation. She was one of ten educators in the country selected for the $25,000 award. Broad is also an educational honorary member of Delta Kappa Gamma International Society, nominated by her colleagues.

Unlike many parents, teachers, and administrators, Broad believes in "mainstreaming" children with disabilities into classrooms with so-called normal children. "My dream is that special ed and regular ed will be one" (Angel, 1989, p. 1A). Broad has known her chosen profession since seventh grade when a younger brother was diagnosed with infantile autism. "I realized then I wanted to teach handicapped students to reach their potential," she said in an unpublished biography written for the teaching award. Her work day is divided between the classroom and conducting workshops for other teachers to demonstrate how special education students can be successfully placed in "regular" classrooms.

Initially Broad refused to be nominated for the Michigan teaching award, but she decided to accept if she could share the honor with her students and colleagues. "One of my teaching philosophies is to utilize the vast variety of resources available in the community . . . emphasizing the partnership of school, parents, and community" (DeFrancisco, 1992h). The award allowed her to affirm these resources. In response, the community declared an official "Cynthia Ann Broad" day of celebration January 25, 1990. In referring to Broad's award and the honor it brought to the entire school district, her school principal, Jim Cambridge said, "Everyone here is even more upbeat than before. The whole school is now a winner. . . . This is a boost for the whole community" (LaRue, 1989, p. 5).

On the day of the celebration, there was an all-school assembly where Broad was honored and where she gave what others described as a very moving presentation. Broad chose to tell a story, since the majority of the audience were children. A local newspaper writer said she captured the attention of 300 children plus adults as she acted out the story of *Pinocchio* and compared teaching to the work of the old wood carver (Mooty, 1989, p. 1). "Teachers are artists and creators, just as are wood carvers," Broad said (DeFrancisco, 1992h). "The wood carver begins with a block of wood *as it is*, and shapes it, brings life to it. Teachers do much the same when they accept the child as she or he is, then work to help that child develop."

The speech included in this collection was given at the climax of that

day of celebration. A dinner/reception was held in her honor at the Grosse Point Yacht Club. After the dinner several colleagues, friends, and state officials spoke to honor the teacher prior to her keynote address. When Broad approached the podium to speak, the audience gave her a standing ovation. Before beginning her prepared comments, she gave special thanks to her mother, a colleague, and her brother for being there. She also introduced the student teacher she was currently supervising, saying, "She's a keeper." Broad had a written manuscript, and knew it well since she referred to it only occasionally.

Approach of the Speaker

Two years after the speech, Broad reflected, "I don't consider myself a speaker or speech writer. I see it as teaching and sharing. When I write a speech I do a mapping of words, thoughts that have meaning to me and integrate them in the speech" (DeFrancisco, 1992h). In her thoughts for this speech were the events, personal influences, and previous students in special education which she felt would be most inspirational to the audience.

She said: "The speech was so me. You can see Michigan in that speech—Thomas Edison, Port Huron. . . . It [the speech] goes back to my childhood—watching the space program on T.V. as a child, and the effect it had on me. We were going to use Christa McAuliffe's research from space in class." Broad said the class was watching Christa as the space shuttle *Challenger* lifted off and then exploded on January 28, 1986. In her speech she wanted to remember the feelings her class had shared that day: frustration, shock, and sadness.

In more general comments, regarding her role as a public speaker representing Michigan teachers, she said, " . . . it's frightening for me to be a representative for the many teachers, so I hope I can communicate the way teachers feel today" (Mooty, 1989, p. 1). She said her goal in public speaking is "to bring all men and women together to get excited, celebrate teaching. . . . It keeps going back to the children. Without the students I wouldn't be teacher of the year" (DeFrancisco, 1992h).

"I Touch the Future: I Teach"

Thank you. I'm thrilled, excited—even a little overwhelmed by all this attention. But I'm honored and privileged to be acknowledged by all of you. All of us tonight, for a brief moment, are celebrating the worth of teaching.

And I say unhesitatingly, we *need* to celebrate the value of teachers in our society. [Applause]

Even though there is a dark cloud over our educational system, even though educators must deal with public criticism and huge societal problems, problems such as illiteracy, poverty, crime, child abuse, and divorce.

In spite of all this, teachers need to be recognized for their tremendous efforts to bring out the best in our children and in doing so, the best for our society.

So I would like to share the recognition you have given me with *all* the men and women in education, who day in and day out—and often with very little notice—try to light the spark of curiosity and to plant the seed of success in the hopes of creating a bright future for their students, who will in turn, help our country live up to the promise of its great beginning.

I remember another teacher who lived and died trying to carry out that mission.

It was this week, four years ago, on January 28, 1986, when the solid rocket boosters on the space shuttle *Challenger* ignited.

I remember—as I'm sure you do—a moment of immense pride, nearly extinguished by painful loss, when Christa McAuliffe "slipped the surly bonds of earth" in the pursuit of passion—of learning—adventure.

She represented the aspirations of all teachers—and of countless millions of Americans who dreamt of a future of unlimited potential—who identified with her free spirit and personal courage.

She made us all proud to say—"I touch the future, I teach."

I think Christa would have liked one of my favorite quotes. It reads: "In times of change, it is the learners who will inherit the earth while the learned will find themselves beautifully equipped for a world that no longer exists."

She recognized that good teaching requires the ability to learn and to adapt to new conditions and expectations.

She recognized that teaching is an instrument to empower those whom she taught.

A poem in her college yearbook by Ralph Chaplin is a fitting memorial to her mission, as a teacher.

Entitled, "Mourn Not the Dead," the last stanza reads—

> But rather mourn the apathetic throng
> The cowed and the meek
> Who see the world's great anguish and its wrong
> And dare not speak!

Christa McAuliffe stands as an inspiration to all of us. She encouraged all of her students to push themselves as far as they could go.

She encouraged a high personal standard of success—independent of the success of others.

To be acknowledged as The Michigan Teacher of the Year is especially significant to me because, for the first time, the field of special education is being recognized as part of the mainstream of American education.

It's an acknowledgement that public schools have the obligation to educate *all children*—the central premise of Public Law 94–142—the Education of All Children Act.

In the pursuit of excellence, it's easy to give more attention to those children who already seem to have a head start towards success and to relegate the more difficult child to the background.

We can't afford such impatience in the name of efficiency. We simply can't predict human success or failure.

I'd like to tell you the story of two children—two educationally handicapped children.

The parents of the first child were not considered successful. His father was unemployed with no formal schooling. His mother was a teacher—and there was probably tension in the family because of this mismatch.

This child, born in Port Huron, Michigan, was estimated to have an IQ of 81. He was withdrawn from school after three months—and was considered backward by school officials.

Physically, the child enrolled two years late due to scarlet fever and respiratory infections. And he was going deaf. His emotional health was poor—stubborn, aloof, showing very little emotion.

He liked mechanics. He liked to play with fire and burned down his fathers's barn. He showed some manual dexterity, but used very poor grammar. But he *did* want to be a scientist or a railroad mechanic.

The second child showed not much more promise.

This child was born of an alcoholic father who worked as an itinerant and a mother who stayed at home.

As a child she was sickly, bedridden, and often hospitalized. She was considered erratic and withdrawn. She would bite her nails, and had numerous phobias. She wore a backbrace from a spinal defect and would constantly seek attention.

She was a daydreamer with no vocational goals, although she expressed a desire to help the elderly and the poor.

Who were these children?

The boy from Port Huron became one of the world's greatest

inventors—Thomas A. Edison.

And the awkward and sickly young girl became a champion of the oppressed—Eleanor Roosevelt.

These children—and thousands like them—touch the heart and challenge the mind, but they are the children I love to teach and children we can't afford to ignore.

And so I'd like to say "thank you" to my colleagues, administrators, and the parents of my students. Their encouragement, support, and active involvement in creating an exciting, challenging, and joyful learning environment has created a climate for success for me, for L'Anse Creuse Public Schools, and for my students.

And truly it is my students who won this award for me.

I discussed the nominating questions for this award with my students. I said I had a problem.

They asked, "What's your problem?"

I answered, "One of the questions asks me what makes an outstanding teacher. I'm not sure if I am an outstanding teacher, even if that's what I try to be."

One of my students replied, "If this award was for us, would you have a problem?"

I immediately answered, "No!"

And they said, "Well, get this award for us—our room could use this big award." [laughter]

So, to my students, I'd like to say, "Thank you for helping me, and working with me, to solve our problems together. Thank you for helping me become Michigan's Teacher of the Year."

This text is from Vital Speeches of the Day *(April 15, 1990), with minor additional editing based on a videotape of the event. Reprinted with permission from Cynthia Ann Broad.*

Responses to the Speech

Excerpts of Broad's speech have been printed in various publications (*Reader's Digest*, 1991; *Vital Speeches*, 1990). Detz (1991) quoted a portion of the speech in a self-help book on public speaking. Detz said, "Listen to the beautiful power of this acceptance speech. . . . Try reading the excerpt aloud so you can appreciate the full impact of her message" (p. 16).

Broad herself recalled the immediate audience responses. She said, "I was quite taken back with the response of the audience afterwards. A lot of them had index cards with written compliments—proclama-

tions." The comment which perhaps touched her most came from Nick Ciaramitaro, State Representative: "You've inspired me so much that I just want to go back to school" (DeFrancisco, 1992h). Ciaramitaro said he could not read his prepared comments to her after hearing such a moving speech.

Several audience members responded to a survey by the editors. One person wrote, "Cynthia has a marvelous presence when she speaks, it reflects how she really feels. The intensity, the seriousness of purpose, and her love of children are very evident when she speaks. . . ." Another wrote, "Cindy is a natural speaker who uses her tone of voice and enthusiasm to keep the listeners with her. That is something you cannot evaluate from reading the text of her remarks."

Several commented on the focus of the speech, "I touch the future; I teach." The allusion to Christa McAuliffe, teacher and astronaut, was "uncomfortable" for one, and "moving" to others. One respondent said: "I literally had goose bumps over my body and tears in my eyes," as she listened to McAuliffe described as a symbol for teachers who try to inspire students.

Broad's speech had this long-term effect on another teacher:

> My attitude toward my professional responsibilities as a teacher were improved by Cindy's speech. In a period of continual ridicule of the educational system, I was proud . . . and encouraged to continue to study and increase my efforts to provide the best possible learning environment for my students. I also found my focus with individual children changed. . . . I began trying to enhance the child's self-esteem. . . . The result was an increase in the number of approaches used with the children who were having difficulty. Those children were much more positive and willing to put forth a solid effort. . . .

Administrators were also affected. Sally DeSchepper, Grosse Pointe Shores' school board vice-president said: "Cynthia Broad conveyed to me that [there are] new and innovative ways to deliver the learning process. . . . It will be necessary for school districts and the community to adapt to those changes. All students can learn."

Several respondents affirmed that it is the speaker's daily actions which make her words so inspirational and influential. "I am aware first-hand that these are Cindy's words and sentiments. . . . These words clearly represent Cindy's actions."

Elizabeth Taylor

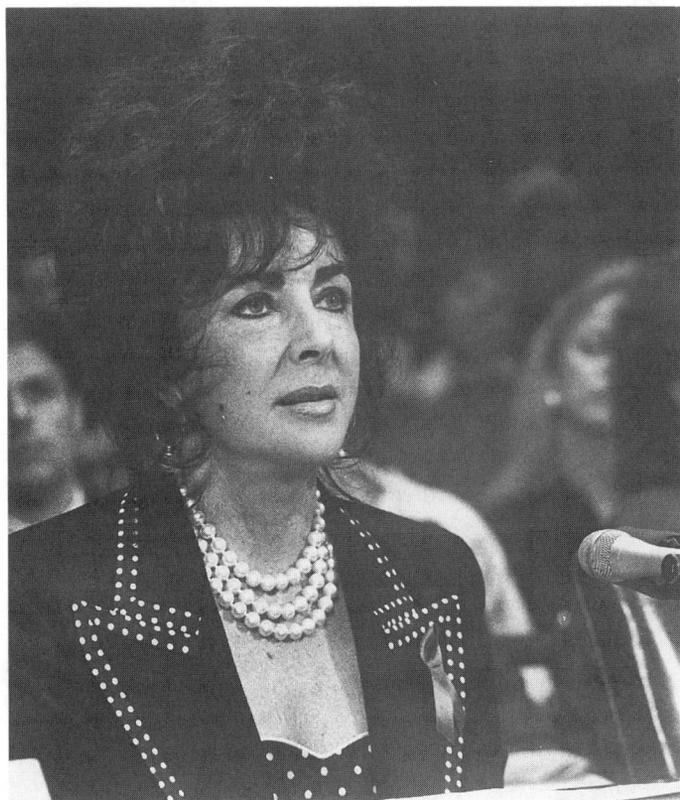

Background

Elizabeth Taylor made this statement on March 6, 1990, to the U.S. House of Representatives Task Force on Human Resources, chaired by Representative Barbara Boxer. Taylor was the first of a panel of witnesses, testifying in her capacity as Founding National Chair of the American Foundation for AIDS Research. The hearing came at a point when AIDS had claimed 73,000 lives in the United States—and the President's

proposed budget to fight the disease had been decreased from the amount requested by his Secretary of Health and Human Services. Representative Boxer said in welcoming Elizabeth Taylor: "I want to say that your involvement in this AIDS issue has been extraordinarily helpful in bringing attention, focus, and compassion to the fight against this epidemic. We know that your privacy is something that you value, and we know that you are giving it up to be here with us today" (Task Force, 1990, p. 2).

Approach of the Speaker

When asked on an earlier occasion what prompted her public statements on the subject of AIDS, Taylor responded:

> First, I became aware of the fact that there was a new and very serious disease that was destroying many young people in the arts community at the very prime of their lives. Second, I had a strong sense of compassion for those people for whom literally nothing could be done. And finally, I was outraged that nothing was happening, that no one was doing anything, that no one seemed to care—and then I realized that if I didn't become involved, I had no one to blame but myself. (Miller, 1987, p. 106)

When asked about the response she has received to her efforts, Taylor said:

> An overwhelmingly positive response from those whom we have reached! But the vast majority of Americans have not yet been reached, and they are still not aware that this crisis affects us all— our families, our friends, and ourselves. Reaching these Americans is the challenge—helping them to understand and to feel more comfortable about becoming involved with a controversial issue. (Miller, 1987, p. 102)

Statement to the Task Force on Human Resources of the House Committee on the Budget

Thank you, Madam Chairwoman. It is an honor for me to appear before this distinguished Task Force of the House Budget Committee. Thank you.

I have been involved in the fight against AIDS for many years now. I am committed to this struggle because the tragedy of AIDS has affected me very deeply. So many of us have seen those we love, friends and family members, die of this devastating disease. So far, AIDS has killed over 70,000 Americans. That is more than died in the Vietnam war. Up

to 1 million Americans are infected by HIV, the virus that causes AIDS. All of these people are in grave danger. Incredible as it may seem, the darkest period of the AIDS crisis still lies ahead of us.

Over the past few years we have started to see progress—some times major progress. But I am afraid that we are entering a new, very difficult period in our fight against AIDS. Just when it seemed that society's compassion and understanding of AIDS was growing, we are witnessing a very disturbing resurgence of ignorance and misinformation about this disease.

For example, we have all heard recent reports that the number of new AIDS cases is slightly lower than expected. As a result, some people are suggesting that the worst of the AIDS epidemic will soon be over. We are also hearing that AIDS only threatens people who are perceived to be on the margins of our society, such as people of color and gay men. The thinly veiled message is that the majority of Americans do not need to care about AIDS. Finally, we are hearing complaints that federal AIDS spending is too high, especially when compared to what we spend on other illnesses.

I am deeply concerned about these disturbing misconceptions about AIDS. They are misleading, wrong-headed, and very dangerous. Any suggestion that the worst of the epidemic is over or that it will not in some way affect the majority of Americans simply is not true. The cold, hard facts tell us a very different story.

First, according to the latest statistics from the Centers for Disease Control, the number of people diagnosed with AIDS will more than double in the next year and a half.

Second, the virus that causes AIDS continues to spread at an alarming rate. Women and people of color now constitute the majority of new infections, and many of these people are being infected through heterosexual contact.

Third, AIDS is an infectious disease—a deadly infectious disease that threatens an ever-growing number of people in the prime of life. Given the perils of AIDS, the resources we have so far devoted to this epidemic, rather than being extravagant, are minor compared to the resources we have long devoted to research on other diseases.

I have talked to many doctors and people with AIDS throughout the country. They all tell me one thing: health care facilities for people with AIDS are already overwhelmed. Some urban hospitals are literally overflowing. There are no available beds—patients must spend days waiting for a regular room. AIDS is pushing our health care system to its limits and beyond, endangering all Americans. And yet, incredibly the worst is yet to come. The demand placed on these facilities for AIDS-related health care is expected to double in the next year and a half.

That is why I am here today. I have come to urge you to endorse

the plan outlined in the Comprehensive AIDS Relief Act introduced in the Senate today by Senator Kennedy and Senator Hatch.

The first letters of this bill appropriately spell C-A-R-E. This bill will provide urgently needed health care for people with AIDS and HIV infection, and it can help save our health care system from disaster.

AIDS is a major national crisis. As a nation, we have responded generously to the earthquake that struck San Francisco last October. Sixty-five people died in San Francisco and the property damage in the millions. In response, billions of dollars of federal aid were made available almost immediately.

A similar disaster is now striking most of the nation's major cities. Cities like Atlanta, Dallas, Boston, Los Angeles, Miami, New York simply do not have the resources to cope with the AIDS disaster on their own. The federal government must come to the rescue.

As a first step, the CARE bill will provide emergency relief to our cities hardest hit by AIDS. The bill will also help provide comprehensive care for all people with AIDS and HIV infection throughout the country.

The CARE bill will also allow people to receive treatment and care in their homes. That is so much more humane and less expensive than hospital care. More importantly, the CARE bill will help pay for crucial early treatment for AIDS and HIV disease. Right now, up to 1 million people urgently need early treatment.

Thanks to research, treatments now do exist for people who are HIV infected and have not yet developed any symptoms, but many people cannot pay for these treatments because they need our help. Without treatment, many of these people will become seriously ill in the next few years. Unless we act decisively we risk losing this precious chance to save lives. We need the resources now to provide those people with care.

Finally, support for treatment and care is important, but we must continue and strengthen our commitment to AIDS research to find effective treatments and a cure. Recently there have been charges that AIDS research has received more than its fair share of federal funds. AIDS demands our urgent attention because it is an infectious illness, spreading rapidly and killing people in the prime of their lives. We don't want to take money away from research for cancer or heart disease or any other serious illness. We feel that our nation can and should provide the necessary resources to fight all of those diseases. The health of our people must be a top priority.

We cannot let up on our efforts to fight AIDS. The struggle that lies ahead threatens to overwhelm us. The people on the front lines of this fight need our help urgently to save lives. We cannot let them down. We need their energy, their dedication, and their love in the dark days that lie ahead. Thank you.

This text is from Hearing Before the Task Force on Human Resources of the Committee on the Budget, U.S. House of Representatives, March 7, 1990.

Responses to the Statement

Several members of the Budget Committee and its Task Force warmly thanked Taylor after her statement, including Representatives Panetta, Boxer, Guarini, Bielenson, Kildee, and Kaptur. Several questions were also asked.

Representative Boxer asked:

> Ronald Reagan recently went on TV with a 30-second spot talking about the need for compassion, and many of us were very pleased because as we fought this fight we felt that he was a very late entry into the fight. If he were to ask your opinion on what else he could do at this time to help us with this disaster aid approach and early intervention, which is very important at this stage, how do you think that he could help us? How do you think that George Bush could help us with this battle? (Task Force, 1990, p. 5)

Taylor responded:

> I think to address more directly the issue as it is, more honestly. It is wonderful that he is willing now to help for pediatric AIDS, but I think it would be more meaningful if people spoke out in their effort to fight AIDS and had no barriers.
>
> It is almost as if there still lies that stigma attached to the homosexual community. It is like it is sad and tragic about children; that, we can talk about, but we still can't talk about homosexual AIDS, and I think it is mandatory that we face that AIDS touches not only children, unfortunate women and gay people and now the heterosexual community; everyone with AIDS is a fellow sufferer.
>
> There shouldn't be any difference in our emotions or our feelings or our helping. We should help everyone because everyone, as a friend of yours said, is somebody's child. (Task Force, 1990, p. 5)

Leon Panetta, Chair of the full Budget Committee, asked if she had presented her arguments to the Administration. Taylor responded: "Yes I have. I spoke to Mrs. Bush yesterday, and she is very well informed about AIDS, and she is very receptive and is more than willing to help" (Task Force, 1990, p. 6).

Representative Boxer asked whether private fund raisers, like the American Foundation for AIDS Research, could be expected to compensate if federal funding was not sufficient. Taylor responded:

> No, I think it is on such a horrendous grand scale now that only the government can take care of the numbers. In the private sector we can help rapidly, perhaps more rapidly than the government, but we can't raise the kind of figures that you are talking about here today. We can help morally, we can give compassion and love and care, which is as important as money, particularly in this illness,

but money and lots of money is the only thing that is going to build centers, hospices, care units.

It takes volunteers to people those units, and there we can help, but it takes billions of dollars for research. We have raised $25 million for research, and that is a drop in the bucket, and of course the government has to do more. (Task Force, 1990, p. 7)

In a letter over two years later, Boxer (1992a) reflected that "Ms. Taylor's participation was invaluable then, and still is today, in the ongoing battle for adequate funding for AIDS programs." In an accompanying statement, Boxer (1992b) wrote:

Elizabeth Taylor's status as a highly respected film star has proven an invaluable asset in a country with a short attention span for crisis. However, Ms. Taylor's personal commitment of time and energy in her efforts to increase AIDS awareness and educational programs which promote prevention cannot be ignored. Her participation in the March 6, 1990 Task Force hearing in which she provided her support of early intervention programs and the Ryan White CARE Act represents one of the first crucial steps on the road to the inclusion of a $1 billion, 50% increase in AIDS funding recommendations in the House Budget Resolution for fiscal year 1991. The resolution asked that Medicaid include a program of early intervention so that those who are HIV-positive could seek help *before* they develop full-blown AIDS. Also, for the first time, the 1991 budget resolution included a recommendation of funds to target pediatric AIDS.

In 1990, Elizabeth Taylor warned Congress that this country must prepare for the darker period that lay ahead and she was right. Her contribution to that preparation, which has brought attention, focus, and compassion to the AIDS epidemic, is greatly appreciated.

Janice Payan

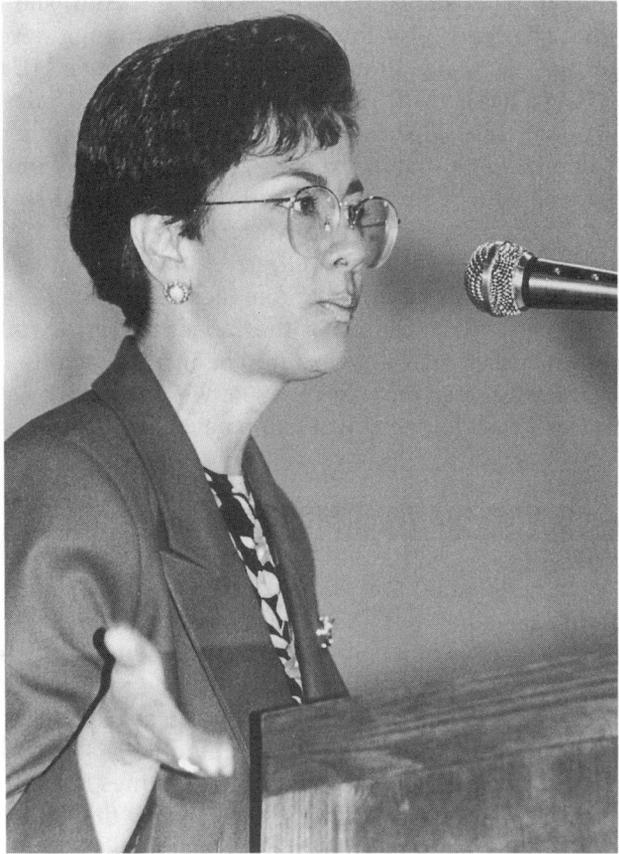

The 1990 Adelante Mujer (Onward Women) Conference was organized by a small group of Hispanic American women in the Denver, Colorado area. One of the organizers, Dr. Cecilia Cervantes, now Dean of Continuing Education at Western New Mexico University, said the

75

organizers had three goals for the conference: to help Hispanic women in the areas of employment, training, and education (DeFrancisco, 1992g).

Another organizer, Olivia Armijo Killough, Director of Human Resources at U.S. West, Inc., helped select Janice Payan as a keynote speaker for the conference. She said Payan was asked to speak because "she is an excellent role model. She is proud of her heritage—didn't give up what she is to be successful. . . . And, she is willing to share what she has [by] mentoring others." Killough described the speaker as "an easy going, down to earth, caring woman" (DeFrancisco, 1992f).

Payan has an M.B.A. and is Vice President of Sales at U.S. West, Inc. Killough said, "She is probably one of the highest paid women in Colorado. Janice has broken the glass ceiling for women in the corporate environment. There are lots of women in social services, but they are more rare in the corporate world."

There were over five hundred women present to hear Janice Payan, "from grass roots to highly professional," Killough said. The organizers were particularly proud of the large number of young women at the conference, which was meant to be inspirational to them. The speech, which was given on May 19, 1990, was followed by a choice of seventy-five self-development workshops available to the participants.

Approach of the Speaker

Payan (1992) said that she prefers to use more informal approaches to giving apeeches, but—since this was a thirty-minute speech—she spoke from a manuscript. She nonetheless sought to create an informal, personal exchange and reflected: "I tried to have excellent eye contact with women throughout the room and pace the speech for extra emphasis at key times." She said of her intentions: "I felt an overwhelming responsibility to share some of the learnings I have had in my life and career. . . . I kept thinking 'I wish I knew then at age 20 what I know now at 39'—I wished someone had shared their wisdom with me at that age."

"Opportunities for Hispanic Women: It's Up to Us"

Thank you. I felt as if you were introducing someone else because my mind was racing back ten years, when I was sitting out there in the audience at the Adelante Mujer conference. Anonymous. Comfortable. Trying hard to relate to our "successful" speaker, but mostly feeling like

Janice Payan, working mother, glad for a chance to sit down.

I'll let you in on a little secret. I still am Janice Payan, working mother. The only difference is that I have a longer job title, and that I've made a few discoveries these past ten years that I'm eager to share with you.

The first is that keynote speakers at conferences like this are not some sort of alien creatures. Nor were they born under a lucky star. They are ordinary Hispanic women who have stumbled onto an extraordinary discovery.

And that is: Society has lied to us. We do have something up here! We can have not only a happy family but also a fulfilling career. We can succeed in school and work and community life, because the key is not supernatural powers, it is perseverance. Also known as hard work!

And God knows Hispanic women can do hard work!!! We've been working hard for centuries, from sun-up 'til daughter-down!

One of the biggest secrets around is that successful Anglos were not born under lucky stars, either. The chairman of my company, Jack MacAllister, grew up in a small town in eastern Iowa. His dad was a teacher; his mom was a mom. Jack worked, after school, sorting potatoes in the basement of a grocery store. Of course I realize, he could have been hoeing them, like our migrant workers.

Nevertheless, Jack came from humble beginnings. And so did virtually every other corporate officer I work with. The major advantage they had was living in a culture that allowed them to believe they would get ahead. So more of them did.

It's time for Hispanic women to believe we can get ahead, because we can. And because we must. Our families and workplaces and communities and nation need to reach our full potential. There are jobs to be done, children to be raised, opportunities to be seized. We must look at those opportunities, choose the ones we will respond to, and do something about them.

We must do so, for others. And we must do so, for ourselves. Yes, there are barriers. You're up against racism, sexism, and too much month at the end of the money. But so was any role model you choose.

Look at Patricia Diaz-Denis. Patricia was one of nine or ten children in a Mexican-American family that had low means, but high hopes. Her parents said Patricia should go to college. But they had no money. So, little by little, Patricia scraped up the money to send herself.

Her boyfriend was going to be a lawyer. And he told Patricia, "You should be a lawyer too, because nobody can argue like you do!" Well, Patricia didn't even know what a lawyer was, but she became one—so successful that she eventually was appointed to the Federal Communication Commission in Washington, D.C.

Or look at Toni Panteha, a Puerto Rican who grew up in a shack

with dirt floors, no father, and often no food. But through looking and listening, she realized the power of community—the fact that people with very little, when working together, can create much.

Dr. Panteha has created several successful institutions in Puerto Rico, and to me, she is an institution. I can see the wisdom in her eyes, hear it in her voice, wisdom far beyond herself, like Mother Teresa.

Or look at Ada Kirby, a Cuban girl whose parents put her on a boat for Miami. Mom and Dad were to follow on the next boat, but they never arrived. So Ada grew up in an orphanage in Pueblo, and set some goals, and today is an executive director at U.S. West's research laboratories.

Each of these women was Hispanic, physically deprived, but mentally awakened to the possibilities of building a better world, both for others and for themselves.

Virtually every Hispanic woman in America started with a similar slate. In fact, let's do a quick survey. If you were born into a home whose economic status was something less than rich . . . please raise your hand.

It's a good thing I didn't ask the rich to raise their hands. I wouldn't have known if anyone was listening.

All right. So you were not born rich. As Patricia, Toni and Ada have shown us, it doesn't matter. It's the choices we make from there on, that make the difference.

If you're thinking, "that's easy for you to say, Payan," then I'm thinking: "little do you know . . ."

If you think I got where I am because I'm smarter than you, or have more energy than you, you're wrong.

If I'm so smart, why can't I parallel park?

If I'm so energetic, why do I still need eight hours of sleep a night? And I mean need. If I hadn't had my eight hours last night, you wouldn't even want to hear what I'd be saying this morning!

I am more like you and you are more like me than you would guess.

I'm a third-generation Mexican-American . . . born into a lower middle-class family right here in Denver. My parents married young; she was pregnant. My father worked only about half the time during my growing-up years. He was short on education, skills, and confidence. There were drug and alcohol problems in the family. My parents finally sent my older brother to a Catholic high school, in hopes that would help him. They sent me to the same school, to watch him. That was okay.

In public school I never could choose between the "Greasers" and the "Soshes." I wanted desperately to feel that I "belonged." But I did not like feeling that I had to deny my past to have a future.

Anybody here ever feel that way?

Anyway, the more troubles my brother had, the more I vowed to avoid them. So, in a way, he was my inspiration. As Viktor Frankl says,

there is meaning in every life.

By the way, that brother died after returning from Vietnam.

I was raised with typical Hispanic female expectations. In other words: if you want to do well in life, you'd better. . . . Can anybody finish that sentence?

Right!

Marry well.

I liked the idea of loving and marrying someone, but I felt like he should be more than a "meal ticket." And I felt like *I* should be more than a leech. I didn't want to feel so dependent.

So I set my goals on having a marriage, a family and a career. I didn't talk too much about those goals, so nobody told me they bordered on insanity for a Hispanic woman in the 1960s.

At one point, I even planned to become a doctor. But Mom and Dad said, "wait a minute. That takes something like 12 years of college."

I had no idea how I was going to pay for four years of college, let alone 12. But what scared me more than the cost was the time: In 12 years I'd be an old woman.

Time certainly changes your perspective on that.

My advice to you is, if you want to be a doctor, go for it! It doesn't take 12 years, anyway.

If your dreams include a career that requires college . . . go for it!

You may be several years older when you finish, but by that time you'd be several years older if you don't finish college, too.

For all my suffering in high school, I finished near the top of my graduating class. I dreamed of attending the University of Colorado, at Boulder. You want to know what my counselor said? You already know. That I should go to a business college for secretaries, at most.

But I went to the University of Colorado, anyway. I arranged my own financial aid: a small grant, a low paying job, and a big loan.

I just thank God that this was the era when jeans and sweatshirts were getting popular. That was all I had!

I'm going to spare you any description of my class work, except to say that it was difficult—and worth every painful minute. What I want to share with you is three of my strongest memories—and strongest learning experiences—which have nothing to do with books.

One concerns a philosophy professor who, I was sure, was a genius. What I like best about this man was not the answers he had—but the questions. He asked questions about the Bible, about classic literature, about our place in the universe. He would even jot questions in the margins of our papers. And I give him a lot of credit for helping me examine my own life.

I'm telling you about him because I think each of us encounters people who make us think—sometimes painfully. And I feel, strongly,

that we should listen to their questions and suffer through that thinking. We may decide everything in our lives is just like we want it. But we may also decide to change something.

My second big "non-book" experience was in UMAS—the United Mexican American Students. Lost in what seemed like a rich Anglo campus, UMAS was an island of familiarity: people who looked like me, talked like me, and felt like me.

We shared our fears and hopes and hurts—and did something about them. We worked hard to deal with racism on campus, persuading the university to offer Chicano studies classes. But the more racism we experienced, the angrier we became.

Some members made bombs. Two of those members died. And I remember asking myself: "Am I willing to go up in smoke over my anger? Or is there another way to make a difference?"

We talked a lot about this, and concluded that two wrongs don't make a right. Most of us agreed that working within the system was the thing to do. We also agreed not to deny our Hispanic heritage: not to become "coconuts"—brown on the outside and white on the inside— but to look for every opportunity to bring our culture to a table of many cultures.

That outlook has helped me a great deal as a manager, because it opened me to listening to all points of view. And when a group is open to all points of view, it usually chooses the right course.

The third experience I wanted to share from my college days was the time they came nearest to ending prematurely. During my freshman year, I received a call that my mother had been seriously injured in a traffic accident. Both of her legs were broken. So was her pelvis.

My younger brother and sister were still at home. My father was unemployed at the time, and I was off at college. So who do you think was elected to take on the housework? Raise your hand if you think it was my father.

No???

Does anybody think it was me?

I am truly amazed at your guessing ability.

Or is there something in our Hispanic culture that says the women do the housework?

Of course there is.

So I drove home from Boulder every weekend; shopped, cleaned, cooked, froze meals for the next week, did the laundry, you know the list. And the truth is, it did not occur to me until some time later that my father could have done some of that. I had a problem, I was part of the problem.

I did resist when my parents suggested I should quit school. It seemed better to try doing everything than to give up my dream. And

it was the better choice. But it was also very difficult.

Which reminds me of another experience. Would it be too much like a soap opera if I told you about a personal crisis? Anybody want to hear a story about myself that I've never before told in public?

While still in college, I married my high school sweetheart. We were both completing our college degrees. My husband's family could not figure out why I was pursuing college instead of kids, but I was. However, it seemed like my schoolwork always came last.

One Saturday night I had come home from helping my Mom, dragged into our tiny married-student apartment, cooked a big dinner for my husband, and as I stood there washing the dishes, I felt a teardrop trickle down my face.

Followed by a flood.

Followed by sobbing.

Heaving.

If you ranked crying on a scale of 1 to 10, this was an 11.

My husband came rushing in with that . . . you know . . . that "puzzled-husband" look. He asked me what was wrong.

Well, it took me awhile to figure it out, to be able to put it into words. When I did, they were 12 words:

"I just realized I'll be doing dishes the rest of my life."

Now, if I thought you'd believe me, I'd tell you my husband finished the dishes. He did not. But we both did some thinking and talking about roles and expectations, and, over the years, have learned to share the domestic responsibilities. We realized that we were both carrying a lot of old, cultural "baggage" through life.

And so are you.

I'm not going to tell you what to do about it. But I am going to urge you to realize it, think about it, and even to cry over the dishes, if you need to. You may be glad you did. As for me, what have I learned from all this?

I've learned, as I suggested earlier, that Hispanic women have bought into a lot of myths through the years. Or at least *I* did. And I want to tell you now, especially you younger women, the "five things I wish I had known" when I was 20, 25, even 30. In fact, some of these things I'm still learning—at 37.

Now for that list of "five things I wish I had known."

First: I wish I had known that I—like most Hispanic women—was underestimating my capabilities.

When I first went to work for Mountain Bell, which has since become U.S. West Communications, I thought the "ultimate" job I could aspire to would be district manager. So I signed up for the courses I knew would help me achieve and handle that kind of responsibility. I watched various district managers, forming my own ideas of who was

most effective—and why. I accepted whatever responsibilities and opportunities were thrown my way, generally preparing myself to be district manager.

My dream came true.

But then it almost became a nightmare. After only eighteen months on the job, the president of the company called me and asked me to go interview with his boss—the president of our parent company. And the next thing I knew, I had been promoted to a job above that of district manager.

Suddenly, I was stranded in unfamiliar territory. They gave me a big office at U.S. West headquarters down in Englewood, where I pulled all the furniture in one corner. In fact, I sort of made a little "fort." From this direction, I could hide behind the computer. From that direction, the plants. From over here, the file cabinet. Safe at last.

Until a friend from downtown came to visit me. She walked in, looked around, and demanded to know: "What is going on here? Why was your door closed? Why are you all scrunched up in the corner?"

I had all kinds of excuses.

But she said, "You know what I think? I think you're afraid you don't deserve this office!"

As she spoke, she started dragging the plants away from my desk. For a moment, I was angry. Then afraid. Then we started laughing, and I helped her stretch my furnishings—and my confidence.

And it occurred to me that had I pictured, from the beginning, that I could become an executive director, I would have been better prepared. I would have pictured myself in that big office. I would have spent more time learning executive public speaking. I would have done a lot of things. And I began to do them with my new, expanded vision of becoming an officer—which subsequently happened.

I just wish that I had known, in those early years, how I was underestimating my capabilities.

I suspect that you are, too.

And I wonder: What are you going to do about it?

Second: I wish I had known that power is not something others give you.

It is something that comes from within yourself . . . and which you can then share with others.

In 1984, a group of minority women at U.S. West got together and did some arithmetic to confirm what we already knew. Minority women were woefully under-represented in the ranks of middle and upper management. We had a better chance of winning the lottery.

So we gathered our courage and took our case to the top. Fortunately, we found a sympathetic ear. The top man told us to take our case to *all* the officers.

We did. But we were scared. And it showed. We sort of "begged" for time on their calendars. We apologized for interrupting their work. Asked for a little more recognition of our plight. And the first few interviews went terribly.

Then we realized: we deserve to be on their calendars as much as anyone else does. We realized that under-utilizing a group of employees is not an interruption of the officers' work—it is the officers' work. We realized that we should not be asking for help—we should be telling how we could help.

So we did.

And it worked. The company implemented a special program to help minority women achieve their full potential. Since then, several of us have moved into middle and upper management, and more are on the way.

I just wish we had realized, in the beginning, where power really comes from. It comes from within yourself . . . and you can then share with others.

I suspect you need to be reminded of that, too.

And I wonder: What are you going to do about it?

Third: I wish I had known that when I feel envious of others, I'm really just showing my lack of confidence in myself.

A few years ago, I worked closely with one of my co-workers in an employee organization. She is Hispanic. Confident. Outgoing. In fact, she's so likeable I could hardly stand her!

But as we worked together, I finally realized: She has those attributes; I have others. And I had to ask myself: do I want to spend the time it would take to develop her attributes, or enjoy what we can accomplish by teaming up our different skills? I realized that is the better way.

I suspect that you may encounter envy from time to time.

And I wonder: What are you going to do about it?

Fourth: I wish I had realized that true success is never something you earn single-handed.

We hear people talk about "networking" and "community" and "team-building." What they mean is an extension of my previous idea: We can be a lot more effective working in a group than working alone.

This was brought home to me when I was president of my Hispanic employees' organization at U.S. West Communications. I wanted my administration to be the best. So I tried to do everything myself, to be sure it was done right. I wrote the newsletter, planned the fund-raiser, scheduled the meetings, booked the speakers, everything.

For our big annual meeting, I got the chairman of the company to speak. By then, the other officers of the group were feeling left out. Come to think of it, they were left out.

Anyway, we were haggling over who got to introduce our big

speaker. I was determined it should be me, since I so "obviously" had done all the work.

As it turned out, I missed the big meeting altogether. My older brother died. And I did a lot of painful thinking. For one thing: I was glad my team was there to keep things going while I dealt with my family crisis. But more important: I thought about life and death and what people would be saying if I had died.

Would I prefer they remember that "good ol' Janice sure did a terrific job of arranging every last detail of the meeting?" Or that "we really enjoyed working with her?"

"Together, we did a lot."

All of us need to ask ourselves that question from time to time.

And I wonder: What are you going to do about it?

Hispanic women in America have been victims of racism, sexism and poverty for a long, long time.

I know, because I was one of them. I also know that when you stop being a victim is largely up to you.

I don't mean you should run out of here, quit your job, divorce your husband, farm out your kids or run for President of the United States.

But I do mean that "whatever" you can dream, you can become.

A couple of years ago, I came across a poem by an Augsburg College student, Devoney K. Looser, which I want to share with you now.

> I wish someone had taught me long ago
> How to touch mountains
> Instead of watching them from breathtakingly safe distances.
> I wish someone had told me sooner
> That cliffs are neither so sharp nor so distant nor so solid as
> they seemed.
> I wish someone had told me years ago
> That only through touching mountains can we reach peaks
> called beginnings, endings or exhilarating points of no return.
> I wish I had learned earlier that ten fingers and the world
> shout more brightly from the tops of mountains
> While life below only sighs with echoing cries.
> I wish I had realized before today
> That I can touch mountains
> But now that I know, my fingers will never cease the climb."

Please, my sisters, never, ever, cease the climb.

Adelante Mujer!

This text is from Vital Speeches of the Day *(September 1, 1990) and is reprinted with permission from Janice Payan.*

Responses to the Speech

Payan (1992) wrote in retrospect: ''[I had a] sense that they were hanging on my every word and [were] surprised at the candor—we definitely connected and were all energized—amazing for an early Saturday morning speech.''

Payan received a standing ovation after the speech. One conference organizer commented on the large number of young people at the conference, and said Payan ''really spoke to them'' (DeFrancisco, 1992g). Photographs taken after the speech show Payan surrounded with young women from the audience. Among those enthusiastic young women was Payan's eleven-year-old daughter—who had observed her mother for the first time as a public speaker.

Barbara Bush

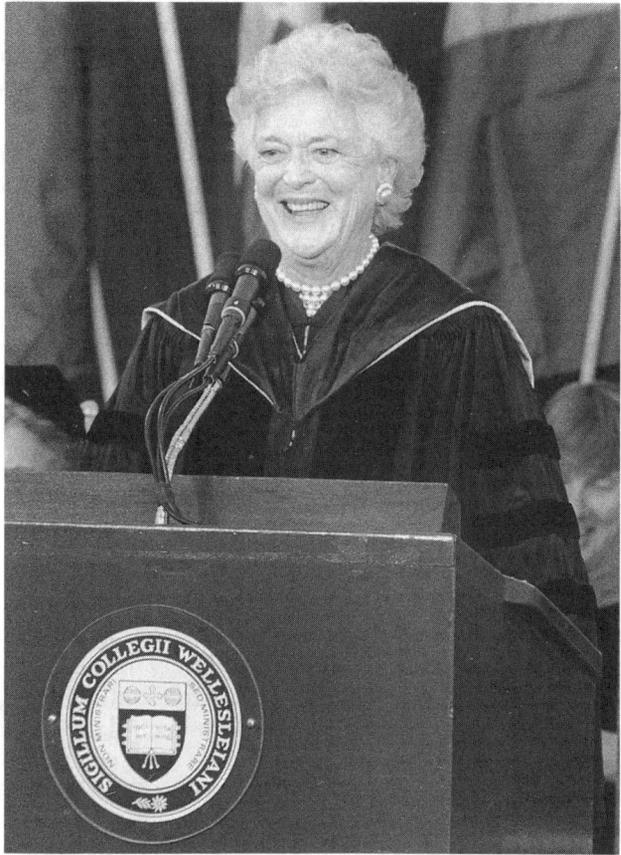

Barbara Bush spoke at the 112th commencement exercises of Wellesley College, June 1, 1990. Her address had been preceded by weeks of controversy. Approximately 38 percent of the graduating class, 150 students, signed a petition protesting her selection. Their petition read

87

in part: "We are outraged that Wellesley is honoring a woman who has gained recognition through the achievements of her husband, which contradicts what we have been taught over the last four years at Wellesley" (Schlosberg, McCarthy, and Ramos, 1990, p. 1). Some students also objected to Bush's silence on issues such as gun control and abortion. One of the protest leaders said: "It is distressing to see a woman who does not voice her own opinion or say what she believes" (Borger, 1990, p. 32). One senior wrote to The *Wellesley News*: "Barbara Bush is a poor choice for commencement speaker. . . . By refusing to discuss her views, she sends a message to all women not merely to "stand by your man," but to "stand behind your man" (Abrahamson, 1990, p. 20).

Numerous other students disagreed. One student wrote that the values of marriage and child rearing exemplified by Barbara Bush are "the foundations of society" and that the protests were a kind of reverse discrimination against an "upper-class white woman" (Todd, 1990, p. 22). Several writers to The *Wellesley News* cited Bush's efforts to promote literacy and her leadership in other charitable causes (Sloan, 1990, p. 23; Whipple, 1990, p. 22).

Alumnae who wrote to the school newspaper were divided on the issue. Some praised the thoughtful position of the protesters and their contribution to open dialogue. Those who disagreed often commented on the poor image of Wellesley that was being created in the national press and some worried that the protests would impair the college's fund-raising efforts (Stone, 1990, p. 23).

The college's administrators were subdued in their public statements, President Keohane noting that the petition was not unprecedented. (A petition had been circulated protesting Gloria Steinem's appearance two years earlier.) Administrators publicly discounted the effect of the controversy on fund-raising or future enrollments. The Vice President of Resources believed the college would be harmed only if Bush withdrew or if there were a negative disruption during the graduation exercises. He commented: "People are talking about Wellesley . . . [and about] the whole issue of dialogue. It's a reminder what we as a women's college are about . . . and that in itself is a positive" (McCarthy, 1990, p. 3).

The widespread discussion of the controversy resulted in the address being broadcast live by ABC, CBS, NBC, CNN, C-Span, and NPR.

Approach of the Speaker

Bush declined to answer her critics in advance and took no public offense at the protest. She said to reporters that the protesters are "very reasonable. They're 21 years old, and they're looking at life from a

different perspective. I don't disagree with what they're looking at. . . . In my day, they would have been considered different. In their day, I'm considered different. *Vive la difference*" (Borger, 1990, p. 32). She was also reported as being most concerned about the effect of the controversy on fund-raising at Wellesley. She said: "I'd like to write a letter saying, 'Please give to Wellesley.' This is very normal. I understand it. It's no big deal" (Walsh and Schrof, 1990, p. 25).

However, in spite of the surface appearance of calm, Bush and her advisors were clearly aware of the national interest in the controversy, and planned their strategy accordingly. Members of her staff visited with Wellesley students on several occasions—seeking a profile of the graduating class and identifying concerns which could be addressed. Out of these explorations came the emphasis on diversity and choice— themes which were high on the students' agendas. Bush also made the strategic move of inviting Raisa Gorbachev to join her on the program. This invitation answered in part the student petition (which did not call for Bush's withdrawal, but rather the addition of another speaker). This strategy created an additional focus of interest and news coverage even though Mrs. Gorbachev's qualifications could logically be criticized on similar grounds to those of Mrs. Bush.

Bush's address was reportedly drafted by a speech writer based on conversations with her. Others on her staff also contributed ideas, and the line "When it's your own kids, it's not called 'babysitting' " came from the personal experience of one of her aides (Clift, McDaniel, & Bingham, 1990, p. 26). Some of the content of her address is very similar to other speeches by Bush in the spring of 1990, including a little-noted commencement address at the University of Pennsylvania.

Bush's understated response to the protests and gracious manner toward her critics in the weeks before the address surely enhanced her credibility. Her ethos was also increased by a quiet, warm self-confidence before and during the speech—the more remarkable because she was once so shy she cried when she had to speak to the Houston Garden Club.

Commencement Address at Wellesley College

Thank you very much. Thank you President Keohane, Mrs. Gorbachev, trustees, faculty, parents, Julie Porter, Christine Bicknell and, of course, the Class of 1990. I am thrilled to be with you today, and very excited, as I know you must all be, that Mrs. Gorbachev could join us. This is an exciting time in Washington, D.C. But I am so glad to be here. I knew coming to Wellesley would be fun, but I never dreamed it would be this much fun.

More than ten years ago when I was invited here to talk about our experiences in the People's Republic of China, I was struck by both the natural beauty of your campus . . . and the spirit of this place.

Wellesley, you see, is not just a place . . . but an idea . . . an experiment in excellence in which diversity is not just tolerated, but is embraced.

The essence of this spirit was captured in a moving speech about tolerance given last year by the student body president of one of your sister colleges. She related the story by Robert Fulghum about a young pastor who, finding himself in charge of some very energetic children, hits upon a game called "Giants, Wizards and Dwarfs." "You have to decide now," the pastor instructed the children, "which you are . . . a giant, a wizard or a dwarf?" At that, a small girl tugging at his pants leg, asked, "But where do the mermaids stand?"

The pastor told her there are *no* mermaids. "Oh yes there are," she said. "I am a mermaid."

Now this little girl knew what she was and she was not about to give up on either her identity *or* the game. She intended to take her place wherever mermaids fit into the scheme of things. Where *do* mermaids stand . . . all those who are different, those who do not fit the boxes and the pigeonholes? "Answer that question," wrote Fulghum, "and you can build a school, a nation, or a whole world."

As that very wise young woman said . . . "Diversity . . . like anything worth having . . . requires *effort*." Effort to learn about and respect difference, to be compassionate with one another, to cherish our own identity . . . and to accept unconditionally the same in others.

You should all be very proud that this is the Wellesley spirit. Now I know your first choice today was Alice Walker, known for *The Color Purple*. And guess how I know?

Instead you got me—known for . . . the color of my hair! Alice Walker's book has a special resonance here. At Wellesley, each class is known by a special color . . . for four years the class of '90 has worn the color purple. Today you meet on Severance Green to say goodbye to all of that . . . to begin a new and very personal journey . . . to search for your own true colors.

In the world that awaits you beyond the shores of Lake Waban, no one can say what your true colors will be. But this I do know: You have a first-class education from a first-class school. And so you need not, probably cannot, live a "paint-by-numbers" life. Decisions are not irrevocable. Choices do come back. As you set off from Wellesley, I hope that many of you will consider making three very special choices.

The first is to believe in something larger than yourself . . . to get involved in some of the big ideas of your time. I chose literacy because I honestly believe that if more people could read, write and comprehend,

we would be that much closer to solving so many of the problems plaguing our society.

Early on I made another choice which I hope you will make as well. Whether you are talking about education, career or service, you are talking about life . . . and life must have joy. It's supposed to be fun!

One of the reasons I made the most important decision of my life . . . to marry George Bush . . . is because he made me laugh. It's true, sometimes we've laughed through our tears . . . but that shared laughter has been one of our strongest bonds. Find the joy in life, because as Ferris Bueller said on his day off . . . "Life moves pretty fast. Ya don't stop and look around once in a while, ya gonna miss it!"

I won't tell George that you applauded Ferris more than you applauded him!

The third choice that must not be missed is to cherish your human connections: your relationships with friends and family. For several years, you've had impressed upon you the importance to your career of dedication and hard work. This is true, but as important as your obligations as a doctor, lawyer or business leader will be, you are a human being first and those human connections—with spouses, with children, with friends—are the most important investments you will ever make.

At the end of your life, you will never regret not having passed one more test, not winning one more verdict or not closing one more deal. You will regret time not spent with a husband, a friend, a child or a parent.

We are in a transitional period right now . . . fascinating and exhilarating times . . . learning to adjust to the changes and the choices we . . . men and women . . . are facing.

As an example, I remember what a friend said, on hearing her husband complain to his buddies that he had to babysit. Quickly setting him straight . . . my friend told her husband that when it's your own kids . . . it's not called babysitting!

Maybe we should adjust faster, maybe slower. But whatever the era . . . whatever the times, one thing will never change: Fathers and mothers, if you have children . . . they must come first. You must read to your children, you must hug your children, you must love your children.

Your success as a family . . . our success as a society . . . depends *not* on what happens at the White House, but on what happens inside your house.

For over fifty years, it was said that the winner of Wellesley's annual hoop race would be the first to get married. Now they say the winner will be the first to become a CEO. Both of those stereotypes show too little tolerance for those who want to know where the mermaids stand.

So I want to offer you today a new legend: The winner of the hoop race will be the first to realize her dream . . . not society's dream . . . her own personal dream. Who knows? Somewhere out in this audience may even be someone who will one day follow in my footsteps, and preside over the White House as the president's spouse. I wish him well!

The controversy ends here. But our conversation is only beginning. And a worthwhile conversation it has been. So as you leave Wellesley today, take with you deep thanks for the courtesy and the honor you have shared with Mrs. Gorbachev and me. Thank you. God bless you. And may your future be worthy of your dreams.

This text was provided by Mrs. Bush's Press Office subsequent to the address. Construction of one sentence has been edited based on a text released to the press by Mrs. Bush's Press Office on the day of the address. The ellipses are in the original text and do not indicate omissions.

Responses to the Address

One journalist called it "the speech of her life" (Carlson, 1990, p. 21). Tom Brokaw of NBC News said it was "one of the best commencement speeches I've ever heard" (Clift, McDaniel, & Bingham, 1990, p. 26). The immediate audience of students, faculty, parents, and friends received Bush with more than courtesy. Videotapes show that listeners were both animated and attentive; there was an atmosphere of excitement and electricity before and during the address. Wellesley President Keohane introduced Bush as exemplifying the college's motto: "not to be the passive recipient of good works, but to do them." The audience interrupted the speech ten times with applause and cheers—most sustained after Bush spoke of a possible future spouse of a president in the audience and wished him well. The responsiveness of the audience clearly affected Bush's manner, timing, and delivery. At one point she commented that they had applauded more for Ferris Bueller than her husband, and this departure from her text was included in the subsequent version of the address circulated by the White House. Bush received a standing ovation before and after her address and twice more when she and Mrs. Gorbachev stood and then descended from the rostrum. While there was no overt hostility to Bush, one telling moment occurred when President Keohane, in introducing Raisa Gorbachev, spoke of her thesis earning her "an advanced degree from the Leningrad Pedagogical Institute and the reputation of a pioneering sociologist." Keohane was interrupted by spirited applause and turned to Bush to say in an undertone: "These are the sociologists." It is more likely that these

were the protestors affirming the kind of credentials that they saw lacking in Bush.

On her return to the White House, Bush was greeted by a large sign from her staff that read "A Job Wellesley Done." She had, however, been premature in saying at the end of her address that "the controversy ends here."

Three months after the speech, the co-author of the petition said: "As people who care about issues we cannot say it is over. We have to continue to work for these issues." The class secretary "thought (Bush's) speech was very well written. She knew exactly what to say to get the crowd behind her. It was directed to us as individuals. I really liked some parts, about always remembering the importance of your family and friends." But the class treasurer disagreed: "Sure, she addressed the family, but I thought she painted too nice of a picture. . . . She didn't deal with poverty, child care for working women, abortion. . . . I wish she had been more political. There's so many issues she could have talked about. I thought she was almost defending her position—almost apologizing" (Kao, 1990, p. 1).

One year after the speech, the editors (DeFrancisco and Jensen) surveyed a random sample of 1990 Wellesley graduates. Those who had been in favor of Bush addressing their commencement had the most favorable and specific memories a year later. One spoke of her "charm and humor." Another particularly remembered the image of a mermaid. One respondent said the choice reaffirmed her belief that "Wellesley nurtured and respected diversity" and confounded critics who looked on the college as "a bunch of unshaven, radical feminists." Another graduate who favored the invitation found Bush to be "a warm and compassionate person" and her address to be "genuine and heartfelt." On the other hand, a graduate who had not favored the invitation to Bush still did not believe she was a good representative of the class of 1990 because she left school for marriage and had not "struggled for a diploma"; she also criticized the speech as a "one-sided" focus on family. One graduate wrote that her perceptions of Bush had changed as a result of the address. This student had wanted a speaker who had achieved prominence through "sweat, hard work, brains, savvy, without [the] privilege of family, money, or marriage"; to her surprise, she found Bush "younger and stronger thinking" than expected, "in tune with the young feminist," a woman who despite privilege was "smart and strong and hard working and dedicated—everything I'd admired a self-made woman for—with something more, WARMTH." Possibly Barbara Bush would call the reflections of these audience members a continuing "worthwhile conversation."

Molly Yard

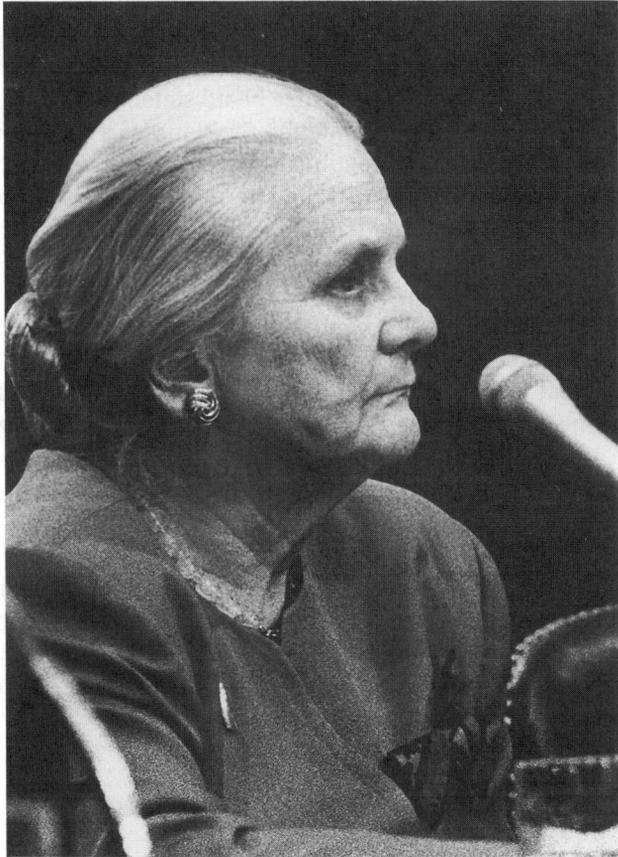

Background

When President George Bush nominated David H. Souter to serve as associate justice of the Supreme Court, he opened a floodgate of criticism and concern, particularly from minority groups and feminists. One of those voicing concern was Molly Yard, President of the National

Organization for Women (NOW), the largest feminist organization in the country.

David Souter, known as a conservative, was to replace William Brennon, an established liberal. The appointment was seen as a pivotal nomination, giving conservatives a clear majority on the court. One of the issues most publicized was the belief that Souter's vote in the high court would likely overturn the landmark decision in the case of *Roe vs. Wade* in 1973, which gave women the legal right to abortions.

When the senate hearing for Souter's nomination was held, Molly Yard was there to testify, but she was not alone. On the morning of September 18, 1990, the senate committee heard statements from other leaders such as Faye Wattleton, President of Planned Parenthood Federation of America, and Kate Michelman, Executive Director of National Abortion Rights Action League. In the afternoon, Yard spoke as part of a panel, which also included Elizabeth Holtzman, former Congressional representative and current New York City Controller; Helen Neubourne, Executive Director of the NOW Legal Defense and Education Fund; Gloria Allred, a Los Angeles attorney and feminist activist representing Norma McCorvey (the "Jane Roe" plaintiff in *Roe vs. Wade*—McCorvey also sat at the table as a silent participant); and Eleanor Smeal, head of the Fund for the Feminist Majority and former president of NOW. After Holtzman's initial testimony, committee Chair Joseph Biden limited subsequent speakers to five minutes.

The immediate audience for Yard's statement was the all-male hearing committee, which consisted of Senator Biden and thirteen others. She spoke extemporaneously from notes. By the time Yard spoke many of the journalists had left, but her remarks did air on radio and later appeared on C-SPAN cable television. Her statement was accompanied by a more formal written statement which was later added to the official Congressional records.

Approach of the Speaker

Molly Yard speaks from experience. She has provided half a century of leadership in the feminist, civil rights, and trade union movements. In that time, public speaking has become an almost daily activity. She became president of NOW in July, 1987, and is the orator for NOW's Freedom Caravan for Women's Lives which travels throughout the states organizing pro-choice voters. These speeches are rarely written out. Marilyn Barnes, assistant to the president of NOW, said Yard prefers to speak extemporaneously. *The Washington Post* called her "The Unsinkable Molly Yard" as she continues to address social issues with conviction.

We can glean some of Molly Yard's thinking as she went into this hearing from her letter to the editor published just days before her testimony:

> . . . The strict constructionists have found a legalistic shell to cover their real goal—rolling back the gains that women, minorities and poor people have made through the courts. . . .
>
> Beware of magicians with nothing up their sleeves, politicians who want something to be "de-politicized," and presidents who nominate Supreme Court justices while claiming not to know or care about their views. They've got a surprise in store—in this case, a Bork in sheep's clothing. (Yard, 1990, p. D26)

Testimony to the Senate Judiciary Committee

These hearings are taking place on David Souter, because you must replace Justice Brennan. For women and all minorities, all women, no matter our color, no matter our economic circumstances, no matter our age, all lesbians and gays, for all minorities of every race, Justice Brennan stood for the highest standards on individual rights, and it is painful for us to see him go.

I appreciate the fact that on the floor of the Senate last week, you spoke of Justice Brennan and his contribution to this country. I think I have never felt that I was speaking at a more solemn occasion, because we are here literally on behalf of the lives of the women of this country. It is no little matter. We have been struggling for years to eradicate discrimination and to be free in this society.

When this Constitution was written, African-Americans were slaves and women were the property of their husbands. We had no rights. We did not vote, we could not serve on juries, we could not own property, we could not be much of anything. And we had hoped that, through the democratic process of this country, we could step by step win our freedoms, and we have made progress. We did finally win the right to vote. We celebrate this year the 70th anniversary of the right to vote for women in this country.

But we have a long ways to go, and when the Supreme Court in 1973 gave us the *Roe vs. Wade* decision edict, that Court declared freedom for the women of this country. You have no freedom if you can't control your life, and none of you will ever face that problem. Not one of you. If your birth control fails, which is why most women get abortions in this country, and you can't get an abortion and you are forced to carry a pregnancy to term, you haven't any freedom to plan your life, to carry out your life, to do with your life what you dream it to become.

You know, Justice Brennan said that the way women are treated in this society, we think we treat them well, but he said, "The real treatment is ending up not putting women on a pedestal but putting them in a cage." And we have been in that cage, and the door was opened in 1973. How can you contemplate letting that door close on us again? Because we are absolutely convinced that David Souter (and we listened very carefully, we hoped we were wrong, but we are not wrong) will be the fifth vote to overturn *Roe vs. Wade.* And I tell you, we are not going to obey the law in this country. Women will not. There will be lawlessness everywhere. The jails won't be big enough to hold those who break the law and the people who help women break the law.

We are literally—I don't know how to say it to you so that you understand that women's lives are on the line. And if they can't control them because abortion is illegal, they will either break the law and/or they will die. Never, please, forget that illegal abortion was the leading cause of death in this country, maternal death. And it will be again. It will be again.

I would just like to say that, you know, I sit at a desk of the largest feminist organization in this country—250,000 of us—but we speak for many more than that. Last April 1989, we brought 650,000 people here, women, men and children, to petition this Government, Congress, the Supreme Court, and White House, asking that *Roe vs. Wade* not be overturned. And we understand so well why our forebears came to this country and why people keep coming to this country from all over the world. They come for freedom, for freedom from interference by Government on what they believe in, what religion they practice, with whom they associate, what they speak out on, and, above all, to run their lives as they see fit.

Would you deny women that right by allowing *Roe vs. Wade* to be overturned? Would you allow the discrimination against women to go on and on, in education, in employment? In every area I get these letters day after day after day after day about what women suffer and the pain they go through, and yet we have a nominee and we have no idea how he is going to treat sex discrimination.

I wish there was some way to make every one of you understand what is at stake here.

This text is from Hearings before the Committee on the Judiciary, *U.S. Senate, September 13–19, 1990.*

Responses to the Statement

The Senate Hearing Committee provided the most immediate response to the panelist's statements. Senator Biden began the questioning followed by Senator Strom Thurmond who said: "Mr. Chairman, we have a lovely group of ladies here. We thank you for your presence. I have no questions." The women on the panel visibly winced at Thurmond's use of the antiquated term "lady." Biden then recognized Senator Orrin Hatch. The following exchange occurred between Yard, Senator Hatch, and Senator Alan Simpson:

> Hatch: I happened to listen very carefully to all of your testimony, and I respect you for it. Ms. Yard, we've known each other for a long time. Your testimony was very moving, it was very sincere, it was eloquent. So was yours, Ms. Smeal, and others as well. I don't mean to slight anybody here. And I respect you for it. But there is another point of view that is equally as moving, equally as relevant, equally as thought about, and equally as emotionally appealing.
>
> . . .
>
> Yard: But you must remember that every poll in every state and nationally shows that the vast majority believes that it is a woman's right to determine whether or not she will have an abortion. . . . The point is not whether somebody thinks it's wrong or right. What the polls show is that people believe that you should make the decision yourself. We aren't insisting that people who oppose abortion have them at all. What we are insisting is that each one of us has the right to make the decision for herself. I don't insist that they have an abortion, and by the same token, they can't insist that I can't make the choice not to have one.
>
> . . .
>
> Hatch: . . . As important as this may be to you, and it is important, and I admire you for feeling the way you do. I can never get mad at somebody who really believes in what they do. I might disagree violently, but I never, never will find fault with your sincere belief. . . .
>
> . . .
>
> Yard: I don't want your admiration. What I want is for you to understand that it is totally unacceptable to turn back the clock. This body, the Senate Judiciary Committee, has made it very clear that you can't be a racist and sit on the Supreme Court. Well, I say you can't be a sexist and sit on one, too. If you don't understand what freedom for women means, you don't deserve to be on the Court.
>
> . . .

Simpson: . . . And I look at the testimony of Ms. Yard. A statement
of Judge Souter's, you quote on page 8, that 'I don't think unlimited
abortion should be allowed.' That was Souter's statement. . . Then
you go on to say that 'Senators, this is the language of the right wing.'
And then you go on to right wing it some more. As you know, I am
pro-choice. I strongly support a woman's right to choose . . .
however, I'm always concerned about sweeping statements . . .
emotional statements and all of you are very skilled at this. You do
more talk shows than we will ever do on the U.S. Senate floor. You
are very good at your work. So is Faye Wattleton and so is Kate
Michelman. So let's get that out. There is power and potency in what
you say, but you know how to get it across and you know just exactly
what you're doing here. There is no naiveness here, no naivete. You
are it. So now, let's just go forward here. . . . If you support unlimited
abortion rights I do think you do a disservice to the cause we share,
to ensure that women do have this freedom to choose. Because even
Roe vs. Wade—don't shrug, I see that all the time. I get tired of
watching shrugs and kind of looking up at the ceiling when Strom
Thurmond says something courteous. Let's just stay in this picture
and just listen for a minute. Maybe that wouldn't be an untoward
and maybe it might even be a courteous thing to do, without casting
a glance and a shrug and 'who are these boobs?' And, 'how did they
not listen to what we say to them and can't they hear us?' That is
a tiresome arrogance.

. . .

Yard: Through you, if I might, apologize to Strom Thurmond if he
didn't like my glances but we are greeted every time we come before
him as ladies, you are all so attractive. Somehow it does not sit well.
Maybe you could explain to him that we would like to be treated
the way you treat everybody else. You don't say to men, gentlemen,
you all look lovely. (Nomination . . . Souter, 1991, pp. 706–710)

In the days that followed, the media publicized the heated discussion.
Feminists across the nation demanded an apology from Alan Simpson
and the Senate Judiciary Committee. The furor did lead to a private
meeting on September 19 between Alan Simpson, Molly Yard and
Eleanor Smeal, but Simpson refused to apologize. Instead, he suggested
the women extend an apology to Senator Thurmond. Furthermore, he
said the feminist leaders were claiming unequal treatment because that
"is a refuge when you have no argument."

In the final committee decision, only Senator Edward Kennedy voted
against Souter's confirmation. The Senate as a whole voted 90 to 9 to
confirm him.

Although Yard's words may have been ineffective with their immedi-
ate audience, other reviewers offered different impressions. Mann (1990)
wrote:

Molly Yard, president of the National Organization for Women, gave one of the most compelling testimonies of her long career before the Senate Judiciary Committee Tuesday afternoon. She was pleading— you might say begging—for the men on the committee to understand the impact of abortion rights on women's lives. What she got in return for her eloquence was a patronizing lecture from Sen. Alan Simpson (R-Wyo.), who was more concerned with senatorial courtesy than the fact that women will die if abortion—until 1973 the leading cause of maternal death—is made illegal again. (p. D-3)

Anne Forfreedom (1990–1991) said: "Molly Yard . . . held the audience spellbound. There was not a sound while she spoke in a deliberate, somber tone, with a plea for women's rights that recalled the 19th century eloquence of Elizabeth Cady Stanton" (p. 25).

Bishop Leontine Kelly

Bishop Leontine Kelly preached at the opening and closing worships of a National Ecumenical Gathering of Student Christian Conferences which met December 28, 1990 through January 1, 1991, at the Galt House in Louisville, Kentucky. The conference was entitled "Celebrate," and

was the first ecumenical student gathering held in twenty years. Several thousand college students, campus ministers and church officials attended, representing a dozen different denominations from around the nation and the world.

Leontine Kelly was elected a bishop of the United Methodist Church in 1984, at age 64. She was the first African-American woman to be named bishop of any major denomination in the United States. Kelly became a popular religious speaker in the 1960s before she was ordained a minister. Her speech style was considered "preaching rather than speaking" (Smith, 1992, p. 623). One author wrote that her "soul-stirring sermons" surprise those who expect a small, grandmotherly type (Marshall, 1984, p. 166).

The following sermon is from the opening worship at the ecumenical conference on December 28, 1990. Kelly spoke in a large ballroom, at times utilizing a podium, but more often moving about and using large gestures as she spoke.

Approach of the Speaker

The speech included here reflects Kelly's life-long concerns for religion and equality, values she attributes to her parents Reverend David Turpeau and Ila Turpeau. She was taught at a very early age that social and political involvement was the duty of Christians. At one time, the basement of her family's Cincinnati parsonage was used as a station for the Underground Railroad carrying fugitive slaves.

When asked about the role of women in church leadership, she said:

> I believe that women and other victims of oppression can use the powers of leadership in new ways. They can make clear what "love" really is even as they battle for justice in structures and systems. Their ability to overcome obstacles should not invite a repeat performance of autocratic oppressive leadership. Sharing power does not lessen either the professionalism of a woman or the work. It only enables persons to use their individual gifts in celebration of diversity. Women of color have to "do battle" in righteous indignation over injustices on many fronts. When their "sisters" do not oppose racism within the system and do not understand that unity includes love for all persons regardless of color or sex, then they become a part of the instruments of oppression that must be overcome. I do not believe I have sacrificed my integrity in order to become a leader of the Church, I believe I was chosen by God. . . . I have tried to love people on my journey, but love includes sharing your own perspective and the context of your journey with God. You cannot love oppressive action. You can love the persons who act or who permit oppressive action as human beings who must be confronted and held responsible for their actions. (Kelly, 1992)

Kelly said her usual style of preparation is to outline major ideas and then to speak extemporaneously. Commenting on her goals in preparing this sermon, Kelly said she hoped "to interpret the Word from the Biblical perspective of Paul, and from my own personal experience and understanding of the purposes of God for the diversity of human gifts in today's world" (Kelly, 1992). Regarding her choice of readings on Paul, she said, "It is evident that I disagree with Paul and the cultural understandings of his day, especially slavery and women, but Paul's theology is basic to me and to the Church"

"Celebrating the Diversity of Our Gifts"

We listen for the word of the Lord as it is recorded in Paul's letter to the church at Corinth in the twelfth chapter reading from the fourth through the seventh verse from which our theme is chosen.

> Now there are varieties of gifts, but the same Spirit. And there are varieties of service, but the same Lord. And there are varieties of working, but it is the same God who inspires them all in everyone. To each is given the manifestation of the Spirit for the common good.

This is the word of the Lord. Thanks be to God.

The words of Paul always inspire me. I long ago gave up defending my ministry as a woman as people have tended to quote some of Paul's misconceptions. [laughter] For the theology of Paul is fundamental for each of us in the Christian church wherever we are, and the particular understanding and analogy of the Universal Church of Christ as the body of Christ is one that we understand as we recognize the unity of our own bodies and what it means to us individually when that body is in any way out of harmony. And the least disruption can make us persons who know that a cut finger is not supposed to be. There are many disruptions in our lives that enable us to know that the personal physical body can be changed and be less than the kind of balance that is given it in creation. Surely we know that the church itself can know disharmony. In the words that Paul writes to the church at Corinth, there is the analogy of a body that is perfect, and none of us are perfect. But it is that analogy of perfection that can be, that is always the goal. That is the purpose of God enabling us to understand what the little boy meant when he spoke to the Sunday school teacher as she read the story of creation to her church school class. She read to all the first grade, God created this and it was good, and on the next day God created this and it was good. And he listened to all the "it was goods" and he finally said to the teacher, "Well if it was all so good, what happened to it?"

[laughter]

We come in confession because *WE* know we happen to God's world every day. And we happen to God's world in ways that are contrary to the will of a purposeful, intentional God who creates in harmony. We look at Paul and think about Paul at the time that he writes to the church at Corinth. We know a Paul whose life has been turned around. He was an all-knowing Paul, a very exclusive kind of a Paul, a very sure Paul, a Paul who knew that he was right until one day he met Jesus on the road. If you don't know this story of Paul on the road to Damascus, a group of you just get together and read that again, [laughter] just read that again, because whenever you take a bit of the scripture it always falls in place. It's like the pieces of a puzzle—and that is what is so exciting about the word of God. None of it holds it all, it all links into all that has gone before. Because the God that Paul talks about, you see, the God who Paul thought he understood was a fallacy. As an intelligent, able, brilliant representative of the Hebrew community, he persecuted the Christians who would dare proclaim that Jesus was Lord and that the Messiah had come. It is this Paul who had turned completely around, is so open to the newness of the power of the Spirit in his own life that he is able to write about it so that centuries later when we read the word we feel (or I do) [laughter] we feel the power of the Spirit. [laughter and applause] You know, I may not look like a black preacher [laughter], but my discoloration is a part of the history of this country. You don't have to see *Roots* to understand that. [laughter and applause] You don't have to worry about clapping for me, just listen to me, you take my time when you clap, [laughter] and I do think I have something to say tonight. I want to say, you see, Paul is moved by the Spirit to accept Jesus Christ as Lord of his life. You cannot really believe in this Jesus Christ without the Spirit, and Paul said that it is by the power of God's Spirit that you are able to believe and that Spirit is available, it is God with us, it is God alive in the world. It is this empowered Paul, you see, who pushes back the parameters of the Judaism of his day to include a world of us outside of those parameters—a Paul who not only writes about the church as a very diverse community, but understood from the global perspective, even the perspective of the world that was wrong at that time, that all people were God's people; that there were varieties of gifts and varieties of abilities, and all of it was as good as God's creation, for all that comes from that. And in Paul, as he struggled with his own understanding of a new call, a new mission, who says to the Apostolic Council that they come together. Led by Peter they begin to say that in order to be a part of this new community, which was not yet separated from Judaism, that you needed to believe in Jesus Christ but you also needed to be circumcised. And that left out all of the Gentiles, those non-Jewish persons who lived in the known world.

And it certainly left out women. [laughter] Have you ever thought about that? You don't have to go to school too long to know that we can't be circumcised even now. [laughter] The whole sense of an exclusive nature of a community of faith believing in Jesus Christ and witnessing of Jesus Christ through the power of the Spirit came to Paul as completely foreign to what Jesus had come to show the world. Even Peter is surprised as he goes to the house of Cornelius to preach to Cornelius, a Roman centurion, to preach to a Gentile. Peter knows the good missionaries, but he is amazed that the Spirit descends on the house of this Gentile and people are filled with the Spirit. It's like Jonah, you know, only so far if you don't belong. You're not supposed to feel it all the way. You learn what we teach you and you content yourself with that. You are patient and you are kind, but don't believe it to the extent that you think it includes you.

Gee, I understand this because I come from a people who heard the Gospel. (I'm an old history teacher, you know, one of my former students told me that I now teach in the pulpit instead of preach in the classroom.) [laughter] At any rate I learned that, and we hear that Black people from Africa heard about Jesus Christ for the first time in the midst of slavery. I would refer you back to the early Christian fathers of the church who came from Northern Africa. You know, all of a sudden they're not supposed to be Black. Egypt is not included in Africa. Read your church history—it's exciting. But at any rate, even if my forebears had never heard it till they heard it on the plantation in Louisiana or somewhere (my people come from Louisiana) it's not the first time they heard the Gospel; you see, wherever the Gospel of Jesus Christ is preached or taught or heard, the message is the same because it is the same God, it is the same Lord, it is the same word, it is the same Spirit, and the color of the face, and the culture to which the message goes, it is the word of freedom! It is the word of liberation! So that in the midst of my people they heard the good news of the Gospel of Jesus Christ. And when you hear that good news, the system may be so tight that you can't really move yet, but you know that wrong is over because it had no business being anyhow. It does make sense to me because that's where I come from. I just want to bring you with me.

If you don't want people to know who they are in the sight of God, then don't tell them about God, and don't introduce them to Jesus Christ. And then don't talk about the power of the Spirit and think you are going to walk away and people are going to hear that and believe that and stay where you put them. No where in the world has it happened. And it didn't happen in the day of Paul.

Paul understood as he preached of Jesus Christ in the great Roman city of Corinth as he established his first church there, as he established that church there at Corinth, as he loved his church; Paul had no idea

that when he became a missionary to all of the people that he would have to be involved in their personal lives in terms of their understanding of marriage, that he would have to be involved with them in expressing to them what it means to take communion, and what it means to come to the communion table. He didn't know he had to be involved with vying with some other leaders in terms of who was telling the real truth and who wasn't. But Paul is involved in the total life of the individual, because the Gospel that Paul preaches is involved in the totality of the life of the individual. A sovereign God claims *all* of a creature whom God has shaped. And all of our lives are a part of our faith journey. Religion is not a *portion* of my life. What I believe is my total life, and what else I do with my life is that which takes its rulings from what I believe and makes the difference. Paul knew this. Paul could not be the same. As I read the scripture for the first time I did something I hadn't done before. I kind of listed down on each side just what those three verses that are quoted there, what it says in terms of God inspiring each one of us—the variety of gifts, varieties of service, and varieties of working. The scripture from Ephesians which you have already read talks about the different parts that we play in living out and working out and serving, utilizing the talents that God has given us. Varieties of abilities are listed on one side, but on the other side there is a sameness. It is the same Spirit, it is the same Lord, it is the same God who inspires it all in everyone. And that understanding of the sameness of God, not only that it is the same God to whom we all look and from whom we all come and to whom we all must go on some day of accountability, which is in God's time, but it is also to understand the oneness of that God and the unchangeability of that God. We change, we differ, but God is the same. And it is the God of justice and righteousness who struggles through history, through individuals, through groups of people, through the whole story of the Bible to help people understand that the purpose of God in this world is for justice and righteousness.

This spring I had the opportunity as a United Methodist Bishop to go on an Episcopal visitation to visit the chaplains of the United Methodist Church in Italy and Sicily and Germany. Even in retirement there is fun. And there I went on Army bases and Air Force bases and Naval bases of the United States in these countries. I am aware today that many of the persons that I met on that trip in April are probably now in Saudi Arabia. I had many experiences, and I could keep you here all night telling you about them. (My friends who are here, and my daughter especially, know that I don't ever finish, but I do stop. You'll be glad to know that.) [laughter] But one experience that I can never forget happened in the home of a clergywoman whom I had known in Virginia. We were in Stuttgart, Germany, and her husband was a judge in the United States Army, and we were waiting for him to come for

dinner that evening. I shall never forget when he came. He came in and he met me and he dropped a little piece of cement in my hand, and I knew what he was going to say, and you know what I am going to say. He had been in Berlin that day, and he said, "Bishop Kelly, this is a piece of the Berlin Wall." And we talked about it, but during the whole conversation my mind went around and back and up and down, as I thought about having read an editorial in *The Christian Century*, when the wall came down in Germany. You remember seeing that? You remember seeing on television the people actually taking the wall down themselves? Do you recall that no political analysts predicted when the wall was coming down. Everybody takes credit for it now—you know [laughter] everybody knew when, but nobody had said a thing. It's the only thing that they kept quiet—if they knew it. But, you have the feeling that the groundswell came up from believing people who felt there need not be a wall and they literally took the wall down with their hands. In *The Christian Century* editorial the statement said that when the wall came down in Germany the people sang in German, "We Shall Overcome." I thought about it and I sat there. I could hardly go to eat my dinner, and I was hungry. But I could hardly move because I thought about the fact that when in China those college students confronted the government in the face of tanks and at the risk of their lives they sang in Chinese, "We Shall Overcome." And then in Prague, Czechoslovakia, in the revolution against an oppressive Communist government the word came out that when the people rose up in revolt they sang in their native language, "We Shall Overcome." And when Nelson Mandela stepped out of jail in South Africa after twenty-seven years of tortured imprisonment, the people sang "We Shall Overcome." Oh let me tell you, that song was made popular in the sixties with Martin Luther King, Jr., but that song was born in the slave fields of this country by black people who had no way of knowing that they could overcome, but they knew a Savior who had overcome. [applause] Let me tell you, we do get together sometime, but we don't strategize enough to be able to take a little ditty out of a cotton field and the corn fields of slavery and make it an anthem of freedom around the world—only God can do that! And God's spirit is alive today in reality! You see God moves in history.

I like Robert Macabee Brown's phrase (Dr. Brown, who is one of my favorite theologians—and if you haven't read his *Unexpected News*, and his *Liberation and Spirituality*, read them). It's very clear. In fact, the Gospel is so clear, I don't see how people mess it up. [laughter] It's very clear, it's just that we don't want to do it! We find ways of making it complicated to live out. But it is so clear! Dr. Brown says when people worry about the church being involved in politics: "Listen, when God told Moses to go down to Egypt and tell Pharaoh to 'let my people go,' you can't get any more political than that." [laughter] Any time you tell

a king what to do, that is political. Because we are political people as human beings, we make decisions together, and where two or three are gathered together, the Holy Spirit may make it, but politics always does. Somebody makes the decisions. We are political animals, and there is no part of our life that we leave out of our understanding of God's presence and God's use of individuals in history to change the world. It is very clear. It is the story of the Bible. Paul is saying that we who have accepted Jesus Christ in our lives have abilities and gifts that are diverse. And they are different. But they are all to be used for the common good—the good of all—that's their purpose. In this particular instance, Paul is talking about those persons who are so ecstatic over the Spirit. They are so moved by the Spirit as they utter in unknown tongues and become ecstatic, but they don't go far enough to understand that the Spirit doesn't make them feel good just for themselves. The Spirit is purposeful for doing the will of God in the world. And there are so many people who get up on cloud nine as if the world doesn't need what the Spirit can do with the courage it gives so that you can step forward to say "no" to them. [applause and laughter] And that you can walk the streets of our cities and say "no" to homelessness. And you can look into the eyes of a child and say I promise you in your life a better world. What good does it do to be ecstatic and not be grounded in the understanding that the word of God became blessed in Jesus Christ and walked this earth so that we might know why we are given the gifts and why we are given the talents and why the variety and the diversity does not defy the opportunity for unity.

I commend you for being here, whether you are here by your choice or somebody else's. [laughter] I commend you for being here. There are so many other places you could be, and I know you know them, but you are here and your being here is a witness to the whole world. A few years ago I had a chance to go to Bolivia, and I remember an Hispanic university student saying to me, "Bishop Kelly, will you go back to America and tell the people there that we understand what the Gospel says. And we are poor, but we are not stupid! We understand the relationship between your wealth and our poverty. And when you come back," she said, "come back speaking Spanish, please."

And, I am as aware of the fact that for me [gap in tape recording] Paul writes and speaks and lives as a new man after Jesus has touched his life. And he shares the good news of the understanding of the people with whom he shares. Sharing the good news of the Gospel of Jesus Christ is more than just a task of the church of Jesus Christ. No matter how we organize ourselves to get the job done of communicating the Gospel, we must be aware of the fact that when we do it we are involved in that which is permeating and central to the greater understanding of a Creator God who did indeed intervene incarnationally into the life

of the world in the person of Jesus Christ for the salvation of the world! This is the good news. It is too good to keep to ourselves. If you here this week are so moved that you know you have heard and felt and experienced and shared the good news—if you can leave here and keep it to yourself, you don't have it. Because it wasn't made to be kept to ourselves. The good news is to share. And that is the word of Jesus and that is the task of Paul and that of each one of us. It is too big to be slotted in a particular place only for a particular people alone, too accessible to be labeled 'hands off.' It is in one sense all that we have to say and do. The Church of Jesus Christ is to interpret God's love for all creation.

We know that empowered by the Holy Spirit, the Gospel of Jesus Christ is communicated by the words of love and acts of love. The message is a message of love and has been known to communicate God's love even when the instrument carrying the message is faulty. The Hebrew community was chosen by God as a group of people who worship the one Sovereign God so that others would acknowledge one God and be blessed. Christians believe that God's promises to the prophet Jeremiah were kept when the word of God covenanted in stone became enfleshed in Jesus Christ, the new Covenant. This Jesus becomes the model for evangelism. He meets people where they are, loves them, ministers to them, and lifts them. The kingdom of which he preaches is the kingdom of which they are to become a part. Repentance and baptism will enable their membership. Their faithful discipleship will enable others to know of his life and teachings so that they too shall come a continuous growing group of persons who will witness to God's reign on this Earth. Judgment for fitness is both God's prerogative and God's timing. The invitation is to whosoever will let them come. We are still asking, "but do they have to come through our Church? Can't they get there some other way?" In the global understanding we are talking about saying that Jesus is the Christ, and seeing what we do and the way we love each other and the way we treat each other that we not only know that he is the Christ, but that he has touched our lives and made us new and we cannot make differences between people because we know that God has accepted us. Isn't it amazing that you can't go back and be in your own all Black church and enjoy it unless the doors are open for anybody who wants to join? You can't go back and be a member of your all White church and enjoy it, not fully, unless you realize that those doors have no business being closed to anybody who wants to come that way by Jesus. You can't go in your community that is Asian or out of your community and knock on doors to tell people about Jesus Christ but only respond to them if they look like you. You see, the message is a hard message, and it is not easy to do, but the Spirit will enable you not only to want to do it, but by the power of

God to do it. You see we are here as Episcopalians and Presbyterians and United Methodists and African Methodists. We all come from many different roots and we all have histories and journeys. But when we get to talking, I look at the program areas of each of our denominations and we all need some kind of area on Church and society to help people realize that it doesn't all happen in the sanctuary on Sunday morning— that they've got to get out there and do something. And all of us have religion and race groups, or some group in which we pray for one another as different races. At least once a year we have certain kinds of programs to let people know we know there are other races in the world. But that doesn't affect our politics. Our government has not yet heard—our governments of the world have not yet heard that the message of the movement is no longer from East to West, it is from North to South. And as the wall came down in Germany people with nothing who acknowledge God are making a claim on this world. And for many of us it isn't fair sometimes.

I come from California to you. And already the world is out there, and people are shaking. When in Los Angeles the census comes out that it is 50 percent people of color and 50 percent white, you can believe that it is a different configuration than that—it is probably 60–40. But people who have never been in the minority with certain colored skins in this country are more concerned about who their neighbors are going to be than they are about what they believe. I found that out. (I've got a good manuscript here, I promise you I've got it, but well, I do my work.) As a Bishop of the church I went to a meeting, you see, in northern California. I was Bishop of northern California and Nevada, and I went with one of our district superintendents (you don't know our policy), at any rate I went to help a group of people understand that the Bishop appoints the pastor—even if she is a woman she still does it. [laughter] They had sent me a résumé and a picture of their next pastor, and I was born in the Methodist parsonage, so I didn't even have to be a Bishop to know you didn't do it that way. But, at any rate I went, and I remember as we were sharing—one of the elderly men became so angry with me and he picked up his Bible and he said, "Bishop Kelly, this Bible is my Bible and that discipline is your Bible." And I said, "No." (I wasn't exactly singing 'Amazing Grace.') [laughter] And there I was a Black woman, and I was in quite a foreign territory, and I was seeing the Lord's work in a strange land. But at any rate, I said "No, we are both United Methodists, and that Bible is my Bible, and my discipline is yours." The elderly man didn't bother me, but a young man, probably in his forties, with tears in his eyes, said to me, "Bishop Kelly, I joined this church to keep my children pure, and you might send us anybody as a pastor." And I said (I talked long enough to be sure I was hearing "racially pure"): "the church of Jesus Christ? You joined a Christian

church to keep it racially pure? It doesn't fit the message!" And then when he told me about a 99-year lease their church had given to the Christian School, I said "Brother, you're talking to the wrong Bishop." As a Black woman and a Black mother I know that the Christian school system was established in this country to defy integration of schools. Now they may teach Christ there, I'm not saying that. I know where it came from, so that what I am saying as we read the scriptures that are so clear and talk about being one body of Christ, it is not just the good liturgical feeling in a worship session. It is that which affects our politics, our life together, our struggling to love one another and to know that we are not the center of the world. The world is God's world and all people are children of God whether they know it or not! [applause] It is for us who pray to know this Jesus Christ, who bear the responsibility of enabling other people to know this Jesus.

I will be with you through the week so I don't have to do it all at once. But finally, as we think about the gifts and abilities of all peoples, we think about the children of this world. The children who are already God's children who don't have to prove it anyway, who are God's children, and we recognize the value of the church in helping children know that they are part of God's kingdom. That as undeveloped as their talents are, as limited as their abilities may be, as unknown as many of their gifts are as they seem hidden in their childhood, that the Church of Jesus Christ is committed to each child, particularly as we recognize the fact that God chose the way of the child to come incarnationally to us in Jesus Christ.

In South Carolina there is a woman who has written a witness for us. It is in the form of a prayer. You may have seen it, you may have heard it, you may have prayed it. I leave it with you as you come to witness that you are not just here for yourself or for one another, but you are here for another generation, many of whom have already been given up on, many who are already called the "lost generation" because of the ills of the society. She writes:

> Pray and accept responsibility for children who like to be
> tickled, who stomp in puddles and ruin their new pants,
> who sneak popsicles before supper (you're not too far from
> this in age are you?), who can never find their shoes. And
> we also pray and accept responsibility for children who
> can't bound down the streets in a new pair of sneakers,
> who don't get dessert, who don't have any room to clean
> up, whose pictures aren't on anybody's dresser, whose
> monsters are real. We pray and accept responsibility for
> children who spent all their allowance before Tuesday, who
> throw tantrums in the grocery store, who pick at their food,
> who squirm in church, who scream on the phone. And we

also pray and accept responsibility for children whose night-mares come in the daytime, who eat anything, who have never seen the dentist, who aren't spoiled by anybody, who go to bed hungry in our rich land, and cry themselves to sleep. We pray and accept responsibility and will advocate for the children who want to be carried and for those who *must* be carried. We pray for those we never give up on and for those who don't get a second chance. We pray and accept responsibility for children whom we smother and for those who will grab the hand of anybody kind enough to offer.

This is no video show in which we live. This is no television story that we can turn on and off. This is the love, the life, that God has given to each one of us. The varied abilities, varied gifts, diverse opportunities—all coming here to say that I believe or I want to believe that this one God who reveals the Godself in this Jesus and through Jesus lives as the Spirit in this world would use me, even me. Never ready, never right, never smart enough, never on time, all the "nevers" in this life, yet this God would bridge the gap between what I am and what you are to what we can be to make the whole world a better place so that people might *know*, even those who worry so much about the second coming of Jesus and have yet to deal with the first coming. [applause] They struggle for answers to hard issues and hard questions, who meet together and may mention who they are in terms of where they come from, but who know who they are in Jesus Christ. They seek to get some piece of the puzzle that is theirs alone that they can go back home to work on and give to God and watch God put the pieces in place in amazing ways. This is the God by whom I am called.

If you are afraid of any part or of any time in your life, remember the life of Paul, read the life of Paul, remember the life of each Biblical individual that God uses and hear the words of God, "I will be with you." It will not be easy, but I will be with you. No matter what, I will be with you. For me the hymn writer has written it more beautifully than anyone. We sing the hymn in our churches, most of our churches across denominational lines. It is a great hymn of the Christian church. One day it came to me what it really meant. The words:

> How firm a foundation ye saints of the Lord
> Is laid for your faith in God's excellent word
> What more can God say than to you God has said
> To you who for refuge to Jesus have fled?
> Fear not, I am with you, be not dismayed
> For I am your God, I will still give you aid
> I'll strengthen and help you, and cause you to stand
> Upheld by my righteous, omnipotent hand
> When through the deep waters I call you to go
> The rivers of woe shall not you overflow
> For I will be with you, your troubles to bless
> And sanctify to you your deepest distress

When through fiery trials your pathway shall lie
My grace all sufficient shall be your supply
The flame will not hurt you, I only design
Thy dross to consume and your gold to refine
Oh, the soul that on Jesus still leans for repose
I will not, I will not desert to its foes
That soul, though all Hell shall endeavor to shake
I'll never, no never, no never forsake

That is the fate that we invite *you* and every generation to, to change the world.

This speech was transcribed from a videotape recording. The speaker then made minor editing changes. The exclamation points and italics are hers. The editors have made additional minor changes for clarity, but the extemporaneous quality of the sermon has been intentionally preserved. Used with permission of Leontine Kelly.

Responses to the Sermon

The speaker was very aware of her audience's attentiveness during her sermon: "Their attention was humbling for me in the crassness of this world and the interpretation by too many that their generation has little interest in religion. . . . During the sermon, tears were evident and at the close small groups joined for prayer." She said in the days that followed she received individual comments from audience members, "in terms of how my words connected with them and challenged them" (Kelly, 1992).

Michael Heaney was one such young person in attendance. He said Kelly's opening sermon was the "focal point of the conference" and that her message was discussed in small group sessions throughout the following week (Heaney, 1992). He described Kelly's style:

> I found Bishop Kelly's sermon to be very powerful, largely because of the way she was able to 'grip' me—her style can be so intense that I was drawn into what she was saying. She was also effective because she took breaks from those periods of intensity in order to let it all sink in. (Heaney, 1992)

Chris Frakes, another student attending the conference, said:

> She is one of the best preachers I've ever heard. She's amazing, partly because she is so precise in the ways that she thinks about the issues, and also because of her dynamic style. She has so much energy! The result is you stay with her mentally the whole time. (DeFrancisco, 1992r)

April Chatham, a professor of speech, watched Kelly's address on videotape. She was impressed that Kelly used gender inclusive pronoun references to God throughout her sermon. Even references to God as "he" in the original hymn Kelly recited at the end of the talk were deleted or changed (Chatham, 1992).

Reverend W. Scott Grotewold, United Methodist campus minister at the University of Northern Iowa attended the conference with a group of students. He had never had an opportunity to hear Kelly speak before, but he knew of her reputation as "a powerful and energetic speaker." He described the experience as follows:

> As one who writes messages on a weekly basis and then speaks them aloud—most people I know call these "sermons"—I constantly find myself in search of the "perfect sermon." Listening to other "preachers" becomes an exercise in walking a tightrope between support and criticism. One criterion I use in writing my own sermons is to find the proper balance between substance, style and structure. To be theologically sound is not enough; McLuhan was right: the medium is the message.
>
> And so it was that I was initially bewildered by Bishop Kelly. Her message was not easily outlined. She ranged broadly from one topic to another and the "critical reviewer" in me scrambled to keep up. Finally—blessedly, thankfully—the experiential part of me took over, and I was able to encounter the truth and the spiritual dimension which Bishop Kelly imparts. Her deep faith, her infectious enthusiasm, and the intensity of her life's experiences convert even hardened "reviewers" into excited fans. And, in the end, her well-rounded message of faith is cohesive, whole and complete. Like every other great Christian preacher, Bishop Kelly shares the message of hope and moves the individual toward commitment.
>
> Imagine the atmosphere in a ballroom filled with thousands. . . . It has been two decades since anything like this has been attempted. The walls which we have constructed—racial, geographic, political, denominational, and on and on—are intact. It is the opening meeting of the Gathering, Bishop Kelly stands before the group to speak.
>
> And the walls come a-tumblin' down! (Grotewold, 1992)

Geneva Overholser

Geneva Overholser, editor of *The Des Moines Register*, delivered the prestigious "Ruhl" lecture for the School of Journalism at the University of Oregon in Eugene, May 14, 1991. The annual lecture is in honor of journalist Robert Ruhl, who was known for his willingness to voice criticism of organizations such as the Ku Klux Klan. Each year a

117

distinguished journalist is invited to explore the boundaries of ethics in the news media. This year's Ruhl lecture took on added significance because it was held in conjunction with the School of Journalism's 75th anniversary. To recognize the event, a special symposium was held the day after the lecture featuring other well-known journalists, some of whom were on hand for Overholser's address.

Overholser became a celebrity journalist through an editorial in which she encouraged rape victims to come forward and be named, in an effort to put faces on the invisible victims of such crimes (Overholser, 1989). One woman did. Nancy Ziegenmeyer, who had been abducted and raped nine months earlier, came forward, and staff writer Jane Schorer wrote her story.

The day that the first of the five-part story appeared in the paper, Overholser wrote an editorial to her readers explaining the paper's ethical decision in printing the story.

> I am convinced that we have a unique opportunity to make a difference. Not with salacious details used gratuitously, but with the truth. I concluded that, were I to meet Ziegenmeyer's courage with my timidity, shy away from offending readers, and render her story more palatable, I would be compounding the injustice. And I would be missing a chance to inform and to move readers in a meaningful way. (Overholser, 1990)

However, Overholser's position on naming victims of rape was not without controversy. Many feminists and news organizations disagreed. "What is happening to this alleged victim is a feminist nightmare," said Los Angeles attorney and activist Gloria Allred. "It's the survivor being placed on trial. . . . I think it's enough to put fear in the hearts of other rape survivors, to make them think about proceeding . . . with charges if their names will end up in the newspapers" (Kantrowitz, et al., 1991b, p. 28).

Given the controversy, Arnold Ismach, Dean of the University of Oregon School of Journalism said he invited Overholser to give the Ruhl lecture because he felt she had an important perspective to present and that she could provoke discussion in the audience (DeFrancisco, 1991b). She spoke at the Student Union Ballroom. Dean Ismach estimated there were more than 500 people in attendance. Of these, about 150 were journalism students required to attend, but another 150 to 200 students attended voluntarily—which the Dean said was uncommon. In addition, there were approximately a dozen media reporters and editors present, compared to the usual two to three. The speech was open to the public, resulting in an additional 200 or more audience members. In explaining the unusually large attendance, Ismach said that the issue of naming rape victims does not align neatly with a political party, particular age group, or sex. As a consequence, Overholser drew a diverse group of

people. The following is an excerpt from the Dean's introduction of
Overholser:

> . . . We are privileged today to have as our speaker an exceptional
> journalist who truly works in the tradition of Robert Ruhl. If there
> is an editor in America today who needs no introduction, it is Geneva
> Overholser. Her role in bringing the issue of press coverage of the
> crime of rape to public attention has made her, if not a celebrity,
> then a provocative news figure, both inside the newsroom and out.
> Her newspaper, The Des Moines Register, last month received a
> Pulitzer prize for its groundbreaking series on rape that Newsweek
> magazine said, and I quote: "Ratified the vision of Geneva
> Overholser." I'm going to read a bit more of that Newsweek article,
> because it captures so well the style and spirit of this remarkable
> woman who was named 1990 Editor of the Year by the Gannett
> Company, the nation's largest newspaper group: "In little more than
> two years," Newsweek wrote, "she has fashioned what may be the
> most feminist daily in America—a newspaper proving that so-called
> women's issues can be important to every reader." . . . Her
> accomplishments have brought her not only acclaim but a number
> of significant roles in professional organizations. . . . I give you
> Geneva Overholser.

Approach of the Speaker

Overholser said she gives a major address approximately every six
months and tries to use these occasions to organize her own thoughts
about current issues. "I really want to say something that comes from
my own experiences—and couldn't [come from] other editors."
Overholser recalled having strong opinions before she held a high
editorial position and was not as able to voice her views. When she
speaks, she tries to remember those earlier days and compensate for the
unspoken concerns.

Overholser said of the Ruhl lecture:

> The lights were so bright I couldn't see . . . [the audience], which
> I didn't like, but I could tell they were responsive and agreed with
> my feelings on the issues. The best part was after the formal
> questions; students came up. They were wonderful—women and
> men [with] less conventional, fresh views. They look at me and see
> there is room for this. It is such a joy. These are bright young people
> and this gave them an opportunity to be excited. (DeFrancisco, 1991e)

"Today's Journalism Ethics: Too Pure By Half"

Thank you very much indeed for that lovely introduction. I notice the . . . names of other journalism schools other than your own do not roll easily off your tongue, Dean Ismach.

You know I have been thinking—I think there is a name for what I have become recently—that is "tinhorn celebrity." I used to despise editors who got a lot of publicity until I became one. It is not a state for which there is much recommendation actually. . . . (These lights really are bright. [Shades eyes with hand.] If you will forgive me I'll do this every now and then just to see that there are human beings out there.) The one phrase from that *Newsweek* article that you can imagine was a big hit in my newsroom was the one about becoming America's most feminist daily. I have sports reporters with names like Buck Turnbull, you know, and political reporters and they were going around saying, "I wouldn't work anywhere but America's most feminist daily." And one of them said, "I don't think John McCormick, this guy who wrote this *Newsweek* article, has been reading our farm section lately." There is really more to *The Des Moines Register* than anything that could be narrowly captured in a phrase like that. But, despite my tinhorn celebrityhood, I am very much pleased to be with you here today. Dean Ismach's invitation to me to deliver the 16th Ruhl lecture, and especially before a real descendant, [Ruhl's niece was present] is a very great honor indeed. I find that making significant addresses—or speeches that I HOPE will be significant, anyway—is a fine occasion to organize my thinking about things that matter to me. And I found, in organizing my thoughts for THIS speech, that there are so many things mattering to me at this moment that I am going to give you one whirlwind of a speech, I think, hopping around quite a lot.

I think we need a whirlwind. We as a nation are a fairly torpid lot these days. We are still recovering, to my way of thinking, from a period seen by many as a great success—the Reagan years—but which I must tell you still look to me like something of a disgrace. Here was a president who, far from calling on us to be the best we could be, far from challenging us to contribute and overcome and achieve, assured us that we were all very well, thank you—when in fact we were not and are not.

He told us he would rein-in government spending, and then proceeded to preside over our becoming the world's biggest debtor nation.

Moreover, not only are we torpid, we are also these days a rather timid and fearful people. Worried about bad news, seeking refuge in secrecy, we prefer not to know the worst. And, unsurprisingly, in the face of all this, newspaper readership is on a downward curve.

What, you are surely wondering, does all this have to do with press

ethics? Well, it occurs to me that we have real problems that no one is addressing very effectively. And that's where we come in.

I went to a gathering of wise men and women recently—academics and professionals of various sorts—in which the common assumption on which the conversation was based was that government was simply unable or unwilling to address the nation's problems, and that the solution had to come from elsewhere.

And one of the elsewheres, certainly, is the press. We can make a difference—more than we are now doing.

I am reminded of a story told by a colleague of mine, David Hawpe, editor of the *Louisville Courier-Journal*. David uses this story when he is asked by irate readers why in the WORLD he thinks he has a right to do such and such.

Well, says David in his drawl, let me tell you about my grandmother and grandfather. This couple lived up in the mountains. And every day, they'd go down into town. And every day, the grandfather would ride on their one mule, with the grandmother walking beside him. One day, their neighbor couldn't keep back her question any longer: "James," she says to the grandfather, "Why is it you always ride, and Sarah always walks beside you?"

"Why it's simple," answers James. "She ain't got no mule."

We in the press are like James: We have a mule. And we're very lucky indeed to have it. Few people have such a fine mule.

In a society that feels leaderless, we have a remarkable opportunity. But we aren't using it nearly as well as we might.

What is keeping us from being more effective? Five things occur to me:

One, we don't include, on our staffs, or among our readers, the full range of our society. We are getting better about this, but not fast enough. Our newsrooms are still dominated by one race, and by one sex. Our leadership positions are almost exclusively the enclaves of this one race and sex.

And, even as we address these issues of greater diversity of race and sex, we are hiring people more alike in their background, their thinking, their experiences, their economic status, their values.

Unsurprisingly, then, our readership is similarly limited in its representation of society as a whole.

I was interviewing candidates for a fellowship program recently, and was struck by a conversation with one reporter who is a truly remarkable writer. He works for a big city daily in a city known for its race problems. He writes compellingly about the troubles that blacks face in the city.

We asked him if it ever makes him unhappy that those he writes about don't read his work.

"No," he answered. "It's not my job to get mad. It's my job to stay cool."

But neither he nor any of us should be staying cool about not reaching large portions of our society.

This failure to reach brings me to my second hindrance. Just as we are not inclusive in our staffing or in our readership, we are not inclusive in our topics—that is, in what we take seriously. In many ways, the list of what newspapers take seriously is a mirror of the old line between the public and the private. Matters of the marketplace, and of government and politics, belong in newspapers. Matters of home, the heart and spirit, don't.

There are other exclusions. Certain specific topics, for example. Rape is among them. That's why, I think, the series we ran in *The Des Moines Register* a year ago was so powerful. Because we haven't been writing about rape, we haven't been putting a face on the crime. We haven't been bringing to people's attention the shameful fact of our leading the world in the incidence of this crime.

Violence against women, in general, is not taken very seriously. Reporting on gays and lesbians is another arena of reporting that was virtually nonexistent until quite recently.

There is, in fact, a sort of politically correct thinking in journalism. We don't lean too far to the left or right on our editorial pages, generally. We operate in a remarkably narrow spectrum, really, in what we report on, as well. Those who are in power in our nation—in government, in business—determine what is taken seriously, and we in the press dutifully take the cues.

Take an example of two very different ideas, each of which might be seen as far out by large portions of the public: Star Wars, and the notion that the United Nations might actually fulfill the dreams established for it at its onset. You tell me which you think is farther out. I can tell you that Star Wars has in recent years gotten a lot more ink and been taken a lot more seriously, because Ronald Reagan ordained that it should be.

I heard a lecture recently at Harvard by Robert Coles, who writes so movingly of children. He was mulling over our society's failure even to *try* to instill in our youth, in school, a system of values. Not certain religious faiths, but rather values such as consideration, honesty, human decency. This has plenty of public-policy implications. But I don't see much of it written up in our newspapers.

We play a huge role in determining what is taken seriously, and we paint a rather narrow canvas.

Here's my third hindrance: fear and timidity. I mentioned the nation's fearfulness. We in the press are pretty fearful too. At the same editors' gathering where I heard Coles, I heard a wonderful address by

Harvard Law Professor Alan Dershowitz. He told us that we should worry much more about what we're NOT getting into the newspaper, and much less about what we ARE getting in.

I think he's right. We are so fearful about being sued these days that we let lawyers make decisions editors should be making. We are so worried about the bottom line, that we may well be—albeit less consciously—allowing advertisers to make decisions that editors should be making. And we are so fearful of offending readers deeply concerned about privacy that we may be allowing *cautious* readers to make choices that *bold* editors should be making.

Think, for example, of what happens during a war. Typically, during any crisis, as the crisis deepens, diversity of opinion narrows. How many editors were more worried about what their readers thought of their decision to run or not run a flag on the front page than they were about whether they were offering a full range of dissent as well as approval of the war in the Gulf?

Of course the press must be responsible. But a responsible press reaches out, a responsible press sometimes offends. Would today's cautious standards have allowed for the publishing of the Pentagon papers, for Watergate reporting—even, indeed, for the pioneering coverage of the fight for civil rights? I recently served on a panel with a South African editor who said that he found that American newspapers' reporting on race relations in South Africa was far bolder and more inclusive than our reporting on race relations here.

On to hindrance number four. We have grown too highfalutin and insiderish. This may be partly a product of those successes I was just bragging about. After Watergate, many reporters began to feel that no journalism is worth doing unless it unseats the mighty. After Watergate, who wants bowling scores?

I'll tell you who does: our readers. We have lost touch with the best of newspapers' success in the old days when editors knew what they were about—a daily chronicling of events, the low as well as the high.

Now, we're not even very good at telling people why they should care what a city council decision means to them. Indeed, we have succeeded in making politics intolerably dull. We're so insiderish the public can't even understand the lingo. We cover the back room, we do polls, we make predictions, we hash over the process endlessly, but we can rarely be bothered with the flesh-and-blood voter and his or her humble notions of what matters.

Even political reporters are bored by now, and many are wanting out. They want to write about something people *care* about. But people do care about politics. If you don't think so, try this: Put a list of local neighborhood groups in your newspaper, with a list of phone numbers

for their officers, and projects they have underway. You'll find an interest, all right.

Hindrance number five may also have its roots partly in past successes like Watergate. We have bred a kind of journalism in which almost everything is unhappy, a failure, a daunting problem.

I know—some silly notion of happy talk is an ENEMY of real journalism. Yet I have found myself, since I became editor of *The Register* two and a half years ago, going through three permutations of thinking about this matter of good news.

When I first became editor I dutifully despised the notion of brisky, breezy, good-news-goes-down-easy newspapers. By God, *The Register* was a SERIOUS newspaper.

I would give speeches, and people would ask me why we had to be so godawfully negative about everything, and I'd trot out the Journalism 101 lecture. You know: When dog bites man, it isn't news. When man bites dog, it is. We are fortunate in this society to have mostly good things going on, so the news—that which is unusual and extraordinary—tends to be bad.

Then I entered a second phase of thinking. It was clear to me that one reason our sports section has such a loyal following is that it celebrates human achievement. People need that. An unrelenting diet of negative stories dulls the senses. We'd get and keep readers more effectively if we gave them some variety.

More recently, I have decided that, in fact, we have become so pessimistic in our society that sometimes the successes *ARE* the news. The difficulty overcome, the problem vanquished—this IS man biting dog. And I am fully convinced, now, that we are not doing justice in our duty of holding up an accurate mirror to society when we fail to show people the successes as well as the problems. Good, hard, digging reporting on proposed solutions, high goals, people who've triumphed over challenge after challenge. This IS respectable journalism.

If those are the five *hindrances* to our greater effectiveness, what are the *solutions*? I have some ideas:

First, include people. We have a sort of dutiful notion of affirmative action. We must put joy into it. The reason you include a greater diversity of people is that this brings a richer diversity of talents and thoughts.

Different people, with different experiences, ask different questions. They have different gifts. They bring different enthusiasms. There is great hope in including.

But we must not only include, we must make comfortable. I am reminded of a friend during my time at *The New York Times* who was rather cynical about the advances in diversity there. "Sure, they hire women and blacks now. And then they teach us all how to be white boys."

To truly accommodate diversity takes some work: Raising consciousness about the validity of different viewpoints. Even changing some of our old patterns. It's little wonder we can't bring young women into some of our editing positions—or young men, either, for that matter—with the hours such as they are. People want a balance in their lives today.

Yet we in society are stuck halfway through a revolution. Women are working, men are working, and all the stuff that used to be taken care of at home is up for grabs. The workplace is going to have to change to accommodate this, before we will truly be able to take full advantage of diversity.

This will help us with hindrance number two. Our topics will become more diverse as our workforce does. The more interests and areas of knowledge we have represented on our staff, the more areas we will cover well.

It will take some imagination, of course. And it will take some debate as to how to handle new areas effectively. Debate is surely what we've been engaging in since our rape series. Out of debate and dispute grow stronger decisions—and broader, more diverse coverage.

We must ask ourselves basic questions that we aren't asking. Here's an example: With what do you typically associate the phrase, "You can't throw money at _____?" Most commonly, I think, the answer is—at poverty, at education, at some social issue. I've never heard anyone say, "You can't throw money at national security."

We in the press play a huge role in agenda setting. We must play that role more consciously, take our responsibility seriously, and cast the net wider.

As for the fear and timidity, my third hindrance, I'd say we must go on the offensive, preaching the value of the First Amendment to ALL people, and we must do it with great sensitivity. We've been arrogant here, pulling press freedom around us like a cloak rather than unfurling it as a banner to wave proudly over all.

In this bicentennial year, we have our work cut out for us. A recent American Society of Newspaper Editors [poll] showed that the First Amendment would fail a ratification vote if it were taken today.

We must help our own writers understand the importance of freedom of speech. We must help advertisers understand the value of a rich mix in our newspapers. We must fight the fight for freedom every single day, and we must fight it on the toughest battlegrounds.

Alan Dershowitz, back at Harvard, told a wonderful story that illustrates beautifully the essential indivisibility of free speech. He recalled a time when a faculty member was trying to have *Playboy* removed from a university library.

Just for an exercise, he said, let's pick one magazine and one book

that we'd like removed because we don't think much of them. Then we could see how many would be left in our libraries across America.

He used to think, he said, that if you carried this out long enough you'd have nothing left but *My Friend Flicka* and *My Fair Lady*. Then he found out that *My Friend Flicka* had once been banned because it contained the word bitch (referring to a female dog). And *My Fair Lady* had been banned, too: Because it had a colonialist mentality.

Free speech, Dershowitz reminded us, means protecting that speech that you most dislike. It means a concerned feminist protecting misogynist pornography; a black person, the literature of the Ku Klux Klan; a Jew, the speech of a holocaust denier.

We've got our work cut out for us—and not just on press freedom issues. We have it cut out for us economically, as well. Newspaper owners have become accustomed to rather remarkable profit margins—sometimes to the tune of 40 percent. As newspapers seek to be ever more effective in reaching readers, and to reverse a decline in readership, adequate resources in staffing and newshole will be essential.

We won't get those readers, however rich our resources, unless we fight hindrance number four—the highfalutin, above-it-all habits we've fallen into. The editor of our "Neighbors" section recently made an interesting remark.

We were examining what we should do to be a better local newspaper. And he mentioned that he had begun of late to handle phone calls and letters requesting that we mention something very differently than he'd handled them previously. "I've started looking for a way to get things INTO the newspaper," he said, "rather than finding justifications for keeping them out."

People love it. Often, the best-read stuff in the newspaper is the stuff in the smallest print: Bowling scores, drunk-driving arrests, divorce listings.

Yet we sometimes seem to spend most of our time as journalists worrying more about whether we're paying adequate homage to the Serious Newspaper God than whether we are reaching readers.

Political coverage is a great place to tackle this. We must quit writing insider stuff, find out what matters to people, get candidates to focus on it, give people tools for action, put voters' thoughts into the process, display it attractively, write it wonderfully. Nothing could matter more, and yet, in nothing do we operate more traditionally, less imaginatively.

As for the final hindrance—the prevalence of doom and gloom—the solution is simple: Spotlight solutions. Take note of things that work, of difficulties overcome, of people making change. Without this, the mirror we hold up is warped.

We're into debunking simplistic notions, alerting the unwary, finding the stench behind the pretty facade. That's good. But here's a simplistic

notion about which we in the press ARE the unwary, and which ought to be debunked: That anything happy, hopeful or victorious (except sports) is beneath us, not worthy of our attention, and that any journalism that pays attention to it is not serious.

Sometimes I think our commitment to objectivity has bled us of our passion, and even of our purpose, and made our work less valuable. This is NOT just a job. This profession of ours has an enormous impact on the world around us. We can make people feel powerful or powerless, make issues come alive or die, give people tools for action or strip them of their belief in their ability to act.

I read a book last weekend by a former *Register* photographer, a Pulitzer Prize winner named Don Ultang. The book is called *Holding the Moment: Mid-America at Mid-Century,* and, as the jacket blurb says, it is about a more optimistic time in the life of our nation.

I don't want to concede optimism to history. My 13-year-old daughter told me last week that she had just read a magazine story about environmental disasters getting the better of us, and found it entirely realistic. Oh, she said, it probably wouldn't happen within the next 10 years. But maybe the next 20.

This is a time in international relations when there is much to be hopeful about. There is no superpower threatening us. The potential for global cooperation has never been greater. With the rich diversity of talent in this country, we should be able to seize an historic moment, when our model of democratic liberalism and free-market economics has more appeal than ever, to provide real leadership. Not the sort of leadership that forces its will on others, but the sort that inspires.

But that requires us to put our own house in order. Optimism begins at home. We can make change in this country. We can build values, the values of an engaged civic culture, of people caring about one another. We can heal the wounds of racism and economic inequities. We can achieve the REAL good feelings that come not from hiding from difficult realities but from triumphing over them.

We in newspapering, and in the media at large, can help. We can help people believe that it is the knowledge—and not the hiding from it—that can set them free. And we can bring them the knowledge and the tools that give them potential for triumph. We can't do it all at once. It won't be easy. It will involve vigorous debate. We'll have to do what is doable today.

But the press has an enormous role to play.

That's an ethic for our time: An ethic of believing in our ability to make change. That's what brought me into journalism 20 years ago. The change is no less needed today.

We've got the mule. Let's get on it.

This text is based on a manuscript provided by Geneva Overholser and is used with her permission. Emphasis has been retained in the places indicated by the author. The editors have amended some passages to include extemporaneous remarks transcribed from a videotape provided by the University of Oregon's School of Journalism.

Responses to the Lecture

Dean Arnold Ismach said he watched the audience throughout Overholser's speech, and felt more "chemistry" between the speaker and audience than even the topic could explain. "She engages the audience," he said. "I have been organizing speakers for fifteen to twenty years and she stood out." He said that after the speech people from the audience came up because they wanted to meet and touch her (DeFrancisco, 1991b). In a written summary of the event, Ismach (1991) said that Overholser gave a "pull-no-punches address that should be required reading for all journalists" (p. 2).

Margaret Gordon, Dean of the University of Washington's Graduate School of Public Affairs, was also an invited speaker at Eugene, and she attended Overholser's speech. She made similar comments: "She was an extremely effective speaker. In addition to what she said, the way she says it is full of energy; she engages her audience (DeFrancisco, 1991c)." In addressing Overholser's suggestion that the media need to publish more "good" news, Gordon said, "People are afraid to move to a town when bad news isn't balanced by good, especially when related to government; [it] leaves people with the impression that government isn't solving problems. I just think she's right on that one and I hope people listen" (DeFrancisco, 1991c).

Carrie Dennett, a senior majoring in journalism, said "I pretty much agreed with everything she said . . . especially [about] minorities being needed in the newsroom and in newspaper coverage. We are supposed to be a reflection of society, but we're not there yet. . . . She spoke very intelligently and her position—where she is—inspired me" (DeFrancisco, 1991a).

Referring to the question and answer session which followed the speech, Jennifer King, Assistant Dean at Oregon's School of Journalism, said: "Her ability to think on her feet was exciting to watch" (DeFrancisco, 1991d).

Faye Wattleton

Faye Wattleton served as President of Planned Parenthood of America, Inc. from 1978 to 1991 (when she became host of a nationally syndicated television talk show produced by Tribune Entertainment Co.). She represented the organization's interests around the world, speaking on

family planning and women's reproductive rights.

Wattleton was one of five featured speakers at the Triennial National Convention of the Young Women's Christian Association (YWCA) of the USA, which met from May 15–19, 1991, in Atlanta, Georgia. Kimberly Hebart, Program Operations Assistant of the YWCA in greater Atlanta, explained that Wattleton was a particularly appropriate speaker for the organization because of its dual missions to eliminate racism and sexism. "The YW has a long history of being an advocacy-oriented organization for women," she said (DeFrancisco, 1992p).

The speech was presented in the ballroom of the Hyatt Regency Hotel as one of the first activities in the scheduled events for May 16, 1991. The room was filled with women delegates "from teens to senior citizen age, and a variety of races. There were people from all over the USA, as well as from at least ten to twelve other countries," explained Barbara Bruegger, Executive Director of YWCA Cobb County, Georgia (DeFrancisco, 1992n).

Liz Flowers, the Public Policy Manager of the YWCA of Greater Atlanta, described an aura created in the room as Wattleton was escorted from the back, down the center aisle, and toward the speaker's stand. "I remember feeling her presence as she passed by, I felt goosebumps" (DeFrancisco, 1992o). She was introduced by Rita Marinho, Vice-President of the National YWCA of the USA. Wattleton received a standing ovation before even beginning her speech.

Approach of the Speaker

Faye Wattleton (1991) reflected on her speech in correspondence to the editors of this anthology. She obviously had the dual missions of the YWCA on her mind as she prepared the speech. She said that she focused on reproductive freedom, realizing that these rights are particularly at risk for poor women, and that women of color are disproportionately poor. She also discussed her commitment to reaching young people through speeches, such as college commencement addresses and speeches for youth organizations.

> Preparing and delivering these speeches was tremendously meaningful to me, both personally and professionally. As a parent, I have a vested interest in the institutions that help shape new generations of thinking, caring young people. As an African American woman, I feel a special affinity for groups that, like the YWCA, have historically struggled to abolish racism and sexism. And, as a reproductive rights advocate, I felt proud and inspired to share Planned Parenthood's important vision with so many people who have the energy and commitment to help realize that vision. (Wattleton, 1991)

Address at the Triennial Convention of the YWCA

Art Buchwald once said, "Whether these are the best of times or the worst of times, they're the only times we've got!" I think that, for all of us concerned with the future of women and young people, these are wonderful times to "Celebrate Our Collective Power!" For me personally, Atlanta is a very special place to think about power. I come here often to visit my mother. It was she who really taught me the meaning of power—the ability to make my own decisions and to live by the standards of my personal values—that anything is possible—and that human dignity is everyone's birthright.

That same principle is what got your organization started, nearly 150 years ago. Your dual goal of eliminating sexism and racism represented the moral vision of the mid-19th century—when the women's movement was born as a direct outgrowth of the abolition struggle. And it is just as relevant today as it was 150 years ago. We have made great strides—the right to vote, the right to education, the right to our own bank accounts. But we have a long way to go.

Our lives have been traditionally limited to childbearing and childrearing. The economic demands of World War II helped open doors to women outside the home. But in the '50s, the pressures of the "father knows best" and Norman Rockwell syndromes returned women to the kitchens and our traditional, subordinate roles.

But the 1960s and '70s were times of revolutionary changes, fueled in large part by breakthroughs in our ability to control our reproduction—the Supreme Court decisions in *Griswold* and *Roe* that recognized our right to use contraceptives and to have safe abortions—and the technological breakthrough of the birth control pill. Control over fertility gave women the concrete tool with which to escape sexual and reproductive repression. Reproductive liberation has been central to empowering women to control our lives!

But those doors are still not fully open. Teens and poor women still don't have adequate access to the means to control their fertility. The strands of racism and sexism are inextricably intertwined. Women of color are disproportionately poor, and we suffer inadequate access to all aspects of health care—including reproductive health care. We are twice as likely as white women to have unplanned pregnancies, and twice as likely to seek abortions.

If we want to open the doors of empowerment to all women, we must keep our eyes on the big picture. That reminds me of a story about one of my hometown heroes, Yogi Berra. One day in Yankee Stadium, back in the days when streaking was the fad, two people jumped out of the bleachers stark naked and ran around the bases! When Yogi got

home and told his wife about it, she asked: "Were they boys or girls?" Yogi said, "I don't know—they had bags over their heads!"

The big picture is a future worth having, and for all of us, a future worth protecting! But the future of millions of women in our society is at risk. And although the most disadvantaged citizens are the chief victims, all women are in danger.

This battle to return women to "our places" got underway with the election of Ronald Reagan and the New Right agenda. A decade later, the restructuring of the Supreme Court is in place. And the restructured court handed down rulings in 1989 and 1990 that took women's power to control their fertility and gave that power to the states. In 1991, we await the court's decision in *Rust vs. Sullivan*.

The clearest evidence of the government's punitive agenda is not just its attack on abortion rights, but its repeated attacks on family planning programs. Title X provides contraceptive services to four million women each year—of whom 80 percent are poor, 40 percent are women of color, and 33 percent are teens. Title X helps prevent half a million unwanted births and as many abortions each year—and saves millions of tax dollars.

Yet this program may be destroyed if the court upholds crippling regulations imposed by the Reagan/Bush Administrations. Giving any information about abortion to a woman would be prohibited, even if she asks for it, and even if continuing the pregnancy would endanger her health. This "gag rule" would force doctors to promote right-wing propaganda, and become government agents of oppression and harassment. We are optimistic that even this Supreme Court will overturn this unconstitutional censorship. If it doesn't, family planning providers will be faced with giving up government funds or being muzzled. Once again, women—not men—are the target.

This cruelty has already been exported to the world's poorest women. Under the Mexico City policy, foreign family planning agencies are barred from receiving U.S. funds if they counsel a woman on abortion. This is in the same part of the world where 250 million women lack access to family planning—and where more than 200,000 women die every year from illegal abortions.

Other targets in the battle to strip women of our power are teenagers. Each year, more than a million teens of all races become pregnant. For minority teens, the disadvantages of youth and poverty place them in double jeopardy. Like their adult sisters, they are twice as likely as their white peers to become pregnant. And that gap is growing worse: In the 1980s, pregnancy among white teens dropped slightly, while the rate among minority teens increased. Teen pregnancy has been said to cause a host of social ills—poverty, school drop-out rates, joblessness. Others think those problems help cause teen pregnancy. If you were 15,

undereducated, with no real options in your life, and no hope for a different future, what would motivate you to avoid getting pregnant?

The importance of family communication is a widely shared value in our culture. My daughter Felicia and I have always been open with each other on sexual matters—though it used to be that she asked all the questions—now, I do! But laws cannot force a family chat. While most pregnant teens do talk with their parents about sexual topics, others feel they can't. And when it comes to admitting sexual intercourse, let alone pregnancy, the barriers can be daunting.

Some teens don't want to disappoint their parents. Some have deeper fears—of being condemned, or being disowned, or facing violent abuse. Whatever their fears, young women who live in states with restrictions avoid telling their parents by going out of state. Others risk their lives to illegal abortionists. And still other teens ask a judge's permission for an abortion. A judge can decide that the young woman is too immature to have an abortion, but mature enough to have a baby—without her parents' permission. Imagine adolescent girls organizing themselves to go before a judge, and to face the likes of the Michigan judge who recently declared that he would allow abortions only for incest victims, or for white girls who had been raped by black men!

Whether such laws are aimed at teens or adults, at contraception or abortion, at home or abroad, the goal is the same: To consign women, against our will, to secondary roles in society—to treat us like property— property of the government, property of judges, property of parents.

Margaret Sanger understood the necessity of liberation 75 years ago, when she founded the modern birth control movement. She said reproductive autonomy was "for woman the key to the temple of liberty." Martin Luther King, Jr., understood reproductive liberation when he declared that birth control was for people of color "a profoundly important ingredient in [our] quest for security and a decent life."

The consignment of our lives to the imprisonment of government-required childbearing cannot be tolerated. If we are to secure our equality, we must control our sexuality and our fertility! How can women have access to the boardroom if the government has control over our bodies! How can the developing world achieve economic growth, when it is being ravaged by population growth? How can racism and sexism be eliminated when women are unequal and repressed?

The YWCA has long been a leader on these frontlines. The empowerment of young people through education in your National Coalition to Support Sexuality Education is a hallmark. Your consistent advocacy for reproductive rights is unfaltering. Your concern about the world beyond our shores—illustrated by your endorsement of the Atkins-Snowe bill, which would overturn the Mexico City policy—is an illustration of your vision.

We must join together to shift the debate to the issue of prevention. Preventing unintended pregnancy begins with sexuality education at home and in the schools in grades K–12. Dr. Gwen Baker has taken that idea a step farther—she has led the New York City Board of Education in efforts to make condoms available to students who want and need them. Make sure that your school board follows her visionary example.

Write, call, and lobby your elected officials. Better birth control must become a priority—the U.S. has had only one breakthrough in thirty years. Assuring easy availability of birth control services must become a priority. We must eliminate phony barriers designed to make women feel like moral recalcitrants, ashamed of our sexuality. And let us stop this fifty-state oversight of our personal privacy and morality. We must secure *Roe vs. Wade* before it is too late. Tell Congress to pass the Freedom of Choice Act—now!

Finally, remember that the best way to affect the political process is to become a part of it. Women have the power to turn political institutions upside down on this issue—if we make the preservation of reproductive rights not a single issue, but a bottom-line issue! Just as we would not elect someone to office who ran on an "end the right to vote for women" platform, politicians who run on an "end repro-ductive rights" platform should not get the vote of a single woman in this country! Through the power of the vote, women could turn this issue around. It's in our own self interest to do so!

Remember: one person's efforts can make [a difference]. Consider the phenomenon that meteorologists call the "Butterfly Effect": A single butterfly stirs, deep in a jungle. Its wings make tiny air currents. A passing breeze picks up those currents, and they become a gentle wind. Then a momentary gust picks up that wind—and so on, and so on, until—weeks later—the movement of that one butterfly at that one moment changes the course of a tornado on the other side of the globe!

This year we celebrate the 200th anniversary of our Bill of Rights, which started with a single stir among people who were determined to secure freedom for all. The promise of fundamental individual rights has swept the globe—the promise of justice, equality, and liberty.

As Queen Victoria said, "I am not interested in the possibility of defeat." May each of us determine to never consider the possibility of defeat, but to press on until justice, equality, and liberty are ours.

This manuscript was provided by Faye Wattleton and is used with her permission.

Responses to the Address

Wattleton received a standing ovation again at the conclusion of her address. "The audience was very supportive and receptive. She was speaking on a topic which is near and dear to the organization. It was exciting that she was there and speaking on a population that the YWCA serves," said Barbara Bruegger (DeFrancisco, 1992n).

The success of Wattleton's speech can be measured by the collective response the YWCA made to her call for activism, according to Beverly Stripling, Director of Advocacy and Public Policy of the YWCA of the USA (DeFrancisco, 1992q). Stripling explained that at the time, Salt Lake City was being considered as a future site for the Olympics, but the state does not support women's reproductive rights. Immediately following the conference, representatives from the YWCA voiced their objection regarding this site selection to Olympic officials. "It was successful," Stripling said. "Atlanta was selected instead" (DeFrancisco, 1992q).

Wattleton's effectiveness can also be measured in the way that she reached out to a variety of individuals, according to Liz Flowers: "When you define feminism in our culture, it usually means white middle class. And, here she is, a woman of color holding a very powerful position and speaking out on an issue which has wrongly been credited to others. It is [also] important that she is a single parent. These send powerful messages. She embodies corporate and noncorporate—all together. She is very appealing to a lot of different groups. . . . She was definitely one of the more dynamic speakers and they were all good" (DeFrancisco, 1992o).

Charlayne Hunter-Gault

Background

Charlayne Hunter-Gault is the national affairs correspondent for *The MacNeil/Lehrer News Hour*. Hunter-Gault has earned the highest honors in journalism, including Emmy awards and the 1986 George Foster Peabody Award for Excellence in Broadcasting.

In 1961, she and Hamilton Holmes became the first African Americans to attend the University of Georgia. Hunter-Gault described her response to the hostility she encountered there: "If you've ever been in the middle of a riot or the eye of a hurricane, you know it's very calm. That is exactly how I felt the night of the riot" (Lanker, 1989, p. 62). She explained that she stayed because she knew the world was watching and because she felt such a commitment was necessary (Hunter, 1970). Her auto-biography, *In My Place*, 1992, reflects her particular interests in activism and in young people, as she recreates the historic times of the 1960s for those who did not live in them.

Thus, it was appropriate that she be invited to speak to youth at the time of their graduation from Ithaca College, Ithaca, New York. The ceremony took place on May 18, 1991, at South Hill Field. It was Ithaca's 96th commencement, and she addressed some 1,350 graduating students. The audience spilled onto nearby parking lots and the lawns of private homes.

Hunter-Gault was introduced by College President James J. Whalen. He explained why she was selected to speak:

> At Ithaca College we challenge our students to strive for excellence, both in cultivating their minds and preparing for their future careers. We seek to inspire them to become the very best they can be in the realm of personal achievement and as members of society. If one were to look for a model of such excellence, it would be necessary to look no further than this platform and this year's commencement speaker, Charlayne Hunter-Gault.

Approach of the Speaker

In a telephone interview, Hunter-Gault described what was foremost on her mind as she prepared the commencement address. The United States had ceased "Desert Storm" military actions the month before in the Persian Gulf, where she served as an international correspondent. "I had just returned from the Gulf, and young people were on my mind. I was seeing this almost void in young people's lives," Hunter-Gault said (DeFrancisco, 1992d). When asked what she meant by a "void," she responded, "Maybe they have too many choices—making up their minds—what they want to do. In the Gulf it was a stark contrast to see the young people in the military. Their involvement in service seemed to be sharpening their awareness of other people . . . [in contrast to] sexism, racism, and homophobia back on campuses. . . . It tells me people aren't involved enough or they wouldn't have such narrow views."

Hunter-Gault said she makes time for commencement addresses because: "I think these are the most important speeches you can make

to young people who have so much life in front of them." She is very aware that "this is their day," and rejects those who would use the platform to advance their own political agendas. She writes her own speeches and said she generally speaks from the manuscript to stay within a ten to fifteen minute framework (although she actually spoke twenty-five minutes). In selecting the speech topic she said: "I try to consider what was unique about inviting me." This time she felt it was her experiences regarding race and war which would be most relevant.

Commencement Address at Ithaca College

Thank you Mr. President, members of the board of trustees, faculty, staff, friends, loved ones of the class of 1991, which I think is the biggest class I have seen in my life. [cheers] I have decided that an institute where both faculty and students alike refer to their president as "J. J." couldn't be all bad.

I greet you this morning, the Class of 1991, with the greatest amount of admiration and respect. Even if I didn't remember my college years and the differences between each of them—and I do remember them well—I have shared the experience of your parents and loved ones this morning on the occasion of my daughter's college graduation in the not too distant past; and I have just finished freshman year all over again with my son, who is now doing what he calls a "deep chill" in what we, his father and I, hope will be a brief interim before he goes out and finds a summer job. . . .

So that what you and your parents have experienced to get to this point—the highs and the lows, the joy and the pain, the bank accounts stretched to the limit, and most recently the anxiety of finding a job after graduation—all constitute one of the sources of my empathetic admiration and respect.

Additionally, you have earned my empathetic admiration and respect having completed what surely must have been one of the most difficult years of all . . . and here I refer not to the challenges posed by your professors in the last semesters of your formal college work (because by senior year, they should have been a piece of cake, right?!) . . . but the challenge to your concentration posed by some of the most stunning events we have known in any of our lifetimes.

I still find it hard to believe that within the span of one short year—from one graduation season to the next—we have witnessed such unimaginably dramatic events as a world in which peace was breaking out to a world suffering the wrenching aftermath of war. And I feel as if I am speaking something akin to a foreign language even as I now

routinely place events of the past nine months as being "before the war" or "after the war."

Still, as brief as it was, it was a war. And while it came and went with the fury of light-speed, I believe we owe it to ourselves to spend a little more time raising questions about how such a thing could have happened at this advanced stage of civilization and in this era of advanced communication. . . . And, while it was brief—just 100 hours— its byproducts were and continue to be profound. And I believe that we owe it to ourselves to spend a bit more time trying to discern its lessons.

In the interest of time, and because the geopolitical aspects of the story are still developing, I think it prudent to save that part for another day.

What I want to share with you this morning is how the time I spent covering the war affected the way I came to view this country, and the young people who are its future . . . you and young people like you . . . young people whom I got to know at various stages of the conflict—as they prepared for war, as they fought it and as they returned home—most wiser, if not that much older than when they left.

I didn't know this young, volunteer army and I was curious about its members, and how they got to where they were. When I asked, many of them told me they joined the military because it was the only way they could afford to get an education. I have to admit I came close to tears listening to such a story from a 19-year-old airman who had been packing to go to war precisely at the same time my 19-year-old son was packing to go to college.

What really got to me was that the young airman told me that he felt vulnerable and afraid of the unknown as it lay ahead of him in the vast, hot desert; but he also talked about his duty to his country with an earnestness that I hadn't heard since John F. Kennedy called on my generation to "Ask not what your country can do for you, but rather what you can do for your country."

At that moment, I wanted to say, "time out." Let me be a mother for a moment and not a journalist. Let me put my arms around this young man who could be my son and tell him that it was going to be all right. But I didn't know that it was going to be all right and, besides which, I also had a job to do. So as gently as I could, I encouraged the young man to talk about his fears and share them with the American people, who I felt needed to know.

Still, no matter where I went in Saudi Arabia, I couldn't get away from young men and women like this particular airman and the answers he gave. Some of that I attributed to military indoctrination. As an army brat, I knew a little bit about that. But, I discounted that as the sole reason, a doubt confirmed when I went to find some of the same people after

the war was over and they had returned to their homes in America.

I found that they shared a common relief to be back home. Alive. Some of that had to do with being exposed to political systems radically different from their own, with fewer of the freedoms that I think many of them who had never been outside the United States had always taken for granted.

But many of those same service men and women who had talked with such pride about their military mission were back home now, talking with equal conviction about the awareness they had come to about the problems back home.

Until the actual fighting started, many of them had a lot of time on their hands. In fact, one of their chronic complaints had been about the idle time, and the endless sand, and no beer, and no women or men. But one of the things they had time to do was think. And when I talked with some of them after their return, it was clear to me that they had been thinking quite deeply.

Listen to young Captain Cynthia Mosley, a battalion commander whose unit was responsible for providing food, fuel and ammunition. Their mission took them to the front line, along the highway from Kuwait to Iraq. Here is what she told me:

"The worst part was on Highway 8 . . . seeing the bodies scattered all out on the highway and the children that appeared as if they had not eaten in days and wandering around."

She told me that she still has nightmares about what she saw on Highway 8. She dreams about the faces of those children and yet . . . the nightmares and the memories are fueling a new determination. This is how Captain Cynthia Mosley put it:

> You know, we want to excel and be the very best that we can be.
> I think sometimes, though, we tend to feel that fame or money are
> the things that we need to aspire and try to accomplish. But being
> out there—it took me to realize—that those things are not important
> at all. We could have all the money in the world and we couldn't
> have done much with it . . . just seeing those children out there
> . . .[made me] really geared up [to] coming back and get[ing]
> involved in the community . . . anything that my hands can do and
> do by way of service because those are the things that I came to
> realize are important; not being famous or rich.

For Air Force Staff Sergeant Susan Brown, the war yielded a lot of love letters after my first interview with her was broadcast. She's beautiful, she's a redhead, and she's fetching, but beyond that, the war yielded a lesson of togetherness.

"We pulled together and we got through this," she said, "And [now]," she said, "I think we need to focus our efforts on our own

homeland and the problems that we have here. If we could just maybe get half the support that we got over there for the troops for maybe the homeless and the hungry, I think we would really come a long way in helping our own [selves]." [Audience applause, to which Hunter-Gault responded:] I'll tell Staff Sergeant Susan Brown about that!

Without exception, they talked about the bonding they experienced with one another, similar to some of which I've seen here. Some of you are quite bonded, I've noticed, but they also talked about the absence of the kind of racial tension that had been so prevalent during Vietnam.

Listening to these young men and women speak, I began to have a fantasy. . . and it formed something like this: that we lived in a country where every citizen—male, female, of every color and hue, of every orientation, upon reaching a certain age would be REQUIRED to perform, with adequate compensation, some service to the country— not necessarily armed service. Although that would be an option—I know that's not for everyone. But service to the country that could take many forms, using the broadest definition of service and the broadest definition of national security.

This, of course, is not an original or a new idea . . . but one whose time may have come, given the problems facing the country, and resonating throughout our colleges and universities all over America . . . problems that are sapping the vitality of our national soul . . . joined by a mean-spiritedness that seems aimed at the essential variety of American life.

It was once honored and taken for granted that Americans took variety as the seasoning in their lives, that we looked on it as the basic seasoning of our culture. Some of us were later than others in gaining that honor, and some of us are still not in the habit of taking it for granted. In fact, one black marine in Saudi Arabia told me that he welcomed the war as an opportunity to earn his rights as an American citizen and that if he should be killed in the fighting, it, too, was as he put it "part of the package."

At any rate, there once seemed to be a consensus that the multiplicity of our styles and opinions were the lifeblood of our greatness. Now, there seems to be a pervasive attitude of resentment and spite that is well along the path toward dishonoring our variety and trying by very sophisticated means to make certain that we think twice before we take our variety positively and for granted.

My fantasy saw this call to service as a way to instill commitment to our nation's high ideals by requiring that our citizens start early on thinking beyond themselves and caring for others. In the process, fostering a kind of communication that does not exist among us today, except in the kind of extraordinary circumstances Staff Sergeant Susan Brown described—where everybody had a common objective and

worked toward a common goal. That is the kind of communication that breeds understanding, empathy and respect . . . that is the enemy of ignorance, prejudice and hostility.

In my fantasy, young people would not have to go all the way to the desert of a foreign land to reach this level of consciousness, but would learn from the turmoil of the struggles they have seen and experienced on campuses across America as they have tried to come to grips with issues of fairness and justice. They will have learned from history classes broad enough to have included the lesson of a Frederick Douglass, who said, "There can be no progress without struggle" and a Paul Gagnon who has admonished that "Citizens need to tell one another, before it's too late, what struggles have to be accepted, what sacrifices have to be borne and comforts given up, to preserve freedom and justice."

My fantasy is that young people will not be deterred by the fact that much of their visible adult leadership has failed to set good examples . . . indeed has exploited the explosive tensions in our society for narrow political gain.

In my fantasy, every young person would wake up in the morning prepared to test his or her assumptions against the realities encountered in service during that day; and would have the courage, when called for, to surrender those that proved shallow or wanting or harmful to others.

In my fantasy, those young people would not be content to live their lives in isolation, however splendid or reassuring, but have the courage to confront the unknown, even when it is as close as the person sitting next to them, but who may as well be as far away as Iraq when it comes to human understanding.

Just by way of perhaps one final test (I know you think you have done all your tests, but let's do one more right now) . . . let me just ask you at this moment, (those of you who are still awake back there, in back) [cheers from the audience] okay, all right, are you ready for this test? How many of you have ever tried, seriously tried, to imagine what life is like for someone who looks different from you, who perhaps speaks a different language or comes from a different culture or orientation? And failing that, has tried to communicate in a way that would address fears, misconceptions and biases? Look around you at this moment and ask yourself how well you know your classmates who have been here with you for four years . . . ask yourself if this beautiful environment, in all its magnificent, sunny splendor, is a true reflection of the real world.

In fact, part two of that question is: How many of you have thought that was important to do?

As I look at the struggles on college campuses today, I might wish for more civility, and more empathy. But let's face it, many of the adult

role models aren't doing much to demonstrate a better way. [cheers]

I think that you young people are in the vanguard of a continuing, unfinished American Revolution and I think that as with students of my generation, the nation may have abdicated to you, perhaps involuntarily, the responsibility to write this chapter of our history.

There are those who contend that your generation does not possess the sense of common purpose that moved my generation forward. But if patriotism can be reborn, as one of the Gulf veterans observed, then why not a sense of common purpose? What are the real options? And where will they lead?

In my fantasy, whatever your respective majors, you would graduate this day, if not with a degree in communications, [then with] a commitment to communicate and a willingness to join me on the journey I have devoted my professional life to . . . the search for truth.

Although I am convinced it's an illusive goal, as a journalist, I keep reaching for it, approaching each new assignment both as an exercise in informing myself, as well as the public on whose behalf I work, in the hopes that our judgments—mine and the public's—will be made on the basis of information and reason, rather than on rigid ideology and unyielding prejudice . . . a lesson I would hope was among the first and most constant during your four years at this institution.

I diligently try to remain open to new information, especially when it challenges my own assumptions. I am trained to ask questions, not answer them, and I often find the world as confusing as perhaps you do—although when I was your age, I thought I had ALL the answers, and maybe you do. But today, as routinely as I put on my makeup in the morning, I raise questions about the society I cover—the governors and the governed—my own beliefs as a citizen, and whether or not I have done enough to serve each.

Our role as society's truth seekers will always leave us with people who are uncomfortable with what we do . . . but as one veteran journalist put it a long time ago, our mission is to "comfort the afflicted and afflict the comfortable." We didn't join the search for applause.

In my fantasy, change, which is inevitable, would be easier if the truth were told, and we in the business must take greater pains than we do now to tell it, as my generation used to say (somewhat ungrammatically), "like it is."

In my fantasy, I see your faces . . . Charles Callaway, from the School of Theatre Arts [cheers, speaker smiles] . . . Monica Rodriques from the School of Business [cheers], Julie Woods from the School of Communication [speaker and audience cheer], Charles Leitch from the School of Health and Science [cheers], Lynn Kompass from the School of Music [cheers]—and all of the 1,352 members of your class . . . I am looking at your faces and I am seeing you taking your place in society,

hoping that you will realize all your dreams and ambitions, but also hoping that you are suitably prepared for the bad times, where some of those dreams may be deferred.

The economic indicators with which I am sure you are all too familiar tell us that a lot of dreams are going to have to be deferred . . . and the social indicators tell us that in times like these, the human spirit contracts.

In my fantasy, those of you who have had the experience of a liberal arts education and did not miss its meaning will be prepared to wage war against that tendency, drawing strength from your ideals, your sense of your own self-worth and faith from the kind of thinking that guided William Grant Egbert, who in his words created this institution "out of nothing except optimism."

You might wonder why I spent so much time this morning on fantasy . . . well, I probably wouldn't be here this morning, but for the power of fantasy. You see, when I was 12 years old, I had this fantasy that one day I would grow up to be like my comic strip role model, girl reporter, Brenda Starr. Even my high school counselor tried to bring me down to the reality of my life's chances: being black in the segregated South, where no school would prepare me and no paper would hire me held out little hope that my fantasy would ever come true.

At 16, I took the first big step, applying to the University of Georgia's Journalism School. It had never admitted a black applicant in its 175-year history. Soon, I found the entire power of the State of Georgia allayed against me and my fantasy. My dream was deferred. But I pressed on, undaunted by the obstacles and inspired by the support of people of good will. And we prevailed. Although I walked alone through the jeers and taunts and people telling me "nigger go home," even the tear gas from the riots outside my dormitory protesting my presence, which had been ordered by the federal court, I was not alone. And knowing that gave me the courage to continue that journey.

It is painful for me to see that struggle is not over, even thirty years after I first walked onto that Georgia campus . . . and that our powerful coalition of people of good will has been torn asunder.

But because I have a capacity to fantasize and because of everything that I have ever been taught, believed, and learned through experience, I believe now not that it's always darkest just before it gets pitch black, but that before it gets pitch black, people of good will on all sides will step forward and say:

"Enough!"

"Come let us reason together."

"I understand your pain."

I have shared some of my fantasies with you this morning because I believe that within you lies the power to turn them into reality.

I can only hope for my sake and the sake of all of us who want our lives to be productive and happy, in a country that values each of us equally, that you will act to make that so.

In closing, having begun with lessons from the war, let me leave you with the lesson of a man of peace, a man who inspired revolutionary change through nonviolence. According to Ghandi, there are seven big sins in life. The first is wealth without work. The second is pleasure without conscience. The third is knowledge without character. The fourth is commerce without morality. The fifth is science without humanity. The sixth is worship without sacrifice, and the seventh is politics without principle. I believe that I have touched all of the bases here in this enormous and wonderful-looking class.

Once again, congratulations to you and to all who had a hand in bringing you here today.

This manuscript was provided by Charlayne Hunter-Gault and is used with her permission. The editors have amended some passages to include extemporaneous remarks based on a videotape provided by Ithaca College. The ellipses were contained in the speaker's text and do not indicate omissions by the editors.

Responses to the Address

The immediate response was a standing ovation from the audience. The public relations office of the college received some 200 newspaper clippings on Hunter-Gault's address from graduates' hometown newspapers which had reported the event. A reporter for the *Ithaca Journal* described a scene of onlookers nodding in agreement with the speaker. This was the second of three graduations for one parent in the crowd, Marie Harrison. Harrison said, "Usually these things are all the same—here's your diploma, go conquer the world. But I like this woman. Even more now than on TV" (Yaukey, 1991, p. 1).

Geraldine Ferraro

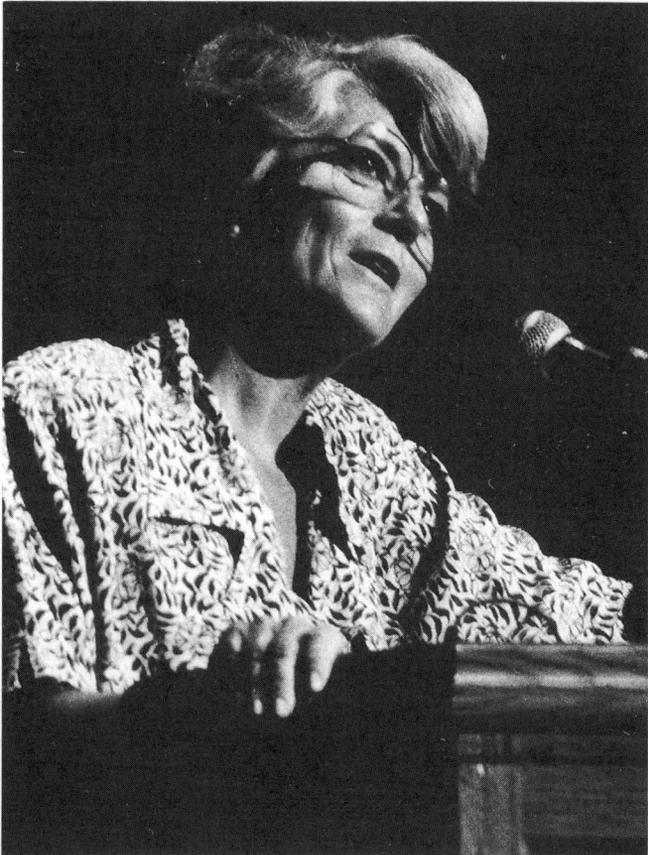

Geraldine Ferraro, Democratic nominee for Vice President in 1984, addressed the 17th annual National Women's Music Festival in Bloomington, Indiana, on June 2, 1991. Her keynote address was planned by organizers to be the high point of three days of lectures, entertainment,

workshops, and presentations focused on women's self-education and discovery. Mary Byrne, producer of the festival, said she decided to invite Ferraro after watching Senate hearings on the appointment of Supreme Court Justice David Souter last year. "I felt women just had to get in the national arena of trying to get representation," Byrne said (Friedman, 1991, p. 2). Ferraro addressed an audience of approximately two thousand in the auditorium of Indiana University. Ferraro's address had increased significance because it followed shortly after she announced her intention to run for the U.S. Senate in New York in 1992.

Approach of the Speaker

Prior to the address, Ferraro said: "The festival attracted me because it's more than just music. . . . It's an attempt to look at the empowerment of women's lives in a wide variety of areas, something that's even evident in the way the festival is set up to accommodate women with disabilities and those in need of child care" (Morse, 1991).

Although many in her immediate audience were disillusioned by the political system and, in fact, attended the festival because of its radical agenda, Ferraro brought a message of achieving power within the system. While at the festival, she said:

> I've spoken at over one hundred universities all over the country [and I hear from students] "Oh, politicians are no good. Politics stinks, everybody's a crook." No we're not, we're not all crooked. And politics is not a terrible business. It is the way to achieve *power*. And dear God, if we don't start getting active politically—and that's not only people running but active like what you're doing today, and going back to your homes and making sure who your candidates are, and making your voice heard as far as you can. That's how we're going to start making a difference. . . . We've got to make a difference, we've got to start making our voices heard. (Hochberg, 1991, p. 42)

In an interview three months later, Ferraro indicated that this address was an updated version of a speech she has given in numerous places. She said it evolved from her own experiences, including being a member of Congress, which formed her strong beliefs that women are under-represented in the political system and that women's voices do make a difference. Ferraro emphasized that she was speaking to this particular audience and was not making campaign statements for New York voters to overhear. She recalled her surprise at a critical question from the audience after her speech, which challenged her for not addressing human rights. Ferraro said she had chosen her theme because the festival organizers had asked her to speak about "women in politics," and it had not occurred to her that a large part of the audience would be from

the lesbian community. She added, however, that she welcomed the question-answer period as an opportunity to focus on her listeners' specific concerns.

In the same interview, Ferraro indicated that this speech focused on one of several themes that she frequently addresses, including health care and individual rights. Although she is assisted by speech writers, she emphasized her direct involvement in the creation of her speeches, indicating that as many as four drafts might pass between her and a speech writer. She said: "I put a lot of me into speeches. I want it to be me. I want to talk to what they want to hear." She also said she always focuses on the immediate listeners and never tries to address a larger media audience. She consciously avoids speaking too long because she feels she could not hold the listeners' attention. (Jensen, 1991b)

Address to the National Women's Music Festival

Thank you for that very kind introduction. I am delighted to be here with you this afternoon to have a chance to participate in the National Women's Music Festival. The only problem I have is that I can't sing, I can't dance, and I won't play the piano in front of more than two people and only if they're related. I find it absolutely mind boggling that I would have the nerve to get up here knowing the string of talented individuals who have performed. It reminds me of the time I went to visit one of the high schools in my congressional district shortly after being elected in 1978. I wanted the kids to understand how important voting was and what kind of an impact people in the federal government had on their lives. So I talked about what a member of Congress does. And then I invited questions. Being an extremely shy group, the first question was: "So, how much money do you make?" My answer was: "sixty thousand dollars." Their response: "Oh My God." One boy yelled out: "You make more than my father." Of course, I got a little bit defensive and I asked what his father did for a living. He said: "milk man." And I said: "Oh, well, that's a fine job, but I worked hard to get my college education, I'm a lawyer and I had to run for this office in order to get it. When they still moaned and groaned, to show how cool I was, I added: "hey, how much does Michael Jackson get paid for one appearance?" Without missing a beat, in unison they replied, "Oh, that's different, he's got talent."

Today I offer you not the musical talent that you've been enjoying this weekend, but instead some thoughts on other ways to make our quality of life better. I see that the workshops and conferences you have been attending have focused on "anything or everything that either

affects or could enhance women's lives." Let me suggest to you that there is one area that has a disproportionately larger impact on our lives than perhaps it should, and it's one in which we have very little say. I'm talking about politics.

So what I'm going to do this afternoon is give you about twenty minutes of prepared brilliance on the subject of women in politics and then I will take your questions.

Let me start by saying that the election of 1984 was a wonderful learning experience for me. In running for national office you have a chance to practice politics on the highest levels. And for all the differences I had and still have with Ronald Reagan, I can only admire his skills as a politician.

So, in a spirit of bipartisanship because there might be one or two Republicans here today, I thought I would borrow one of Mr. Reagan's techniques and talk about the movies. If you recall, a while back a marvelous film won the Academy Award. It was called *Chariots of Fire* and it told the story of Harry Abrahams, a member of the British Olympic team in 1920. After losing a race to his arch-rival, a dispirited Abrahams turned, as movie heroes usually do, to the woman in his life.

Feeling sorry for himself, he said, "If I can't win, I won't run." To which she responded, "If you don't run, you can't win." But, he whined, "I've worked so hard, what will I aim for?" Again she had the answer. "Go out and beat him the next time."

In that scene are the principles that go to the heart of women's opportunity in politics and set the guidelines for our future successes.

If you don't run, you can't win. And if you go out and work as hard as you can, and you aren't successful, go out and do it again and beat him the next time.

I just want to assure you all that that was not an announcement.

Please note that while the scene came from a movie about the athletic exploits of men, the political wisdom came from a woman.

Unfortunately, like the Olympics, what's happening politically is of interest to most people only every four years. It would be much better for this country if voters had a longer span of public attention. And women and people of color and other under-represented groups specifically have the most to gain. Voter apathy smiles on those who wish to preserve the status quo. And the status quo is not committed to dramatic progress on electing more women.

Today women are, by any objective measure, grossly under-represented in elective office. I would say shockingly under-represented, except nobody is shocked. That's simply the way it is.

In 1974, Jeanne Kirkpatrick wrote a book called *Political Woman*. Published by the Center for the American Woman and Politics at Rutgers University, it was a study of female state legislators from around the

country. One of the jacket blurbs lauding the book was written by Bella Abzug. (I would bet that was probably the last time that Bella praised Professor Kirkpatrick's views.)

In her book, Kirkpatrick wrote that she found the most important and interesting thing about women's involvement in politics was that it was so insignificant. Sure, women have always been active and enthusiastic campaign volunteers. But, she wrote, "half a century after the ratification of the nineteenth amendment, no woman has been nominated to be president or vice president, no woman has served on the Supreme Court."

At the time, there was no woman in the cabinet, no woman in the United States Senate, no woman serving as a governor of a major state, and no woman mayor of a major city.

To be sure, in the seventeen years since then, we have made some progress. Associate Justice Sandra Day O'Connor sits on the Supreme Court. Women have been represented in every cabinet since President Nixon's. Barbara Mikulski and Nancy Kassenbaum serve in the United States Senate. Women like Ann Richards, Barbara Roberts, and Joan Finney sit in the governor's office in states as diverse as Texas, Oregon, and Kansas.

How did that all come about? Well, I can tell you that someone like Barbara Mikulski did not win election to the Senate because the people of Maryland decided it was time to elect a woman to the Senate. No groundswell erupted demanding that history's gender injustices be righted. She won because she had built a record of achievement and distinction, first in a neighborhood in Baltimore, then in the city council, and then in the House of Representatives. It happened because she is an outstanding politician, and because she has an excellent record of leadership. It happened because Barbara inspires people. And it happened—it just *so* happened—that she is a woman.

We are making our presence felt in local elections as well. According to the National Women's Political Caucus, there are now 140 women serving as mayors of cities with a population of 30,000 or more.

It's also interesting to note that we now have 57 women elected to statewide office nationally, many to high profile jobs that can serve as a springboard for a run for governor or the Senate in the near future. What particularly pleased me in this past election cycle, is that both parties in Minnesota, Michigan, and Iowa had gender balanced slates for governor and lieutenant governor. The trick now is reversing the male-female positions on those slates.

And the numbers I have given you are good news—but not good enough. We must put them in context. We still are only 2 percent of

the Senate, 6.4 percent of the House of Representatives, and 17 percent of statewide elective offices. Remember, we are 51 percent of the population.

It's interesting to note that despite the activity, though a woman has been nominated to be vice president, no woman has been nominated, or even seriously contested for the nomination of her party for President of the United States. What's going on?

In 1987 Congresswoman Pat Schroeder considered the race, and her travels around the country generated the only real political enthusiasm that summer. Pat Schroeder brought some marvelous strengths to her campaign. At that time, she had fifteen years in Congress behind her. She is a Harvard educated attorney who is extremely articulate. She is an acknowledged national authority on defense strategy and policy. But her decision not to run was based in large part on her conclusion that presidential politics requires more expertise in counting delegates than counting warheads. And so after careful thought, Pat took herself out of the campaign. It was a difficult decision for her and you will recall, she cried. Pat was roundly criticized for that. "Her actions would make it harder for every woman candidate who followed," they said. Well, I didn't agree.

A few months ago I thought of Pat Schroeder as I walked my two miles on my treadmill and watched the morning news. Marty Lyons, a New York Jets tackle, was hanging up his jersey. He started to speak about ending his playing career—and then he started to cry. The male reporter who was doing the piece commented: "He is not only a great football player, but he's a great human being." I listened carefully and I searched three newspapers later that morning. I found no comment anywhere that his crying would make it harder for every 250-pound white football player who came after. Yes indeed, the old double standard is alive and well.

On the Republican side, Professor Kirkpatrick was urged by many to make the race for President. She declined, citing what she called the "mean maleness" of presidential politics, which, she said, "shares a number of characteristics with some purely male competitive sports."

Interestingly enough, the debate over women as presidential or vice presidential candidates has turned chiefly on the question of qualifications. We are constantly asked: "Is there a qualified woman?" To which women have rightly responded: "compared to whom?"

The fact is that the American electorate is accustomed to expect certain types of experience in candidates for national office. It doesn't hurt to be governor of a large state, to be vice president, or to be a senator of long experience. In fact, in the last fifty years, no one except Dwight Eisenhower made it to the oval office without having held one of those jobs. Like it or not, at this point in our country's political development,

very few women hold those requisite positions.

I am not suggesting that every woman who wins election to the Senate or to a governor's mansion or who attains some seniority in the House of Representatives can or should run for President. That must be a personal decision.

But we must put ourselves in a position to make that run if we choose. Every time a woman runs for elective office, it's like throwing a stone in a lake: the ripples spread far beyond the immediate point of impact. In the lake of U.S. politics, the Presidency is no mere stone, it's a boulder. When a woman finally does run for that office, the ripple effects will create a wave of change that will be felt everywhere.

We all know that women have not yet achieved equal opportunity with men. We still have to work harder to be given a chance to prove ourselves. And voters still need to be taught that women are equally capable of handling the tough issues that face this country from its neighborhoods to its state houses. But the voters are learning.

Now why is that important? In a book called *In a Different Voice*, Harvard Professor Carol Gilligan argues that women's voices are essential to good government. That's not necessarily because we are more caring or more effective, but because we bring another dimension to the political process. According to Dr. Gilligan, instead of engaging in confrontation, women are more apt to negotiate. Instead of looking at short-term solutions to problems, women are more apt to think in terms of generations to come. Instead of thinking in win-lose terms, women are more apt to see the gray area between.

And from my experience I see that it is the women elected officials who are more sensitive to the needs of women. Now I'm not putting down male legislators when I say that. It's as expected. Who do you think was the loudest voice in Congress on agent orange legislation? It was Tom Daschle of South Dakota, now a Senator, who had served in Vietnam. Who do you think introduced the legislation to give recompense to Japanese Americans who were interned in prison camps during the second World War? Bob Matsui and Norm Mineta, two Japanese Americans. Who do you think speaks loudest on civil rights issues? You're right, the black caucus. (If they had not been upfront for sanctions against South Africa, I honestly believe that Nelson Mandela would still be in jail, and that we would not be on the way to seeing apartheid eliminated in that country.) On Israel? Steve Solarz and Tom Lantos and Mel Levine to name a few. So it is expected that women legislators would be the ones who would pick up on issues that affect women particularly. I can guarantee you that if 51 percent of the U.S. Senate were women, Justice Souter would not be sitting on the Supreme Court and we would not be facing the reversal of *Roe versus Wade*. It's women's voices we hear loudest on day care, comparable worth,

and flextime. They are the ones who speak up on issues like nutrition programs for poor pregnant women, prenatal health care, immunization programs, and Head Start. Women legislators are the people who insist that something be done to help the aging population which is predominantly poor and predominantly female. It may be because each one of us can picture ourselves in that same vulnerable position. And more often than not, it is the voices of the women political leaders that you hear in opposition to war.

We are living through critical times. Power balances are being tested in the Middle East. Our troops have returned home from what has now been called "our best war." And although women have always served bravely in our armed services, in the Persian Gulf they saw more military action than ever before.

The expertise those women soldiers brought to their jobs was evident, running the gamut from operating our amazingly sophisticated technological systems, to repairing trucks, to designing strategy, and, of course, to providing medical care.

But as we saw the increased involvement of women in the military, I couldn't help but wish we had more women in Washington making decisions about what that military should be doing. (And the power to make that happen lies in the hands of everyone in this room, because it's associated with the lever in the voting booth.)

. . . The eighties were a time of great excitement. The nineties are going to be a time for great challenges. It's going to be tough. You know it. I know it. George Bush knows it. Dan Quayle may not know it—but I'm sure Marilyn will tell him.

And we have to be ready to meet those challenges. We have to be better able to look forward, as well as looking back.

The eighties were a time of great excitement politically. So many women getting involved. So many historical firsts. Reading through the Directory of Women in Congress, one is overwhelmed by the number of firsts. And that's terrific because it says we're doing better. But we have to remember that when we have fewer women making history, we will have more women making policy.

How fast can this happen? One study pessimistically concluded that forty years from now we'll still have only 53 women in the Congress. I don't buy that. We've got to get more women involved, we have to persuade more women to run. Remember the movie: "If you don't run, you can't win." And while we're at it, we really have to develop the concept that politics is an honorable profession.

We also have to start paying attention to the kind of goals we should be setting for ourselves. Half the House of Representatives? Half the governors? A woman president? When will it happen? In this century? In our lifetimes? I don't know. But I do know this.

It will happen, in time. I'm sure of it. But I'm also sure that it is not just a matter of time. It is a matter of work, and faith, and confidence— of a commitment to the idea that some leaders are born women.

And that's how a woman will one day be elected president. She will be elected not primarily because she is a woman, or in spite of being a woman, but because she has won the confidence of the American people that she can lead.

She will have proven herself as a senator or a governor. She will have shown that she possesses the rare combination of qualities that American people look for in a President, and then it will be time. And history will be made. And tears will be cried like you wouldn't believe. I'm looking forward to it.

Thank you.

This text was provided by Geraldine Ferraro's office in New York and is used with her permission. The editors have made minor amendments based on a videotape provided by Mary Byrne, producer of the National Women's Music Festival.

Responses to the Speech

Dixie Brackman, who served as a personal host to the speaker, later described Ferraro as "professional" yet "real," noting that her interests expressed in private conversations complemented the themes of her speech. She found Ferraro to have a genuine interest in her audience and commented on her availability to conference participants before and after her speech. When describing the atmosphere in the Indiana University Auditorium, Brackman said: "There was something very electric about being in the room with her" (DeFrancisco, 1992e).

Ferraro received loud applause and sustained cheers before and after her address, and was interrupted numerous times by laughter, applause, and cheers—including shouts of "Run, Gerry, Run" at the end of her speech. The most sustained applause came after her mention of Dan Quayle—in a passage that she added extemporaneously after tripping over a line in her prepared text.

Regarding the twenty-minute question period which followed the address, one journalist noted that "Ferraro endeared herself to the crowd by nonchalantly referring to God as She" and wrote that "she handled questions from the audience as deftly as—well, as deftly as a politician!" (Jamakaya, 1991, p. 16).

The questioners asked what she thought about creating a woman's party, how members of this audience could help her New York

campaign, how a woman should prepare to be a candidate, and how Ferraro nurtured herself to keep going. The question that was still on Ferraro's mind months later was stated as follows:

> I think that it's really exciting that you're here, but I can't but notice that in addressing an audience that is predominantly lesbian that you did not choose to use the word once. I wonder when the white women's movement will acknowledge publicly that it probably wouldn't exist if it wasn't for the contributions of thousands upon thousands [of lesbians].

Sustained applause followed this question, and approximately 200 audience members reportedly stood up in support of the questioner (Friedman, 1991, p. 2). Ferraro responded:

> Let me assure you that if I had been asked today to address an issue of discrimination or civil rights, you certainly would have heard me address not only racism and sexism but the attitude[s] of many people in this country toward gays and lesbians—which I feel are very very discriminatory. In this speech I was asked to address the issue of women in politics [a voice in the background said: "that's right"] and so that is what I've done.

Applause followed her answer.

Wilma P. Mankiller

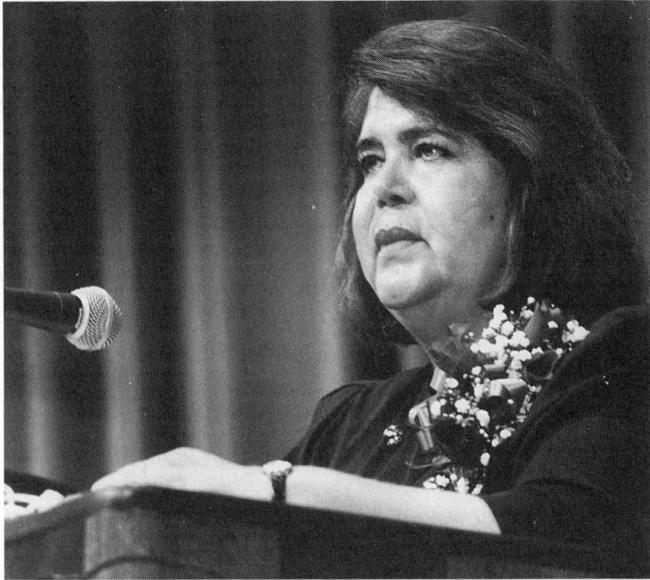

Background

In 1987, Wilma P. Mankiller was the first woman elected Principal Chief of the Cherokee Nation, the second largest native American nation, with offices in Tahlequah, Oklahoma. She was so surprised by the election that she had not prepared an acceptance speech. Four years later, in 1991, she was re-elected with an unprecedented 82 percent of the votes. This time she prepared and presented a speech, which appears in this collection.

Mankiller joined the Cherokee Nation in 1977 as a staff member, working primarily on housing and funding projects. In 1982, Ralph Swimmer, then Principal Chief, asked her to run with him as Deputy Chief. She commented, "This at first seemed like a ludicrous idea. I was a kind of a book wormish, community development person, and it seemed quite a leap . . . to try to go out and sell myself like a tube of

157

toothpaste'' (Mankiller, 1992b). Then she saw Cherokee people living in cars and buses, and she felt a need to take a "personal responsibility" to try to improve the people's housing.

She won that election and went on to successfully run as Chief, but she said people were initially apprehensive about having a woman as a leader.

> People kept trying to argue with me that gender had something to do with leadership, or that leadership had something to do with gender, which is absolute, sheer nonsense. . . . I think that the issue of whether or not there should be a female at the lead of the Cherokee Nation has been settled. . . . What they care about is that the Head Start bus comes on time, that when they go to one of our clinics that the lab tests have been accurate, that when people are teaching adult education classes, that they show up on time. . . . They care about competency and receiving services much more than whether there is a woman or a man leading the tribe. So in that regard I think that the Cherokee Nation may be a little bit ahead of the country. (Mankiller, 1992b)

Gloria Steinem (1992b) pinpointed the central strength of Mankiller's leadership with her people as her ability to help them raise their self-esteem: "She is the best kind of leader, one who creates independence, not dependence, who helps people go back to a collective broken place and begin to heal themselves." Steinem concluded, "Many leaders need to learn this new and ancient secret: one cannot raise a people's self-esteem by placing oneself above the people."

The speech that follows took place during inauguration ceremonies on August 14, 1991, at Northeastern State University's Fine Arts Auditorium, with one thousand people in attendance. The Chief and fifteen Tribal Council members were sworn in during the ceremony which preceded the Chief's speech.

The Chief was introduced by U.S. Congressional Representative Mike Synar from Muskogee, Oklahoma. He said:

> It's not just that she has led a new world interest in the Cherokee Nation and shared the story of the Cherokee Nation around the world. But, she's made a difference with people—white, black, red, young and old, rich and poor. . . . She is a role model not only for Cherokee women, but for all women. She very well may be the best example of what hard work and success in America is all about. (Cherokee Advocate, 1991, p. 1)

Approach of the Speaker

What do we know about Wilma Mankiller—the speaker? We can gain some insight from her entertaining, opening remarks at a more recent

speech given at Mt. Mercy College in Cedar Rapids, Iowa, on September 14, 1992. She explained that when she travels outside her nation, people are always curious about her name and that men often "have trouble calling me 'Principal Chief.' " She told of one speaking engagement at a "very prestigious eastern college" where a young man asked since "Principal Chief" was a "male term," how should he refer to her? He offered suggestions . . . "Chieftess". . . . "Chiefette." "Finally I told him to call me 'Miss Chief,' or 'mischief,' " Mankiller said. The same student asked about the origin of her last name. She told the Mt. Mercy audience that it was originally a title for men who were similar to captains in each village. One of her ancestors in the 18th century chose to keep the title as a family name. However, when answering the young man's question she simply said, "It's a nickname, and I earned it!"

On a more serious note, during a question and answer session at Wartburg College, Mankiller (1992b) identified the constant themes in her message as she spoke at the inauguration ceremonies, and as she continues to speak around the country.

> I don't change my message very much. With native people there's more focus on specific issues that we have in common. And with just women, I think there's a whole other issue and so I may change it just for women . . . although my basic message is the same. It's one of humanity and people dealing with each other more levelly. It's one of equity and women being treated with balance and harmony . . . and for our people, it's a message of hope . . . rather than focusing on all the problems and negative things, focusing on the positive things that we see in our communities.

Mankiller clearly is committed to teaching Cherokee history in her talks. She tells a story of her people's loss of land and pride, due to the U.S. government's forced relocations from Georgia and South Carolina to Oklahoma, in the infamous "Trail of Tears" in 1837 (Mankiller, 1992b). The Cherokee began to rebuild, becoming fairly prosperous and more literate than their non-Indian neighbors, until the Civil War ended and pressure came to open up Indian territory. From 1906 to 1971, chiefs were appointed by U.S. presidents. In 1976, when Congress returned leadership selection to the Cherokee people, Mankiller explained that the people's view of leadership had changed. The first two elected chiefs were similar to ones appointed by the U.S. government.

> They were bankers, lawyers, and Indian chiefs. . . . Our people began to see leadership in our tribe as something that only wealthy, prominent people could aspire to. . . . And so, when I was initially elected in 1983 [as Deputy Chief] from a large poor family, it was very significant that I was a woman, but it was equally significant that I was a daughter of the people. That people had enough confidence in ourselves again to elect someone from down the road,

someone just like themselves, and so I believe that we were able to
reclaim leadership. (1992a)

Inaugural Address as Principal Chief of the Cherokee Nation

I'd like to thank Congressman Mike Synar for the very nice
introduction. He has been a tremendous help to the Cherokee Nation
during the time that I have been in office and we appreciate his
leadership.

I'm sure that Deputy Chief John Ketcher and I, and this Tribal Council
feel the same degree of gratitude to you who have supported us during
this past election, either by voting for us, saying prayers for us, or just
being there when we needed you. I also would like to express my
personal gratitude for the support you have given me the last eight years
I have been in office.

During that time, I have received a lot of honors and recognition,
much of it undeserved. Much of it should have gone to the employees,
to the Tribal Council, or to the citizens of the Cherokee Nation. But
honors and awards are meaningless in comparison to the gratitude I feel
and the tremendous honor that I feel when I think about the fact that
you elected me to represent you and the Cherokee Nation. No honor
I could have ever received in the past or in the future is greater than
that honor. I appreciate that and I will always remember it.

Today is a day for celebration, not just because we end one term
of office and begin a new term. It's a time for celebration because the
Cherokee Nation still has a strong, viable tribal government. Not only
do we have a government that has continued to exist, but we have a
tribal government that is progressing and getting stronger. We have
managed to move forward in a very affirmative way. Given our history
of adversity, I think it is a testament to our tenacity, individually and
collectively, that we have been able to keep the Cherokee government's
voice alive since time immemorial.

Basically, what we are doing is keeping the flame of the Cherokee
Nation government alive. At times in our history and most particularly
around the turn of the century, that flame dimmed considerably. Many
people have gone before us, some just completed serving, and the
people we have elected today will tend that flame and make sure that
the Cherokee Nation continues.

Around the turn of the century when there was a concerted attempt
to abolish the Cherokee Nation, no one ever gave up the dream of having
the Cherokee Nation revitalized. People would walk to each other's
homes in the rural communities, people rode horses, they went to
churches and went to ceremonial grounds, and met in little community
groups, old men and women, and talked about ways to keep the

government alive. And it worked.

Our people by many standards are outwardly very aculturated. People say we are very progressive. But I don't think any tribe in this country, no matter how traditional that tribe might be, has fought more valiantly or more passionately for the right to self-governance and tribal sovereignty than the Cherokee Nation. In fact, much of Indian law that other tribes rely on relative to tribal sovereignty is based on a Cherokee case that went to the U.S. Supreme Court.

After the tragic forced removal of our people from our homelands in the southeast, we had incredible devastation, bitter division, loss of lands, lives, government, economy, and everything we had ever known. When the last contingent arrived in April of 1839, we began immediately to establish a government for our people and a community. That's very important for those of us who are charged with that responsibility today to remember. Our ancestors fought valiantly to make sure that this government did survive.

The U.S. government promised us, in exchange for land and many lives in the southeast, that we could live here in Indian Territory without interference forever. Believing that, we began in 1839 to rebuild a strong viable Cherokee tribal government. We built schools, for both men and women. We built, in fact, the first schools west of the Mississippi, very remarkable first schools, Indian or non-Indian, west of the Mississippi. We built schools for the education of women, which was a very radical idea for the time. We re-established a judicial system in Indian Territory. We built beautiful institutions of government, some of which still stand today. They're now the oldest buildings in what is now Oklahoma. We printed newspapers in Cherokee and English. We built an economic system and began to rebuild our government.

Around the turn of the century our tribal government was again devastated, and that flame that I spoke about earlier was dimmed. When Oklahoma came into being, our tribal government was diminished significantly. Our schools were closed down. Our tribal judicial system was stopped. Most importantly to our people, land we had held in common was allotted out in individual allotments. The Allotment Act precipitated some of the worst cases of land abuse and land fraud in the history of Indian-U.S. relations which is well documented by Angie Debo's literature. Despite all that, our people clung to the idea of some sense of destiny and control over their lives and continued as a culturally distinct group of people and government.

From 1906 to 1971, the chiefs of the Cherokee Nation were appointed by the president of the United States. However, during this period there were always Cherokees meeting and talking about revitalizing the Cherokee government. In 1971 with the election of Chief W. W. Keeler, we saw the first step towards again revitalizing and rebuilding

the Cherokee Nation.

The best argument I could make for the existence of tribal government is to compare where our people were in the last century when we, in essence, were more literate than our non-Indian neighbors to the period from 1906 to 1971, when there was no tribal government. By the time we had our first election after statehood in 1971, our people had some of the lowest educational attainment scores in the state. They were living in dilapidated housing, without jobs, and were in very poor health. They had lost a sense of control over their lives as a result of external factors.

In 1971 when Chief Keeler began revitalizing the Cherokee Nation, he started it in a storefront here in Tahlequah. The tribe had very little income and resources, and in many cases none beyond what Chief Keeler would take out of his own pocket and use to help people. Since 1971, we have grown to the point that we now employ about 900 people. There is an annual budget of $52 million. We have forty separate organizations with volunteers working in various communities. We have begun to have an impact, at long last, in turning around some of the educational attainment levels. We have begun to have an impact on housing, health care, and many other issues. All the progress that we have made in the last twenty years has been by our own hard work and determination. Mike spoke about my hard work and determination, but I don't think that is a characteristic that I have by myself. I think it is a mark of the character of our people. Unlike some tribes, we didn't have marketable natural resources. Whatever we have done in the last twenty years, we've done through our own absolute determination to make sure that the Cherokee Nation existed and survived.

I wanted to share a little of our history with you because I think that it's important to put what is happening today in perspective. Those of us who were sworn in today, and who were elected, are temporary people. If you look at the totality of Cherokee history, we're not going to be here for a very long time. And it is our job to keep that flame going and to do everything within our power to make sure that we have a responsible and honest tribal government that you can be proud of, that listens to you and advocates for you. I also wanted to take a minute to remember all the people, our ancestors, and people that have gone before us who have worked here to preserve the Cherokee Nation. It is not just these people here on the stage who are responsible for the preservation of the Cherokee Nation. Its communities, its culture, and its heritage. It's up to all of us, every tribal member to take part in making sure that we survive into the 21st century as a culturally distinct group of people. Every Cherokee, whether full-blood or mixed-blood, whether rich or poor, whether liberal or conservative, has a responsibility to honor our ancestors by helping to keep our government, our communities,

and our people very strong.

The Cherokee Nation really is not, as people always seem to think, those buildings south of town or any of our field offices or the clinics. The Cherokee Nation is wherever Cherokee people are. That is the Cherokee Nation. The people are the Cherokee Nation.

My style of leadership, and what I hope I have brought to the Cherokee Nation, is to build communities, families, and people and not just build buildings and monuments. The words "tribal sovereignty" and "self-governance" are meaningless unless the people are actively involved and are able to participate in all aspects of the government.

And so today we celebrate this transition from one term of office to the next; the move from electing our Tribal Council at large to a system of electing our council by districts. And we should celebrate the fact that despite everything that has happened to us as a people we have indeed survived. We should celebrate the fact that we are here and we still have many attributes of our culture that are very strong.

If you look at the problems we've faced and are facing in their totality, it is almost overwhelming. We face a crisis in education. We face a crisis in health care, housing needs, jobs, and basic infrastructure. There are still people in our tribe who do not have the basic minimal services that all Americans, I think, should have. But we have never been better equipped to deal with all these issues and problems. We are equipped because we are positive and we believe in our people, and because we believe in our ability to have some control over our lives. We are equipped because we believe that we have reached a point where we have been able to start trusting our own thinking again. We have a professional staff, active community support, and a good set of newly elected tribal leaders who are ready to deal with all these issues in a very aggressive way.

During the last two decades with Chief Swimmer, Chief Keeler, and myself, we made some headway in dealing with all these problems and I am proud to say that I have been a part of that. But I also think that we have a long, long way to go. So I would ask our staff, and our tribal members, and also the people who have been elected to recommit yourselves to grappling with these problems with as much force as you can. Let's really roll up our sleeves and try to turn them around. Let's use this next four years for activism, advocacy and hard work and see if we can really have an impact.

I would also ask the tribal employees, the tribal citizens, and the council to get out of their offices and out of their homes and talk with people. Learn what's going on in the communities. Listen to people. Interact with people. Get involved. Too often we hear from people who have an axe to grind or a complaint. Let's hear from people who want to do some volunteer work. Let's hear from people who want to provide

some public service. Let's hear from people what want to join the team, and let's all hold hands, figuratively, and see what we can do to turn things around. We have made progress. I think we are an excellent organization. I am very proud to be associated with this organization. But we have to do more. We have to do more when we have the drop-out rate we have. We have to do more when our people don't have access to the health care that they need. We have to do more when we still have people in eastern Oklahoma who have to live in extremely poor housing or without indoor plumbing. That's unconscionable. And I don't think that we should stand for it. We should collectively figure out some way to do as much as we can and work as hard as we can to try to turn things around.

I also want to pay special tribute to the Delawares and the Shawnees who have come into our tribe by treaty. It is very difficult for a tribe which has its separate history, a separate language, and a separate culture to find their niche within the Cherokee Nation umbrella. The Delawares and Shawnees are led by competent, responsible, honest people. They are doing many things in collaboration with the Cherokee Nation. I spent a lot of time reaching out to those organizations because of their particular situation and working with them and I think it is very important to acknowledge that they are also part of the Cherokee Nation and the collective Cherokee family. And I am very proud of that.

Finally, I'd like to tell my family how much I appreciate their support and for all they have had to put up with. I've missed so many ball games, family reunions, and family dinners. I got an irate letter from a California Cherokee who was extremely upset because he had come to visit in Oklahoma and I hadn't seen him. In fact he said he hadn't seen me in six months. I wrote him a letter and told him that I haven't seen my mother in about three months. My family has been very forgiving of me for missing a lot of those things. I'd like to also especially thank my brother Don, who just a little more than a year ago donated a kidney to me. Without that I certainly wouldn't have been able to run for election and withstand the rigors of a campaign and then look forward to four more years in office.

I would like to thank all of you for taking the time to share this day with us. My feeling toward the Cherokee people is one of friendship and love. And that love and friendship has been returned to me a thousand fold over the past eight years. The relationship that I have developed with many of you and people everywhere has been one of the most rewarding things that has ever happened to me. I appreciate it, and I leave with you and give back to you a strong sense of friendship and love as we begin this new term. There is a lot of hard work to do. We're ready to do it in the most positive and forward thinking way we can.

I'd also like to congratulate the people here. I will say it again that working with this past council was unbelievable. It was an excellent Tribal Council and represents a tremendous loss of experience and diversity. The new council is going to have a hard act to follow, but I think it is up to the task. It's a group of people that I think that you will be proud of. With that, we are ready to go back to work. Thank you very much.

This extemporaneous speech was presented from notes and later transcribed and edited by Chief Mankiller's staff. It is used with permission from Chief Mankiller.

Responses to the Address

Mankiller received a standing ovation at the conclusion of her address. Jo Montana, former mayor of Vinita, Oklahoma, was at the inauguration and has heard the Principal Chief speak on several occasions. She commented of Mankiller: "She has a very forward style, but not aggressive. . . . She can pull herself through the most controversy calmly" (DeFrancisco, 1992k). Ralph Swimmer of Tulsa, who was Mankiller's predecessor as Principal Chief, said: "The essence of the speech is that she is differentiating what the tribe can do for the tribe, from [what the] federal government [can do]. I think she primarily has demonstrated her leadership by being available to the people, to [the U.S.] Congress, senators, to the community. . . . People are able to see her and see that she is working for them. . . . She's got the attributes of leadership and it comes through every day" (DeFrancisco, 1992m). Oklahoma Representative Mike Synar, who introduced Mankiller at the event, said of Mankiller's credibility: "It was one well-delivered and well-received speech because of who she is and what she has done for the people. The substance of the speech hit the themes that Cherokees have been thinking about for a long time" (DeFrancisco, 1992l).

Anita Hill

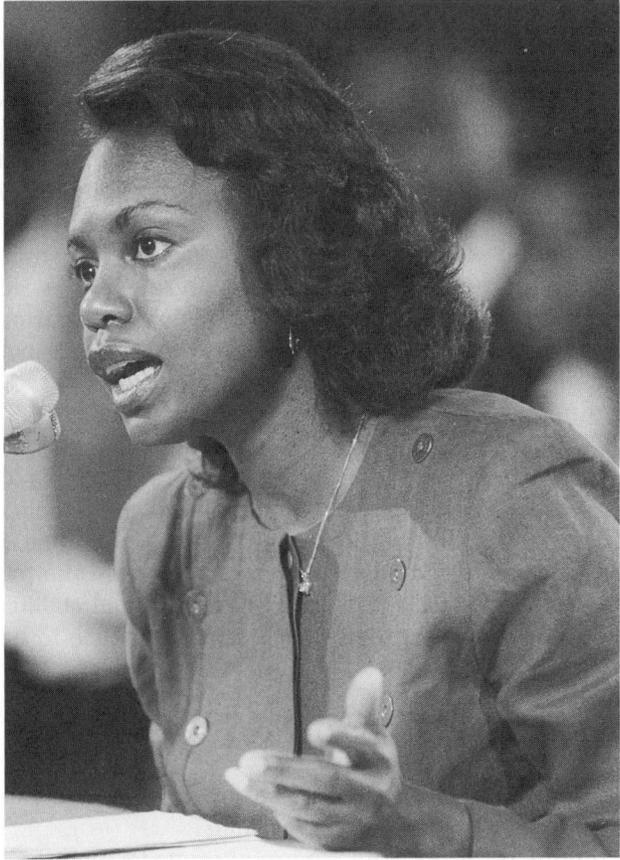

Anita Hill, professor of law at the University of Oklahoma, reluctantly became a key speaker in the confirmation hearing for Supreme Court nominee Clarence Thomas, in October of 1991. In her affidavit, Hill alleged Thomas had engaged in inappropriate conduct toward her while

he was her employer. The speaker came forward only after her confidential testimony to the FBI was disclosed to the public on National Public Radio and she was subsequently subpoenaed by the Senate.

After earning a law degree from Yale in 1980, Hill practiced law with a private firm in Washington, D.C. In 1981 a mutual business associate introduced Hill and Thomas, and she was soon hired to be his special legal counsel at the Department of Education. Hill later followed Thomas to the Equal Employment Opportunity Commission (EEOC) where he served as chair. In 1983 Hill left the EEOC to teach at Oral Roberts University. In July of 1991, President George Bush nominated Clarence Thomas to replace retiring Justice Thurgood Marshall. At that time, Hill filed a confidential report of her allegations. The report went largely unnoticed by the Senate Judiciary Committee. In frustration, Hill wrote her own affidavit and asked that it be distributed to all members of the Senate committee. The committee received Hill's statement the night before they were to vote on the Thomas confirmation. The group chose not to address Hill's accusations, presumably because she asked that her name be kept confidential. The Thomas confirmation vote was 7 to 7, sending the president's nomination to the Senate floor without a recommendation from the Senate committee.

After Nina Totenberg on National Public Radio disclosed some of Hill's affidavit, the Senate committee and Anita Hill were forced to go public. The hearings were re-opened in the old Senate caucus room. Thomas and Hill took their respective turns sitting at a table with microphones across from the all white, male Judiciary Committee. Seating behind the witnesses accommodated 106 members from the public. Hill testified on October 11, 1991. Thomas gave a formal statement prior to Hill's testimony, and subsequently made a response to her allegations.

Approach of the Speaker

Anita Hill did not plan to make a public statement regarding her experiences with Clarence Thomas.

Public records leading to her ultimate testimony illustrate the degree to which she struggled with this decision. When Rick Seidman, an aide to Senator Ted Kennedy, contacted her on September 5 regarding rumors of sexual harassment by Thomas, she said she needed time to think about whether she would discuss such rumors. Four days later she agreed to talk, but wanted to keep the deposition confidential and refused an FBI investigation. In giving her story to Harriet Grant, Chief of Nominations for Judiciary, on September 12, Hill said she wanted to share her concerns with the committee to "remove responsibility" and "take it out of [her] hands" (Kaplan, et al., 1991, p. 28). On September 19, Hill decided the entire Senate Judiciary Committee should be told because,

"she didn't want to 'abandon' her concerns about Thomas." She said she did not want to involve the FBI because she was "skeptical about its utility" (Kaplan, et al., 1991, p. 28). Finally, on September 23, after several conversations with the Judiciary staff, she agreed to the FBI investigation. She later released her statement to all one hundred senators, but never opted to go public.

When her story was released on National Public Radio and it was apparent that Hill would be called to testify, she asked to give her statement before Thomas was allowed to speak on the issue. However, the Senate Judiciary Committee did not honor her request.

Subsequent to the hearing which followed, Hill explained why she came forward:

> It was suggested that I had fantasized, that I was a spurned woman and that I had a martyr complex. I will not dignify those theories except to assure everyone that I am not imagining the conduct to which I testified. . . . I had nothing to gain by subjecting myself to the process. In fact, I had more to gain by remaining silent. The personal attacks on me without an iota of evidence were particularly reprehensible, and I felt it necessary to come forward to address those attacks. (Associated Press, 1991b)

Hill said she hoped her experiences would encourage sexual harassment victims to speak out. "I would like to assure them they no longer have to suffer in silence." She added a hope that the awareness of sexual harassment fueled by her testimony would not end overnight (*Newsweek*, 1991, p. 85).

In an acceptance speech for an award from the American Bar Association's Commission on Women, Hill again explained why she spoke out, forfeiting her privacy. "We must, even at some individual risk, participate in the education of our colleagues" (Associated Press, 1992a, p. 4A).

One year after Hill's senate testimony, Katherine Couric of NBC's "Today Show," asked Hill how she would like to be remembered in the future. She answered, "I want them to think of me as a catalyst for positive change. Fifty years from now, I would like to be the person who challenged us to do better, and I think we can" (Couric, 1992).

Testimony to the Senate Judiciary Committee

Mr. Chairman, Senator Thurmond, members of the committee.

My name is Anita F. Hill, and I am a professor of law at the University of Oklahoma. I was born on a farm in Okmulgee County, Oklahoma, in 1956. I am the youngest of 13 children.

I had my early education in Okmulgee County. My father, Albert

Hill, is a farmer in that area. My mother's name is Irma Hill. She is also a farmer and a housewife.

My childhood was one of a lot of hard work and not much money, but it was one of solid family affection as represented by my parents. I was reared in a religious atmosphere in the Baptist faith, and I have been a member of the Antioch Baptist Church in Tulsa, Oklahoma, since 1983. It is a very warm part of my life at the present time.

For my undergraduate work, I went to Oklahoma State University and graduated from there in 1977. . . . I graduated from the university with academic honors and proceeded to the Yale Law School, where I received my J.D. degree in 1980.

Upon graduation from law school, I became a practicing lawyer with the Washington, D.C., firm of Wald, Hardraker & Ross. In 1981, I was introduced to now-Judge Thomas by a mutual friend.

Judge Thomas told me that he was anticipating a political appointment, and he asked if I would be interested in working with him.

He was in fact appointed as assistant secretary of Education for civil rights. After he was, after he had taken that post, he asked if I would become his assistant, and I accepted that position.

In my early period there, I had two major projects. The first was an article I wrote for Judge Thomas' signature on the education of minority students. The second was the organization of a seminar on high-risk students, which was abandoned because Judge Thomas transferred to the EEOC, where he became the chairman of that office.

During this period at the Department of Education my working relationship with Judge Thomas was positive. I had a good deal of responsibility and independence. I thought he respected my work and that he trusted my judgment.

After approximately three months of working there, he asked me to go out socially with him. What happened next, and telling the world about it, are the two most difficult things—experiences of my life.

It is only after a great deal of agonizing consideration and sleepless nights that I am able to talk of these unpleasant matters to anyone but my close friends.

I declined the invitation to go out socially with him and explained to him that I thought it would jeopardize at—what at the time I considered to be a very good working relationship. I had a normal social life with other men outside the office. I believed then, as now, that having a social relationship with a person who was supervising my work would be ill-advised. I was very uncomfortable with the idea and told him so.

I thought that by saying no and explaining my reasons, my employer would abandon his social suggestions. However, to my regret, in the

following few weeks, he continued to ask me out on several occasions.

He pressed me to justify my reasons for saying no to him. These incidents took place in his office or mine. They were in the form of private conversations, which not—would not have been overheard by anyone else.

My working relationship became even more strained when Judge Thomas began to use work situations to discuss sex. On these occasions he would call me into his office for reports on education issues and projects, or he might suggest that because of the time pressures of his schedule we go to lunch to a government cafeteria.

After a brief discussion of work, he would turn the conversation to a discussion of sexual matters. His conversations were very vivid. He spoke about acts that he had seen in pornographic films involving such matters as women having sex with animals and films showing group sex or rape scenes.

He talked about pornographic materials depicting individuals with large penises or large breasts involving various sex acts. On several occasions, Thomas told me graphically of his own sexual prowess.

Because I was extremely uncomfortable talking about sex with him at all, and particularly in such a graphic way, I told him that I did not want to talk about this subject. I would also try to change the subject to education matters or to non-sexual personal matters, such as his background or his beliefs.

My efforts to change the subject were rarely successful.

Throughout the period of these conversations, he also from time to time asked me for social engagements. My reaction to these conversations was to avoid them by eliminating opportunities for us to engage in extended conversations.

This was difficult because, at the time, I was his only assistant at the Office of Education—or Office for Civil Rights. During the latter part of my time at the Department of Education, the social pressures, and any conversation of his offensive behavior, ended. I began both to believe and hope that our working relationship could be a proper, cordial and professional one.

When Judge Thomas was made chair of the EEOC, I needed to face the question of whether to go with him. I was asked to do so, and I did.

The work itself was interesting, and at that time it appeared that the sexual overtures which had so troubled me had ended.

I also faced the realistic fact that I had no alternative job. While I might have gone back to private practice, perhaps in my old firm or at another, I was dedicated to civil rights work, and my first choice was to be in that field. Moreover, at that time, the Department of Education itself was a dubious venture. President Reagan was seeking to abolish the entire department.

For my first months at the EEOC where I continued to be an assistant to Judge Thomas, there were no sexual conversations or overtures. However, during the fall and winter of 1982, these began again. The comments were random and ranged from pressing me about why I didn't go out with him to remarks about my personal appearance. I remember his saying that some day I would have to tell him the real reason that I wouldn't go out with him.

He began to show displeasure in his tone and voice and his demeanor and his continued pressure for an explanation. He commented on what I was wearing in terms of whether it made me more or less sexually attractive. The incidents occurred in his inner office at the EEOC.

One of the oddest episodes I remember was an occasion in which Thomas was drinking a Coke in his office. He got up from the table at which we were working, went over to his desk to get the Coke, looked at the can and asked, "Who has put pubic hair on my Coke?"

On other occasions, he referred to the size of his own penis as being larger than normal, and he also spoke on some occasions of the pleasures he had given to women with oral sex. At this point, late 1982, I began to feel severe stress on the job. I began to be concerned that Clarence Thomas might take out his anger with me by degrading me or not giving me important assignments. I also thought that he might find an excuse for dismissing me. In January of 1983, I began looking for another job. I was handicapped because I feared that if he found out, he might make it difficult for me to find other employment, and I might be dismissed from the job I had. Another factor that made my search more difficult was that there was a period—this was during a period—of a hiring freeze in the government.

In February 1983 I was hospitalized for five days on an emergency basis for acute stomach pain, which I attributed to stress on the job. Once out of the hospital I became more committed to find other employment and sought further to minimize my contact with Thomas. This became easier when Allison Duncan became office director, because most of my work was then funneled through her, and I had contact with Clarence Thomas mostly in staff meetings.

In the spring of 1983, an opportunity to teach at Oral Roberts University opened up. I participated in a seminar, taught an afternoon session in a seminar at Oral Roberts University. The dean of the university saw me teaching and inquired as to whether I would be interested in further pursuing a career in teaching beginning at Oral Roberts University. I agreed to take the job, in large part because of my desire to escape the pressures I felt at the EEOC due to Judge Thomas.

When I informed him that I was leaving in July, I recall that his response was that now I would no longer have an excuse for not going out with him. I told him that I still preferred not to do so. At some time

after that meeting, he asked if he could take me to dinner at the end of the term. When I declined, he assured me that the dinner was a professional courtesy only and not a social invitation. I reluctantly agreed to accept that invitation but only if it was at the very end of a working day.

On, as I recall, the last day of my employment at the EEOC in the summer of 1983, I did have dinner with Clarence Thomas. We went directly from work to a restaurant near the office. We talked about the work I had done, both at Education and at the EEOC. He told me that he was pleased with all of it except for an article and speech that I had done for him while we were at the Office for Civil Rights. Finally he made a comment that I will vividly remember. He said that if I ever told anyone of his behavior that it would ruin his career. This was not an apology, nor was it an explanation. That was his last remark about the possibility of our going out or reference to his behavior.

In July of 1983 I left the Washington, D.C. area, and I've had minimal contacts with Judge Clarence Thomas since. I am of course aware from the press that some questions have been raised about conversations I had with Judge Clarence Thomas after I left the EEOC. From 1983 until today, I have seen Judge Thomas only twice. On one occasion I needed to get a reference from him, and on another, he made a public appearance in Tulsa. On one occasion he called me at home, and we had an inconsequential conversation. On one occasion he called me without reaching me, and I returned the call without reaching him, and nothing came of it.

I have, on at least three occasions, been asked to act as a conduit to him for others. I knew his secretary, Diane Holt. We had worked together at both EEOC and Education. There were occasions on which I spoke to her, and on some of these occasions, undoubtedly, I passed on some casual comment to then-Chairman Thomas.

There were a series of calls in the first three months of 1985 occasioned by a group in Tulsa, which wished to have a civil rights conference. They wanted Judge Thomas to be the speaker and enlisted my assistance for this purpose. I did call in January and February, to no effect, and finally suggested to the person directly involved, Susan Cahall, that she put the matter into her own hands and call directly. She did so in March of 1985.

In connection with that March invitation, Miss Cahall wanted conference materials for the seminar, and some research was needed. I was asked to try to get the information and did attempt to do so. There was another call about the possible conference in July of 1985.

In August of 1987 I was in Washington, D.C., and I did call Diane Holt. In the course of this conversation, she asked me how long I was going to be in town, and I told her. It is recorded in the message as August 15. It was in fact August 20. She told me about Judge Thomas'

marriage, and I did say congratulate him.

It is only after a great deal of agonizing consideration that I am able to talk of these unpleasant matters to anyone except my closest friends, as I've said before. These last few days have been very trying and very hard for me, and it hasn't just been the last few days this week.

It has actually been over a month now that I have been under the strain of this issue.

Telling the world is the most difficult experience of my life, but it is very close to having to live through the experience that occasioned this meeting. I may have used poor judgment early on in my relationship with this issue. I was aware, however, that telling at any point in my career could adversely affect my future career, and I did not want early on, to burn all the bridges to the EEOC.

As I said, I may have used poor judgment. Perhaps I should have taken angry or even militant steps, both when I was in the agency or after I left it. But I must confess to the world that the course that I took seemed the better, as well as the easier, approach.

I declined any comment to newspapers, but later, when Senate staff asked me about these matters, I felt I had a duty to report. I have no personal vendetta against Clarence Thomas. I seek only to provide the committee with information which it may regard as relevant.

It would have been more comfortable to remain silent. It took no initiative to inform anyone—I took no initiative to inform anyone. But when I was asked by a representative of this committee to report my experience, I felt that I had to tell the truth. I could not keep silent.

This text is from Congressional Quarterly *(October 12, 1991).*

Responses to the Testimony

The most immediate and perhaps influential audience was the line-up of senators Hill faced during her testimony. They questioned her for seven hours immediately following her statement. We can glean some impressions from the senators' questioning. Alan Simpson suggested Hill had come forward because she had a "secret crush" on Thomas (*Associated Press*, 1991a, p. 4A). Arlen Spector accused her of "flat-out perjury" when she told the Senate she could not recall whether a Senate aide told her such allegations could prompt Thomas to withdraw his nomination. Orrin Hatch inferred that Hill's accusations were borrowed from a 1988 sexual harassment case in which the pornographic movie "Long Dong Silver" was discussed and from the novel *The*

Exorcist (*The Des Moines Register*, 1991, p. 6A). In contrast, Patrick Leahy said:

> Professor Hill presented her story with dignity, courage, and intelligence, and she maintained an extraordinary grace under the pressure of a political onslaught that was orchestrated by the White House. . . . Is it any wonder that she hesitated to come forward—8 years ago or today? . . . If anyone needs to know why so many women keep experiences of sexual harassment or rape locked up inside, they need look no further than Anita Hill's 72 hours in Washington. . . . Mr. President, I believe Anita Hill. (Congressional Record, 1991, p. 514649)

After the questioning of Hill, Thomas made a 90-minute response. He admitted he went home during her testimony and did not watch it. He said the airing of Hill's accusations resembled a "high tech lynching for uppity Blacks. . . . I cannot shake off these accusations because they play to the worst stereotypes about black men in this country."

Special sessions were held the following Saturday and Sunday to hear witnesses for both sides. There had not been a hearing on a Sunday since the Watergate scandal, which increased the drama of the event. Hill's testimony was said to be the most watched in the history of television ("Frontline," 1992). All the major television networks dropped their regular programming for two days. The full Senate vote took place on Tuesday, October 15, and Thomas was confirmed 52 to 48.

Few speakers receive as much national attention as Anita Hill did when she addressed the Senate committee. There were public opinion polls taken across the country and news interviews with persons on the street, in the workplace, on college campuses, and even in bowling alleys. A *Newsweek* survey of 704 adults, taken October 10–11, showed most believed Thomas was innocent; only 27 percent of the women and 17 percent of the men believed Thomas harassed Hill (1991a, p. 28). "Letters to the Editor" sections of newspapers were filled with opposing views. One direct comment on Hill as a speaker came from Jeanne Martin (1991), of Fontanelle, Iowa: "Talk about grace under pressure, courage and self-control. Professor Anita Hill is the one who should be on the Supreme Court" (p. 5C). Some anti-feminists saw Hill's testimony as a feminist plot. Phyllis Schlafly said, "It was the work of radical feminists" (*San Francisco Examiner*, 1991, p. A-14). Others, such as Kathleen Sullivan, professor at Harvard Law School, said, "I found her testimony today entirely credible, calm, and controlled. . . . She is in no way a [part of a] liberal feminist plot" (Brokaw, 1991).

In the months following Hill's testimony there continued to be many reflections on the impact of her statement, particularly related to the issues of sexual harassment, racism, and women in politics. Awareness of sexual harassment has increased across the nation, as is evidenced

by special media reports (Kantrowitz et al., 1991a) and new books rolling off the presses (e.g. Morrison, 1992; Phelps & Winternitz, 1992; Webb, 1992). Roxanne Conlin, President-Elect of the Association of Trial Lawyers of America said the Hill testimony may change the way women and men work together across the country (Yepsen, 1991, p. 4A). And Marguerite Bantlin, who settled her sexual harassment case with the University of Arizona said, "That testimony was a turning point for women in this country" (Leatherman, 1992). Since the Thomas confirmation hearings, inquiries at the EEOC on sexual harassment jumped 250 percent and actual charges filed are expected to rise accordingly. Hill herself said, "The overwhelming response to my testimony has been at once heartwarming and heartwrenching. I'm learning I am not alone in my experience of sexual harassment. . . . Sexual harassment is an equal opportunity creature where women are concerned . . . unwanted advances do not cease when objected to, and the object is power and ego, not genuine interest. . . ." (Yoachum, 1991). Rosemary Bray, an editor for the *New York Times Book Review*, explained why both gender and race made Hill's testimony so influential:

> The near-mythic proportions that the event has already assumed in the minds of Americans are due, in part, to the twin wounds of race and gender that the hearing exposed. If gender is a troubling problem in American life and race is still a national crisis, the synergy of the two embodied in the life and trials of Anita Hill left most of America dumbstruck. Even black people who did not support Clarence Thomas' politics felt that Hill's charges, made public at the 11th hour, smacked of treachery. Feminist leaders embraced with enthusiasm a woman whose conservative political consciousness might have given them chills only a month earlier. (1992, p. 56)

African Americans were deeply affected by the Hill/Thomas hearings (see, for example, Chrisman & Allen, 1992). Sam Fulwood of the *Los Angeles Times* explained: "As a black person, you couldn't help but be moved emotionally at the sight of two black people talking about sex and the whole bit before a panel of white men" ("Frontline," 1992). Patricia King, a law professor said, "It's been drilled into us [black women] since birth that you don't betray black men. . . . I think that many people saw her as a traitor. She was a traitor to him and a traitor to the community because she washed all that dirty laundry in public. I'm glad she did" ("Frontline," 1992). Hill felt that race played a major role in why her testimony was criticized.

> Those people who find me offensive do not find me simply offensive because I was a woman who testified against Clarence Thomas about certain behavior, they find me offensive because I'm black . . . because I'm a black woman. The public did not have a historical context or a social context in which to place my experiences. They

Rita Arditti

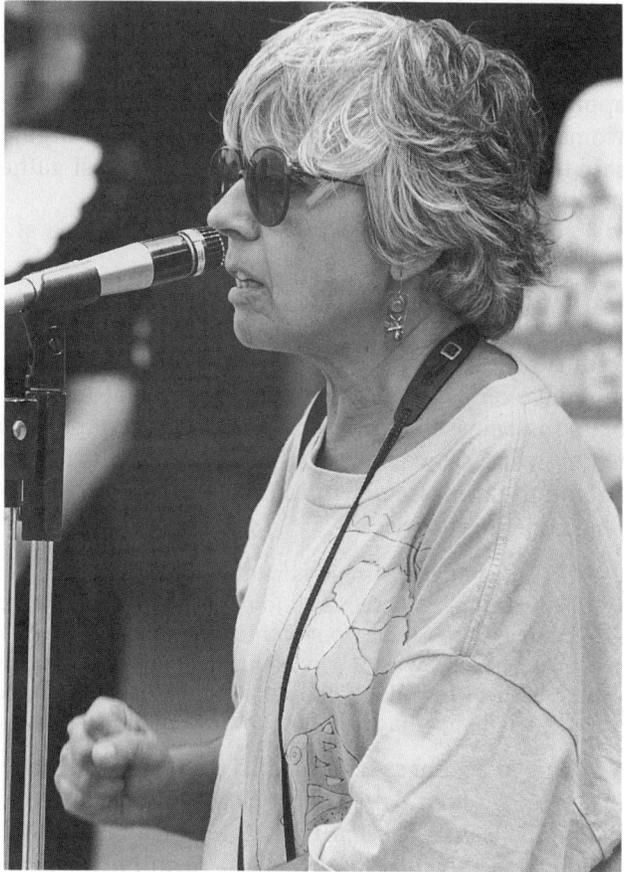

Background

Rita Arditti was one of a number of speakers at a rally sponsored by the Massachusetts Breast Cancer Coalition, October 27, 1991. The rally began on the Boston Common and participants then marched to Government Center—where the speeches took place. The Commons had special

significance because of the long history of outdoor addresses given on this site. Lise Beane, a member of the Women's Community Cancer Project and the Massachusetts Breast Cancer Coalition, said about the rally atmosphere: "There was a synergy with the women face to face in this public arena that you don't get with an inside lecture" (DeFrancisco, 1993d). Speakers included both women and men who had personal experiences as victims and survivors of breast cancer. The organizers, interested in a broad spectrum of speakers, invited Arditti because of her Hispanic background and also because of her known interest in environmental causes of cancer. Her audience of approximately 4,000 was a cross-section of the general public, including women, men, and children. Amy Present, an organizer for the event, said that to her knowledge it is still the largest gathering on this topic in the United States (DeFrancisco, 1993e).

Approach of the Speaker

Arditti reflected fifteen months later that the rally was "an incredibly moving event." She remembered the visual impact of the bright pink balloons released on Boston Common juxtaposed against the black clothes worn by women with breast cancer. Her challenge was to convey an important message within her allotted time of two to three minutes. She said in retrospect:

> I really felt very strongly that the larger social/political aspects and environmental issues had to come out very clearly because all the time we are saying "one in nine" and now "one in eight," but we have to ask "why." Why is this happening? I felt that, much as we have been organizing and agitating, we haven't . . . [focused on] why this is happening and how to prevent it. (DeFrancisco, 1993a)

In preparing her speech, Arditti was influenced by her reading of One in Three: Women with Cancer Confront an Epidemic and Cancer As a Women's Issue: Scratching the Surface. Although she had spoken previously to small groups, this was Arditti's first experience with a large audience. She later reflected: "I think if I had thought about that, I would have said no."

"One in Nine"

I want to talk about an area that does not get much attention when discussing breast cancer: the environment. I have breast cancer, my cancer is considered "incurable" because it has spread to other organs.

had not been familiarized with some of the sexual misconduct that has been experienced by black women historically through slavery . . . and also, we have been fed the stereotypes of black women who are sexually promiscuous. . . . ("Frontline" 1992)

Politically, Hill's testimony also seems to have had a long-term impact. Women seeking Senate seats attributed the treatment of Hill during her testimony as their stimulus to run for office in 1992. For example, Lynn Yeakel, a political unknown, captured the Democratic nomination for Senator from Pennsylvania, April 28, 1992. In the fall of 1992 she ran against Republican Senator Spector, but lost by a narrow margin. Many felt her initial success was due to public outrage over Spector's behavior at the hearing. Even those supporting Spector's re-election, such as the American Federation of Teachers, have reprimanded him for his behavior toward Anita Hill. As one reporter said, "Anita Hill may have lost one battle, but six months later it's clear she launched an army in the war against sexual harassment" (Adams, 1992). Anita Hill may well have been a conscience on the shoulders of many political nominees and voters alike during the election of 1992.

I live with that awareness every day of my life.

I think we need to stop the conspiracy of silence about cancer and the environment. I want us to stop feeling that cancer is a private and individual tragedy. As long as we retreat into the private, personal realm we will not have the power and the resources to fight and bring this issue into the social and political arena. We need to look at the *big picture*, at the context—social, economic, and political—in which we lead our lives and in which we develop cancer.

It is widely known that 80 percent of cancers are environmentally induced. That means that what we put in our bodies, what we breathe, what we eat, what we drink, the radiation we get, where we work and live, is responsible for 80 percent of all cancers. In spite of this fact, with which even the most conservative scientists agree, *nothing is practically done to track and eliminate pollutants.* Our food is full of additives, herbicides, pesticides, hormones, and other poisons.

Breast milk has been shown worldwide to be contaminated. In some areas of this country, it has been advised that women who eat fish twice a week should not breastfeed because of the level of contaminants in their milk. Many of the contaminants, like PCBs, PBBs, DDT and its derivatives, are fat soluble; they concentrate in the body's fat, our breasts have large numbers of fat cells, are these contaminants being stored in our bodies—giving us breast cancer? If the milk is dangerous to the babies, isn't it going to be dangerous to the mother? Our breasts are picking up the poisons around us.

Recently I was looking at some papers on the contamination of breast milk. I was enraged. There was not one word in these papers about the mother, about what would these poisons do to the mother. Not one word. Women do not count. Even when discussing breast milk contamination women do not exist.

The National Cancer Institute is a public institution run with public funds. That means that they should be accountable to the people who fund them. They should have representation and decision making power for women with cancer, the poor, so called minorities, people at high risk. They need to hear from us. They need to hear about the paradox of women being invisible even while [researchers are] studying the contamination of breast milk.

The link between toxic materials and breast cancer needs to be thoroughly and exhaustively investigated. I recently read an article that came out in the October issue of *Ms.* magazine, the new *Ms.* magazine, the one that does not carry advertising anymore. It is entitled "The Clan of One-breasted Women" and it was written by a woman from a Mormon family, Terry Tempest Williams, a family where practically every woman got breast cancer. She writes about the healthy lives that these women had, no smoking, no drinking, living close to nature, and

the fact that prior to 1960 only one woman in her family faced breast cancer. And then she writes about a recurring dream she had as a child of a "flash of light" in the night in the desert. And finds out, now, as an adult that this flash of light was due to testing of the bomb in 1957, to nuclear fallout raining on her family while driving in the desert. Her mother developed breast cancer 14 years afterwards, the time that it takes for radiation cancer to become evident. She encourages us to question *everything*, because as she puts it "blind obedience in the name of patriotism or religion ultimately takes our lives."

If we want prevention and cure for breast cancer (and for all cancers), we have to demand an end to the pollution of our bodies and of the environment. We must eliminate the carcinogens and toxic materials all around us if we want to end the cancer epidemic, if we want to save our lives and the lives of the next generation.

This text was provided by Rita Arditti and is used with her permission. Emphasis has been retained in the places indicated by the author. The editors have made several minor changes in punctuation and syntax for clarity.

Responses to the Speech

Perhaps audience member Ellen Leopold summed it up best:

> I remember how she was—she was very unsentimental and direct. When you see all of these women speak who have breast cancer it is very moving; but Rita, unlike the other speakers, did not address the personal. It was a relief after all the others. She was direct and forceful. She called for activism. It is hard when you are quite small to be an imposing speaker, but Rita is! (DeFrancisco, 1993b)

According to Amy Present, 1991 was the beginning of a major grassroots effort to bring attention to breast cancer, and Arditti was a part of it. Arditti has continued to address links to pollution, but in 1991, "she was a lone voice" on this issue (DeFrancisco, 1993e). Lise Beane said that Arditti's link to the environment was new information. "Until then we had received canned information from sources such as the American Cancer Society. This was like winning a battle to get past that canned information. It was a fairness issue in that we got a chance to hear a different view from the government. Isn't it strange that there is three times more breast cancer since the 1960s, but no one has brought out this link before?" (DeFrancisco, 1993d). Another member of the audience also commented on Arditti's message about the environmental link to breast cancer:

> After more than 30 years of intensive effort and billions of public dollars of investment, the cancer establishment has utterly failed to reduce the breast cancer mortality rate. Why? Perhaps this is because, as Rita Arditti underscores so forcefully in this important speech, research has been directed at conventional medical treatments for cancer, the same old "slash, burn and poison" modalities which don't work, rather than environmental toxins. The bold vision of Rita Arditti and other like-minded activists will result in re-orienting the women's cancer movement more firmly towards this goal, cancer prevention through the identification and elimination of environmental carcinogens. (Spiegelman, 1993)

Arditti received audible reactions from the audience as she spoke—particularly when she commented on women being invisible even as their breast milk was being studied. She said of her listeners' responses: "I was very gratified because people did tell me afterward that it worked—that they felt that I was able to bring out the environmental connection quickly and in an effective way. So I was extremely happy." She was particularly pleased that responses continued months and even a year afterward. At the 1992 rally, a woman sought her out to say: "You spoke last year. I really remember what you said." Arditti said that such feedback made her feel that "it did fall on open ears" (DeFrancisco, 1993a). One organizer confirmed that Arditti's remarks were not only received, but later influenced the planning for the 1992 rally (Jensen, 1993).

The positive response of one listener led Arditti to write further on the subject. Tatiana Schreiber called Arditti to say that she liked her speech and their conversation led to collaboration on an article entitled "Breast Cancer: The Environmental Connection." Arditti said of the speech and its aftermath: "Taking the step of being public really helped to develop and do more work about the ideas. . . . I was doing it alone—so it was harder—but when I was public about it, I got more support—and could do more work—so it was a very empowering process" (DeFrancisco, 1993a).

Pat Cain

Pat Cain and Jean Love, professors of law at the University of Iowa, spoke at the University of Northern Iowa on February 17, 1992. They were invited by the UNI Gay/Lesbian Organization and the Women's Studies Program to address the need for an inclusive human rights policy on

campus. This was particularly relevant because the president's cabinet at the University of Northern Iowa had recently denied a request that the university extend human rights protection to "sexual orientation and associational/affectional preferences."

Cain and Love were hired by the University of Iowa College of Law in 1991. An openly lesbian couple, their joint appointment has since drawn a great deal of attention. Recently their pictures appeared on the front page of *The Chronicle of Higher Education* in connection with a story on "Homosexuals in Academe." They helped lobby the Association of American Law Schools to adopt a policy protecting lesbian and gay rights, a policy which now guides 175 law schools in the United States.

Cain and Love spoke in the Schindler Education Center at UNI to an audience of approximately two hundred people. Laura Kress, a student and member of UNI-GLO introduced the speakers. A show of hands revealed most students in the audience were juniors and seniors, with an equal number of faculty and community members present. Jean Love warmed up the audience with a dialogue in which she raised questions about the nature of legal rights and the frequent denial of those rights on the basis of sexual orientation. Love's exchange with the audience is not included in its entirety because audience comments were often inaudible. She was followed by Cain's more formal remarks.

The following is Jean Love's summary and transition into the speech by Pat Cain.

> Now, I have to leave Pat time, so I am going to give you a quick little synopsis of the ways in which society can discriminate on the basis of race, sex, or sexual orientation. Imagine three columns in your mind. At the top of each of these columns is going to be a phrase that describes one of the three ways in which we as a society—all of us, including gays, lesbians, and bisexuals—can discriminate against groups of people. . . . The first way we can do it is by disrespecting or denying another person's personhood, right? With Blacks you start with the institution of slavery. That is the most stark denial of personhood that we know in our history in this country. We said slaves were property—that is a total denial of personhood. To move on into the ways that we treated Blacks after the Civil War, the way that we treated women in this country for the period up through the late 1800s and early 1900s, we denied Blacks and women legal rights. They couldn't hold property, for example. We acknowledged them as human beings but they couldn't hold property. They couldn't vote. They couldn't sit on juries. Okay, those are some of the ways in which you can deny a person's very personhood. Well, there are some other ways you can do it—by inflicting violence, gay bashing (alive and well and kicking in the 1990s), and through hate speech. Members of *all* the groups that we have talked about tonight are victims of hate speech still in the 1990s. These examples are just illustrative of the ways in which we can

diminish a group by diminishing the personhood of the people within that group.

A second way, of course, that we can discriminate against a group, or subordinate, or oppress that group is by denying them opportunities for public employment, for public education, for other types of public benefits, such as credit or housing. And then, a third way that we can denigrate a group—is by interfering with that group's ability to form family relationships. That is, of course, a key issue in the gay, lesbian, bisexual community, but it didn't originate with our community. Think back again to the institution of slavery. What did it do? It broke up Black families that came from Africa and it broke up the families of slaves who were born in this country. Think about the institution of marriage and family law in this country. Sometimes we have had rules saying only fathers could have custody of children. Other times we have had rules saying only mothers could have custody of children, just as a couple of "for examples." Move on up into even more modern times, interracial marriage was legally prohibited in many states in this country until the Supreme Court ruled it in violation of the equal protection clause. When did that happen? Not until the 1960s. And now, of course, coming into our own community, I am sure you know there is no state in which gays and lesbians can legally marry. There are very few states in which gays and lesbians can legally adopt children jointly, just as a couple of "for examples." So having laid that groundwork, I am now turning the podium over to Pat.

Approach of the Speaker

In a telephone interview after the speech, both Cain and Love said they felt an obligation to speak on this issue (DeFrancisco, 1992a). Cain said: "I feel a particular responsibility since I have tenure. I'm not risking losing my job. I'm in a privileged position." Although she greatly values her right to a private relationship, Cain finds it "absolutely necessary to come out" because silence is what the opposition wants. She said she experiences substantial speech anxiety prior to a public address and "incredible tension" because she cares about the topic so passionately.

Although Cain and Love were aware that this audience was particularly supportive of the subject, they also recognized that the audience did not necessarily have legal knowledge. Thus they approached this occasion as educators, with a legal message fueled by personal conviction. Cain and Love also realized that, on this and all occasions, they are role models whose professional status can give hope to women, gays, lesbians, bisexuals, and other minorities in their audiences.

Address at the University of Northern Iowa

Now what I want to do is talk about the legal theories that have been used to address these three categories of harm that have been inflicted on gays, lesbians, and bisexuals [as introduced by Jean Love]. I am going to focus some on litigation because we are talking about developing legal rights for gays and lesbians. I have to say we haven't been terribly successful in the courts in our battles, litigation wise, but there are two ways to change laws—one is through the courts and the other is through the legislature. The kinds of theories that I am going to talk about are also, of course, theories about equality and privacy and all of those major principles that unite us as a country. So there are all kinds of theories that one would like to elaborate on if one is going to talk about changes that are brought about legislatively. But, I am primarily going to focus on litigation.

Now first are the types of harms that are inflicted on us as individuals because of our personhood, to our individual dignity, or harm to our individual person. One of the types of discriminatory efforts by the states that Jean did not mention and fortunately we don't have to worry about here in Iowa is sodomy laws. Sodomy laws have to do with your right to be sexual in the way you want to be sexual with the person of your choice. And there are still about twenty-five states in this country that have criminal sanctions for sodomy. Sometimes for heterosexual sodomy as well as same-sex sodomy. And, probably the most famous case that has yet occurred in our community is the case that took the Georgia sodomy statute to the Supreme Court to argue on the basis of a constitutional right to privacy that the Georgia legislature should not be allowed to criminalize us because of our private sexual conduct. That was the case of *Bowers vs. Hardwick*. How many of you here know the case of *Bowers vs. Hardwick*? [A few hands were raised.] Ah, well, I'll talk a little bit *more* about *Bowers vs. Hardwick*.

Michael Hardwick was a young man who worked in a gay bar, who had once been arrested for drinking in public when he came out of the gay bar at 4:00 in the morning. He actually says that it was a typical type of gay harassment by the Atlanta police. This warrant was still outstanding, or at least according to the police was still outstanding (Michael himself says he had actually gone down to pay off the fine associated with this). . . . He was home late from his work in the gay bar and was in his bedroom with a male companion when a policeman knocked on the front door. An overnight guest who was sleeping in the living room let the policeman into the house and the policeman asked where Michael Hardwick was at that time—where his bedroom was, and the guest kind of waved him down the hall. The policeman walked

into the bedroom and caught Michael Hardwick in the act of sodomy with his male friend, and arrested him, didn't stop him as a matter of fact—according to Hardwick, apparently stayed there for a little bit of time to be sure that the crime was committed [audience laughter] and immediately arrested the two of them and took them downtown and booked them.

Now this was in the privacy of his own bedroom, and I emphasize that quite strongly because at a national level the people who try to organize around gay rights issues . . . were looking for exactly the right case to take up to the Supreme Court on this issue of whether or not the privacy rights that can be found in the Constitution extend to gays and lesbians. And they thought this was a terrific case because here was . . . a man arrested in his *own* bedroom in his own home. I mean as many people who have talked about the case have said, it is not a question of what Michael Hardwick was doing in his bedroom, it's a question of what the state of Georgia was doing in Michael Hardwick's bedroom.

Larry Tribe, a law professor at the Harvard Law School, handled the case, at oral argument, before the Supreme Court. The ACLU was involved in [the case] originally. And Lambda Legal Defense, a national gay rights organization which I've been on the board of for about eight years now, was also very actively involved in the case. It went up to the Supreme Court in 1986 and the ruling was 5 to 4 in favor of the State of Georgia. They ruled in favor of the Attorney General Michael Bowers (I love this case—I'm from the state of Georgia, so I have great connections with this case. I went to law school in the state of Georgia.) I read the briefs in this case, especially the one written by Michael Bowers who said, "yes sodomy law is very, very serious in the state of Georgia, and I intend to go out and knock on people's doors and enforce this law." It was pretty frightening to read the briefs. . . . You knew exactly how [the Supreme Court was] going to vote. Well if you were me, you knew how they were going to vote when you saw that White wrote the majority opinion. But even if you didn't have any predisposition to know how Justice White was going to rule in that case, the lead-in sentence was: "The Constitution gives no protection to homosexual sodomy." The right in his mind was whether someone had the right to commit homosexual sodomy, not whether someone had the right to make choices about their personal sex life in the privacy of their own home. So, we lost on that particular attack dealing with homosexual sodomy.

Now, why bother to attack homosexual sodomy? The laws rarely are enforced despite what Michael Bowers says he wants to do in the state of Georgia, so that people don't stand around and worry about the fact that someone is going to come in and arrest them. The reason that the legal community wanted to fight so hard to get the Constitution

applied to a case of homosexual sodomy as a criminal statute and get it knocked down, is because that criminal status is used against us, is argued against us in so many other contexts.

A good friend of mine who practices law in Tennessee told me of representing a lesbian mother trying to get custody of her children, and the lawyer on the other side got up and said something like, "Well, your honor, this woman is a criminal in this very state. How can you give these children to a criminal?"

So the very status of being identified as a criminal because of these intimate decisions about your life can be used against you in many other aspects of your life. It's not just about the right to commit sodomy in your own bedroom as Justice White [suggested]. And even if it were, the privacy rules of the Constitution should have applied. . . . While nobody that I know is now fighting to bring another sodomy challenge before this Supreme Court, I will tell you there have been a number of challenges in the state courts. There have in fact been three successful challenges over the past few years—the state of Kentucky, the state of Michigan, and most recently the state of Texas, which of course is also very dear to me having been there since 1974. None of these are final decisions by the top Supreme Court in that state. They are interim decisions under the state constitution, which for example in Texas has a very explicit right of privacy provision. . . . In fact, two trial level judges, one in Austin and one in Dallas, have ruled that the sodomy statute of Texas is unconstitutional under the state constitution. That case is on appeal right now. The interesting thing in Texas is that the attorney general of Texas in deciding to continue the appeal (after all he has got to represent this state, and that includes taking the state criminal law all the way to the Supreme Court of Texas to see whether it is valid or not) actually met with leaders of the gay community to talk to them about the fact that he wanted to continue the appeal. But, he wanted to let them know that he did not intend to make outrageous arguments in his brief, such as citing *Leviticus* as though that were binding on the state of Texas. He also of course met with Christian fundamentalists on the other side as well, and they begged him to make these arguments. But, he said that he did not think, in view of the separation of church and state in this country, . . . that was appropriate and he was not going to make that kind of appeal. Well, that's where we are right now, on trying to litigate about individual privacy, individual dignity.

The second type of harm is still a very individual harm, even though we are talking about denial of benefits in a public place. As someone over here talked about: [if] I say I'm a lesbian, maybe my employer will fire me or maybe I won't get the job. Well that is a discrimination against me individually in the public sphere. We have a lot of legislation that

protects racial minorities and persons who are discriminated against on the basis of sex; Title VII, for example, under federal law. A lot of states also have anti-discrimination laws. As to sexual orientation, Laura [the student who introduced the speakers] told you there are five states that have statewide anti-discrimination laws that will protect me because of my sexual orientation in my employment choices, in my housing choices, in my credit choices. The theory behind these statutes is what I want to talk about. The theory of equality, equal access to the public sphere, equal access to housing, equal access to education.

Equal protection is a concept that is also in our Constitution. The Fourteenth Amendment says no state shall deny any person equal protection of the laws. Now it says, no *state* shall deny equal protection of the laws, it doesn't say that no person, no private employer shall deny a person equal protection of the laws. So the concept of equality insofar as it is in our Constitution tells states how they have to treat individuals, but it doesn't tell private persons how they have to treat each other. The equal protection arguments that are being litigated right now are of course running into trouble because of *Bowers vs. Hardwick*. I'll get into that in a minute, but there is only one category of employer that can be sued under the equal protection clause of the Fourteenth Amendment, and that is a state employer. Now who is the most discriminatory state or governmental employer when it comes to gays or lesbians? The military. So what we have are whole series of cases that are litigated . . . in the context of the military. And so far we haven't met a lot of success on those fronts either. Although, I want to tell you about two recent cases.

There is the *Steffan* case. Joe Steffan was a young man who was kicked out of the Naval Academy shortly before he was about to graduate because when his commanding officer called him in and asked him whether or not he was homosexual, he said yes, he was, and that's grounds not to get his diploma, much less get his commission. So he was kicked out of the Naval Academy and he challenged that on equal protection grounds. If you have read any press on this case, this is the famous case where the judge at trial level called him a "homo" in the process of the trial. The lawyers on Steffan's behalf tried to get the judge to recuse himself. They said this was evidence of prejudice, calling someone a "homo." And he said, "It just means homosexual, that's all it means. I didn't *mean* anything by it, I don't care how he heard it.". . . [The judge] also originally dismissed the case saying that there was no claim that could be pursued because, after all, the class "homosexuals" is defined by conduct, not by status. And, we have a ruling from the Supreme Court that the conduct can be criminalized by the state. Well, my goodness, if the conduct by which you are identified can be criminalized by a state, how can there be *any* Constitutional protection

for homosexuals? And this is why we've gotten arguments now about whether or not sexual orientation is a status or a conduct. We can argue it is not conduct. If it is only status, maybe we can get around *Bowers vs. Hardwick* which after all is only about conduct. Well, it's a very lawyer-like type of argument; you know, it's like I am this but I don't do that. I always say as an existentialist I have a lot of trouble with this because I think of the phrase by Jean Paul Sartre, "I am the sum of my actions," and I truly believe that. Of course I am the sum of *all* of my actions, not just the sex that I do. But nonetheless, the status/conduct distinction, even though it is argued by lawyers, seems to me to get us very little. I have the right perhaps to say "I am a lesbian" so long as I also say, "but I never engage in the conduct that most lesbians engage in." [laughter] Some right, huh? [laughter] So the judge knocked Steffan's claim out. It went up to the D.C. Circuit Court of Appeals. The D.C. Circuit Court of Appeals said, well we're willing to make the conduct/status distinction, so we'll send it back down to the judge and let him reconsider now whether the Navy has the right to discriminate on the basis of sexual orientation. And, about three or four weeks ago we got the ruling from the district judge who said, "Well of course the Navy has the right to discriminate on the basis of sexual orientation. Why? Because we are talking about people in the military. And we have really got to be careful about the people in the military. For one thing, we don't want them to have AIDS. So, we know that homosexuals have AIDS and they're more likely to pass it to other homosexuals, so if we open up the military". . . Now the interesting thing is none of the lawyers made this argument, none of the lawyers. Certainly not the lawyers for Steffan, and clearly not the lawyers from the other side. This was the judge's way of deciding that the discrimination, the decision to bar all homosexuals from the military, was justified.

Now we had another argument too. I love to tell this argument—it's a shower argument. The military is full of shower arguments.[laughter] It's why women can't go into combat, because they would have to take showers with the men as well as you know [be in] foxholes with them. But, the shower argument in [the] *Steffan* [case] goes like this: If we allow homosexual men into the military, they would have to take showers with straight men, and all of the straight men would then be standing around in the shower saying, "Oh my God, someone may be considering me a sexual object." [laughter] We all know this is very uncomfortable. I'm not sure how many men know, but I think we who are women have been made sexual objects for a long while; we certainly know that's uncomfortable. [laughter] But because of [the showers] it is justifiable to keep [out] all gays and lesbians, and I thought, well, why don't they just buy some shower curtains? [laughter] In essence the judge in the *Steffan* case, (now this is on appeal to the D.C. Circuit Court of Appeals),

is saying, because of society's prejudice, because of men who are prejudiced against homosexuals or *fear* them because of their homophobia, because of our assumptions about homosexuals and AIDS, because of society's prejudice, that's a good enough reason to keep all homosexuals out of the military. And indeed that is consistent with *Bowers vs. Hardwick*. The Supreme Court actually said that the state of Georgia could criminalize homosexual contact. Why? Because it had been a moral concern for six millennia of Judeo-Christian heritage. In other words, their moral vision about what should be is sufficient reason to criminalize those who are engaged in the prohibitive behavior. So . . . the Supreme Court gave the lower court judge in the *Steffan* case a right to say that society's prejudice was sufficient grounds to keep all homosexuals out of the military.

And the other military case dealing with the argument about equality is a case called *Pruitt* that was just decided by the Ninth Circuit. . . . Dusty Pruitt is a lesbian who was in the Army and was also a minister. She was interviewed by the Los Angeles press about how she could reconcile all these parts of her life—her lesbianism, her religion, her ministry, and being in the Army—a very complex set of concerns to try to reconcile. She gave an interview to the press, it was printed in the *L.A. Times*, and she was immediately discharged from the Army. The case was originally brought on First Amendment grounds, that is the freedom to speak and talk to the press. But the Ninth Circuit didn't buy that as a justifiable ground. They did buy the equal protection argument. And they said despite *Bowers vs. Hardwick*, we think the Army has to prove why it is reasonable to discriminate against people based on their sexual orientation. And citing another case, an earlier Supreme Court case that dealt with a race discrimination issue, the Ninth Circuit has said, furthermore we don't think it is sufficient to take society's prejudice as the only justification. So the Ninth Circuit has remanded the case. . . . This means the case goes back down to the district level, the trial court, with the Ninth Circuit Court of Appeals' direction: What they're actually saying is: okay Army, we want you to go to trial and we want you to prove in trial why your discrimination is reasonable. We don't just assume it is, and the fact that there is prejudice in our society does not make it reasonable. I am really looking forward to that trial. I think this could be a major breakthrough for the issue of equality in the armed services. If you've kept up with this in the newspapers you know that every single study that has been done has shown that gays and lesbians serve in the military, they serve well in the military, they are not subject to blackmail and all of these other kinds of stereotypical assumptions about them that have cropped up over the years, and there really is an interesting question about why it is that the Army wants to kick all homosexuals out. And, if it is about the showers, then they ought to

get shower curtains. [laughter]

The final area, and this I think is really the most serious area for gays and lesbians, is the right to form family relationships. That is one way that we are clearly discriminated against, even if we have all [sorts of] civil rights protection, even if you had your anti-discrimination policy here at UNI, even if the legislature of the state of Iowa makes Iowa the sixth state to have a civil rights law protecting gays and lesbians. These laws only protect me in my individual capacity in terms of getting a job, in terms of getting housing, or public benefits.

What I want, and not all gays, lesbians, or bisexuals may want this, but what I want is recognition and legal protection for my family choice. I'd like to get married. That's a very non-feminist thing to say. Jean and I have this ongoing debate with the radical feminists who are our good friends throughout the country who think it's heresy to ever say that you want to get married, [laughter] but I say let us get married and we'll show you what we can do to the institution of marriage. [laughter] It will become a newer, finer, more equal [institution]—I mean, if you get rid of the gender imbalance in marriage, you've gotten rid of what I think the main problem is. I've gotten rid of that already, of course. [laughter] What I would like doesn't have to be marriage so much as it has to be legal recognition of my relationship. We don't even have that. If I were to die tomorrow . . . I've written a will, so I can take care of that problem, but Jean is not my intestate heir. If I were to get very sick tomorrow, of course I've written a durable power of attorney for health care [in Texas], to take care of her, yet that might not be good in Iowa, but I'll get around to it Jean. If we were married, if anything happened to me, she, as my spouse, would have certain standing to talk to the hospital, to talk to the doctors, etc. I can't tell you how many young men in Austin, Texas, dying of AIDS have had to go in and arrange to contract in advance for their own funerals because the funeral homes in Austin will not recognize the wishes of their lovers. They won't recognize the wishes of the individual. Your family members have standing to decide what happens to you after death, and your intimate relationship does not have that kind of standing. So it's about very important personal choices that I would like to have that kind of recognition.

Well, as to gay marriage, we have litigated that one, too, over the years and we have never won one of those cases. The most recent gay marriage case was just litigated in Washington, D.C. Washington, D.C. is the sixth state or sixth jurisdiction to have an anti-discrimination policy that includes gays and lesbians, so it is against the law for the District of Columbia to discriminate on the basis of sexual orientation. Two young men went in and asked for a marriage license and were refused, so they brought suit saying that was discrimination on the basis of sexual orientation and their claim was violation of the anti-discrimination law.

The judge in that case just ruled against them on various grounds, but here is the one I love. Back to sodomy again. . . . The judge ruled: to be married there is a requirement in the law that you consummate the marriage, but there is a sodomy statute for gays and lesbians, so how are they going to consummate the marriage without breaking the law? Therefore we can't have a marriage law that was meant to include people who are forced to commit this criminal act. You got it? Now, the *law* prohibits even consensual sodomy, which was exactly what was the case in *Bowers vs. Hardwick*—consenting adults, I mean what consenting adults do in private is criminalized. I don't think it has been enforced in the District of Columbia. They don't have a Michael Bowers who is out knocking on doors. So that's the latest attempt at marriage.

However, my favorite case is not exactly a challenge to marriage, but is a challenge to the *Bowers vs. Hardwick* decision again. This case, too, arises in Georgia. This case, too, involves Michael Bowers, who is still the Attorney General of Georgia, and I've got the complaint actually with me, so I have to tell you these facts. They are absolutely wonderful.

The case involves a young woman who is a recent graduate of law school in the state of Georgia, Emory Law School. Her name is Robin Shahar. She engaged in a Jewish marriage with her long-term lesbian lover just last summer. They changed their name to Shahar. They each had different last names, and they changed to the same name, Shahar, which means the act of seeking God, and some of the facts alleged in the complaint are:

> On July 28, 1991, a distinguished Rabbi performed a Jewish marriage ceremony in Hebrew and English for plaintiff and her partner of 4½ years who are both of the Jewish faith. It is this event that precipitated the plaintiff's loss of her employment in violation of the plaintiff's fundamental constitutional rights. They had in the prior year before their marriage, met with the Rabbi to plan the marriage ceremony and to talk about their spiritual commitment to each other and why they were going to have this ceremony. As to plaintiff's hiring and firing, plaintiff began her legal studies at Emory University School of Law in 1988. She had attended Tufts University as an undergraduate, graduated Magna Cum Laude and was a member of Phi Beta Kappa. During the summer of 1990 after a second year of law school, plaintiff worked as a summer law clerk for the Georgia Department of Law, that is for the Attorney General of Georgia. Plaintiff's summer work for the Department of Law led to a permanent job offer. By letter of September 19, 1990, defendant, Michael Bowers, informed plaintiff that 'my staff and I were very pleased with your performance this summer, and we offer you the following salary,' etc. By letter dated November 4 plaintiff accepted the offer. She then got an acceptance of her acceptance (they were

very formal about this, with a full written record of all the correspondence). On or about June 11, 1991, (this is after she has graduated and shortly before her wedding, but after she had changed her name), she telephoned Bob Coleman who was an assistant Attorney General that she was going to be working for, and she called him just to check in and to let him know that she had a new last name because she thought it should show up on her employment records, and she explained why she had a new last name. On July 9, 1991, plaintiff received a call from Coleman's secretary asking her to come meet with him. When she arrived he handed her the following letter signed by Michael Bowers:

"I regret to inform you that I must withdraw the State Law Department's offer of employment which was made to you in the fall of 1990 which was to commence on September 23, 1991, to serve at my pleasure (that's the general way one serves the state, at its pleasure [laughter]). This action has become necessary in light of information which has only recently come to my attention relating to a purported marriage between you and another woman. As the chief legal officer of this state, inaction on my part would constitute tacit approval of this purported marriage and jeopardize the proper functioning of this office.

Sincerely,"

So, she is filing suit with the help of the ACLU and Lambda and several other groups. The claim is violation of her religious liberty. She is being punished (losing her job is a punishment), because of her religious beliefs and her desire to enter into a religious ceremony, which she did. She is making an equal protection claim, that she is being denied this job because she is a lesbian, and she is making a claim based on the freedom of association—that is, she has the right to engage in this intimate association and not be punished for it, and not lose her job for it. Now this is a very interesting case to me because it brings together the public arena [employment concerns] and this concern about recognizing my relationship—all of it's right there in the same case. Michael Bowers gave this to us. It also implicates the *Bowers vs. Hardwick* decision because Bowers says: "as the chief legal officer of this state, inaction on my part would constitute tacit approval of this purported marriage and jeopardize the proper functioning of this office." Because she was going to work in the criminal division and we are talking about criminal law. He is assuming, of course, just because she is married, that she is breaking the law. There is an interesting kind of invasion of privacy assumption there. But, it's because of the sodomy law of the state of Georgia that he is firing her. Now I don't know if this is the case to overrule *Bowers vs. Hardwick*, but if I had to pick a case to go to the Supreme Court on this issue, this is one of the better cases I could pick. So I want to say thank you, Michael Bowers. I am

sorry for Robin Shahar's pain, but, my God, if she doesn't win this case, then we all are in trouble. Thank you.

This text was transcribed from a videotape of Cain's extemporaneous speech and is used with her permission. The editors and Cain made some deletions and changes to enhance the clarity of the extemporaneous comments.

Responses to the Speech

The audience was largely comprised of students enrolled in a class on gay and lesbian studies and others associated with the sponsoring groups. The event, however, was well publicized and also attracted other students, faculty, and members of the surrounding community.

The audible responses to Cain's irony and wit indicated a receptive mood. More telling were the perceptive comments and questions raised after the speech in a question and answer session. These indicated an appreciation of the speaker's message, and a personal identification with the speaker.

The editors distributed a written survey to a random selection of men and women in the audience. Several respondents commented that the speech gave them a more precise and factual understanding of points of law and legal practices. One woman wrote: "While the basic legal issues were not new—the specific details and examples were interesting and added to impact and understanding." Another appreciated the specific description of the *Bowers vs. Hardwick* case. And, another wrote: "Thanks for the *facts*! An issue this vital should indeed be addressed with well prepared arguments—as it has been tonight. Issues are so easily discredited by . . . unbacked emotional thunderstorms." Another member of the audience similarly commented that it was "refreshing" to hear a "legitimate scholar" discussing "this issue in a logical and rational manner supported by thought and concrete facts and not in the 'feel good self-help vein.' "

In answer to a survey question which asked whether the listeners' attitudes had been changed, most respondents indicated that they already agreed with the speakers' positions, but several wrote that they were now more resolved to act on their convictions. Typical comments were: "I was inspired"; others said their beliefs had been "strengthened" or "reinforced." The speakers evoked strong emotions in some listeners. A woman wrote: "[The speech] has angered me more. The facts presented have made me feel so outraged, I want to do more to reverse the present situation." A man responded: "I have been made to understand discrimination in a new and more personal way. I am angry!

I hope to find a way to fight this discrimination.''

Several respondents commented favorably on Pat Cain's manner and style. One listener described her as a ''powerful'' woman and an ''excellent role model for all women.'' Listeners commented on the speaker's humor, and one respondent found her ''forceful, credible, articulate, intimidating, challenging, friendly, . . . compelling.'' Another described her as ''brilliant.'' A faculty member called Cain an ''excellent speaker, warm, humorous. No sob stories. My students who were there were impressed.''

Eight months after the human rights campaign at UNI which included the public appearances by Cain and Love, the university president added protections based on sexual orientation to the UNI human rights policy statement.

Nina Totenberg

Background

Nina Totenberg has been the legal affairs correspondent for National
Public Radio since 1975. During that time she has covered the Watergate
trials, the Iran-Contra hearings, and the Bork nomination as well as
reporting on the daily work of the Supreme Court and congressional

judiciary committees. In 1987, she broke the story of Douglas Ginsburg's use of marijuana, which caused him to withdraw as a Supreme Court nominee. She has been involved in controversy several times for refusing to disclose her sources, including an occasion in 1977 when she reported Supreme Court Justices' predispositions toward the appeals of Watergate conspirators. On October 6, 1991, Totenberg read to an estimated nine million NPR listeners portions of Anita Hill's affidavit to the Senate Judiciary Committee alleging sexual harassment against Supreme Court nominee Clarence Thomas. This disclosure of the affidavit itself and attendant details uncovered by Totenberg forced the committee to conduct public hearings on the allegation. One analyst wrote that the disclosure and subsequent hearings "forever changed how American politicians think about women" (Bardach, 1992, p. 46).

Totenberg was criticized by some Thomas supporters for her disclosure and was attacked by several Republican senators—including Alan Simpson, who questioned her objectivity and journalistic ethics. Totenberg responded: "Nobody has disputed the truth or accuracy of my story, that a credible witness made a serious allegation to the Judiciary Committee that was largely not investigated" (Bardach, 1992, p. 50).

In response to this disclosure and suspicions that senators or their staffs had leaked this information for partisan purposes, the Senate empowered a special counsel to investigate leaks about its deliberations. The special counsel, Peter E. Fleming Jr., subpoenaed Totenberg and other journalists and demanded that they reveal the sources of their information. Refusal could entail a possible contempt of Congress conviction and a prison sentence. Totenberg's response was made to the special counsel in the Senate Hart Office Building, February 24, 1992.

Approach of the Speaker

Reflecting on her statement several months later, Totenberg said that she "thought about it quite a while." Although she "did not consider it a speech per se," she added, "I knew it had to have a rhetorical sound; I knew it would be quoted" (Jensen, 1992i).

Before writing the statement, Totenberg reviewed several Supreme Court decisions and Anthony Lewis's book Make No Law. She said of her frame of mind: "I felt the Senate had chosen a confrontation—and I wasn't going to dodge that bullet at all. I was going to wear it as a badge of honor—and make them face it. . . . [I felt this] embodied the whole question of freedom of the press."

Totenberg actually wrote her statement while on vacation in the Caribbean, when she had "time to think." She began from a few basic facts that her attorney, Floyd Abrams, advised must be included. She

then "sat down and wrote it out in longhand." She remembers: "It was not difficult for me to write. It poured right out in an hour or two." Her text was then faxed back and forth to Abrams, who made very minor changes—essentially adding one sentence.

She subsequently "ran it by the powers that be at NPR." She found that some of them "didn't care for it; it wasn't the choice of words some of the bureaucrats at NPR would use, but I didn't care—they weren't going to jail."

Totenberg knew that her statement "had to have a zinger at the end," and from the earliest stages of considering her presentation, she always had an idea that she wanted to end with the Black quotation. She had attended Justice Black's funeral at which his words were read and remembers the irony of Richard Nixon and John Mitchell sitting in the front row. Totenberg said: "I forget a great deal, but this I would never forget. That image was stamped into my brain." She remembered that scene when she began thinking of her statement, and said of Black's words: "I may have [included them] more for me than anyone else" (Jensen, 1992i).

Statement before the Senate Special Independent Counsel

My name is Nina Totenberg. I have worked as Legal Affairs Correspondent for National Public Radio for 17 years. Prior to that I worked as a staff reporter for a variety of publications, including *New Times Magazine*, *The National Observer*, *Roll Call*, *The Peabody Times*, and the *Boston Record American*. In addition I have written articles for, among others, *The New York Times Magazine*, *The Harvard Law Review*, *The New York Times Book Review*, *New York Magazine*, *Parade Magazine* and *The Christian Science Monitor*, and I am a special correspondent for the "MacNeil-Lehrer News Hour." In total, I have been a reporter for 27 years, and have covered the Supreme Court for 23 years.

I began writing articles and broadcasts about Justice (then Judge) Clarence Thomas on June 27, 1991, the day Justice Thurgood Marshall announced his retirement. In the following months, I wrote and delivered dozens of broadcasts about Judge Thomas. I wrote analyses of his legal opinions, his speeches, his background. I wrote profiles. I wrote political analyses about the support for and opposition to his nomination. I supervised other staff reporters and free-lancers across the country who were sent out upon my request to gather information and conduct interviews.

I investigated Judge Thomas' background as thoroughly as I could,

probing everything from his boyhood to his tenure at the EEOC. And finally, I co-anchored the live NPR-PBS coverage of the first and second rounds of confirmation hearings on the nomination of Judge Thomas to the United States Supreme Court.

During the continuing process of covering the Thomas nomination, I obtained the contents of an affidavit filed by Professor Anita Hill with the Senate Judiciary Committee. At no time did I receive a copy of any FBI report with respect to the Thomas nomination. The affidavit charged Judge Thomas with sexual harassment of Ms. Hill during the time when Hill worked for Thomas at the U.S. Department of Education and the EEOC.

I obtained the contents of the affidavit as a result of my unequivocal promise that I would not disclose the identity of my source or sources.

On October 6, 1991, after interviewing Professor Hill and after speaking with a wide variety of other sources, I broadcast a report detailing Hill's charges. My report also included an account of how the Judiciary Committee had handled those charges.

Within the next day or two, I destroyed all notes, copies of documents, phone logs, or anything else that might lead to the identification of the source or sources of my story.

I appear here today under subpoena, notwithstanding that my attorney clearly informed the Special Counsel that I will not under any circumstances cooperate in this investigation. The reasons are threefold. First, and perhaps least important from any legal perspective, is a matter of personal honor. I gave my word, and I will not break it. The second is a matter of professional principle. Journalists must be able to promise confidentiality to their sources. When they do so, they should keep their word. The third, and by far most important, is the first principle of the Bill of Rights—the First Amendment to the Constitution.

I find myself a bit embarrassed to be wrapping myself so totally in the grandeur of the First Amendment. At the same time, I believe this is exactly the kind of situation the Founding Fathers had in mind when they wrote the First Amendment.

At the beginning of our Republic, in 1798, one party, the Federalists, sought to silence its critics in the upcoming election by making it a crime punishable by up to two years in prison and a fine of $2,000 to "write, print, utter or publish" any material that would bring government officials into "contempt or disrepute." (See A. Lewis, *Make No Law*, 1991.) Under the Sedition Act, editors and publishers of opposing Republican party papers were jailed and fined. But many of our most famous Founding Fathers were outraged by the Act—James Madison and Thomas Jefferson called it a blatant violation of the First Amendment. Jefferson, after being elected President, pardoned those convicted under the act and within less than a half century the law (which lasted only three years)

was in such disrepute that Congress paid back many of the fines that had been imposed under it. In 1964, the Sedition Act was, at long last, held unconstitutional.

I suspect that Congress may one day look back on these press subpoenas with equal disdain.

The revelation that triggered the renewed Thomas hearings may have been an embarrassment. But that's all it was. It was not a crime. It was a story of how the confirmation system was working or not working depending on your point of view. If you believe that Judge Thomas was a decent man, unfairly maligned by the charges leveled by Professor Hill, then he was perhaps the victim of a politically inspired leak. If you believe that Professor Hill's charges were accurate or even that they were initially insufficiently investigated by the Senate, you may view the person or persons who helped me as whistleblowers. But in either case, it is the duty of the press to report legitimate stories—to pursue them, to check their accuracy, and then to report them without fear or favor. Thus is public deception avoided and robust debate promoted. No one has disputed the legitimacy or basic truth of my story. Indeed, the story seemed to have had enough merit that the Senate felt compelled to hold a second round of hearings to explore the charges.

To subpoena reporters—and thus to threaten them with prison—in order to force disclosure of their sources, is, I think, very much akin to the Sedition Act of 1798. The similarity may well be wholly unintended, but the threat to press freedom and public knowledge is all too real.

I will not be a party to this effort, even if it costs me my liberty. That is not First Amendment flag-waving. I'm no braver than the next. But my job would not be worth having, and a free press would no longer be free, were I to help you. And thus I respectfully decline.

I began covering the Supreme Court in 1968. In the 23 years since then, I have covered a lot of momentous decisions. But as I prepared for this appearance, I remembered most the words of the late Justice Hugo Black of Alabama in the Pentagon Papers case—words that would be his last as a Justice of the Supreme Court, words that at his instruction were read shortly afterward at his funeral:

> The press was protected [in the First Amendment] so that it could bare the secrets of Government and inform the people. Only a free and unrestrained press can effectively expose deception in Government and paramount among the responsibilities of a free press is the duty to prevent any part of the Government from deceiving the people. . . .

This text was distributed to member stations by the NPR Public Information Director and is used with permission from Nina Totenberg.

Responses to the Statement

The audience present to hear Totenberg's statement was small because
Fleming had rejected Abrams's request that the proceedings be open to
the public and press (Wilner, 1992). According to Totenberg, there was
no immediate response from the special counsel nor from the other
attorneys who comprised her immediate audience (Jensen, 1992c).
However, her refusal to reveal her sources prompted a later response
from Mr. Fleming. On March 16, 1992, he issued subpoenas to the
Chesapeake and Potomac Telephone Company for the home telephone
records of long-distance calls by Totenberg and Newsday reporter
Timothy Phelps, as well as records of calls from NPR and Newsday's
Washington bureau during the period of September 23 to October 6,
1991. Enforcement of these subpoenas was delayed—pending approval
of the Senate Rules and Administration Committee. Senator Daniel
Patrick Moynihan, a member of that committee, objected to Mr.
Fleming's tactics and promised "blood on the walls of the committee
room" if the investigation into reporters' sources was pursued. On March
25, 1992, the special counsel's actions against Totenberg and Phelps
ended when chairman Wendell Ford and ranking Republican Ted
Stevens of the Senate Rules and Administration Committee upheld the
journalists' objections. One of Totenberg's colleagues wrote of the
episode: "The press should write it on the wall as an axiom: The more
embarrassed public officials become about their own flawed
performances, the sooner they will look for ways to blame the press.
That usually isn't a problem—until the officials try to use the law to
place the blame" (Denniston, 1992, p. 55).

June E. Osborn

Background

The 104th session of the Iowa Academy of Science convened in Cedar Falls, Iowa, April 24, 1992. Dr. June E. Osborn, Chair of the United States National Commission on AIDS and Dean of the School of Public Health at the University of Michigan, opened the session as keynote speaker.

She spoke at the University of Northern Iowa student union to four hundred science educators from Iowa and around the nation.

Approach of the Speaker

Osborn granted interviews to local media and the editor (DeFrancisco, 1992c) just prior to her speech. She said she writes her own speeches and prefers to give them extemporaneously; however, the large amount of factual information about AIDS requires manuscript speaking. Osborn is overwhelmed with invitations to speak. She estimates that she accepts approximately one in twenty invitations. Osborn felt it was important to accept this speaking engagement because of the potential assistance these scientists could provide in the search for effective medical treatment of AIDS.

When asked how she might adjust her speech for the scientific professionals in the audience, Osborn responded that she would give them the same general message she gives to laypeople. She explained that laypeople and medical professionals simply have not thought enough about AIDS. Osborn said her main goal in the speech was to confront the overwhelming denial mechanisms people seem to have about AIDS. This approach reflects the larger goal of her work, as described by Alvin Novick, a professor of biology at Yale University: "The special thing about June is that from the earliest days of the AIDS epidemic she reached out to become involved—initially as a scientist and then as a person who catalyzed the interest of others. More than anyone else who is medically involved, she has come to speak respectfully of the vulnerable and of their needs. To a realm of horror, June has brought not just professional competence, but kindness" (Levin, 1992, p. 1H).

"The Second Decade of AIDS"

I am pleased and honored to be with you today to celebrate the 104th anniversary of the Iowa Academy of Science. I have great ambitions for our brief time together, which include an update on the AIDS epidemic, prognostication for its future, and some commentary on our performance thus far. Above all, I would like to leave with such a thoughtful and distinguished audience a sense of concern—an awareness that, for all our fruitful commitment to science, we are not doing well at mobilizing what we know to deal with the greatest health crisis of our time. I'll get back to that much later, but I hope you will

listen to my other comments with that worry very much in mind, for if the best and brightest of our nation's educated people don't respond soon, we will have lost a brief and unprecedented moment in human history when we not only could have saved lives and talent but also could have validated our commitment to learning and to science.

Before I get to that, however, I must make sure we are all starting from the same baseline of information. We are grappling with a newly pandemic virus that spread around the globe rapidly in the decade of the seventies. It is almost certainly not a new virus, but rather one that had led a tenuous survival existence in isolated human enclaves until the combination of urbanization and travel gave it the capacity to explode into a pandemic.

Exactly when that explosion began is speculative; the earliest recorded instance of antibody to the virus in a single human serum specimen dates from 1959, but prior to the 1970s it was essentially absent from those human populations in which it then began its rapid spread around the globe. One of the most complex properties of the human immunodeficiency virus, as it is now called, is that, while antibody specific to the virus appears soon after infection, there is a prolonged interval of clinical "silence." In fact, in most HIV-infected people, no telltale indicator of disease occurs until many years later— indeed, the average interval is ten to eleven years between acquisition of the viral infection and onset of recognizable symptoms.

Two points are worthy of note here: first, those people now becoming ill with HIV and AIDS were, in general, infected before we even knew there was an epidemic agent out there; and second, throughout the decade leading up to our first awareness of what we now call AIDS, in effect the virus had a ten-year running head start.

For those of us caught up in the epidemic, the years since the early 1980s have been so strenuous that it is difficult to keep in mind how new all this AIDS business is, at least when measured against evolutionary time. In fact, it was not quite eleven years ago—in the summer of 1981—that physicians first reported a few clustered cases of unusual infections and tumors that had occurred on either coast of the United States. Initially the new syndrome was recognized solely in gay men with multiple sexual partners. In the year that followed it became evident that injection drug use and heterosexual as well as homosexual sex constituted significant risk behaviors that could spread the virus, and that similar cases were appearing all around the world.

By 1983, as recognition of special risk for people with severe hemophilia, transfusion recipients and infants born to infected mothers accrued, scientists were hot on the trail of the causative virus. And it was less than nine years ago that the novel but deadly syndrome was finally given a durable name—the acquired immune deficiency

syndrome or AIDS—reflecting the common feature of immune devastation caused by what was soon isolated and identified as a newly epidemic retrovirus. It was an exhilarating, dreadful time to be a scientist, for the tools were there to analyze what was happening and to guide society's response, as they had never been before in comparable historic pandemics.

In the first year or so of the epidemic, these events were little noted, other than a bit of censorious journalistic coverage of extreme gay lifestyles—except by those of us in the infectious disease community who had been worrying for some years about the rampaging sexually transmitted disease epidemic that had been underway in the United States. We shuddered at the possibility that a new disease might be at hand, but initially we tried to be more rational and turned to familiar agents or hypotheses of microbial synergism or toxic/environmental factors to explain the unusual events. Thus, for a brief while, AIDS was only a small cloud on the horizon, but its ominous shadow expanded swiftly. For those of you who are Tolkien enthusiasts, it was as if the Nazgul had swept out of the Dark Tower and were flying high above the plain, shrieking their chilling threats of death and misery.

But as the numbers of cases grew inexorably, and as epidemiologists and scientists began their marathon efforts to cope with what would indeed become a world-class epidemic, it became clear that we were in the grips of a great new event in human ecology—a new infectious disease was in our midst, and it seemed not to have the tractable properties of Legionnaire's disease or toxic shock syndrome. The forgotten language of epidemics and contagion and modes of transmission was revisited and revived.

I guess it should not have been surprising that the response of the public was remarkably atavistic. What had been an unjustified comfort level about infectious diseases was suddenly destroyed by the advent of something new, frightening, deadly, and sexually transmitted. Such a primitive response was probably the natural consequence of the hubris of preceding decades, but it was surprisingly refractory to reassurance; indeed, when the epidemic was finally noticed and named, public response was hostile, and the insistence on fear and rejection of the people who were ill was both dogged and misplaced.

All that is very sad, for it obscured the remarkable early success of the epidemiologists in understanding the limited modes of spread of the new virus. We were, in fact, very lucky; had the newly pandemic virus that lay at the base of all this trouble turned out to be highly contagious, like measles, for instance, there would have been little time to react; and containment efforts would have been vastly disruptive.

Happily—and this is the only good news I'm going to give you— the human immunodeficiency virus, as it is now called, is .very

inefficiently transmitted (except by injection of substantial quantities of blood). That merciful property emerged very early, and yet as scientists raced with remarkable success to supply insight and knowledge about the new syndrome called AIDS, it was a matter of their deep frustration that fear raged unrelentingly in the face of increasingly firm fact. Discrimination against people caught in the path of the newly epidemic virus interfered with even the most fundamental efforts to describe, to prevent and to treat diseases that it spawned.

It was soon evident that the virus of AIDS could not be casually acquired: only sex or blood or injecting drug use or birth to an infected mother could spread the virus. Hundreds of loving family members who had cared for dying sons and daughters for months without precautions— sharing toothbrushes and razors, kisses and tears—were checked and double-checked once an antibody test became available to see whether they had put themselves at risk; and not a single one had become infected in the course of such sustained, intimate contact.

Yet public assertions of that dramatic and reassuring finding fell on deaf ears. Just as had happened with the black plague in medieval times in Europe or the nineteenth century rampages of yellow fever in the United States, the collective response to AIDS was to stigmatize, to marginalize and to cordon off people ill with the new disease. To make matters much worse, many of those caught in the first wave of infection were marginalized already. It was a tragic irony that, for the first time in human history, we were armed and ready to cope with a new pathogen, through our science, and yet seemed impotent to take advantage of our insights. Instead, the public was insistent on the right to panic.

It is easy to feel discouraged ten years later, since so many of those awful reactions are still with us. But it really has been a short time as such things go—and the magnitude of what has happened, the sharp upward slant of the curve of people becoming ill, the inexorable penetration of the epidemic into adolescent age groups—all those features should serve as an arresting reminder to us that this is no arcane fiction or history of somebody else's troubles. Rather, it is ours to cope with, to greater or lesser effect, in the interest of our children's children. It is like the day after Hiroshima. A new force has entered our world— in this case a biologic one rather than a physical one—and it will never again be gone. We know a lot that we can do to mitigate its effect, but we must overcome our country's denial and inertia, for it is getting very late!

As the National Commission on AIDS said, in its comprehensive report to the President and Congress in September of 1991:

The people of the United States have arrived at a crossroads in the history of the HIV epidemic. In the months to come they must either engage

seriously the issues and needs posed by this deadly disease or face relentless, expanding tragedy in the decades ahead. In just ten years the human immunodeficiency virus (HIV), the causative agent of AIDS, has claimed more American lives than did the Korean and Vietnam wars combined. If, from this day forward, there were never another instance of new infection, the upcoming decade would still certainly be much worse. The amount of human suffering and the number of deaths will be much greater.

That was the way we began our report, culminating two years of careful work and study. The commission had been mandated, in the congressional legislation that created it, to advise Congress and the President on issues and needs arising from the AIDS epidemic, and it had been our hope that the use of stirring rhetoric in the Executive Summary of the report would startle people into renewed awareness, attention and resolve.

Rhetoric shouldn't be necessary, of course, for as they say, the numbers should speak for themselves. As of now, after only one decade, nearly a quarter of a million young Americans have been diagnosed with AIDS and another million, at least, are already infected with HIV and approaching a time when they will need care for a slowly but ultimately lethal disease. At the time that report was written, there had been 120,000 deaths from AIDS in the United States, but we can predict with awful certainty that by the end of 1993 that number will leap to 350,000 deaths!

If one is the kind of person to whom numbers speak, then those awful statistics ought to shout! Nothing like this has happened since modern science took over, and if one realizes just how powerful that science has been—and how little advantage we have taken of the insights it has yielded—then the harsh cacophony of the tragedy is deafening!

But I am very much afraid that, for most people, numbers have a tendency to numb. Throughout the epidemic we have had to struggle against a ferocious tendency to categorize, to lump people into groups, and to dismiss the individual tragedies by a kind of class-action denial. Propaganda has had a lot to do with that. Talking about "those gays" or "drug addicts" in pejorative terms is something politicians felt comfortable with. Talking about sexual behavior, injecting behavior and adolescent risk is something our whole society is uncomfortable with. We have adopted a stance of "Just say no" in the face of the flagrant fact that such an approach does not work. And through lack of leadership—a strong central voice saying, "This is a big trouble, and we must reexamine our society's stances on fundamental issues that are putting our kids at risk"—the so-called issues of AIDS about which people have argued and legislated and litigated have been allowed to be trivial and peripheral, while the central themes to which we should attend go

unspoken.

Before I proceed, let me return to the commission's summary of where we stood as we faced the second decade of AIDS, and quote it at some length. After our opening warning that numbers would surely get much worse, we went on that:

> . . . The face of AIDS will change as well; thus far it has focused its devastation predominantly on young men. In addition, it is also a disease that affects an entire family—now, all too often, mothers, fathers, and children die swiftly, one following the other, leaving a few orphans as a grim reminder of what was once a family.

> Workers on the front lines are struggling heroically to cope with illness and death, but their tools have been too few, their resources too constrained, and their logistics too crippled by the sabotage of disbelief, prejudice, ignorance and fear.

> Nor has the virus followed rules of fair play. Gay and bisexual men still bear much of the burden of HIV disease. Disproportionately and increasingly the epidemic has attacked segments of society already at a disadvantage—communities of color, women and men grappling with poverty and drug use, and adolescents who have not been effectively warned of this new risk to their futures. And with these shifts have come new anger, mistrust, and attempts to assign blame, which have drowned out the warnings that should signal the magnitude of the mounting crisis. Sadly, this has permitted too many Americans to detach from the fray, to feel the problem is that of others different from themselves, and to retreat into resentful indifference. Diversity, which should be our greatest strength as a nation, has for the moment become a weakness, and has sanctioned a begrudging and sometimes callous response. Even the language of prevention, which should be tailored to the myriad subcultures and ethnicities of people at risk, is constrained in the name of morality, withholding potentially lifesaving information and devices in order to avoid offending a public presumed to be in agreement with such constraints.

> Astonishingly, even our most basic efforts to better understand and respond to this new plague have been hampered. Efforts have been made to constrain or forbid behavioral research; in the face of the most deadly sexually transmitted disease ever to confront humanity, some would prohibit even the study of the human behaviors that put our children at risk. Thus we disarm ourselves in the midst of lethal battle.

> Worst of all, the country has responded with indifference. It is as if the HIV crisis were a televised portrayal of someone else's troubles. It has even appeared relatively painless; many of the torments are hidden because so many people do their suffering and grieving in secret, out of fear of stigma, discrimination, or rejection. But the epidemic will not remain painless much longer even for the most indifferent observer; soon everyone will know someone who has died of AIDS. If we are to honor our fundamental social contract with our fellow citizens, with ourselves,

and with our children, we must somehow develop a sense of urgency. For there is little time left to recognize at a deep and fundamental level that the threat of HIV is all around us and that we must join in this battle for the sake of future generations.

. . . [Use of a military analogy is tempting] because Americans readily understand the need to mobilize rapidly for collective action in response to external threats to life. AIDS is a life-threatening disease of global proportions, and it requires the same national resolve and commitment to address it effectively that we exhibit in times of war.

But the military [mindset] does not work well in this crisis. In war, we tend to look for a human enemy to attack, and alas thus far this tendency has been all too evident in our response to HIV. But in confronting AIDS our response must be just the opposite. Compassion and concern for human suffering must direct our efforts. It is against the virus, not those infected, that this war must be waged. Tragically, to date, too many . . . have failed to understand this fundamental distinction or acknowledge what a massive national effort is needed to contain the epidemic.

The sapping of our collective strength comes from many directions. There has been a dominant undercurrent of hostility toward many people with HIV disease, as if they are somehow to blame. But no one gets this virus on purpose. We do not withhold compassion from people who suffer from other diseases related to behavior. As President Bush stated in his single speech about AIDS [in March of 1990], "Once disease strikes we don't blame those who are suffering. We don't spurn the accident victim who didn't wear a seat belt; we don't reject the cancer patient who didn't quit smoking. We try to love them and care for them and comfort them. [We don't punish them or evict them or cancel their health insurance.]" We must replace the innocent/guilty mindset with sympathy and care for people with HIV disease.

Our nation's leaders have not done well. In the past decade, the White House has rarely broken its silence on the topic of AIDS. Congress has shown leadership in developing critical legislation, but has often failed to provide adequate funding for AIDS programs. Articulate leadership guiding Americans toward a proper response to AIDS has been notably absent. We are accustomed to hearing from the "bully pulpit" about national problems and how we should address them, so perhaps the public cannot be blamed for assuming that such a silence means that nothing important is happening. Their false calm is reinforced by politicians who declare that enough has been done about AIDS since it is "just one disease," and that we should redirect our attention to other diseases that currently kill more people [failing to note the awful annual upswing of the curve of AIDS deaths].

But we cannot turn away from what is coming, lest we be blind-sided. . . . [I]n the absence of a national effort, the virus continues to spread. The cumulative deaths of the first ten years of AIDS will more than double

in the next two . . . [and] AIDS is already the leading cause of death for young men and women in many parts of the country and is climbing relentlessly up the list of causes of "years of potential life lost."

I have quoted at length from the commission's report in hopes that some of you will want to obtain a copy and learn more about our assessment and recommendations. In the remainder of this talk I want to make sure we are all starting at the same place with some fundamentals about the epidemic, look at trends that are beginning to make clear our problems in the second decade of AIDS, and then deal with some policy issues that require urgent attention.

The Facts About AIDS

What, then, are the things we know about AIDS? First, we know that the human immunodeficiency virus is a necessary—and in some clear instances a sufficient—condition to cause AIDS. We have tests as good as any in the biomedical armamentarium to detect its presence. The virus is transmitted by blood, sex, or birth to an infected mother. It is not transmitted any other way. It does not pose a risk to people who hug or kiss fondly or interact with each other in the workplace or schoolyard. It is not a hazard, in the usual measure of that word, in the health care setting. Indeed it is one-hundred-fold less likely to transmit in health settings than is hepatitis B, which virus has been totally blocked by the institution of universal precautions in 1987. So we need not panic or exhaust our resources on needless and aimless testing.

There are clear answers to the most pressing questions people might have about a new infectious agent: yes, you can get it from sex or injection. No, you cannot get it any other way!

Then people want to know about heterosexual spread. Sadly, they often want to hear that it is "rampant" in the heterosexual community, or in some community with which they identify, before they react and decide to care. But now we are talking about efficiency, about real risk at a variable level of risk—and I doubt, if they had a clear picture of what this new disease is, that very many people would really want to take any real chances with this virus, or let their kids do so, for AIDS is awful. To be sure, there are levels of efficiency of transmission with different varieties of sexual intercourse—unquestionably, anal sex is the most risky. I suspect that is true of heterosexual as well as homosexual anal sex, but we have not been allowed to study those kinds of things, and certainly we have not been allowed to warn about varieties of sexual behavior in explicit terms.

The risk of transmission through transfusion of blood and blood products was a dreadful feature of the early epidemic, up until 1985

when the capability to test blood for HIV antibodies dropped the risk nearly to zero. I should remember to reemphasize that, while infection with HIV is silent for as much as ten or eleven years clinically, antibody to the virus which is detected by blood screening appears at three months on the average after infection, and is reliably present by six months in the vast majority of HIV-infected people. Thus the combination of donor exclusion, unit exclusion and antibody testing has rendered the U.S. blood supply remarkably safe so far as HIV is concerned since 1985 for recipients of blood transfusions; and it was, of course, always safe for donors. Sadly, the safety of transfusion recipients remains a difficult problem in parts of the world where screening is unaffordable.

There are other things we know about HIV and AIDS. We know more about the virus and its pathogenesis than about any other infectious agent of man—and only eight years after its discovery! That fact is of particular interest, since it represents the payoff for several decades of investment in what seemed to be "basic research." If the work of the virologists and molecular biologists and immunologists had not proceeded apace in the sixties and seventies, we would not even know how to describe the immunologic deficit underlying the infections and tumors that characterize the acquired immune deficiency syndrome. Of course, none of that work was done with AIDS in mind—it couldn't have been, since AIDS was unknown. In fact, no retroviral infection of man was recognized until 1980, so the work most germane to HIV was extrapolated directly from animal model studies. What a stunning demonstration of the useful serendipity of science!

And we must take careful note of that now, for if one thing is sure, it is that AIDS won't be the last novel microorganism to beset mankind. The dynamism of disturbed ecology—both human and biospheric—is becoming ever more turbulent, and whatever we consider "basic" in our science today may become urgently fundamental tomorrow.

(Parenthetically, I have had the privilege for the last year of serving on a committee of the National Academy of Sciences and Institute of Medicine looking at Emerging Microbial Threats to Human Health. The report of that study will be available in a few months and should be of great interest to a broad array of thoughtful people; while the conclusions aren't firmed up or quotable yet, I assure you that they will underscore the importance of maintaining a pace of basic as well as applied science in anticipation of future microbial trouble.)

But back to my main thesis: our ability to tap preexisting knowledge to learn quickly about AIDS has paid off in ways that should have made the second decade of AIDS easier—and indeed they have for individuals who know how to tap into the system and can afford to do so. There are several antiviral drugs that have therapeutic effects, delaying significantly the progression of immunologic deficiency and its

manifestations. Careful clinical research and analysis of AIDS yielded the insight that *Pneumocystis carinii* pneumonia not only characterized the syndrome but played a dramatic role in its dire prognosis; and in the wake of that insight new ways of preventing that pneumonia through prophylaxis were devised. Other opportunistic infections have yielded to research efforts, and some of the tumors of AIDS are beginning to submit to better control.

These are not esoteric bits of progress. It used to be the case that a person, once diagnosed with AIDS, had only a slim chance of living out the year. Now it is not uncommon to have people live productive lives even after the diagnosis of AIDS for two, three or even five years—and remember, we haven't even had the virus in hand for eight years! It is in that context that people express the goal of turning HIV disease into a livable, chronic condition—quite analogous to juvenile diabetes. Cure is highly unlikely once infection is established—but that more realistic goal is yielding steadily to aggressive research efforts, and people with AIDS are benefiting with longer intervals of productive life.

Therefore you can perhaps understand the frustration one feels when the statement is made that we have "done enough AIDS research" and should turn our attention to other diseases. The progress has been rapid and promising; its results are almost directly pertinent to over a million young adults, and it is likely to be important for untold numbers of people not yet infected in this country if we do not do better at prevention. Around the world it is estimated conservatively that by the end of the decade there will be forty million people infected with HIV. And unlike any other major disease, it is dynamic, unstable and basically out of control. Can you imagine—those of you old enough to remember the summer polio epidemics—announcing in the midst of that ongoing crisis that "we've done enough about polio and should turn our attention elsewhere"?

While I am on the topic of biomedical progress, let me comment quickly about vaccine. There is progress toward an AIDS vaccine, but let me caution you about that, for it is not clear what we would do with such a vaccine if we had one—at least not in this country and not for many years. It is unlikely that any vaccine will reach the level of widespread usability in less than ten years; but even if we had the perfect vaccine in hand, it would only be an adjunct, a help to our present efforts. It will never replace the education for prevention by avoidance of risk that we must do already and have shied away from so tragically. There is no way out: we must learn to talk to our kids and be frank with ourselves about sex and drugs; if we do, not only AIDS but a remarkable number of other problems in this society may yield to inexpensive preventive intervention.

I know that I surprise people when I say that the best imaginable

vaccine wouldn't fix things, but there are several reasons for making that statement. First, even our best vaccines are only 90 percent to 95 percent effective, and those are against agents for which so-called herd immunity plays a role. Nothing in the present pipeline of candidate AIDS vaccines has anywhere near that level of immunogenicity.

Because our good vaccines are directed to rapidly transmitted, acute infectious diseases, the protective effect is realized swiftly and the epidemic abates, so that further exposure to wild virus in a vaccinated population drops rapidly after a vaccine campaign or systematic program. But our world is now laced with HIV, lurking quietly and durably. Those vaccines are also effective either empirically or by design because they mimic durable natural immune mechanisms. But with HIV there has yet to be demonstrated any durable protective immunity, so there is no nature to imitate. Finally, the distribution and utilization of even our finest vaccines is problematic—the resurgence of measles attests sadly to that fact in the past couple of years. I don't think a vaccine against a virus that is sexually transmitted would fare anywhere near so well—I think the same parents that currently object to sex education in the schools would boycott in droves any effort to immunize their kids in early adolescence against HIV. If you have trouble seeing what I mean, imagine what the compliance would be with a syphilis or gonorrhea vaccine. We are so busy denying that our kids are sexual beings that we seem very prone to, as the saying goes, cut off our nose to spite our face.

It is important to realize these things about vaccines so we do not get lazy in our present, potentially effective efforts at prevention. Every time a minor bit of progress in vaccine development is reported in the papers, one can almost hear the sigh of relief that suggests people think that the epidemic crisis will soon be over. But it won't. Vaccine will be extraordinarily important in parts of the world where the epidemic has already gotten far out of hand and where the focused warnings of prevention have been blunted beyond usability. But that is why I speak so urgently. For us, during the next decade, there is still a chance to avoid that scale of calamity with preventive education, and vaccine would only add to—not supplant—what must be done—so we must not let ourselves be becalmed by false hope of miraculous interventions.

What Other Facts Do We Know About AIDS?

There is much more promising news on the biomedical science front in the epidemic. Indeed, I think we are doing very well, in general, although there are far more worthy research proposals than funds to support them—which is tragic in such a dangerously unstable circumstance.

But there are other facts that should be brought out as well. For instance, the role of injection drug use in this epidemic is dramatic and constitutes a real "wild card" in what has otherwise been a remarkably accurate series of predictions about the dynamics of the epidemic. Whereas even sexual transmission of the virus is inefficient and submits to further decrease by use of condoms, limitation of sexual partners and other modes of knowledgeable avoidance, injection drug use is remarkably efficient. In every part of the world there have been examples of drug injecting populations where one year there were less than 1 percent infected and the next year 50 percent! Needle-sharing is the common vehicle.

That phenomenon was first illustrated along the East Coast of the United States in the late seventies and early eighties, but it has been repeated over and over. Whereas all our other epidemic projections have been accurate and almost eerily on target, we have done very poorly with the most volatile facet of our epidemic. We have declared a war on drugs with no accommodations for the prisoners of that war, for in no large city in the United States can a poor person get treatment for drug addiction with less than a four-week wait on a waiting list. And meanwhile, we cavil and argue about what we might seem to condone with needle-exchange programs or bleach instruction. Just look at what we are condoning instead!

The need to do better about the drug aspect of the epidemic is really urgent. In the summer of 1991 the commission issued a separate report entitled *The Twin Epidemics of Substance Use and HIV*, and I am pleased to say that it played a role in provoking reexamination of policy in this difficult area. But look how long we have waited! And most of our big cities are teetering on the edge of a volcano as their drug users are infected at the level of 5 percent or 10 percent and nothing is holding them back from escalating suddenly.

Projections and Policy Needs

Let me conclude with some projections for the second decade and some related policy issues that require urgent attention.

First in the area of health care: that is a hot topic these days, as you all know, and there is an occasional tendency to turn to the AIDS epidemic as a source of the problem. But let me quote again from the commission report:

> . . . in an important sense, the only thing new about our present quandary is the virus, . . . [in fact] most of what we are experiencing represents old problems that have been poorly patched and bandaged or ignored entirely. The HIV epidemic did not leave 37 million or more Americans without ways to finance their medical care—but it did dramatize their

plight. The HIV epidemic did not cause the problem of homelessness—but it has expanded it and made it more visible. The HIV epidemic did not cause collapse of the health care system—but it has accelerated the disintegration of our public hospitals and intensified their financing problems. The HIV epidemic did not directly augment problems of substance use—but it has made the need for drug treatment for all who request it a matter of urgent national priority. Rural health care, prison health care, access to health care for uninsured and underinsured working men and women—these issues and many more form the fabric of our concern.

So, without going into the details, let me point out the urgency of health care issues as this epidemic swells. I have already alluded many times to the need for intensified research endeavor, and I have tried to point out in several ways the foolishness of further prudery when it comes to preventive messages to help our children understand and protect themselves from risk. The projections are very real: we will need to care for a million young adults already infected, even if we didn't have any additional new infections! As a nation, we must pull together and stop the hatefulness.

Hubert Humphrey once said that the true test of a society was how it cared for those in the dawn of life, the children; in the twilight of life, the elderly; and in the shadows of life, the sick and the handicapped. It is our generation's fate to be sorely tested, and I hope with all my heart that it is not too late to generate an adequate response.

I want to close by reading one last bit from the commission report. Belinda Mason was one of two people appointed to the commission by President Bush in 1989 (the other ten voting members were appointed by Congress). At that time she was President of the National Association of People with AIDS—a beautiful, gentle and articulate woman who was as eloquent and wise as anyone I have known. At our first hearing in September 1989 Belinda agreed to change places briefly and be one of our witnesses; and when she was dying two years later she used some of her last energy to help extract from that testimony the part she most wanted us to remember. It is at the front of the Executive Summary and reads as follows:

> We must learn to practice the justice, freedoms and compassions that we take so much pride in talking about in civics classes and teaching our children about when we tell them what it is to be an American.

> Our response to AIDS must take into account how all people with AIDS and HIV live and recognize that we aren't all in San Francisco or New York using systems that are collapsing from the weight of us. Some of us are in Kentucky and Alabama and Missouri and Iowa still trying to find a doctor willing to treat us or a home care agency that will send the nurse without requiring a baseline antibody test for her. . . .

I have to say that people living with AIDS and HIV want nothing more or nothing less than what all of you take for granted today—a place to live, the right to have a job, decent medical care, and to live our lives out without unreasonable barriers. We are not asking for extras, only to be included in what America already delivers to her privileged people.

. . . But compassion is not going to happen because of a report that we make or an edict that somebody in Washington delivers. It will begin in the small towns in the quiet country throughout America when people understand that people living with AIDS and HIV are just like us because they are us.

This manuscript was provided by June E. Osborn and is used with her permission. The editors altered it slightly to include extemporaneous comments transcribed from tape.

Responses to the Speech

According to those surveyed at the event, Osborn accomplished her goal to educate the audience. The most common response was that the speaker had heightened awareness about the severity of the AIDS threat to the public. One person reflected: "I have [a] renewed sense of urgency [about] the importance of preventive education. Disgust and impatience with head-in-the-sand politics. Fund cuts are a step to catastrophe." Another said that Osborn helped increase awareness regarding future directions of the National Commission on AIDS.

Nearly all the respondents reacted to Osborn's concerns about insufficient support from the U.S. government. One of the more outspoken said: "I'm determined to get the Republicans out of the White House! They can't think clearly about health issues." Another commented in regard to the AIDS epidemic: "Our political leaders are less responsible than even I thought!"

Cheng Imm Tan

Background

Immigrants represent an important component of United States history in that they reflect a continuous process of cultures merging. Yet, the individual needs of immigrant groups have often been overlooked. Cheng Imm Tan, a United States immigrant from Malaysia, is one leader of the Asian American population who works to raise awareness of these people's needs and the prejudices they face.

An article she had written on Asian women and literacy caught the eye of organizers for the 1992 annual conference of the National Network of Women's Fund and they invited her to speak. NNWF is a coalition of women's organizations which supports (financially and otherwise) a variety of women's concerns. The conference enables members of funding groups to learn about current issues and needs of women across the country. The theme for the eighth annual conference was "Funding the Future: Creating Economic Independence for Women and Girls." The conference was held at the Hilton Hotel in St. Petersburg, Florida.

Cheng Imm Tan spoke April 25, 1992, at one of the concurrent workshops titled, "Women's Organizing for Freedom and Justice." The workshop description read: "Throughout history women have organized to empower their communities and create social change. This workshop will discuss the issues around which women are currently organizing and explore the strategies they are developing." Other speakers on the panel addressed the concerns of women from Haiti and women with disabilities.

Approach of the Speaker

Cheng Imm Tan's approach as a speaker is reflective of her way of life as a Buddhist Unitarian Universalist minister. She said she chose to be a community minister "rather than a parish minister" because she wanted to "work in and within the world" (Tan, 1992, p. 15). Tan has addressed violence against women and problems of Asian communities since 1982. She is director of the Asian Women's Project (working primarily with Cambodian, Vietnamese and Chinese women), chair of the Asian American Task Force Against Domestic Violence, and chair of the International Refugee Women's Coalition. Tan has presented workshops on domestic violence at refugee camps in Malaysia and Thailand, to groups in Boston where she has lived for 14 years, and across the United States.

Tan said her goals were clear for the NNWF conference. As the first speaker of the panel, she felt her role was to set the groundwork and tone for the talks which followed. She intended to educate representatives from funding organizations on the needs of Asian Americans, raising the question: "What are the cultural linguistic barriers this group has to face?" (DeFrancisco, 1993f). One of these barriers, she said, is the myth of Asian Americans as a "model minority." She described the myth as the predominant assumption in the United States that Asians are self-sufficient, and that they do not need help. The reality, she said, is that "most Asians aren't making it. . . . A few's success is held up [for public notice] and the rest are ignored."

Tan explained that the myth protects racist practices. Her goal was to unveil the myth.

She had only five to six minutes to speak and thus did not have the time to present the speech in its entirety. She said she rushed through the speech and had to summarize some of her prepared statement, which appears below.

Women's Fund Talk

I would like to start by telling you a story. This is the story of Sothi, a Cambodian refugee woman.

Sothi is a Cambodian woman who survived the disruption of war as well as violence in the home.

Sothi did not come from a rich or well known family. But life was good. She was married to a man who treated her well and they had a son together. They lived near her parents who had a plot of land on which her husband worked. Then the war broke out. Her husband was drafted into the army and she was moved to another province to work on a communal farm. Before too long news came that he had been killed in action. It got increasingly hard. There was not enough food to eat, her son became sick, and medical care was not readily available. Separated from her parents and unsure of what the future might bring, she decided to escape to Thailand to get medical care for her son.

One day while she was getting her 20 liter daily ration of water at the refugee camp in Thailand, she noticed a man staring at her. She had caught his fancy. He pursued her. He came to the house, brought her little gifts, and tried to get her attention. When she refused his advances, he became increasingly violent and threatened to blow the family up with a grenade if she refused to marry him. She married him and together they had three more children, but the violence did not stop. In 1982 they were resettled in Boston, Massachusetts. Under the pressure of adjusting to a new environment, his drinking and gambling increased and so did the threats and the beatings. He would beat her because he could not find a job, because he lost in gambling, because he felt humiliated at the unemployment office.

Isolated in a foreign city, Sothi bore the abuse in silence.

What could she do? Where would she go? With no money, where could she get help? She did not know her way around that well, and she spoke almost no English. The extended family on whom she would have relied for support were not around. She was too ashamed to tell friends what was happening to her and too afraid of his wrath if he knew that she had told others of the abuse. The hope of a better life that helped her endure the terror and suffering began to dim. Several times she

thought of taking her own life to end the pain, but then who would care for her children? So she endured the pain and prayed that he would not kill her.

Sothi's story is not an unusual one. Sothi's story of abuse is shared by approximately four million women in the United States and millions more around the world. For many Asian refugee and immigrant women, the struggle to survive is a multifaceted one.

Since 1970, the Asian American population has doubled each decade. It is the fastest growing group in the United States. Today, 60 percent of the Asian American population are immigrants.

For many Asian refugees and immigrants, life in an American city is a bewildering experience. But for those who have had some education opportunities and class privileges, the struggle to survive has not been as difficult. They are better equipped to take advantage of opportunities that present themselves.

For others, especially those who came from poor rural areas, who have few family connections in the United States, and no marketable skills or the luxury of education, the attempt to meet even the basic needs of food, clothing, and shelter is a constant struggle. Many live in overcrowded situations and work long, tedious hours for low pay and no benefits.

As if the struggle to survive in a foreign land is not enough, those who are the most vulnerable—women and children, like Sothi and Sothi's children, often have to endure yet another injustice—violence in their own homes.

Although much has been done in the last fifteen years since the battered women's movement began to address domestic violence in the United States, for most Asian women, the gains made have not been accessible.

The relative isolation of the Asian communities, which has sometimes afforded some protection from outside insensitivities, has also meant marginalization and invisibility. Violence in the home continues to be seen as a private family matter. Most Asian women are not aware of available resources or of their legal rights. Many also fear reporting abuse because of their fear and distrust of governments and authorities. Like other people of color, they also fear discrimination and unfair treatment.

Emphasis on keeping the family together makes it difficult for women to leave violent husbands or relatives. For the refugee or immigrant woman the choice to leave her spouse or partner is particularly difficult; it often means leaving the only really familiar person to her. In addition, leaving him often means ostracization from the community, losing the respect of her community, and thus her connection to the existing support systems within her culture.

Asian refugee and immigrant women are particularly isolated. Many do not speak or understand English. Even those who do speak English are not confident in using the language. Since shelters and hotlines do not have staff who speak Asian languages, this language barrier ensures isolation. In fact, few battered women's shelters serve Asian women. Many battered women who have fled to a shelter have returned because the unfamiliarity of the shelter environment, language difficulties, and cultural differences make separation from their community unbearable.

For women who have faced the odds and decided to leave, economic concerns present yet another obstacle. Most women who are victims of domestic violence do not have control of the money. Many leave with little besides the clothes on their backs.

In addition, in many Asian cultures, it is the men who are the traditional "bread winners" while women have been socialized to take care of the home and children. As such, male children are not only given more educational and skills-training opportunities, but are given leadership and managerial opportunities and responsibilities. If women are given any skills training at all, it is in the traditional low paying, labor intensive jobs such as weaving, making crafts, being a beautician, where there is no job mobility.

(I just came back from visiting a few refugee camps in Thailand and Malaysia. What I found is that men participate more in "English as a second language" courses and in skills-training courses that stress the development of managerial and administrative skills. There were few women's organizations in these camps to provide skills training. There are long waiting lists and training is available only in stereotyped jobs such as weaving, etc.)

Thousands of years of socialized economic dependence, lack of education and transferable marketable skills and language and cultural barriers have made it difficult for Asian refugee and immigrant women who are trying to make it on their own in the United States.

The lack of bilingual, bicultural advocacy and outreach services for Asian refugee and immigrant women at all levels of the legal, law enforcement, and human service system have made living an unnatural struggle for refugee and immigrant women. The lack of language training and skills-training opportunities compounds the struggle for Asian refugee and immigrant women who are trying to live violence free, economically independent lives.

Nationally, there are but a handful of organizations that provide bilingual, bicultural services to Asian women trying to escape violence in their lives: Asian Women's Shelter in San Francisco, Asian Women's Center in New York, Refugee Women's Alliance in Seattle and the Center for the Pacific Asian Family.

In Massachusetts, out of over 30 battered women shelters, only the Asian Women's Project, an advocacy and outreach program, which has no shelter of its own, has the capacity to serve Cambodian, Vietnamese, and Chinese women, and only one shelter program has hired Asian bilingual staff, i.e. two Cambodian women to serve the enlarging Cambodian population around the location of the shelter.

In addition, because of state and federal cutbacks, services to refugees and new immigrants have suffered. In just one English as a second language class alone in Massachusetts, there are 1200 people on the waiting list. Subsidized childcare is inadequate and low income subsidized housing has become more and more scarce. In Boston, a wait on the priority list can take as long as five years to qualify for subsidized housing.

Job training placements also have waiting lists, but the issue of available child care is another obstacle for women who want to get job training.

The Asian Women's Project, a bilingual direct service program, and the Asian Task Force Against Domestic Violence, which seeks to make more wide ranging structural impact, were created to address this situation.

The Asian Women's Project provides bilingual advocacy and outreach services to Cambodian, Vietnamese, and Chinese women. Cambodian, Vietnamese, and Chinese staff are available to provide emotional support, to help with obtaining a restraining order, welfare services, medical care, divorces, finding shelter and permanent housing, etc. Because of the language barriers, advocacy has been very time consuming. Women not only need help with referrals, but staff has to personally accompany women to almost all appointments because women do not know their way around and need help with translation as a result of the lack of bilingual staff in all sectors of the human service system.

A home-visit outreach model to let Asian women know their rights under the law and also of available bilingual resources has been developed. This model has been very successful in creating trust within the community. It is personal and respects the cultural systems within the community. Outreach and education around issues of domestic violence in the Asian communities has also been done with ESL classes, community organizations, and with community health centers.

In addition, an empowerment program designed to provide women with necessary survival skills has been developed by the Asian Women's Project. This program includes support groups, an ESL tutoring program, a match-a-family program, and a food catering program called Bamboo Shoots.

The ESL program recruits volunteers who are trained to teach English

as a second language and they go to women's homes to tutor. Some of these women are those who have not been able to get into regular ESL classes. Some are in classes but require a tutor in order to catch up with the work in the class. Because of the way Asian women have been socialized, many will not ask questions in class even if they do not understand, particularly if there are men in the class. Hence there are many women who have taken ESL classes for years and still speak very little English, while others have dropped out.

A match-a-family program helps refugee and immigrant women learn the ropes of the American system. Families are matched up with each other and do things together on a regular basis, for example cook and eat, go to the movies, zoos, museums, parks, etc. It is an opportunity for newcomer families to break their isolation, to get to know the resources of the city more, and learn how to use them.

For women who are seeking to live independent violence-free lives, figuring out how to meet the survival needs of the family is a major challenge. None of the women we have worked with can afford market value rents. In Boston, a two bedroom apartment costs at least $850 while welfare payments for a family of three are only $610.

Bamboo Shoots provides Asian women seeking to live independent violence-free lives with an opportunity to use the skills they have to make some money as well as learn new skills, such as quantity buying and cooking, budgeting, and soon marketing, pricing, collaborative administration. Bamboo Shoots caters lunches and dinners to nonprofit [organizations].

The Asian Women's Project also offers leadership and empowerment courses to emerging refugee and immigrant women leaders in the communities. Leadership development is an important key in changing the status of refugee and immigrant women and enables refugee and immigrant women to gain control over their lives.

The Asian Task Force Against Domestic Violence is a coalition of individuals and organizations with the goal of eliminating domestic violence in the Asian communities. In the past few years, the Asian Task Force has consistently highlighted the issue of domestic violence in the Asian communities to bring attention to the seriousness of the issue.

There is a myth in the Asian communities that domestic violence is not a problem. Thousands of years of male dominance means that domestic violence tends not to be taken seriously. In addition, other pressing survival challenges, as well as the fear that acknowledging domestic violence openly as a problem would add fuel to the fire of racism against Asians, have left the issues of violence against women largely unattended within the Asian communities.

However, in Massachusetts, a woman is killed every 15 to 22 days

by her boyfriend, husband, or partner, and last year 9 percent of these women were Asian even though the Asian population is only 2.4 percent.

As a coalition of individuals and organizations, the Task Force has been able to be organized effectively in bringing public awareness to the issues of domestic violence in the Asian communities and in the mainstream communities. We have reached out to community leaders, human service workers, police, and court personnel. We have been able to do this through conferences, training, focussed group discussions, poster campaigns, and vigils, but most effectively through interpersonal interaction. It has been through personal contacts that we have been able to do the essential work of networking and working collaboratively with individuals and groups inside and outside the Asian communities to address domestic violence.

Although there is still much to be done, including the creation of an Asian women's shelter where women would feel safe and supported, I feel that we have made strides.

Breaking the silence of domestic violence and economic dependence and advocating for more adequate and culturally sensitive services to the enlarging Asian communities have not been easy. Particularly at a time of recession when there seems to be a conservative turn to the right, there is decreasing sympathy for granting foreign aid for people who are viewed as foreigners. Because 60 percent of Asian Americans nationally are immigrants, Asians are being viewed more and more as foreigners who are displacing Americans of jobs and other resources.

In addition, the prevailing myth that all Asians are successful and capable of being math and science whizzes at MIT does not help our advocacy efforts. Perhaps these sentiments account for the stark fact that just two-tenths of 1 percent of all major United States foundation grants are targeted to Asian Pacific Islander programs.

Yet things are looking hopeful because Asian refugee and immigrant women leaders are emerging and organizing around these issues. The struggle to eliminate domestic violence and to establish economic independence is first and foremost about women's empowerment. It is about women saying no to violence of any kind. It is about women reclaiming self, reclaiming power, reclaiming her abilities to care about herself and all people.

What can funders do to support this work? What should funders look for? I think that it is important for organizations that are working with refugee and immigrant women to be led by refugee and immigrant women. That not only to have token refugee and immigrant women on the Boards, but to have the executive director and the staff be refugee and immigrant women.

I think it is important that the organization be well connected to the community and establish some strategies for working collaboratively with other service organizations.

I think that it would be helpful for funders to look for quality rather than quantity. Much of the work we do has to start with attitude changing and building alliances and empowerment. Much of this work is slow, so do not look for fast results, but look for sound and firm processes and strategies.

Lastly, fund refugee and immigrant services as much as you can and make a commitment to fund an organization for a longer time. Perhaps five to six years, instead of three. Or take on a project and follow it through all the way. Work with them and help them develop but listen to what they have to say in terms of what their needs are for assistance. You are working with a group that has several setbacks and it takes more time to develop other funding strategies and to become independent.

This manuscript was provided by Cheng Imm Tan and is used with her permission. She spoke extemporaneously at times during the actual presentation which is not reflected here since the speech was not audiotaped. The editors have made minor grammatical changes for clarity, but unusual sentence constructions attributable to Tan's bilingualism have not been altered.

Responses to the Speech

Immediately following the workshop, participants told Tan that she had done an excellent job of providing the audience the necessary context for the remainder of the workshop.

Jean Conger, Executive Director of the Los Angeles Women's Foundation, was the facilitator for the workshop. She said Tan's talk was important because, "there is little information available on the plight of Asian refugees to counter the 'model minority' myth, and to demonstrate the need for services." [Tan provided] ". . . a deeper understanding of the problems faced by immigrant women! . . . The example of a [Asian] woman's life was very heart-wrenching. . . ." (Conger, 1993). Conger said the audience was "moved by the workshop" because she ". . . spoke very passionately and eloquently for her community."

Mary Theresa Li, a Program Development Specialist for Multnomah County's Youth Program Office in Portland, Oregon, also attended the panel. She said: "The workshop was the most powerful I've ever

attended. Women's voices were heard there which were not heard throughout the conference'' (DeFrancisco, 1993g). Li found Tan particularly inspiring: ''As an Asian woman, to see another Asian woman in a leadership position was very moving. . . . She is doing ground-breaking work and serves as a model for the rest of us.''

Maggie Kuhn

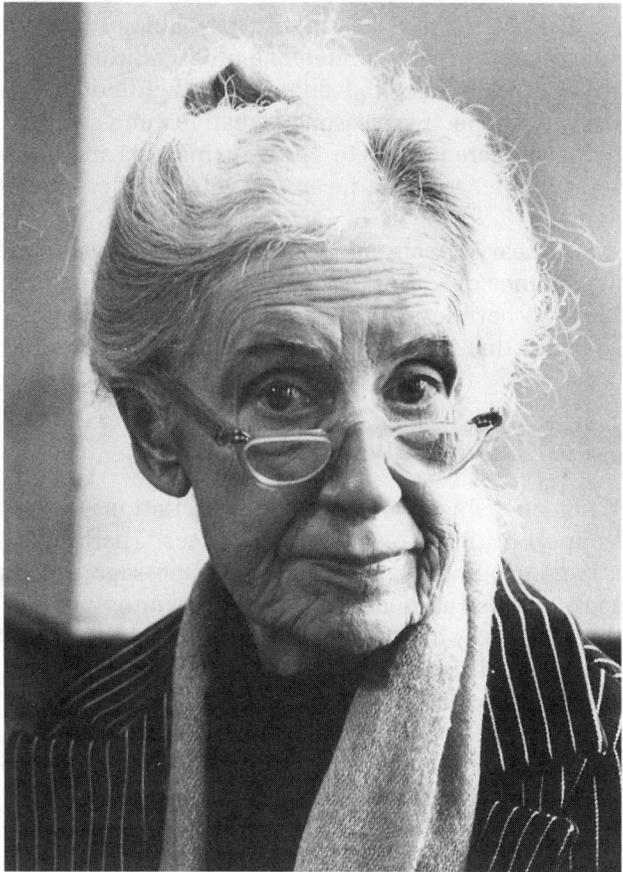

Maggie Kuhn founded the Gray Panthers in 1970, at age 65. This organization embodies her philosophy of "linking the historical perspective of the old with the energy and new ideas of the young" to "eradicate ageism and bring about peace and social justice." The Gray

231

Panthers now has more than 60 networks (chapters) in the United States and has official nongovernmental organization status at the United Nations.

Kuhn spoke on May 2, 1992, as one of the keynote speakers at a three-day conference entitled "Conscious Aging: A Creative and Spiritual Journey," at the Ramada Hotel in New York City. The conference was sponsored by the Omega Institute for Holistic Studies, which describes its mission as "personal and professional development in a variety of subject areas, from health and psychology to multicultural arts and spirituality." In the conference program, the Omega Institute said the American tendency to fear and resist aging denies us "the gifts of age: mature perspective, seasoned creativity and spiritual vision." The goal of this conference was to "provide insights and tools for anyone, at any stage of life, to bring meaning, value and creativity to the process of aging."

Sue Leary, Assistant to Maggie Kuhn, has described the powerful appearance of Kuhn: "[She is] such a little lady in her petite suit—and looks so harmless. Then she says those wonderful outrageous things. I'm sure this is part of the effect" (Jensen, 1992b).

Approach of the Speaker

When choosing among numerous invitations to speak, Kuhn considers "opportunities to reach new audiences," particularly "audiences with a large geographical spread, so the message goes far and wide." She seeks diverse audiences that include young people, because she finds that audiences limited to older people "think in very traditional terms." Her nontraditional goal is "to change the issue of aging and to change the images of aging" (Jensen, 1992h).

Kuhn said it was "a delightful experience to speak to this audience," and commented: "I am not exactly a New Age person, but I can understand the New Age philosophy. I think being on the cutting edge is something all of us must attempt to do in this era of change."

Kuhn described four steps that she follows in preparing a speech. First, she and her assistant, Sue Leary, request as much background information as may be available about the sponsoring group or groups—including their mission and expectations. Then she tries to secure information about the audience—expected size, backgrounds (e.g., the general public, professionals from a variety of fields, or experts from one field). Third, Kuhn said: "I think about and select . . . reading material—for instance, books that I would hope that the audience might read—and I always bring a variety of periodicals, the alternate press, as a way of changing attitudes and enlarging perceptions." Finally, Kuhn prepares "a very careful outline," and writes the speech from the outline.

But she added: "I speak from the outline, I don't read it." This approach is necessary, in part, because her limited vision makes it difficult to follow a text—but also helps her to preserve spontaneity.

When asked whether she likes public speaking, Kuhn responded: "When I first began years ago, I was terrified . . . but as you gain experience and confidence, [speaking] is a challenge and actually a joy." She finds there are some audiences "that you are immediately in rapport with, there's an immediate response and that just revs you up." She said: "[Sometimes] you are rather tired when you go to speak and then you are energized and full of a new kind of vigor when you're in the presence of that audience. You tune in on their energy." She added: "I felt that right away about this group. And I was surprised because I wasn't sure that some of these New Age people—that I would communicate with them and that they would hear what I had to say. But I was amazed."

The energy that Maggie Kuhn brought to this occasion and drew from the audience is reflected by the fact that she held a news conference following the address and later in the day conducted a 2½-hour workshop.

Keynote Address at the Conference on Conscious Aging

Now is the time for repentance, restitution, and reconciliation, and I honor those three functions in the light of the great ethnic racial diversity in our world today. We celebrate it, celebrate it, celebrate it, and move on.

There are three things that I like about being old. First, I can speak my mind, and I do, and I'm always surprised at what I can get away with. I can be outrageous, and I ask you to rate me today—have I been outrageous? And I hope you'll give me a brownie point for that. The second thing that I like about being old is that I have outlived much of my opposition. The people who said to me, "Maggie, that will never work; it's just a crazy idea," they're gone. But the third thing in my life in my old age is the honor and the privilege and the sheer joy of reaching out to people like you and being a part of your future. What a blessing and a privilege—and fun.

This is a new age, and . . . sweeps of change confront us all. The changes have been cataclysmic in our lives and in the life of our society. The changes in my view have occurred because of the collision, head on, of two revolutions that have occurred in this last decade. The demographic revolution where people are living longer today than any time in human history. I am going on 87. I will be 87 in August, and

I have a very full agenda until 90, and then I am going to regroup and see what's for the next decade.

The second revolution is a technological revolution. It has changed the way we work, live, and communicate. The technological revolution, in its application to medical science, has extended life and made it extraordinarily difficult to die with dignity. I have recently signed a living will, and I urge you to do the same. It's reassuring that no external means are going to be used to extend your life when it's clear that it should be ended. The technological revolution has created a whole . . . generation, maybe two generations, of experienced, skilled workers whose skills in the workplace are obsolescent. And it has created a chasm between the new, young workers who know computers . . . [and] the old worker, and declared all of those irreplaceable skills obsolescent.

And I think if we are going to look at history, absorb our history, and recognize how history has affected each of our lives, we [must] realize how important that long view of things is. And especially today is it important as we contemplate the ethnic diversity of our society. One of my personal top priorities as a Gray Panther is to deal with the ethnic diversity in our country and to recognize that ethnic diversity is a part of a world scene. This makes it indeed possible for us to be world citizens because we are so diverse. And we . . . have an awesome opportunity and challenge to understand the history, the roots, of those who occupy the planet with us.

The technological revolution provides a new kind of communication, and I hope that we are going to be using the tool of communication with some wisdom. I don't trust the controlled, managed, manipulated American newspapers—not even *The New York Times*! So, my friends and I regularly read and subscribe to alternative journals, and I have some here to show you. How many of you know *In These Times*? [clapping] Hooray! *The Washington Spectator*? *Dollars and Sense*? *The Nation*? *The Progressive*? *Mother Jones*? Oh, I see we're on the same wavelength. But it's terribly important for you as you reach out in all the circles where you are functioning and making an impact, that you help people to see that the news has been managed, and to get the truth we need to look further—beyond the traditional press. We have the technological opportunities to do that.

Dr. Robert Butler, the psychiatrist, . . . is indeed a remarkably gifted and compassionate person. He organized at Mt. Sinai's School of Medicine here in New York the first center of geriatric medicine in the country, and his book, *Why Survive? Being Old in America*, I widely recommend as required reading.

In Dr. Butler's book . . ., he cites six myths that are widely held about old age. The first is that old age is a disease, a loathsome disease. You never admit how old you are, or, my goodness, you get a face-lift

if you can. It's a disease. *I* say it's a triumph—a triumph over loss, failure, sadness, frustration, rage. It's a triumph.

The second is that old age is mindless. It's just a question of time before your brains get soft. Senility is inevitable. Nothing could be further from the truth. A great deal of so-called senility has been caused by improper medical diagnosis and damn poor medical care because people, in their traditional ailments in late life—heart conditions, kidney failures—unless those are properly diagnosed and treated, . . . [suffer] loss of blood to the brain. But it is preventable! We don't yet know about Alzheimers, but a great deal of research is going forward. But another way to counteract the mindless myth is to contemplate the number, the large numbers, of older people who are going to college today and working for masters and doctorates, and [are] exceedingly prolific as scholars—in late life. Learning never stops till rigor mortis sets in.

The third myth is that old age is sexless. "It's not appropriate for you, grandma; you can't do it anymore." Well, I say that until the end some form of intimacy and loving relationship is necessary. Now . . . women outlive men (we don't know why the males are so fragile) . . . anywhere from eight to thirteen years. Maybe when more men are liberated in addition to all the men here, they'll live long too. But, at any rate, we outlive men. And how do we fulfill our sexuality needs? And I say, . . . maybe there is a possibility of a lesbian relationship in late life. Maybe.

The fourth myth is that old age is useless. "They don't do that anymore, you know." But I say that the skills and the experience and the survival opportunities that we present are prized possessions in the changing world. Without historical perspective, there is no future!

The fifth myth is that old age is powerless. It is true that many of us have infirmities. I have osteoporosis, I have arthritis, I have macular degeneration in both eyes, but I still have a head, and my head still works. And I have a memory and a historical perspective that my peers share, and that historical perspective is extraordinarily important for the future. It cannot be denied.

And the sixth myth is that all old people are alike. We are all cranky and crotchety and hard to get along with. And I say: for contrast, think of Ronald Reagan and me. [clapping and laughing] I've never met Ronnie. I had an opportunity once, and I *refused* it. [loud laughing and clapping] I was afraid that if I were there that I would be impolite. He's a disaster, and it's going to take at least 50 years to overcome what he did, and the combination with George—we've got a lot of hard work to do. [clapping] Thank you. Thank you. We'll do it together.

I'd like to remind you all that the process of aging begins with birth. If there were no right-to-lifers here, you know, I would say that it begins with conception. And one of my one-liners is that it begins with

conception and ends in resurrection. You get the point? It's lifelong. The process of aging doesn't begin when you first find a wrinkle or another gray hair. The process of aging begins at the beginning of life. And the process of aging we share with all living creatures—all the plants, all the birds, all the reptiles, all the animals, including the human animal. And what we have done in an ageist society, in a society that sets old age apart, is to violate the essential wholeness and continuity of life— which is so, so regrettable. . . .

These commonalities that the old and the young share—we've been working away at this for several years and adding to the list, and perhaps as you reflect on this listing, you would add others. . . . These are the things that old and young people share at the present time.

Both the old and the young are marginalized. We are not in the mainstream. Unless you are very rich and old—and then you still keep your membership on the board. And you are not neglected by your children, because, my God, you know, they've got to get that money. But by and large we are marginalized—not taken seriously.

And in the second place, we are relatively dependent and poor— the young on marginal jobs and allowances, and the old on Social Security and pensions. . . . Many, many old women have died poor because their husbands did not sign survival benefits in their pension plans.

The third commonality is that both are going through hormonal body changes, losing hair and growing hair—growing hair in *strange* places. Both the old and the young are in conflict with the sandwich generation. The young with their parents, and the old with their children. But together the old and young can be advocates and help those tortured sandwich people that are under such stress.

The old and the young both have a tremendous opportunity to work for social change and to take the risks of social change, and to test and experiment with new ways of living. . . . I have shared my house, which is a big Victorian house in the Germantown section of Philadelphia, with young people for over 30 years—college students. They have been a very, very interesting group. The first nursing home investigation and research was done in my house. Elma Holder and Linda Horn came and investigated the nursing home scene, the abuses and neglect; that kind of research was done in our house. We investigated the way in which hearing aids were sold and published a report, "Paying Through the Ear," which you do when you buy a hearing aid. Lots of the people who sell you hearing aids don't know anything about deafness, they just know how to turn up the sound.

There are all kinds of opportunities to experiment with new ways of thinking and working. I am an absolute devotee of alternate energy— the sun and the wind—what it could do to our polluted world if we

did away with fossil fuels and nuclear power plants. WHO NEEDS NUKES? And what in the hell do you do with the nuclear waste? Nobody really knows what to do with it. And it endangers the whole planet, and we don't need it. And John Sununu is a fool and Bush was a jackass to take him as Chief of Staff. A nuclear physicist—chief of the environmental president's staff. What a blasphemy! NO MORE NUKES! I recently met a representative of the Raging Grannies. The Raging Grannies are a group of older women who live in Victoria, Canada, and their mission is to do away with nuclear weaponry, nuclear vessels, and nuclear power plants. No more nukes. They wear outrageous hats—the funniest hats you ever saw—amazing hats. And they write satirical poetry which they put to music and sing. And they've had wonderful press, and the younger ones ride out in little kayaks to greet any nuclear-powered vessels that arrive in the Puget Sound. A hearty welcome they provide. I believe that we could generate untold numbers of new jobs for the young and the middle aged and old people in the development of these alternative energy sources. It seems to me that in addition to attacking racism and ageism and sexism we need to marshall our forces and develop a new kind of commitment to new energy. Little windmills on the houses—wouldn't they be pretty? And can't you see solar panels with the sun pouring in? It's the way to go. Let's begin tomorrow. I believe that the environment is threatened in this country and around the world, and we should be tackling that in all of its ugly possibilities . . . all the waste and corruption and abuse of the planet that we have been charged to be stewards of. The planet, Mother Earth, we have violated and endangered, and in the process endangered all of us as human beings.

I believe that older Americans have these essential four goals, the four "M's." First, we are mentors. We are passing our knowledge to the young. Many young people are not at all clear that there is a future for them. But we can begin to affirm their future and help them as mentors to define it for themselves. Joe Perkins, one of the vice presidents of Polaroid Corporation, has set up with Polaroid (which by the way is an enlightened group community of work) a mentoring operation, and the older Polaroid workers are the trainers, the mentors, of the young ones coming in, in this country and around the world.

The second opportunity for us is to be mediators. And certainly in terms of what tragic things have happened in Los Angeles there needs to be mediation. And I hope very much that there will be teams of older mediators of all ethnic groups who are part of the reconciliation and a repentance that must come through the history of our lives which have seen many conflicts resolved. It's most appropriate that we be mediators.

The third role is that of monitors. We are watching (and I use very elegant terms); we are watch dogs and watch bitches of the public

order—watching city hall, watching the state house, watching Congress, watching Bush, watching the Bush-Reagan court. Hah! What a disaster. We've got work to do. And the monitoring is not just spasmodic—about something that happens to make you mad. There can be monitoring that affirms, and congratulates, and commends responsible public office.

The fourth "M" is the mobilizer's role. Mobilizing for social change and justice and peace. Mobilizing, organizing, and bringing together new coalitions of persons who *care* about the environment, who *care* about racial justice, who are working together. Now women have been doing that. I think the women's movement has. It hasn't gone as far as I would like it to go, but it's on its way. And I would hope that there could be a resurgence, a renaissance, a new spirit that carries women forward to be the mobilizers of peace and justice. I am very concerned about the justice system in America.The Supreme Court is a disaster. Many of us protested Clarence Thomas, and I am assuming that many of you did, too. And Bush, you know, in his wisdom, chose the best judge he knew. A *wise* guy. The Gray Panthers have organized a commission for justice reform. We have a very interesting small group of people, that has been chaired by Julia Hall, a sociologist at Drexel University in Philadelphia, who has majored in criminology. We have a Gray Panther group at Graterford Prison, which is one of the biggest, most crowded penitentiaries in the eastern region. We need to look at the lower courts. We need to look at the way in which justices are appointed, the way they perform. This is the way in which we continue to monitor, and work for justice.

The Gray Panthers have another commission to reform and restructure the work place. What is good work? What is work that affirms a person, that is genuinely enjoyable? What work is fair? What work does not harm the environment? What work affirms the products that sustain life, not destroy it? Our research tells us that 70 percent of the people who are gainfully employed in America *hate* what they do. They work only for their paycheck. What a waste! And the first thing I ask a person whom I've not met, "Well, what do you do?" Hmm, good question. So we are looking at work in a new way, and these are the elements [of good work] that we have identified thus far: It's a work team, not competition, right? It's delivered by the team. Good work has child care on the premises. Good work has a pension system that is affordable. Good work has health benefits. Good work has non-retirement. You keep on working as long as you want to. . . . Maybe some of you are a part of work places that could be restructured to include some of these elements and others that I have not mentioned.

In order to strive and survive, you need a goal and a purpose—a passionate purpose that you do everything in your power to work for. My two goals I think I have shared with you. One is to celebrate our

ethnicity, to understand and reach out to those who are different in race and ethnic and religious background from mine. But we are part of the human family. We are one human race, and we celebrate it. And this to me represents a long spiritual journey to understand that oneness that transcends diversity and strife and hatred and fear. And it brings life together in wholeness and joy and peace. I am very concerned about the fact that so many of my peers do not have a goal. You retire from a job, and you retire from life. Right? The rocking chair and leisure world. What a waste! What a waste! We who have no risk to fear, we who have historical perspective, . . . [should] be leading the change; . . . [we should] be out of the rocking chairs. No more rocking chairs! No more leisure worlds. No retiring to a retirement community which John Mackay, former President of Princeton Theological Seminary, called a glorified playpen for wrinkled babies. A glorified playpen for wrinkled babies to keep wrinkled babies safe and out of the way. For, when you retire to a retirement village, unless you organize that retirement village, you are in a playpen, and I'm never going to be in a playpen because I share my house with young people, and I have more young friends than old friends, and I rejoice in the fact that I can reach out to others and survive and thrive.

Another goal of mine is to strengthen and affirm the United Nations. The United Nations is under attack from the far right. The Heritage Foundation has declared war on the United Nations. There is a marvelous article in *The Nation*, and another in *These Times* about the way in which the Heritage Foundation has attempted and is attempting to subvert the work of the United Nations in this country and around the world. And, you need to know that, because the United Nations is the one structure that harmonizes differences, that brings people together, and it's needed more today with the changes in the Soviet Union—those independent republics—and the changes in all of Eastern Europe and Africa. The United Nations is the force, and we should affirm it. I am very proud that the Gray Panthers have consultative status beyond just observer status at the United Nations, and we have direct access to the Economic and Social Council and all the specialized agencies that the Economic and Social Council oversees and directs—the World Health Organization, the International Labor Organization, the Children's Fund, and others. Direct access! I like to brag to say that Jorge Litvak, who chairs the World Health Organization (he's Chilean) has come to see me. You know, really, exciting!

And when we're working for our new health care system, we learn from the other systems of the world that have a good publicly supported health care system (which we do not have). . . . We have examples from them that instruct us as we deal with the policy changes in this country and affirm within this next decade a new health care system free for

everybody. Our health task force has studied the health care of Canada. A group of us spent ten days in Canada visiting the various provinces and the central government, and we learned from them. Another group went to Denmark and looked at the health care system in Denmark. But we have our own needs and our own peculiar political setup, and it seems to me that we have to construct our own . . . new health care system that is free, that is publicly supported, that is delivered by the team—the nurses, and the therapists, and the health educators, and the social workers . . . are part of this new team. Compassionate care for each of us where we live and where we work, and as a last resort the hospital. The hospital ain't good for the health, any way you look at it, and the fact that you have to go to the hospital to get any care is a disgrace. So the new health care system will be at home where you live and in the work place where you work. It will be comprehensive, and human, and compassionate, and free.

And there isn't any reason in the world why one of the richest countries in the world can't cut back the military. Who needs Star Wars? Who needs stealth bombers? Who needs the Pentagon? Not you and me. We need to preserve peace, peace in our time. And I think the issues that we address put us in league with the whole world so that there is indeed peace in our time. It's going to be hard to achieve, but each of you can be and will be a center of a network that is working for a new set of priorities that bring justice and peace to the human community where you and I live and hopefully thrive.

There is so much to do and so little time to do it. And people have so many agendas and there is so much competition in this world that I hope that a new value system can be set up and certainly affirmed in late life. Instead of independence: interdependence. We need each other. Instead of competition: cooperation. We need each other. And we can do collectively what we cannot do competitively. And we need to be intergenerational instead of age segregated. Youth and age together. The old and the young. Free to make change. We need to work together for peace, and harmony, and justice in a troubled world.

I thought it would be fun to close this commentary of mine with a Gray Panther growl. Let's see . . . whether I've omitted anything. You see, I'm getting senile and I just want to be sure that I haven't omitted anything. No. Oh, one more. I did forget something. . . . Self interest, which America is tied up with. Self interest groups compete in Washington today, in every state capital, in every city. Self interest. What's in it for us? What's in it for me? If I'm not going to benefit, the hell with it. Self interest first. But now is the time to affirm the public interest. What is the common good? What can we do collectively, cooperatively, for the common good? Not self interest—but public interest, which we affirm from now until the end.

It has been a joy and a privilege to reach out to you and to affirm what you are doing and to join you on the cutting edge of social change. We need change. We need not fear it—we need to collectively embrace it and manage it so that it does indeed serve the public interest in the greatest, largest sense that we can envision. And our envisioning of the public interest includes vision and hope. There are many people who are hopeless. The terrible tragedies of Los Angeles and in other cities make people fearful and hopeless—feeling futility and frustration. But we can, together, generate hope to move on to the future—together— on a long spiritual journey that has no end, but always enlightened by the vision of the loving care of the neighbor.

Now let's do the Gray Panther growl. Will you stand up? I can't stand—maybe I can—I'll try. No, I guess I'll sit. Now stand tall. Get your feet firm in front. Now raise both arms as high as you can. High, high, high. Stretch, stretch, stretch. We are reaching toward this new public order. We are reaching toward a peaceful world. It's not yet within our grasp, but reach and reach and reach for it. Then relax. And now we reach toward the neighbor with outstretched arms. The neighbor that we can touch here in this great company, but in your mind's eye envision the neighbor in El Salvador, the neighbor in Los Angeles, the neighbor in Brazil, the neighbor next door, the neighbor, the neighbor; neighbors are we all. And then we are reaching toward each other with love and hope and compassion and strength—we reach, reach, reach, reach, reach. And while we are reaching we open our eyes as wide as we can, envisioning the neighbors around the world. Open your eyes wide, wide, wide and envision the suffering and the need and the chaos around the world. Envisioning, envisioning, envisioning. And then we open our mouths, ready to cry out against injustice and to deal with human need. Open your mouth real wide. Now stick out your tongue as far as you can. Way out. Way, way out. Way, way out. Way, way out. (Incidently, that's very good for sore throat.) Way, way out. Way, way out. Way, way out. Now with your arms outstretched, your eyes wide open, your tongue way out, growl three times right from the depth of your belly. Arrrrgh. Arrrrgh. Arrrrgh.

This address was transcribed from an audiotape provided by the Omega Institute of Holistic Studies. It is used with permission from Maggie Kuhn and the Omega Institute. Limited editing has been done—omitting some personal asides to the audience, smoothing occasional sentence structure, and deleting occasional word overlap due to audience interruptions or speaker hesitations. Ellipses indicate this editing. The extemporaneous quality of the speech has been intentionally preserved. Audience responses are noted in brackets in the text only when these responses affected the speaker's next statement.

Responses to the Address

In addition to laughter, applause, and cheers several times during the speech, the audience *growled* at the end and then responded with sustained applause and cheers. The applause eventually developed into clapping in unison.

The Omega Institute circulated a feedback sheet which asked respondents to evaluate conference presentations they had attended. The Institute collected and provided to the editors 52 responses to Kuhn's address. Respondents were asked to rate two aspects of the speech on a five-point scale (5 = excellent, 1 = poor). The ratings for "the keynote overall" averaged 4.86. The ratings for "relevance of content to you" averaged 4.78.

Respondents were also invited to write comments and these assessments were warm and usually very enthusiastic. The most frequent adjective in these assessments (used by 24 respondents) was "inspirational." Numerous listeners commented on Kuhn's passion and energy—which created a presence larger than her words. Several respondents described her as a role model for their own living and aging. One writer noted that Kuhn triumphed in spite of technical problems in the public address system, and another said: "She saved the day and made the trip and money worthwhile." One writer simply commented: "Maggie Kuhn stole the show!" Another said: "Absolutely remarkable. Touched me to the core. I wept."

One respondent felt that Kuhn could have discussed her own history more than she did. The lowest ratings were accompanied by these comments: "Maybe cheerleading will inspire some, but how you change things is a subtler, long-term job." But the overall tone of the written responses is perhaps best summarized by this statement: "Quite apart from my joy in being in her presence, I felt she had a power-packed address of practical information for her hearers. Watching the energy rise in an elder, who is in some ways becoming physically frail, is inspiring and negative-myth dispelling."

Bella Abzug

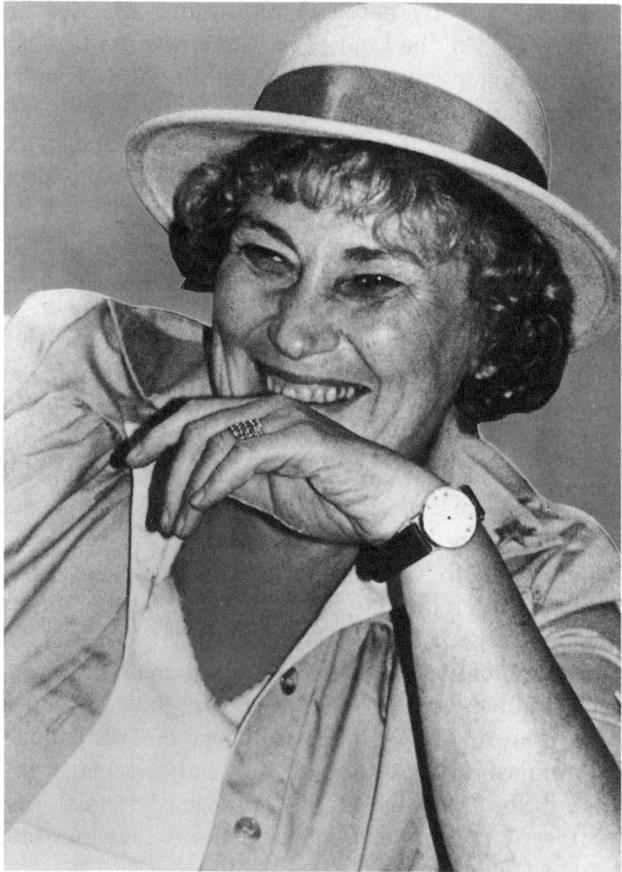

Bella Abzug has been called "flamboyant and fearless," a speaker "gifted with a dynamic delivery," "undoubtedly one of the most vividly colorful political personalities New York has ever produced" (*Current Biography Yearbook*, 1971, pp. 1-3). This reputation and her trademark wide-

brimmed hats have spanned a lifetime of activism. In a recent history of contemporary feminism in the United States, Bella Abzug was one of five women identified as leaders featured on the book's cover (Castro, 1990).

Abzug, a civil rights lawyer, made her most noted contributions from 1971 to 1976 when she became the first Jewish woman on Capital Hill, serving as a democratic representative for the 19th congressional district of New York. By her own definition, she was an activist, even in Congress: "I'm the kind of person who does things the same time that I'm working to create a feeling that something can be done. And I don't intend to disappear in Congress as many of my predecessors have. My role, as I see it, is among the people, and I am going to be outside organizing them at the same time that I'm inside fighting for them" (Abzug, 1972, p. 5).

In the 1990s, Bella Abzug is in her seventies, and remains a voice demanding to be heard. She helped to found the Women's Environment and Development Organization and serves as co-chair. In 1992, two international conferences on the environment were held in Rio de Janeiro simultaneously; one was the United Nations Conference on Environment and Development (UNCED), the other one was a global forum of women called, "Planet Femmea" (Leon, 1992, p. 24). Abzug addressed Planet Femmea, and was selected by the nongovernmental organizations at the UN conference to speak at its Plenary session. It is the latter speech which is printed here.

Barbara Ann O'Leary, one of Abzug's assistants, described the atmosphere on the day of her speech, June 9, 1992. She said Rio was like an "armed camp" (DeFrancisco, 1992i). In fact, a photo from Rio showed Brazilian soldiers watching over the beaches to protect the international heads of state attending the conference (*The Washington Post*, June 10, 1992, p. A20). O'Leary said official papers were required for admission to the speech and only specially invited guests could attend. She estimated there were at least 155 nations represented at the address; less than 20 percent of the delegates were women.

Approach of the Speaker

In a newspaper interview in Rio, Abzug said that her main mission in addressing the UN was to spread and promote the vision of women on themes of environment and development. Specifically, she wanted to persuade the delegates to support Women's Action Agenda 21, an alternative plan for saving the earth. She said it was important to get women's ideas in the U.N. agenda, adding: "This is the first time that women's issues and themes which are of concern to us in the area

of development have been taken seriously in a conference of this nature"
(Leon, 1992, p. 24).

As a representative from the concurrent conference, Abzug knew she
was speaking for the 1,500 women attending Planet Femmea. Although
there were differing views expressed at Planet Femmea, for example
among women from the North and women in Latin America or Muslim
women, Abzug said there was strong consensus on central issues.

> I think Peggy Antrobus of our Committee and General Coordinator
> of DAWN, has expressed it very well. She said that although we are
> divided by race, class, culture and geography, our hope rests on our
> points in common. We are all exploited in our various roles, our
> sexuality is exploited by men, the communications media and the
> economy. We are fighting for survival and dignity because, rich or
> poor, we are all vulnerable to violence. (Leon, 1992, p.24)

Bella Abzug spoke knowing her position did not reflect U.S. officials'
views. In fact, President Bush arrived the day after her address with a
goal to rally opposition to imposed environmental regulation (Wines,
1992, p. A1). In the newspaper interview, Abzug explained what she
saw as Planet Femmea's unique position and opportunity in Rio while
the UN special session met. "We are waiting to see that governments
will do what they have said they will do and we shall continue
pressuring them to do what they did not want to do. We will take the
lead because we are not tied to any interest, except that which enables
to save the Planet" (Leon, 1992, p. 1).

Statement at the Plenary of the United Nations Conference on Environment and Development

Mr. President, Mr. Secretary General, ladies and gentlemen and
other endangered species:

"We women of many nations, cultures and creeds, of different colors
and classes have come together to voice our concerns for the health
of our living planet and all its interdependent life forms."

These were the opening words of the Women's Action Agenda 21.

The Action Agenda was created at the 1991 World Women's
Congress for a Healthy Planet in Miami, Florida, by 1500 women from
83 countries, north and south. The Women's Environment and
Development Organization (WEDO), with its International Policy Action
Committee (IPAC) of 55 women from 31 countries, organized the
Congress.

We further said, "As caring women, we speak for the millions of
women who experience daily the violence of environmental

degradation, poverty and exploitation of their work and bodies. As long as nature and women are abused by so-called 'free market' ideology and wrong concepts of economic growth, there can be no environmental security."

"We are deeply troubled by the increasing quality of life disparities between inhabitants of industrialized nations and those in developing nations and by the growing numbers of poor within rich countries. In all instances, women, children, minorities and indigenous people are the chief victims."

And "by the inequities among children the world over, with millions denied food, shelter, health care, education and opportunities for a full and productive life. We condemn the racism and disrespect of diversity on which this inequity feeds."

"Women are a powerful force for change. In the past two decades, thousands of new women's groups have been organized in every region of the world. Everywhere women are catalysts and initiators of environmental activism. Yet many policy-makers continue to ignore the centrality of women's roles and needs as they make decisions about the future of Mother Earth and her children." Indeed, women are the primary environmental caretakers, the natural resource managers and the forefront of campaigns against efforts to degrade the environment.

We said that "we will no longer tolerate the enormous role played by military establishments and industries in making the 20th century the bloodiest and most violent in all of human history." We declared that "it is urgent that resources currently consumed by the military must be redirected to meet the needs of people and our planet."

"A healthy and sustainable environment is contingent upon world peace, respect for human rights, participatory democracy, the self-determination of peoples, respect for indigenous people and their lands, cultures, and traditions, and the protection of all species."

"Basic human rights include access to clean air and water, food, shelter, health, education, personal liberty, freedom of choice and freedom of information."

We reaffirmed "our right, as women, to bring our values, skills and experiences into policy making, on an equal basis with men, not only at the Earth Summit, but on into the 21st century."

"The overwhelming exclusion of women from national and international decision making and exclusion from economic and political power must end."

We concluded that "the political empowerment of women may well provide the missing part of the equation that is needed to restore the health of our planet."

At each of the four Preparatory Meetings, an energetic women's

caucus from North and South led by the WEDO Steering Committee was recognized as most effective by officials and grassroots community alike. One continues here.

Our intensive organizing and lobbying paid off, for it resulted in UNCED decision 3/5, which directed UNCED Secretary-General Maurice Strong to "ensure that women's critical economic, social and environmental contributions to sustainable development be addressed . . . as a distinct cross-cutting issue in addition to being mainstreamed in all the substantive work and documentation."

Armed with this mandate, literally round-the-clock efforts by the Women's Caucus at Preparatory Committee IV resulted in numerous key recommendations of the Women's Action Agenda approved in UNCED's proposed 900-page action plan, Agenda 21, including a major section on women in 'Strengthening the Role of Major Groups.'

For example, the Rio Declaration of Principles in Article 20 states: "Women have a vital role in environmental management and development. Their full participation is therefore essential to achieve sustainable development."

Another example is the proposal establishing a UN Commission of Sustainable Development and a Secretariat Support Structure "taking into account gender balance as defined in Article 8 of the UN Charter." I hope countries will send women as delegates to this Commission. These sections together with the endorsement of activities to strengthen the role of women, the programme area on women in both sectoral and cross-sectoral sections, together with the recognition of the necessity to increase the proportion of women in decision making is something of a milestone for a major UN conference of this type.

Although the stronger language on reproductive rights and family planning proposed by the Women's Caucus was not accepted, and although conditional phrases were attached by delegates, the essence of the Women's Action Agenda calling for "women-centered, women-managed" health facilities and family planning services to ensure that women and men have the right "to decide freely and responsibly the number and spacing of their children" has been accepted by the Main Committee of this Summit.

Women attending the Rio events are urging the retention and strengthening of UNCED commitments to gender balance, increased numbers of women in decision-making positions, increased funding by governments and international agencies and aid agencies for women's programmes, and especially for UNIFEM. INSTRAW and women's activities in UNEP and UNDP and other agencies dealing with women's concerns should be likewise treated.

Just as the 1975–85 International Decade of Women and the UN 'Forward-looking Strategies for Women' adopted by the United Nations

General Assembly gave a tremendous boost to international, national and community networks, the Earth Summit provides impetus for a newly invigorated, more effective far-reaching women's movement focused around the vision contained in the Women's Action Agenda pledge:

"We come together to pledge our commitment to the empowerment of women, the central and powerful force in the search for equity between and among the peoples of the Earth and for a balance between them and the life support systems that sustain us all."

"We pledge to undertake our Action Agenda 21 on behalf of ourselves, our families and future generations. We appeal to all women and men to join in this call for profound and immediate transformation in human values and activities."

We wish to thank especially the Secretary-General for his support of the Women's Agenda and the access given to NGO's, all of whom made substantive contributions to each UNCED preparatory conference and will continue to do so in the implementation process through a real citizen's movement to move this Agenda and expand it to encompass the earth.

We wish to thank Ambassador Mazarik, Contact Chair for Major Groups; Ambassador Tommy Koh; Philomena Steady, Special Advisor to the Secretary-General on Women; Yolanda Kakabadse, NGO Liaison to the Secretariat and the many supportive delegates. And we issue a special invitation to all of you to visit the Women's Tent, number 11, at Flamingo Park where the truth is being told by upwards of a thousand women a day!

We welcome the support of men. We need—and certainly men need—all the help they can get. We have only one world. Most of us do not plan to colonize the moon or Mars. Let us work together to make our still beautiful and bountiful planet more accessible to the needs and dreams of all people. Let us celebrate the human will and love and caring we feel not only for ourselves but for people of all cultures, colors and creeds. Let us celebrate Mother Earth and heal her bleeding wounds.

Finally, let us look forward to the day when a majority of the Heads of State gathering for the next UN Earth Summit will appear in their silk and cotton dresses, their robes and saris, their turbans and handcrafted jewelry, reporting to an assembly composed of equal numbers of men and women. That's the way it was in Noah's Ark and that's the way it should be in the future.

Thank you, Mr. President.

This manuscript was provided by Abzug's office, Women's Environment and Development Organization, and is used with permission from Bella Abzug. Extemporaneous additions to the speech are not reflected here since no tapes of the address were available.

Responses to the Statement

Barbara O'Leary, who heard Abzug's address, said she received "lots of applause" from the international audience (DeFrancisco, 1992i). Perhaps the most important response for Abzug was the dignitaries' voting choices regarding Agenda 21. The United States, Britain, and Japan were seen as the primary hold-outs on the proposal. The day after Abzug's speech, Britain and Japan announced that they would sign the biodiversity treaty in Agenda 21 which protects the variety of the world's plants and animal life (Robinson & Weisskopf, 1992).

Charlotte A. Price, an Economics Professor at Sarah Lawrence College in New York, had reviewed earlier drafts of Abzug's address and attended her speech. She noted that the speakers were given a rigid 10-minute limit. Just before going on, Abzug was informed that she could have a few more minutes to speak and, "she knew the material so well she could do that. She went well beyond the [prepared] text" (DeFrancisco, 1993c). Price noted that Abzug's mention in the introduction of endangered species was ad-libed. That reference was what seemed to get the audience's attention. "It told them this wasn't going to be a routine drone style of speech. These were people who had heard 30–40 speeches a day. . . . She can win over even an audience of that kind" (DeFrancisco, 1993c).

Carolyn G. Heilbrun

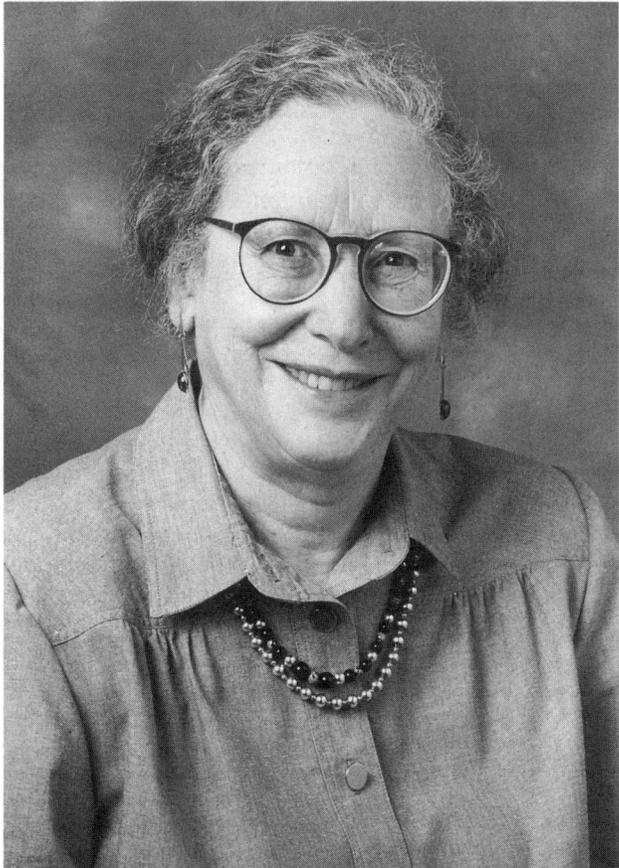

Background

Carolyn G. Heilbrun is Professor of English at Columbia University and has created a new approach to women's biographies in her books *Reinventing Womanhood*, *Writing a Woman's Life*, and *Hamlet's Mother*. She is also well known for her mystery series under the

pseudonym of Amanda Cross. Heilbrun gave the keynote address on June 11, 1992, at the conference entitled "May Sarton at 80," at Westbrook College in Portland, Maine. Heilbrun's selection as keynote speaker seems particularly appropriate given Sarton's (1992) description of their twenty-year friendship: "She always succeeds in making me laugh at myself and, in the kindliest possible way, gives me renewed courage. Without Carol, would I have managed to sustain this curious life? She has been able to help keep the compass set accurately" (p. 41).

Approach of the Speaker

Bradford Dudley Daziel, organizer of the conference, said that Professor Heilbrun was given an open-ended invitation to define her purpose as she chose (Jensen, 1992e). Heilbrun describes in the speech itself her initial choice of a flexible title and the two factors which later focused her thoughts.

The importance Heilbrun placed on her subject is reflected in this passage written a few months before her address.

> May turns eighty in 1992, marking a lifetime richly lived, rich in literary achievement. Happily, 1992 also marks the twentieth anniversary of our meeting; they have been my best twenty years and she is a vital part of them. It comes to this: she has understood love better than anyone, never confusing it with passion. We have known anger and let it pass us by. Flowers and animals and wine have adorned our meetings; above all we have shared conversation and laughter. I greet her now, on this double anniversary, with gratitude, admiration, amazement. (Heilbrun, 1992)

"The May Sarton I Have Known"
© 1992 Carolyn G. Heilbrun

I have called this talk "The May Sarton I Have Known" and the title is deliberately ambiguous. At first, it was ambiguous because I had been asked to supply it many months before I had begun to write the talk, and merely grasped, as is my wont, at a title broad enough to cover all possibilities. And yet, even then, I knew I wanted to say something personal—something about the May Sarton who spoke to me in tones I could hear nowhere else. It was also ambiguous, I now see, because I wanted to relate what I know of May Sarton to my ever-changing ideas about women's biography.

For some years, I have been pondering and writing on the subject

of women's biography—how it may differ from standard biographies of men or of conventional women who were merely events in the lives of men. I was interested in new interpretations of women's lives, and, eventually, new women's lives—new ways that women might live, outside the narrow beam of convention, heedless of Dan Quayle's views on the matter, outside even the expectations many of us born before the end of World War II were taught to accept as "normal," that is: permissible. The clue to a woman's life, I came to see, lay in her ability to resist socialization. Women of achievement often resist that socialization early.

Now, May Sarton's is a life that has never paid tribute to conventionality or received opinion for its own sake, and requires a biography that will not judge her by standards she had the courage to refuse to live by. It is in celebration of that courage that I want to speak today.

For in thinking about May Sarton's life in preparation for today, I realized that I wanted to speak of a life whose courage and extraordinary quality, I might even say whose uniqueness, has been with me throughout the two decades I have known her. Her life is a phenomenon that I want very much to name, and to describe as I have known it, and as it has impressed itself upon me.

Such thoughts were occupying me when two minor events occurred: I happened to read a couple of biographies that brought what I wanted to say sharply home to me, although, to be honest, I think there are a myriad of other biographies that might have done the same, if not so sharply. These books were offered to me as it were accidentally, and with no connection to May, by people who simply thought that, in a general way, I would find them interesting. And then, the second event: on May 21st I read in the *New York Times* the names of those elected to the American Academy and Institute of Arts and Letters. Suddenly, I knew exactly what it was I wanted to say about the May Sarton I have known.

She has been alone most of her life. She has done what she wanted to do and paid the price in loneliness and anger and a great sense of deprivation. She has not borne these burdens in silence, as anyone who has met her knows, and I don't see why she should. I shall return to that point. I want to begin by suggesting that loneliness and deprivation and anger such as May has felt are noticeable and, when they are written of as poignantly and pointedly as she has written of them, they are scorned. But the equally powerful sense of loneliness and deprivation felt by conventional wives and mothers and "ladies" locked in secure marriages has not been scorned; it has not even been noticed until quite recently. Any married woman without close women friends will tell you how lonely one can be surrounded by all the values so highly touted

by Quayle and those for whom he speaks—values which he would not submit to for a moment, but which he can comfortably pretend to honor. I have elsewhere defined conservatives as those who can bear with equanimity the pain of others, and that is a definition wonderfully embodied in today's right wing. What the right wing has neglected to say is that for many of these women embodying "values," loneliness and deprivation are almost unbearable, but are not voiced. For many, May Sarton has voiced the hidden rage, the depression, and allowed them to find their anger embodied in a woman whose voice they can allow themselves to hear because she speaks from a life they know they could never dare.

Now, being alone does not only mean that you are often just that: alone, and sometimes, doubting your vision, though never fundamentally doubting it. Alone also means you are not part of the literary network that rewards its own by electing them to the Academy and Institute of Arts and Letters, giving them prizes, and praising them or, if that seems the clever move, damning them in all the proper journals. Let us look at those announced in the *New York Times* article of May 21, 1992: eighteen days after May's 80th birthday.

First of all, most of them are men; eliminating those either elected or given prizes for accomplishments other than literature—music, art, dancing, architecture—there were about 40 awards, seven of them to women. All the new Academy (as opposed to the Institute) members were men. All the awards went to establishment types, guaranteed not to rock the boat or suggest anything that might make those slightly to the left of Dan Quayle nervous. I am willing to wager there was not one name on that list whose owner did not know most members of the Academy personally, or a few of them well, and had not dined or partied with a good many of them. Virginia Woolf referred to this sort of thing as "all that humbug," but had, all the same, many influential friends and relations.

May Sarton has never been a part of this. Even when she had an influential friend, the friend (I think, for example, of Louise Bogan, poetry reviewer for *The New Yorker*) was unable to commit herself profession-ally to May: what would the men think? May and I used to joke that after she had published seventeen or some such number of books, the only good review she had in the *New York Times Book Review* was for a children's book about a parrot.

May had a vision and she remained true to it. That is amazing enough. But she remained true to it unsupported and largely unrewarded by the critical, the academic, or the literary world. That she was not unsupported financially is due to the fact that, despite all the efforts of reviewers, all the neglect of the academy and people who matter in the literary marketplace, she was read. If she published a book, thousands

of people went out and bought it; other thousands read it. Many of them, sometimes I suspected all of them, wrote to her about it, but that is another story.

Now, about the two books I happened to read. They are Susan Cheever's biography of her father, John Cheever, and Mary McCarthy's *Intellectual Memoirs: New York 1936–1938*. As I have said, I acquired both these books serendipitously. Furthermore, it was only after I had read them and seen their relation to the life of May Sarton that I noticed one of those coincidences that appear as gifts of fate. All three: Cheever, McCarthy, Sarton, had been born in 1912.

I want to add, about Susan Cheever's biographical memoir of her father, that I think it is a fine book. My comments are concerned with her father's life and with the perceptive insights she has offered about that life, the life I hold up as a mirror to May's. Let me read you from a page late in the book:

> In the last years of his life, my father had achieved both wealth and fame. He had won all the prizes and his books had . . . hit the top of the best-seller list. His stories had been adapted for the stage and the movie and television screen, and in the summer of 1981 Channel 13 filmed *The Shady Hill Kidnapping*, a drama for which he had written the screenplay—something he had been wanting to try for years. . . . An occasional guest or journalist or student would come for lunch, which was eaten downstairs in the dining room. [In those years] My mother served soup, a salad, and cheese and crackers or bread, and my father usually peeled himself a piece of fruit for dessert.

End quote. I shall not belabor the comparison with May here.

On to Mary McCarthy. I must admit that she is a woman I have always disliked without ever quite knowing why. I think I early recognized her as the sort of woman who becomes one of the boys; certainly her judgment of other women seems composed wholly of the male gaze; here she is, for example, remembering a fellow woman writer of the thirties: not very attractive, "she was blond, grayish-eyed and dumpy, with a sharp turned-up nose. . . . [She], to my horror, saw herself as seductive. Once . . . I saw her look in the mirror with a little smile and toss of her head; 'Of course I know I'm kinda pretty,' she said." The sneer is palpable. The last time I encountered McCarthy's sneer was when I read her wholly negative review of *The Handmaid's Tale* on the front page of the *New York Times Book Review*. I think it was the most incomprehensible review of that book Atwood received.

McCarthy is credited with nonconformity by Elizabeth Hardwick, who wrote the foreword to these memoirs, a nonconformity arising from "a genuine skepticism about the arrangements of society." Well, I thought, May has that sort of skepticism, for which I so admire her. In

what did McCarthy's skepticism consist? Because she had no talent for the single life, and believed in marriage, she married four times, and felt she had to marry Edmund Wilson because she had slept with him. When she saw people who were not her friends "on the street up in Maine, she would faithfully 'cut them,' " forcing Hardwick to wave to them behind her back. Domestic matters held a high place in her life, which meant that she ground coffee-beans in a wooden and iron contraption that was 'muscle building'; in short, she did not, as a matter of principle, *believe* in labor-saving devices; perhaps she had never had a life demanding enough to require them. She refused to use credit or charge cards to honor her "nonconformist" ideals, and therefore had to carry large sums of money, in fact rolls of bills. Cheever, we can assume, was not against modern conveniences on principle, but he drank too much—he was, indeed, an alcoholic—and struggled secretly with his attraction to homosexuality, all the time surrounded by wife, family, dogs, children, and wide lawns.

Sarton's life has been a different matter altogether. She is never mean for the joy of it, and had no such support system as either of these successful writers. Let us be honest and say she also did not write their sort of crisp, sophisticated prose upholding all the conventions and assumptions and acceptable complaints of their set. Although May published some of her early memoirs in that monument to acceptable cynicism, *The New Yorker*, none of her later more courageous or revolutionary writings at all met their requirements. In speaking to me just a few days before I left for this conference, May mentioned to me, laughing, that two California reviewers of her most recent book had said that she wrote badly but they had been "mesmerized" by what she wrote. It seems to occur to no one to try to reconcile contradictory statements such as these.

The May Sarton I know has, unlike Cheever or McCarthy or, indeed, at least until recently, many other people, lived a life rare in its courage, its solitude, and it marginalization by the literary establishment. As this conference testifies, academics have begun scholarly interpretations of her writings, but this has come late in her life. Had it come this late in the life of Cheever or McCarthy, they would both have been dead.

I only met May in 1972, but I knew her work and recognized without being able to formulate that recognition that hers was a life of courage, and not fashionable courage at that. There were all kinds of fashionable courage in my youth, of which Mary McCarthy and Lillian Hellman, who loathed each other, are good examples. Sarton was brave in a different way. She was brave about her vision, her love of women, her love of the theater, and her admiration for those who were great writers; she admired Virginia Woolf when no American academic considered Woolf worth studying. Sarton had a glimpse of the literary world of

London, but she came back to America where her life was. She wrote of women loving women, but also of women loving men. She wrote poems and memoirs and novels that no one else was writing, or could have written. And she spent lonely hours being sick after her poems were spat upon by one of the day's literary lights.

The celebration of solitude was something altogether new in May's work; not misanthropy, but a choosing the work over the social and professional benefits of a different kind of life. For a woman to choose solitude, and to understand and express its terrors and beauty was close to unique when May did it; it has become more readily comprehensible, even fashionable, since. Anne Morrow Lindberg's supposed isolation on an island in "A Gift from the Sea," was more celebrated but was, in fact, merely an escape from and a reconciliation to a conventional womanly life. The great majority of women, almost all of us in fact, paid almost any price to share the burdens of our life and to guarantee, or attempt to guarantee, continued care and companionship as we edged into our older years. May had not alone chosen solitude, she had written of it frankly. Virginia Woolf created Lily Briscoe, the solitary artist in *To the Lighthouse*, forty years before anyone—and that anyone is May— really lived that life.

By the time I met her she had moved to live alone in an isolated house in a small village in New Hampshire. She was standing outside that house when I first saw her; then we went to visit the donkey of *The Poet and the Donkey*, and the neighboring farmers who had lent the donkey to May; then we walked through her fields. *The Poet and the Donkey*, incidentally, is the best book I know on how to be a writer without ever making any such claim.

May Sarton was forty-five when she began living alone in the house in Nelson. From that day to this she has lived alone, experiencing the magnificent conflict of solitude: the need of outer stimulation, even the welcoming of it, and then, immediately it is granted, the intense longing for those times when "the house and I are alone."

Let me say that in those early years of our relationship she sometimes screamed at me, in person or on the phone, and at first I found myself appalled. Once or twice she said unkind things, and hurt my feelings badly. But it did not take me long to realize that one who lives alone must scream to her friends of her outrage, and the friends soon learn to take it in their stride. If you are living in a stable relationship, there is someone on whom to vent your anger: someone whose love you can trust to endure attacks beyond the reach of most less-committed friendships. But if you live in solitude, you too must rage at times, you too must risk something to express frustration and anger, and those whose love you risk are your friends. So, to live in solitude, you must have friends who cherish you enough to allow you to rage at them when

needs must. It is a tribute to May's gift of friendship that she has never lacked for such friends; few of us are as rich as she in companions whom we can trust to love and forgive us, friends with whom we can dare to be angry, at them and at a dirty world.

For all that, May does not write mean things of people, she does not sneer at them in print; what she remembers is the friendship and the love. That alone, and honors aside, distinguishes her from Cheever and McCarthy. If she has bouts of self-pity—and who has not—they do not become the stuff of her poetry, her memoirs, or her novels. In these, she is more concerned to pay honor.

Her books do not, as Cheever's did, regularly make the best-seller lists. I wonder about those lists. They seem to measure sales in certain stores. They do not measure the effect of books, or how they are treasured, or reread, or used for courage and confirmation of the possibility of courage. But if we could measure the numbers of people to whose lives books made a difference, if we gave prizes for that, or celebrated that, where would May Sarton's reputation be?

Let me be very clear here. May does not offer what the book stores rightly call "self-help books." She is not a "new age" person, nor does she outline techniques for redeeming one's life. She writes the books and poems by the best she knows. That others find courage in her books is not because she has prescriptively put it there. It is because she is a writer who understands the real questions of our time, and names them. She has, for one tiny example, said of the advantage of being old, "I am more myself than I have ever been." I don't know a better evocation of that mysteriously wonderful time: the second half of a woman's adult life, if she is not obsessed with impersonating youth.

May has dared things the best-sellers never dare. She was androgynous before the word had become familiar, and I can speak with some authority on this; when I first used the word 'androgyny' in the title of a book in 1973, it fluttered the dovecotes; today that word is the darling of the media. But before any of this, May had seized on an androgynous view of life and lived it. I need hardly also point out that she wrote of her love of women before that was in any way acceptable to the powers-that-be, and was there, as a figure of hope on the horizon, as many women discovered their own sexual choice, discovered, whatever the sexual choice, the courage of their own desires.

She has written of the old, the sick, the dispossessed, and of the joys and glories of life: flowers, birds, cats, sunrises, and of the endurance of love and the ephemerality and dangers of passion.

So in speaking of the May Sarton I have known, I want to speak mainly not of our occasional visits, our telephone conversations, our infrequent letters, gifts of her books and Christmas poems, and flowers for my birthday chosen with such care that even I, who can scarcely

tell a pansy from a daisy, know I am beholding something marvelous. I want to speak of the woman I have known, through her books and her life, who has been brave, and neglected, and found, and celebrated, and never for one moment tried to be clever, or smart, or with-it, or to write of the angst of those who would sacrifice everything but acclaim, their social life, and the notice of their popular peers. Cheever lived a life protected, rewarded, anguished but never isolated, never sacrificing the benefits that Quayle so idiotically extols. McCarthy had the chance to write bravely of a different world, and never took it. She liked condemning, she liked showing up, she liked writing in great detail and with statistical accuracy of all that happened to her, but she never found the accepted standards of her private world worth questioning. One is not unconventional by cutting people, sneering, carting around rolls of money, and grinding coffee beans in the most arduous possible way even if you can afford something less sensational. Both Cheever and McCarthy had the comfort of the American Academy of Arts and Letters; neither frightened anybody for a moment, or challenged the deepest-held convictions of the society in which they moved. Adultery is not solitude, nor is it revolution. I'm not sure it is even love. Rather, it is a way of finding excitement without paying the price of exclusion.

The May Sarton I have known is an ornery, outspoken, virtuous, feisty, and too-long-ignored woman of courage and a secret knowledge of what matters in life, which she has shared no matter what the price. I shall not be writing her biography; you will hear, later in this conference, from the woman who is. But I would like to say that knowing Sarton has shown me a good deal about the possibilities of women's lives: what it is to be alone, to wish for celebration, and recognition, and prizes, and to understand, beneath the solitude and the rejection, that one has paid a large price for integrity, but not too large a price. Today she has also shown me how, when you are eighty, if you are lucky as May Sarton so late has become, people will gather to celebrate that integrity. And if you are unlucky and they do not come when you are eighty, still you will have left a heritage of courage and risk that will reverberate when the youngest here today is eighty, and even beyond that.

This manuscript was provided by Carolyn Heilbrun and is used with her permission.

Responses to the Address

One editor (Jensen) was present in the audience of approximately three hundred people, which included scholars, readers, and friends of May Sarton from twenty-eight states and two provinces of Canada. The editor

observed attentiveness to Heilbrun's address, heads nodding and other nonverbal indications of agreement or appreciation, laughter (particularly at the references to Dan Quayle), and one interruption of applause. There were several audible "yes's" from the audience at the end of the speech, followed by sustained applause.

Judy Burrowes, a member of the audience and personal friend of May Sarton, said that Heilbrun had done an "excellent job of summing up the courage and integrity that is May Sarton." She suggested that the audience responded so favorably because Heilbrun "was honest and that honesty would [also] be appreciated by May" (Jensen, 1992d).

"Stimulating" and "great" were descriptors offered by other listeners. One conference participant from New York City said she came to the address with reservations about Heilbrun's personal manner and her views on foreign affairs; nonetheless, she found Heilbrun "terribly witty" and said "if nothing else, I will be grateful the rest of my life for her definition of a conservative." Another listener found it a "good speech" although somewhat "shrill"; he also noted with appreciation her characterization of a conservative.

Professor Daziel began his own address the following morning by saying: "Wasn't Carolyn Heilbrun wonderful?"—to which there was considerable audible assent. References to Heilbrun's remarks continued throughout the conference in both formal presentations and informal conversations.

May Sarton was not present for Heilbrun's address, but she wrote in her journal four days later: "All the reports were glowing and all spoke of the constant delighted laughter" (Sarton, 1993, p. 320).

Mary Fisher

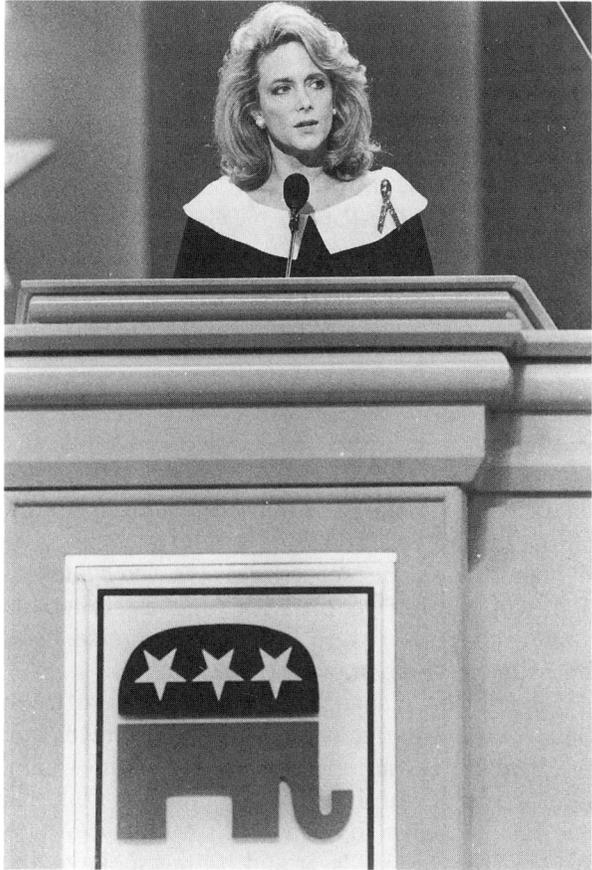

Background

When the Republican party held its 1992 National Convention at the
Houston Astrodome, Mary Fisher was an unexpected speaker with an
unexpected message. She is an artist and mother of two small children.
She is not a politician. But, a year before in New York's LaGuardia

Airport with her sons playing nearby, she phoned her doctor to hear that she had tested positive for HIV (human immunodeficiency virus). "My whole world just did a 180. . . . I couldn't believe it was happening to me," Fisher said (Gleick & Sider, 1992, p. 54).

As a white, affluent, heterosexual woman who does not use drugs, Mary Fisher does not fit the stereotypes of those who suffer with AIDS. Her parents, Marjorie and Max Fisher, are multimillionaires from Detroit. Max Fisher has been a fund-raiser and unofficial advisor to the Republican party for years.

Inspired by Magic Johnson, the professional basketball player who announced his contraction of HIV, Mary Fisher went public in February 1992, in a front page story in the *Detroit Free Press*. Since then she has divided her time among her art, her children, and volunteer work for AIDS. She raises funds in Florida and Michigan for AIDS relief efforts, and has created the Family AIDS Network to provide support systems for family caretakers of those with AIDS (Gleick & Sider, 1992).

Tom Brokaw of NBC News explained why Fisher's address was unusual for the Republican party. The Republican party platform on AIDS suggested a commitment to help, but added that "prevention is linked to personal responsibility and moral behavior. And, that any education about the spread of this disease should stress fidelity, abstinence, and a drug-free life style. Well, of course Mary Fisher maintained all of that and she, nonetheless, is HIV-positive" (Brokaw, 1992). Fisher spoke from the same podium used by Patrick Buchanan, a former presidential candidate, who once said AIDS was God's revenge on homosexuals. Her speech was attended by delegates from the religious right who viewed people with AIDS as sinners and, according to *The New York Times*, were prepared to create hysteria with politically motivated anti-gay attacks (1992, p. 14).

Fisher gave her speech on August 19 as part of an evening convention focus on the American family. Her speech was reminiscent of speeches by Elizabeth Glaser and Bob Hattey at the Democratic National Convention just a month previously in New York. Glaser and her son are also infected with HIV, and her seven-year-old daughter died of AIDS in 1988. However, Glaser and Hattey spoke to an audience comprised of many supporters for their cause. Many participants at the Democratic Convention displayed red ribbons on their lapels, which have come to symbolize support for persons with AIDS. In contrast, Fisher was noted to be the only speaker at the Republican Convention to wear the red ribbon. She said when she looked out at the audience she saw only two people wearing ribbons, her close friends, Gerald and Betty Ford (*The New York Times*, 1992, p. 14).

The speech was introduced through a video clip that provided background on Fisher and ended with her narrating a portion of a letter to her sons—Max, age 4½, and Zack, age 2½:

Each night I rehearse for the day when I must give you over. That is why, as I reach for the day's last kiss and hug, you always hear me say the same four words: "Sleep with the angels."

Approach of the Speaker

Mary Fisher was invited to speak at the National Convention several months after she testified at the Republican platform hearings in May of 1992. In an interview with CNN reporter Charles Bierbaur immediately after her speech, she acknowledged that she knew she "might be used here," in the party's effort to appeal to more liberal Republicans. However, she said she was being "used in a positive sense. I had an incredible opportunity to speak . . . to tell my story and to say how I feel" (Bierbaur, 1992).

During a telephone interview, DeFrancisco (1992j) asked what her goals were as she approached the podium with millions of people across the United States listening. Fisher explained that she had not changed her basic message from previous speeches. "It is the same thing I have been telling people the last seven months. I want to get the truth out . . . that we are one family. . . . I knew I was speaking not only to people at the Astrodome, but to people watching on television. There's a whole group of people out there who are HIV-positive and I wanted them to feel I am one with them." In another interview, Fisher said she knew what she wanted to tell the Republican audience: "That we're in the middle of an epidemic and we all must care for those affected. Be compassionate and then turn that compassion into action" (Gleick & Sider, 1992 p. 56).

Reflecting on the tone of the convention, DeFrancisco asked Fisher how aware she was of those who had spoken before her, such as Pat Robertson and Pat Buchanan, and of delegates on the floor who seemed to oppose her message. Fisher said her speech was written before the convention and that she did not change it. "I was as surprised as everyone else at the level of attack and I knew there were people in the audience not ready to hear what I wanted to say—I was ready to talk over them." She explained that people had told her the noise level would be high during her speech and that she should be prepared to speak over the noise. "I knew I was doing what I believed in."

What Fisher was not prepared for was the attention she received during her speech: "Half way through I realized there was no noise—people were *looking* at me. At that point I didn't know if it was good or bad." She did not know how to interpret their silence until much later, but it did not matter because she said she felt very strong as she spoke.

Fisher said that as a former television producer and a member of President Ford's advance team, she had extensive practice in telling

others how to give speeches. However, she had little public speaking
experience prior to her activist work against AIDS. She consulted several
people in preparing the speech, including her brother and friends in
AIDS support groups. It was important to her to avoid insulting anyone
in the speech. In drafting the speech, Fisher said she provided the
concepts, the feelings, her speaking goals, and pieces of writing. A friend
who serves as her writing consultant provided writing expertise where
needed. A part of her preparation was to know the speech very well.
She was able to look at the audience during much of the address,
referring to teleprompters when needed.

Still, during the moments of waiting in the holding room of the
convention center, she felt the pressure and excitement building. She
said she was very nervous, "but then once I got out there I was fine.
I have a little meditation that I do." She explained that this helped to
center her focus. During the speech she knew where her family and
friends were seated, and she looked to them for support. "I trusted if
I let it happen, it would be fine. It was an emotional, personal
experience." She said that a letter of good luck sent to her prior to the
speech had also given her strength. It was from Bob Hattey, one of the
speakers on AIDS at the earlier Democratic National Convention. She
paraphrased his message, "It may be one of the toughest things you've
ever done, but you will feel free when you've done it."

"A Whisper of AIDS"

Thank you.

Less than three months ago, at Platform Hearings in Salt Lake City,
I asked the Republican party to lift the shroud of silence which has been
draped over the issue of HIV/AIDS. I have come tonight to bring our
silence to an end.

I bear a message of challenge, not self-congratulation. I want your
attention, not your applause. I would never have asked to be HIV-
positive. But I believe that in all things there is a good purpose, and
so I stand before you, and before the nation, gladly.

The reality of AIDS is brutally clear. Two hundred thousand
Americans are dead or dying; a million more are infected. Worldwide,
forty million, sixty million, or a hundred million infections will be
counted in the coming few years. But despite science and research,
White House meetings and congressional hearings; despite good
intentions and bold initiatives, campaign slogans and hopeful
promises—despite it all, it's the epidemic which is winning tonight.

In the context of an election year, I ask you—here, in this great hall,

or listening in the quiet of your home—to recognize that the AIDS virus is not a political creature. It does not care whether you are Democrat or Republican. It does not ask whether you are Black or White, male or female, gay or straight, young or old. [Applause]

Tonight, I represent an AIDS community whose members have been reluctantly drafted from every segment of American society. Though I am White, and a mother, I am one with a Black infant struggling with tubes in a Philadelphia hospital. Though I am female, and contracted this disease in marriage, and enjoy the warm support of my family, I am one with the lonely gay man sheltering a flickering candle from the cold wind of his family's rejection. [Applause]

This is not a distant threat; it is a present danger. The rate of infection is increasing fastest among women and children. Largely unknown a decade ago, AIDS is the third leading killer of young-adult Americans today—but it won't be third for long. Because, unlike other diseases, this one travels. Adolescents don't give each other cancer or heart disease because they believe they are in love. But HIV is different. And we have helped it along—we have killed each other—with our ignorance, our prejudice, and our silence.

We may take refuge in our stereotypes, but we cannot hide there long. Because HIV asks only one thing of those it attacks: Are you human? And this is the right question: Are you human?

Because people with HIV have not entered some alien state of being. They are human. They have not earned cruelty and they do not deserve meanness. They don't benefit from being isolated or treated as outcasts. Each of them is exactly what God made: a person. Not evil, deserving of our judgment; not victims, longing for our pity. People. Ready for support and worthy of compassion. [Applause]

My call to you, my Party, is to take a public stand no less compassionate than that of the President and Mrs. Bush. They have embraced me and my family in memorable ways. In the place of judgment, they have shown affection. In difficult moments, they have raised our spirits. In the darkest hours, I have seen them reaching not only to me, but also to my parents, armed with that stunning grief and special grace that comes only to parents who have themselves leaned too long over the bedside of a dying child.

With the President's leadership, much good has been done; much of the good has gone unheralded; and as the President has insisted, "Much remains to be done."

But we do the President's cause no good if we praise the American family but ignore a virus that destroys it. [Applause] We must be consistent if we are to be believed. We cannot love justice and ignore prejudice, love our children and fear to teach them. Whatever our role, as parent or policy maker, we must act as eloquently as we speak—else

we have no integrity.

My call to the nation is a plea for awareness. If you believe you are safe, you are in danger. Because I was not a hemophiliac, I was not at risk. Because I was not gay, I was not at risk. Because I did not inject drugs, I was *not* at risk.

My father has devoted much of his lifetime to guarding against another holocaust. He is part of the generation who heard Pastor Niemoeller come out of the Nazi death camps to say, "They came after the Jews and I was not a Jew, so I did not protest. They came after the Trade Unionists, and I was not a Trade Unionist, so I did not protest. They came after the Roman Catholics, and I was not a Roman Catholic, so I did not protest. Then they came after me, and there was no one left to protest." [Applause]

The lesson history teaches is this: If you believe you are safe, you are at risk. If you do not see this killer stalking your children, look again. There is no family or community, no race or religion, no place left in America that is safe. Until we genuinely embrace this message, we are a nation at risk.

Tonight, HIV marches resolutely toward AIDS in more than a million American homes, littering its pathway with the bodies of the young. Young men. Young women. Young parents, and young children. One of the families is mine. If it is true that HIV inevitably turns to AIDS, then my children will inevitably turn to orphans.

My family has been a rock of support. My eighty-four-year-old father, who has pursued the healing of the nations, will not accept the premise that he cannot heal his daughter. My mother has refused to be broken; she still calls at midnight to tell wonderful jokes that make me laugh. Sisters and friends, and my brother Phillip, whose birthday is today— all have helped carry me over the hardest places. I am blessed, richly and deeply blessed, to have such a family.

But not all of you [Applause], but not all of you have been so blessed. You are HIV-positive but dare not say it. You have lost loved ones, but you dared not whisper the word AIDS. You weep silently; you grieve alone.

I have a message for you: It is not you who should feel shame, it is we. We who tolerate ignorance and practice prejudice, we who have taught you to fear. We must lift our shroud of silence, making it safe for you to reach out for compassion. It is our task to seek safety for our children, not in quiet denial but in effective action.

Someday our children will be grown. My son Max, now four, will take the measure of his mother; my son Zachary, now two, will sort through his memories. I may not be here to hear their judgments, but I know already what I hope they are.

I want my children to know that their mother was not a victim. She

was a messenger. I do not want them to think, as I once did, that courage is the absence of fear; I want them to know that courage is the strength to act wisely when most we are afraid. I want them to have the courage to step forward when called by their nation, or their Party, and give leadership—no matter what the personal cost. I ask no more of you than I ask of myself, or of my children.

To the millions of you who are grieving, who are frightened, who have suffered the ravages of AIDS firsthand: Have courage and you will find support.

To the millions who are strong I issue the plea: Set aside prejudice and politics to make room for compassion and sound policy. [Applause]

To my children, I make this pledge:

> I will not give in, Zachary, because I draw my courage from you. Your silly giggle gives me hope. Your gentle prayers give me strength. And you, my child, give me the reason to say to America, "You are at risk."

> And I will not rest, Max, until I have done all I can to make your world safe. I will seek a place where intimacy is not the prelude to suffering.

> I will not hurry to leave you, my children. But when I go, I pray that you will not suffer shame on my account.

To all within the sound of my voice, I appeal: Learn with me the lessons of history and of grace, so my children will not be afraid to say the word AIDS when I am gone. Then their children, and yours, may not need to whisper it at all.

God bless the children, and bless us all—good night.

This manuscript was provided by Mary Fisher and is used with her permission. The editors made minor changes based on a videotape of the speech.

Responses to the Speech

Amid a fog of smugness and sermonizing, Mary Fisher burst on the Republican National Convention on Wednesday night like a sudden flare of light and warmth. After nearly two days of finger-wagging from puritans and scolds . . . delegates might have been forgiven for starting to despair as the atmosphere seemed to grow more dour by the minute.

But, then, quietly, firmly, came Ms. Fisher. 'I want your attention,' she said kindly, 'not your applause.' She got both. Within a few sentences she had sliced through the blathering of meanness and moralizing that had dominated the first half of the convention. She told her story—and the nation's story—with a rare dignity and clarity. (*Miami Herald*, 1992 p. 16A)

The Associated Press (1992b) wrote that she "did what no other speaker had until then managed to do: she got the crowd to stop bustling about, sit quietly, and listen intently to her words" (p. 4A). Olivia Silva Maiser, a delegate from Los Angeles, said: "She had the audience absolutely spellbound. It was the first time this week that total silence fell over the floor" (Eaton, 1992, p. A3). Television viewers watched as tears welled in many of the delegates' eyes during her fifteen-minute speech. After her speech the audience stood to applaud. Tom Brokaw (1992) of NBC News said in the minutes following her speech, "It was really one of the more eloquent speeches that we've heard on that subject anywhere, and certainly one of the more eloquent speeches that we've heard this week" [at the Republican Convention].

Mary Fisher's speech stood out in contrast to earlier speeches at the convention. Mary Louise Smith, former chair of the Republican National Committee, was on the convention floor that night. She said she was "seated in a listening mood—and listened well." She recalled that when Fisher asked for the delegates' attention, "the hall quieted down far beyond anything comparable to even the major speeches." She said of the speech that it was "as much about tolerance as it was about AIDS." She believed that "many in the audience were affected emotionally [she saw people "openly weeping"] and many were affected by the implications for the party, but there were others in the audience who were not touched in that same way." She said: "They were touched because here before them stood a young woman who had AIDS and was probably going to die leaving two children, but I don't think that message of tolerance came through to them vis-á-vis the party." She went on to say that Fisher's "message is not consistent with the spirit that was present at that convention." She contrasted it with Pat Buchanan the night before "vilifying everyone" and called the contrast "such an enigma." Smith did not believe that "the people who controlled the convention were able to see it in the sense of what it meant." She speculated on what audience members could be thinking when Fisher said "I am one with the lonely gay man," since "they had just applauded Buchanan's speech the night before." She wondered if Fisher "realized the gulf of feelings that she was speaking into." (Jensen, 1992j)

Deborah Potter (1992) of CNN interviewed delegates from Minnesota regarding Fisher's speech and found mixed reactions. Potter asked delegate Marlene Reid: "Do you think it was appropriate to have a woman with HIV speak to this convention?" Reid responded:

> I don't see the point in it. We've already spent a tremendous amount of money on AIDS and the AIDS research and to get AIDS under control. We didn't have a woman with cancer up there speaking to us (it's not that we're not sympathetic) or heart disease. More money is being spent right now on AIDS and AIDS research than there is

on cancer and heart disease. And so I don't think it should be disproportionate that way.

Ruth Hatton, another delegate from Minnesota, agreed that Fisher was an effective speaker, but disagreed with Fisher's position that ignorance causes the spread of AIDS. "It's promiscuity," she said. "We've got to preach abstinence" (Eaton, 1992, p. A3).

Marty Keller, an alternate delegate from California, one of the few openly gay delegates at the convention, said this about Fisher's speech:

> I waited for two and a half days to hear the true voice of my party—and I finally did. . . . I heard that our party, the party of Lincoln, the party that says liberty for all, liberty is indivisible, and that we cannot be judging anyone by any characteristic but their humanity—that's the party I joined, that's the party that just spoke with Mary Fisher.

Keller made his comments during an interview with CNN reporter Frank Sesno. Sesno said: "It sounded at times almost like a lecture to those delegates." Keller responded:

> Well, they need it. It's an unfortunate fact that the radical religious right has taken over the platform, is in control of this delegation, is in control of the presidential campaign at this point. And it is almost a bullying attitude here—of people essentially saying: I've got mine and the heck with the rest of you. And I think Mary Fisher has become our conscience tonight. And she's issued a challenge to all of us that this is not tolerable—that we will not win elections if we are going to be the party of exclusion. If we are not going to be the party of all Americans—gay or straight, wed, unwed, black, white, male and female, we do not deserve to be in leadership. (Sesno, CNN, 1992)

Finally, NBC reporter Jim Miklaszewski (1992) said of the impending presidential address: "If President Bush has just half the impact that Mary Fisher had last night, he'll be doing well for himself." The week of October 5, President Bush named Mary Fisher to the National Commission on AIDS, replacing the man who had inspired her to go public with her health condition—basketball star Magic Johnson.

Epilogue

In 1974, Adrienne Rich was awarded the National Book Award for poetry with her collection, *Driving into the Wreck*. Rich refused the award as presented. Instead, she accepted it together with Audre Lorde and Alice Walker, poets who had also been nominated for the award. Rich's acceptance speech consisted of the following statement prepared by the three women. Their words are far more eloquent than ours could be in concluding this collection of speeches by women leaders. They explain the importance and the challenge of attempting to give voice to women's multiple experiences and perspectives. Their collaborative, rather than competitive stance represents goals we have for our readers: that the women in this collection be appreciated for their unique contributions as speakers and leaders, and that their collective voices be heard as a new sound in our time.

"A Statement for Voices Unheard"

We, *Audre Lorde, Adrienne Rich*, and *Alice Walker*, together accept this award in the name of all the women whose voices have gone and still go unheard in a patriarchal world, and in the name of those who, like us, have been tolerated as token women in this culture, often at great cost and in great pain. We believe that we can enrich ourselves more in supporting and giving to each other than by competing against each other; and that poetry—if it is poetry—exists in a realm beyond ranking and comparison. We symbolically join together here in refusing the terms of patriarchal competition and declaring that we will share this prize among us, to be used as best we can for women. We appreciate the good faith of the judges for this award, but none of us could accept this money for herself, nor could she let go unquestioned the terms on which poets are given or denied honor and livelihood in this world,

271

especially when they are women. We dedicate this occasion to the struggle for self-determination of all women, of every color, identification, or derived class: the poet, the housewife, the lesbian, the mathematician, the mother, the dishwasher, the pregnant teenager, the teacher, the grandmother, the prostitute, the philosopher, the waitress, the women who will understand what we are doing here and those who will not understand yet; the silent women whose voices have been denied us, the articulate women who have given us strength to do our work.

This manuscript was published in Ms. Magazine, September 1974, and is reprinted with permission from Audre Lorde, Adrienne Rich, and Alice Walker.

References

Abrahamson, K. (1990, April 11). Abrahamson protests choice of commencement speaker. *The Wellesley News*, p. 20.

Abzug, B. (1972). *Bella! Ms. Abzug Goes to Washington.* M. Ziegler (ed.) New York: Saturday Review Press.

Adams, J. (1992, April 7). Up to the minute, CBS News.

Angel, C. (1989, September 29). Teacher of the year has a goal. *Detroit Free Press*, pp. 1A, 14A.

Applebome, P. (1988, July 18). A skilled politician and speaker. *The New York Times*, p. A13.

Associated Press (1991a, October 28). Simpson shows remorse for his conduct at hearings. *The Des Moines Register*, p. 4A.

_____. (1991b, October 15). Hill blasts Republicans. *The Des Moines Register*, p. 8A.

_____. (1992a, August 10). Hill honored, urges courage to speak. *The Des Moines Register*, p. 4A.

_____. (1992b, August 20). Woman with AIDS urges action. *The Des Moines Register*, p. 4A.

Bardach, A. N. (1992, January). Nina Totenberg: Queen of the leaks. *Vanity Fair*, pp. 46–57.

Batey, T. (1991, May 16). Media giants descend on symposium. *Oregon Daily Emerald*, pp. 1, 12.

Bierbaur, C. (1992, August 19). Interview with Mary Fisher at the National Republican Party Convention, CNN.

Borger, G. (1990, May 28). Behind the Wellesley flap. *U.S. News & World Report*, pp. 31–32.

Boxer, B. (1992a, July 23). Personal letter to Marvin D. Jensen.

_____. (1992b, July 23). Statement of Barbara Boxer on the testimony of Elizabeth Taylor before the Budget Committee's Task Force on Human Resources (unpublished).

Bray, R. (1991, November). Taking sides against ourselves. *The New York Times Magazine*, pp. 56, 94–95, 101.

Brokaw, T. (1991, October 11). Clarence Thomas confirmation hearings. NBC.

_____. (1992, August 19). National Republican Party Convention. NBC.

Burns, J. M. (1978). *Leadership.* New York: Harper & Row.

Campbell, K. K. (1991, January). Hearing women's voices. *Communication Education, 40* (1), 33–48.

Carlson, M. (1990, June 11). The end of another cold war. *Time*, p. 21.

Carpenter, T. (1980, April). Courage and pain: Women who love God and defy their churches. *Redbook*, pp. 19, 149–153.

Castro, G. (1990). *American feminism: A contemporary history*. New York: New York University Press.

Chatham, A. (1992, October 10). Personal letter to Victoria L. DeFrancisco.

Cherokee Advocate. (1991, September). Cherokee Nation inaugurates new legislature: Principal Chief Wilma Mankiller begins second term, pp. 1, 10,11.

Chrisman, R., and Allen, R. (1992). *Court of appeal: The black community speaks out on the novel and sexual politics of Thomas vs. Hill*. New York: Ballantine Books.

Clift, E., McDaniel, A., and Bingham, C. (1990, June 11). A job Wellesley done. *Newsweek*, p. 26.

Conger, J. (1993, March 17). Personal letter to Victoria L. DeFrancisco.

Congressional Record—Senate. (1991, October 15), *137*, pp. 514649–514650.

Couric, K. (1992, October 7). *The Today Show*, NBC.

Current Biography Yearbook. (1971). New York: H. W. Wilson, pp. 1–3.

_____. (1987). New York: H. W. Wilson.

DeFrancisco, V. L. (1991a, July 9). Telephone interview with Carrie Dennett, at her office, *Oregon Daily Emerald*, University of Oregon, Eugene.

_____. (1991b, July 19). Telephone interview with Arnold Ismach, at his office, School of Journalism, University of Oregon, Eugene.

_____. (1991c, July 30). Telephone interview with Margaret Gordon, at her office, Graduate School of Public Affairs, University of Washington, Seattle.

_____. (1991d, August 15). Telephone interview with Jennifer King, at her office, School of Journalism, University of Oregon, Eugene.

_____. (1991e, August 30). Telephone interview with Geneva Overholser at her office in Des Moines, IA.

_____. (1992a, March 10). Telephone interview with Pat Cain and Jean Love at their home in Iowa City, IA.

_____. (1992b, April 16). Interview with Eleanor Smeal at the University of Northern Iowa, Cedar Falls.

_____. (1992c, April 24). Interview with June Osborn at the University of Northern Iowa, Cedar Falls.

_____. (1992d, April 28). Telephone interview with Charlayne Hunter-Gault at her office in New York.

_____. (1992e, May 16). Telephone interview with Dixie Brackman at her home in Indianapolis, IN.

_____. (1992f, July 7). Telephone interview with Olivia Armijo Killough in Denver, CO.

_____. (1992g, July 8). Telephone interview with Cecilia Cervantes, Denver, CO.

_____. (1992h, July 17). Telephone interview with Cynthia Ann Broad at her home in Grosse Pointe Shores, MI.

_____. (1992i, September 18). Telephone interview with Barbara Ann O'Leary in Washington, DC.

DeFrancisco, V. L. (1992j, September 23). Telephone interview with Mary Fisher at her home in Boca Raton, FL.

_____. (1992k, September 23). Telephone interview with Jo Montana at her office in Tahlequah, OK.

_____. (1992l, September 24). Telephone interview with Mike Synar at his office in Washington, DC.

_____. (1992m, September 25). Telephone interview with Ralph Swimmer at his home in Tulsa, OK.

_____. (1992n, October 21). Telephone interview with Barbara Bruegger at her office in Atlanta, GA.

_____. (1992o, October 21). Telephone interview with Liz Flowers at her office in Atlanta, GA.

_____. (1992p, October 21). Telephone interview with Kimberly Hebart at her office in Atlanta, GA.

_____. (1992q, October 21). Telephone interview with Beverly Stripling at her office in Washington, DC.

_____. (1992r, December 20). Telephone interview with Chris Frakes at her home in Wellman, IA.

_____. (1993a, January 3). Telephone interview with Rita Arditti in Key West, FL.

_____. (1993b, January 30). Telephone interview with Ellen Leopold at her home near Boston, MA.

_____. (1993c, January 30). Telephone interview with Charlotte A. Price at her home in New York.

_____. (1993d, January 31). Telephone interview with Lise Beane at her home near Boston, MA.

_____. (1993e, February 6). Telephone interview with Amy Present at her home near Boston, MA.

_____. (1993f, March 10). Telephone interview with Cheng Imm Tan at her home in Boston, MA.

_____. (1993g, March 16). Telephone interview with Mary Theresa Li at her office in Portland, OR.

Denniston, L. (1992, April). Senate says: Why not blame it on Nina? *Washington Journalism Review*, p. 55.

The Des Moines Register. (1985, September 10). Names can boomerang, p. 10A.

The Des Moines Register. (1991, October 13). More probes possible after hearing, p. 6A.

Detz, J. (1991). *Can you say a few words?* New York: St. Martin's Press.

Diehl, K. (1988, August 8). Richards' growing popularity may push her to higher office. *San Antonio Express-News*, p. 1.

Doudna, C. (1986). A still unfinished woman: A conversation with Lillian Hellman. In J. R. Bryer, ed., *Conversations with Lillian Hellman*. Jackson: University Press of Mississippi, pp. 192–209.

Dow, B. J., and Tonn, M. B. (1993, August). "Feminine style" and politcial judgment in the rhetoric of Ann Richards. *The Quarterly Journal of Speech*, 79 (3), pp. 286–302.

Dreifus, C. (1987, February). A talk with Charlayne Hunter-Gault. *Dial 8*, pp. 15–17, 45.

Eaton, W. J. (1992, August 20). Mother with HIV asks GOP to lift silence. *Los Angeles Times* (Washington Edition), pp. A1, A3.

Edmondson, M. and Cohen, A. D. (1975). *The women of Watergate.* New York: Stein and Day.

Feibleman, P. (1988). *Lilly: Reminiscences of Lillian Hellman.* New York: William Morrow.

Fontanelle, J. (1991, October 20). Letter to the editor. *The Des Moines Register,* p. 5C.

Forfreedom, A. (1990–1991). Sexism in the Souter hearings. *The Wise Woman,* pp. 24–29.

Foss, K. A., and Foss, S. K. (1991). Women speak: The eloquence of women's lives. Prospect Heights, IL: Waveland Press.

Frank, K. (1990, Fall). Letter to the editor. *National NOW Times,* p. 5.

Friedman, S. (1991, June 5). Ferraro urges women to enter politics. *Indiana Daily Student,* p. 2.

Fritchey, C. (1974, August 3). Jordan and Holtzman: Advancing the cause. *The Washington Post,* p. A17.

"Frontline" (1992, October 6). Clarence Thomas and Anita Hill: Public hearing, private pain. PBS.

Gailey, P. (1985, September 6). NOW chief describes plans to fight "fascists and bigots." *The New York Times,* p. A18.

Gleick, E., and Sider, D. (1992, August 17). An heiress fights AIDS. *People Weekly,* pp. 54–56.

Gordon, M. (1982, July/August). The unexpected things I learned from the woman who talked back to the Pope. *Ms.,* pp. 65–69.

Gorney, O. (1978, December 5). Feinstein elected mayor, succeeding slain Moscone. *The Washington Post,* p. A2.

Grotewold, Rev. W. S. (1992, October 12). Personal letter to Victoria L. DeFrancisco.

Heaney, M. (1992, December 1). Personal letter to Victoria L. DeFrancisco.

Heilbrun, C. (1992). Untitled. In W. B. Ewert, ed., *Forward into the past: For May Sarton on her eightieth birthday.* Concord, NH: William B. Ewert.

Helgesen, S. (1990). *The female advantage: Women's ways of leadership.* New York: Doubleday.

Hochberg, M. J. (1991, July). Why Geraldine Ferraro wants our support: A candidate at the National Women's Music Festival. *Outlines: The Voice of the Gay and Lesbian Community,* pp. 41–42.

Holley, M. R. (1992). Charlayne Hunter-Gault. In J. C. Smith, ed., *Notable black American women.* Detroit, MI: Gale Research, pp. 535–536.

Hunter, C. (1970, January 25). After nine years—a homecoming for the first black girl at the University of Georgia. *New York Times Magazine,* pp. 24–25, 50.

Hunter-Gault, C. (1992). *In my place.* New York: Farrar, Straus, and Giroux.

Hyer, M. (1979, October 11). After U.S. defiance, Pope orders nuns' obedience. *The Washington Post,* p. A30.

Hyer, M., and Rosenfeld, M. (1979, October 8). A challenge from nuns. *The Washington Post,* p. A25.

Ismach, A. A. (1991). Introduction. *Back to the future: Communications in the twenty-first century.* School of Journalism, University of Oregon, Eugene.

Jacobbi, M. (1990, August). The woman who had to speak out. *Good Housekeeping*, pp. 82–89.

Jamakaya. (1991, July 10). Heat and passion dominate 17th National Women's Music Festival. *Wisconsin Light*, p. 16.

Jensen, M. D. (1991a, July 29). Telephone interview with Susan Ochshorn at Barnard College in New York.

———. (1991b, August 28). Telephone interview with Geraldine Ferraro at her office in New York.

———. (1991c, August 30). Interview with Angela Bowen at the Women's Resource and Action Center in Iowa City, IA.

———. (1992a, June 2 and 18). Telephone interviews with Mary Louise Smith at her home in Des Moines, IA.

———. (1992b, June 4). Telephone interview with Sue Leary at her office in Philadelphia, PA.

———. (1992c, June 8). Telephone interview with Kim Roellig at her office in Washington, DC.

———. (1992d, June 11). Interview with Judy Burrowes at Westbrook College in Portland, ME.

———. (1992e, June 13). Interview with Bradford Dudley Daziel at Westbrook College in Portland, ME.

———. (1992f, August 6). Telephone interview with William Carmack in Norman, OK.

———. (1992g, August 7). Telephone interview with Julian P. Kanter in Norman, OK.

———. (1992h, August 7). Telephone interview with Maggie Kuhn at her home in Philadelphia, PA.

———. (1992i, August 31). Telephone interview with Nina Totenberg at her office in Washington, DC.

———. (1992j, September 1). Interview with Mary Louise Smith at her home in Des Moines, IA.

———. (1993, January 25). Telephone interview with Amy Present at her home near Boston, MA.

Jet. (1989, January 16). 75, p. 40.

Jordan, B. and Hearon, S. (1979). *Barbara Jordan: A self-portrait*. New York: Doubleday.

Kantrowitz, B., Springen, K., and Hager, M. (1991a, October 21). Striking a nerve. *Newsweek*, p. 34–40.

Kantrowitz, B., Starr, M., Friday, C., Barrett, T., Yoffe, E., Wingert, P. Clift, E., Smith, V., and Picker, L. (1991b, April 29). Naming names: The media's role in the Kennedy case fuels a growing controversy: Should the victims of rape be identified? *Newsweek*, pp. 26–32.

Kao, A. (1990, September 12). Class of '90 provides post-graduate perspective. *The Wellesley News*, pp. 1, 12.

Kaplan, D., Cohn B., McDaniel, A., and Annin, P. (1991, October 21). Anatomy of a debacle. *Newsweek*, pp. 26–32.

Kelly, L. T. C. (1992, December 29). Personal letter to Victoria L. DeFrancisco.

Klion, S. R. (1975, June 21). On dumping business. *The New York Times*, p. 26.

Lanker, B. (1989). *I dream a world: Portrait of black women who changed the world*. New York: Stewart, Tabori and Chang.

LaRue, T. R. (1989, October, 18). Macomb county teacher is best in state. *Sterling Heights Sentry*, p. 1.

Leatherman, C. (1992, October 14). Once a little-known law professor, Anita Hill now is a national icon. *The Chronicle of Higher Education*, A18.

Leon, P. (1992, June 13). We women did not achieve all we wanted to, but we achieved enough. *TerraViva*, p. 24.

Levin, M. J. (1992, July 5). We aren't doing enough. *Detroit Free Press*, pp. 1H, 5H.

Lewis, I. (1975, September 8). On truth, justice, and the American way. *Encore American & Worldwide News*, p. 6.

Maley, D. (1991, April 22). Journalist Charlayne Hunter-Gault to be Ithaca College commencement speaker. Unpublished press release, Public Relations Office, Ithaca College.

Mankiller, W. P. (1992a, September 14). Address at Mt. Mercy College, Cedar Rapids, IA.

_____. (1992b, October 6). Address at Wartburg College, Waverly, IA.

Mann, J. (1990, September 21). Outdated patriarchy supports Souter. *The Washington Post*, p. D3.

Marshall, M. (1984, November). First black woman bishop. *Ebony*, *40*, pp. 164–166, 168–170.

Martin, J. (1991, October 20). Letter to the editor. *The Des Moines Register*, p. 5C.

Martin, J. (1974, August 11). A peer of mirror image. *The Washington Post*, p. M14.

McCarthy, J. (1990, May 2). Bush publicity not viewed as harmful. *The Wellesley News*, p. 3.

McCormick, J. (1991, April 22). A Pulitzer for vision. *Newsweek*, p. 69.

_____. (1991, October). Making women's issues front-page news. *Working Women*, pp. 78, 80–81, 106, 108.

Merkin, D. (1991, Summer). Fear and trembling and life notes. *Barnard Alumnae Magazine*, pp. 47–48.

Miami Herald. (1992, August 21). Grace amid the grinches: Mary Fisher's talk on AIDS, p. 16A.

Miklaszewski, J. (1992, August 20). *The Today Show*. NBC.

Millegan, L. (1991, May 14). Media conference begins at university. *Oregon Daily Emerald*, p. 1.

Miller, H. G. (1987, September). Elizabeth Taylor's crusade against AIDS. *The Saturday Evening Post*, pp. 52–53, 102, 106.

Moody, R. (1972). *Lillian Hellman: Playwright*. New York: Pegasus.

Mooty, C. (1989, October 2). She inspires students, peers. *The Macomb Daily*, pp. 1A, 8A.

Morrison, Toni (ed.) (1992). *Rac-ing justice, en-gendering power: Essays on Anita Hill, Clarence Thomas, and the construction of social polity*. New York: Pantheon.

Morse, J. (1991, May 26). Ferraro speech to highlight Indiana festival. *Chicago Tribune*, sec. 6, p. 2.

Moyers, B. (1986). Lillian Hellman: The great playwright candidly reflects on a long, rich life. In J. R. Bryer, ed., *Conversations with Lillian Hellman*. Jackson: University Press of Mississippi, pp. 138–158.

The New York Times. (1992, August 22). Teaching mercy to Republicans (Editorial), p. 14.

Newsweek (1991a, October 21). Newsweek Poll, p. 28.

Newsweek (1991b, November 18). Speaking out, p. 85.

Nomination of David H. Souter to be associate justice of the Supreme Court of the United States. (1991). Hearing before the committee on the judiciary United States Senate, September 13, 14, 17, 18, 19, 1990. Washington, DC: U. S. Government Printing Office.

Overholser, G. (1989, July 11). Editorial. *The Des Moines Register*, p. 1C.

––––––. (1990, February 25). A troubling but important set of stories. *The Des Moines Register*, p. 1C.

Payan, J. (1992, July 2). Personal letter to Victoria L. DeFrancisco.

Pedersen, D. (1988, July 25). Richards: 'I like to make people laugh.' *Newsweek*, p. 22.

Peterson, O. (ed.) (1986). *Representative American Speeches*, 1985, 1986. New York: H. H. Wilson.

Phelps, T. M., and Winternitz, H. (1992). *Capitol games: Clarence Thomas, Anita Hill and the story of the Supreme Court nomination*. New York: Hyperion.

Phillips, B. J. (1974, November). Recognizing the gentleladies of the Judiciary Committee. *Ms.*, pp. 70–74.

Potter, D. (1992, August 19). National Republican Party Convention. CNN.

Ratcliffe, R.G. (1988, July 3). Keynoter: Richards gets supportive call from Dem superspeaker Cuomo. *Houston Chronicle*, p. 1.

Rather, D. (1979). A profile of Barbara Jordan. (Audio Cassette). Danbury, CT: Grolier Educational Corporation.

Reinhold, R. (1988, July 19). 7 Hollywood professionals rate the keynoter. *The New York Times*, p. A17.

Richards, A. (1989). *Straight from the heart: My life in politics and other places*. New York: Simon and Schuster.

Robinson, E., and Weisskopf, M. (1992, June 10). Acceptance of Rio statement linked to other global issues. *The Washington Post*, pp. A1, A20.

Rodrigues, M. (1991, Summer). Overholser exhorts journalists to expand newsrooms and horizons. *Slugline* (Newsletter of the School of Journalism, University of Oregon), p. 7.

Romano, L. (1988, July 18). Keynoter Ann Richards, with her wit about her. *The Washington Post*, pp. B1, B4.

Rosener, J. (1991, June). The valued ways men and women lead. *Human Resources Magazine*, pp. 147, 149.

San Francisco Examiner. (1991, October 16). Phyliss Schlafly, conservative activist, p. A14.

Sarton, M. (1992). *Endgame: A journal of the seventy ninth year*. New York: Norton.

––––––. (1993). *Encore: A journal of the eightieth year*. New York: Norton.

Schlosberg, L., McCarthy, J., and Ramos, T. (1990, April 18). Debate over commencement speaker gains national publicity. *The Wellesley News*, pp. 1, 3.

Schwartz, M. (1988, July 18). Richards practices speech with tongue in cheek. *The Washington Post*, p. A22.

Schwartz, M., and Grove, L. (1988, July 16). Sour note on keynote. *The Washington Post*, p. A7.

Sesno, F. (1992, August 19). National Republican Party Convention. CNN.

Sixtina, M. (1979, October 12). Apology. *The Washington Post*, p. C8.

Slater, W. (1988, July 19). Richards' message personal. *The Dallas Morning News*, pp. A1, A8.

Sloan, D. M. (1990, April 25). Alumna portrays Bush as "jewel" in Wellesley's crown. *The Wellesley News*, p. 23.

Smith, J. C. (ed.) (1992). *Notable Black American Women*. Detroit: Gale Research Inc.

Spiegelman, Donna. (1993, February 1). Personal letter to Victoria L. DeFrancisco.

Steinem, G. (1992a). *Revolution from within: A book of self-esteem*. Boston, MA: Little, Brown and Co.

_____. (1992b). Gross national self-esteem. *Ms.*, pp. 24–30.

Stone, N. G. (1990, May 5). Alumna cites Bush debate as harmful to fundraising. *The Wellesley News*, p. 23.

Tan, C. I. (1992, May). Confronting domestic violence in Asian communities. *Sojourner: The Women's Forum*, pp. 15, 18.

Task Force on Human Resources of the Committee on the Budget of the U.S. House of Representatives (1990, March 7). AIDS funding issues—impact aid, early intervention, research, and prevention. Washington, DC: U.S. Government Printing Office, pp. 1–7.

Time (1987, August 6). Fifty faces for the future, p. 47.

_____. (1992, June 29). Breaking the silence, p. 27.

Todd, A. T. (1990, April 11). Commencement speaker debate exposes Wellesley's 'ills.' *The Wellesley News*, p. 22.

Toner, R. (1988, July 20). Dukakis maintains the pace while pondering next steps. *The New York Times*, p. A1.

Trueheart, C. (1990, September 20). Fuming feminists light senator's fuse. *The Washington Post*, p. D1.

University of Northern Iowa Public Relations Office. (1992, April 10). Women's rights activist speaks to UNI Tuesday. *The Northern Iowan*, p. 4.

Vonnegut, K. S. (1992, January). Listening for women's voices: Revisioning courses in American public address. *Communication Education*, 41 (1), 26–39.

Walsh, K. T., and Schrof, J. M. (1990, May 28). The hidden life of Barbara Bush. *U.S. News & World Report*, pp. 25–30.

Wattleton, F. (1991, July 17). Personal letter to Victoria L. DeFrancisco.

Watts, P. (1991, September/October). Men who (gasp!) manage like women. *Executive Female*, pp. 31–34.

Webb, S. L. (1992). *Step forward: Sexual harassment in the workplace: What you need to know*. New York: Master Media.

Whipple, S. (1990, April 25). Bush controversy draws varied alumnae response. *The Wellesley News*, p. 22.

Who's Who Among Black Americans (1990–1991). Detroit, MI: Gale Research.

Wilner, J. (1992, February 17). NPR subpoenaed on leaks, plans minimal response. *Current*, p. 3.

Wines, M. (1992, June 11). Bush and Rio: President has an uncomfortable new role in taking hard line at the earth summit. *New York Times*, p. A1.

Woodward, K. L., and Lord, M. (1979, October 22). A sister speaks up. *Newsweek*, p. 125.

Wright, J. (1991, May 15). Media urged to mold public agenda. *The Register Guard*, Eugene, OR, p. 1.

Wright, W. (1986). *Lillian Hellman: The image, the woman*. New York: Simon and Schuster.

Yard, M. (1990, September 14). Letter to the editor. *The Washington Post*, p. D26.

Yaukey, J. (1991, May 20). Hunter-Gault tells IC grads: Serve humanity. *Ithaca Journal*, p. 1.

Yepsen, D. (1991, October 12). Lasting impact expected: Iowans see hearing having major effect on behavior at work. *The Des Moines Register*, p. 4A.

Yoachum, S. (1991, November 16). Anita Hill addresses women lawmakers. *San Francisco Chronicle*, p. A7.